Mastering Photoshop Layers

Mastering Photoshop Layers
A Photographer's Guide

Juergen Gulbins

Juergen Gulbins, jg@gulbins.de

Editor: Joan Dixon
Project Editor: Maggie Yates
Proofreader: Jeanne Hansen
Layout and Type: Juergen Gulbins
Cover Design: Helmut Kraus, www.exclam.de
Translator: Jeremy Cloot
Printer: Everbest Printing Co. Ltd through Four Colour Print Group, Louisville, Kentucky
Printed in China

ISBN 978-1-937538-27-9
1st Edition © 2013 by Juergen Gulbins

Rocky Nook Inc.
802 East Cota St., 3rd Floor
Santa Barbara, CA 93103
www.rockynook.com

First published under the title "Photoshop Ebenentechniken für Fotografen"
© dpunkt.verlag GmbH, Heidelberg, Germany

Library of Congress Cataloging-in-Publication Data

Gulbins, Jürgen.
 Mastering Photoshop layers : a photographer's guide / by Juergen Gulbins.
 pages cm
 ISBN 978-1-937538-27-9 (pbk.)
 1. Adobe Photoshop. 2. Layers (Computer graphics) 3. Photography--Digital techniques. I. Title.
 TR267.5.A3G85 2013
 006.6'96--dc23
 2013027184

Distributed by O'Reilly Media
1005 Gravenstein Highway North
Sebastopol, CA 95472

Table of Contents

Foreword

Graphic designers build up complex images layer by layer, starting with the background and gradually adding individual elements and special effects until the image is complete. Many photographers use a similar approach when composing an image, viewing the foreground, the middle distance, and the background as separate zones, be it with regard to focus, lighting, or formal and color-based composition.

The second phase of digital image creation involves processing the images you have captured and often entails optimizing individual image layers separately from one another. For example, a background that has been deliberately blurred requires much less sharpening than the main subject, which will usually be portrayed with maximum contrast. Tonal values, too, often require a layer-based processing approach, with shadows being treated differently from transitions or other elements within the frame. Colors can also be processed in separate zones, with some requiring desaturation while others are intensified. Such processing steps can also be applied with differing strengths from zone to zone to enhance the effect of an image and steer the viewer's gaze within an image.

However, even if you don't use layers or zones of focus in your basic composition, there is a multitude of other reasons to use layer techniques during image processing, and you will get to know many of them in the course of this book.

The Tools We Use

The enormous range of tools available for processing digital images can be confusing, even for experts. To keep things clear, this book uses only Photoshop CS6 and Photoshop CC (the Creative Cloud version, aka Photoshop 14) and refers to equivalent functionality in other versions if necessary. Photoshop's Layers functionality has remained largely unchanged over the course of the past few releases, so most of the tools and techniques described here can be applied to earlier versions of the program as well as to current versions of Photoshop's sister program, Photoshop Elements.

The *CS* in *Photoshop CS* stands for *Creative Suite* and indicates that the version in question is a component of the multi-part *Adobe Creative Suite*. Photoshop CS5 is sometimes referred to as *Photoshop 12* and CS6 as *Photoshop 13*. While this book was being writing, Photoshop Creative Cloud was introduced, also called Photoshop CC or Photoshop 14.

We will show you how to load images for processing from Adobe Bridge and Lightroom, although most other data management systems and Raw converters allow to you to open images in Photoshop using the same basic techniques. Images can also be loaded and opened directly from the Photoshop interface using Mini Bridge or the Image Browser, which has been part of Photoshop since the release of CS5.

In the course of the book we will also be using a few additional tools that perform functions covered by Photoshop in either a more detailed or more sophisticated way, or are simply more user friendly. Most of these tools and plug-ins are available as free trial versions, so try them out before you make a purchase.

Digital photography is an art – and a skill – with enormous potential, and it is quickly replacing conventional analog photo techniques. The speed of development of digital camera and processing technology in the last few years has been breathtaking, and the quality of the resulting images is constantly improving. This book aims to give you a comprehensive introduction to the subject and will help you to quickly familiarize yourself with the ins and outs of the medium, providing a fun way to save time and effort processing your own digital images.

How to Use This Book

Depending on your knowledge level, you can skip the parts of the text that describe techniques you are already familiar with and take more time to study those that interest you most. We assume that you are already familiar with the basic principles of working with Photoshop and recommend that you begin with chapter 1, where the basics of layer techniques are described in detail. This chapter may seem like tough going in places, but it makes a great starting point and reference point for future adventures.

➜ To enable you to follow our examples and hone your own processing techniques, you can download most of the images used in this book from www.rockynook.com/PSL

The chapters that follow sometimes press ahead rapidly, but they always clearly demonstrate the specific techniques they describe. You will also find that we describe these techniques in more detail later in the book to assist us with other processing challenges along the way.

At the end of each chapter we summarize what we have learned and provide a few useful keyboard shortcuts and program settings. If you use Photoshop a lot, you will find that learning and using selected shortcuts will significantly speed up your workflow.

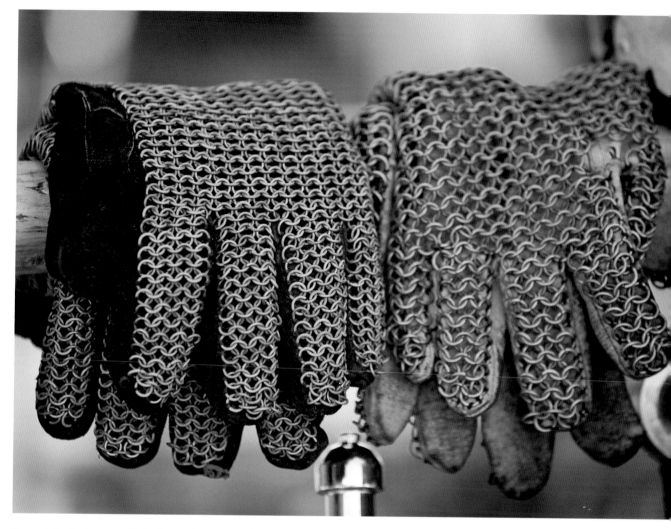

You might find yourself thinking that some of our examples could be more simply processed using fewer steps, but we prefer to thoroughly explore the individual tools and their functionality rather than presenting quick, generalized solutions. This approach will help you to find the right combination of techniques for application to your own unique images.

The Layers panel is the nerve center of virtually all layers techniques, so most of our examples show the layer stack (or parts thereof) that relates to the image we are processing. The illustrations often help to clarify our explanations, so check them out carefully. The text often goes into a lot of technical detail but always provides hands-on examples either in the course of or at the end of each section. This approach may give the book a textbook feel, but it helps to keep our explanations clear and intelligible.

Like Photoshop, knights of old used protective clothing that was built up using various layers. For example, the gloves shown here have a tough outer layer of chain mail with soft leather beneath.

Conventions Used in This Book

Most of the conventions we use are self-explanatory. For example, Filter ▸ Unsharp Mask stands for the Unsharp Mask command in the Filter menu. We use the Ctrl - A typeface to indicate keyboard shortcuts. The hyphen between the two keys indicate that they are to be pressed simultaneously. Menu-based commands, drop-down list elements, and dialog buttons are indicated using either the File typeface or italics: *OK*.

The keystrokes used by the Windows and Mac operating systems are usually the same, although where Windows uses the Alt key, OS X normally uses the ⌥ (Option) key. The ⌥ key is also often labeled alt. (This book uses Alt.), The Windows Ctrl key is equivalent to the Mac ⌘ key, also called the Command key, labeled either cmd or ⌘ (or both). ⇧ indicates the Shift key in both systems (i.e., ⇧ - A stands for a capital A), and ↵ refers to the Enter key. Ctrl/⌘ indicates that the command in question requires use of the Ctrl key in Windows and the ⌘ key in OS X, and the same rule applies to the Alt/⌥ symbols. In some cases, we use only the Windows Alt key reference, as Mac keyboards often label the ⌥ key with the alt symbol too. F7 stands for the equivalent function key.

In some places we refer to the *Context menu*, which is revealed using a right-click or, in OS X, by pressing the Ctrl key and the mouse button. A two- or three-button scroll mouse is a worthwhile investment for Mac users who use Photoshop regularly.

Some screenshots have been cropped to keep them small, and we have dispensed with some white space in the illustrations to keep things clear.

All of the screenshots were captured in OS X, mostly using Photoshop CS6. The visual differences between the user interfaces built into CS3, CS4, CS5, CS, and, recently, Photoshop CC, make no difference to the functionality of the illustrated tools – though newer versions may have some enhancements.

Windows key: Mac OS X key:

Ctrl ⌘

Alt ⌥

⇧ represents the Shift key.

↵ represents the Enter key.

Ctrl/⌘ indicates a press of the Windows Ctrl or the Mac OS ⌘ key.

Who This Book Is For

This book is aimed at keen amateur and professional photographers. We assume that you know how to work your computer, start individual applications, and handle multiple windows and program dialogs. We also assume that you are familiar with the basics of using Photoshop.

My Thanks Go to ...

... everyone who has supported and influenced me, and to all those who have encouraged me with their ideas, their work, and additional information. I am also grateful for all the constructive criticism and suggestions I have received while writing this book. Thanks are also due to my partner and sometime co-author Uwe Steinmueller, and to all the companies who provided me with software, especially Adobe and Nik Software. Finally, my special thanks go to my editor and good friend Gerhard Rossbach.

Juergen Gulbins July 2013

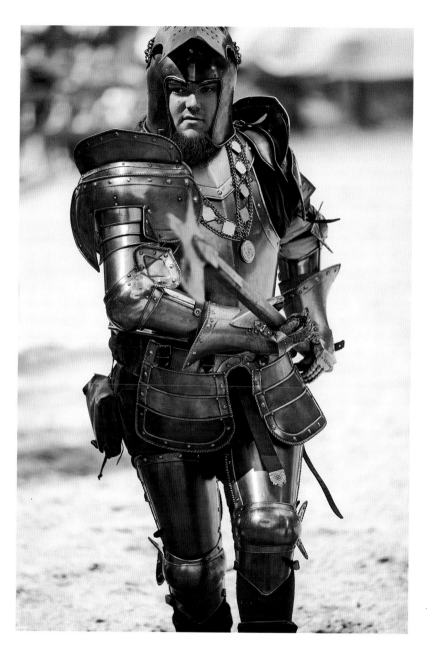

This knight is armored and ready to come to grips with Photoshop layers.

Using Layers to Make Global and Selective Adjustments

1

Image editing processes generally follow the principle of first the basics, then the details. After you have corrected any major (and some less critical) errors, you can go ahead and fine-tune your results. This has proven time and again to be the most efficient way to approach the image editing process.

But what can we do if an error or an annoying detail becomes apparent only after an image has been processed and enlarged? Or if an image is to be used for a purpose other than the original one? Or if it requires emphasis on elements and colors that previous processing steps didn't account for? Or if we want to adjust various parts of an image using different parameters?

In such cases, it is an enormous help if we can return to corrections we have already made and adjust them. It is also extremely useful if the corrections we make are performed precisely in easily identifiable steps. If we want corrections we have already made to remain in place – and this is usually the case – we need to work nondestructively. One of the most established and reliable ways to do this is to work with layers and layer adjustments. Layer functionality is available in many image editors, although Photoshop is still generally recognized as the leader in this field. There are many good reasons to use layer techniques when editing digital images, as you will see.

1.1 Reasons for Using Layer Techniques

Global and Selective Adjustments

First of all, here's a quick definition: when we talk about adjustments, we mean processing steps that improve an image in a visual, photographic sense. This might involve removing or retouching an unwanted element, such as a cigarette butt in a street scene, or adjusting slight under- or overexposure, but it still serves to accent a particular aspect of the image in question, the same way that dodging and burning techniques were used to accentuate and attenuate specific image areas in the days of analog darkrooms. Whether we adjust color or tonal values, these types of adjustments are intended to correct the parts of an image that the camera captured differently from the way we saw them in the original scene.

Cameras see differently than humans in various ways. The human eye and brain work in concert to automatically compensate for the contrast between light and shade to a much greater degree than a camera can when it captures image data. However, this doesn't mean that cameras are inferior to humans, just different.

As in any other area of life, when you capture and process digital images, what you give is what you get, and poor-quality snapshots cannot be turned into perfect images, no matter which techniques you use.

* For example, under Image ▸ Adjustments

When we apply adjustments, we aim to improve already usable images. The term *adjustment* is native to Photoshop,* although whether these adjustments are designed to actually correct perceived errors or simply to optimize the data captured by the camera is moot. We consider these types of adjustments to be legitimate optimization steps that are part of the artistic image creation process, just like the manipulations we used to perform in chemical darkrooms.** The location, the weather, the time of day, your point of view, the framing you use, and your choice of equipment and camera settings all influence the look of your results but are not seen as manipulative or otherwise falsifying elements.

** For example, Ansel Adams' famous zone system was nothing more than a technical approach to artistic visual interpretation.

Selective in this context means an adjustment to tone, color, or any other visual aspect that is applied only to part of an image using a mask or a selection to limit its effect. It is often desirable to attenuate the bright colors of a particular object to prevent it from attracting too much of the viewer's attention or to accentuate the color or form of a particular image element to intentionally steer the viewer's gaze.

After you have made any basic corrections to an image, most other adjustments you apply will be local adjustments to selected image areas. These are the types of adjustments that Photoshop layers are designed to master.

Adjust or Manipulate?

The adjustments described in this book are perfectly legitimate and are no different than the (admittedly more complicated) adjustments we used to make in chemical darkrooms. It is, however, up to the photographer to decide what to change and what to leave alone.

Making Selective Corrections in Photoshop

Photoshop offers three basic methods for making local corrections:

1. Use one of the selection tools to limit the area you want to adjust and then apply a correction using one of the commands in the Image ▸ Adjustments menu.

2. Generally, method 1 can be applied – usually without first making a detailed selection – by using the History Brush 🖌 tool to delete the areas where you don't want the adjustment to take effect. In other words, you paint in the original state of the image data.[*]

3. Use an adjustment layer and a layer mask to exclude the areas you don't want to affect. This method is the main thrust of the techniques described in this book.

All three approaches have their own specific advantages and disadvantages and situations in which they are beneficial. For example, if you use method 1, any changes you make are applied directly to the image pixels, so you need to use a very precise selection. The Photoshop Undo command allows you to change your mind, but this method is limited and functions destructively. Its advantage lies in its use of relatively little memory.

The History Brush method combines the advantages of methods 1 and 2 while circumventing the memory bottlenecks that using layers can cause. This method is, however, destructive, and we won't go into any more detail on it here.

Method 3 is the most flexible and versatile and, when used with Smart Object filters, is extremely powerful. It can also be used with various blending modes to provide even more editing options. The downside of using layers is that they always require much more memory than the other methods, especially when you work with Smart Objects.

[*] In this case, the original state can lie several steps in the past, but it must have been captured on a single layer.

Destructive Versus Nondestructive Processing
Destructive in this context means the pixels that make up an image or layer are altered. *Non-destructive* means that although the appearance of the image changes, the alterations you make can be easily undone or readjusted.

[1-1] The original image

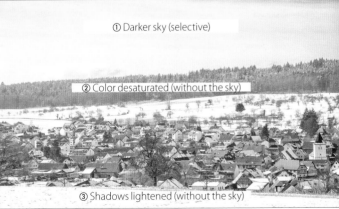

① Darker sky (selective)

② Color desaturated (without the sky)

③ Shadows lightened (without the sky)

[1-2] The corrected image

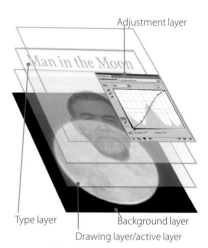

Adjustment layer

Type layer

Background layer

Drawing layer/active layer

[1-3] A simple collage made up of four layers: the background pixel layer (the image of the moon), the image of the face (with reduced opacity), a text layer, and a Curves adjustment layer

1.2 The Photoshop Layers Concept

What Are Layers?

Imagine an image made up of multiple transparent and semitransparent sheets (figure 1-3). If all these layers are 100% opaque, we will only be able to see the uppermost layer, following the basic principle of adding a new layer for each editing step. But Photoshop layers can do much more than just cover the previous layer. The five most important characteristics of layers are as follows:

1. Opacity. Values lie between 0% (transparent) and 100% (completely opaque).

2. Holes, in pixel layers, either where you have erased or deleted image data or where they are smaller than the layer beneath and allow underlying details to show through. This is particularly useful for creating collages.

3. Their ability to be merged (blended) with other layers using various modes.

4. Their ability to apply selective adjustments using layer masks. In other words, limiting the area to which an adjustment is applied.

5. Layer Styles, which can be used to apply special effects.

There are many more quite subtle adjustments that can be performed using layers, and you can use adjustment layers, Smart Filters, and individual layer styles to fine-tune and adjust effects that you have already applied. Layers can also be shown or hidden, allowing you to temporarily switch off their effects, whether for viewing purposes or to create a different version of an image. This may sound trivial, but it is, in fact, an extremely useful function.

Photoshop layers were originally invented with graphic artists in mind, but this book sticks to describing layer functionalities that are most suited for use in a digital photo workflow.

Layers are a powerful tool, but, like anything that gives us an edge, there is a price to pay. Using layers has the following costs:

■ Memory and disk space. Layer-based files take up much more RAM and disk space than conventional image files – or at least they do until you either delete layers or merge multiple layers into one.

* The bit values quoted here apply to each separate color channel. In RGB mode, each pixel has 3 × *n* bits.

■ 16-bit layers require even more memory and processing power. Photoshop CS1 was the first version to offer full 16-bit layer support. This support was expanded in CS2, and CS3 introduced support for 32-bit layers*, although with more limited functionality than for 16-bit processing.

1.3 Layers Panel

Layers panel is the layers nerve center, which you activate by selecting
Window ▸ Layers or by pressing F7. The panel displays the layers contained
in an image from top to bottom. The Background Layer (if present) is always
the lowest. The most important elements of the Layers panel are shown in
figure 1-4. These might appear complex at first, but we will explain their
uses step by step in the course of the workflow.

[F7] indicates the equivalent function key

[1-4] The Layers panel with several layers and different layer types (shown in Photoshop CS6)

Since the release of Photoshop CS6, the top row of tools in the Layers panel
contains the *Layer filter*, which enables you to selectively show or hide lay-
ers according to the criteria you select. Section 8.7 goes into more detail on
this particular topic.

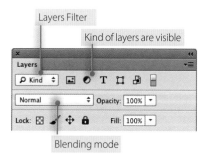

Layers Filter

Kind of layers are visible

Blending mode

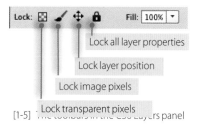

Lock all layer properties

Lock layer position

Lock image pixels

Lock transparent pixels

[1-5] The toolbars in the CS6 Layers panel

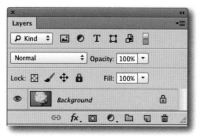

[1-6] When an image is first loaded, it contains just a single pixel layer called Background

[1-7] With the program set to its default settings, this pattern indicates transparent image areas (in the preview window and in the layers panel icons)

In Photoshop versions up to CS5, the *Blending mode* drop-down and the *Opacity* setting were located in the upper row. These two settings are critical to the effectiveness of layer-based editing, and the following sections explain why.

The lock functions located in the next row down are of interest to graphic designers, but we can bypass them in the context of a photo workflow.

The rest of the panel is taken up by the main layers functionality. Every layer has its own name, and we recommend giving each a unique name, even though duplicate names are allowed. Photoshop automatically suggests layer names that are numbered sequentially and correspond to the type of layer, but we strongly recommend that you give your layers explicit names that describe what they do. Failing that, you should at least add a short description of a layer's function to the generic name generated by the program. Unambiguous layer names help you to retain an overview of your work when you are using large numbers of layers in a single image.

Layers come in various types, including *normal, fill, vector, adjustment, Smart Object,* and *Smart Filter.* Smart Objects and Smart Filters are covered in chapter 6.

Pixel Layers

When you open an image in Photoshop for the first time, it will usually have just one regular pixel layer called *Background* (figure 1-6). You can add more pixel layers by copying a whole image or selected pixels from another source and inserting them into the active layer using Ctrl-V (Windows) or ⌘-V (Mac).

Stacks of pixel layers behave like stacks of overhead projector slides. If the uppermost layer is opaque or is the same size (or larger) than the canvas, you will be able to see only the top layer. If, however, a layer is smaller than those beneath, is not entirely opaque, or has holes in it, you will be able to see through to the layer(s) below. Transparent or semitransparent pixels also allow you to see through to the layer below. The simplest way to create transparent or semitransparent pixels is to use the Eraser tool with either 100% or reduced opacity on the appropriate areas. This is a common technique for fine-tuning collages made of multiple pixel layers. Later on, we will demonstrate a more elegant way of achieving the same effect using layer masks.

Transparent and semitransparent pixels are represented by a gray-and-white checkerboard pattern in the preview window and in the layers panel (figure 1-7). If you insert the content of a smaller image or a selection into the active layer (Ctrl-V), the result will be a pixel layer with some transparent areas.

Reducing the opacity of a pixel also allows the layer(s) beneath to show through.

The Background Layer

The *Background layer* is a special layer, indicated by its default lock icon. This layer cannot be moved without changing its status. If you delete pixels on the background layer, the background color will appear in place of the usual transparent pixels. Double clicking the background layer transforms it into a regular layer called *Layer 0* that you can then name and manipulate like other regular layers.

Almost all new images start out as a simple background layer that cannot be manipulated using all the operations available to other layers (such as blending mode or opacity value).

Double clicking the background layer in the Layers panel transforms it into a regular layer.

We usually leave the background layer alone and work on a copy of it or on other, newer layers.

Adjustment Layers

Adjustment layers are an extremely important part of our everyday digital photo workflow. Complex editing jobs involve performing multiple adjustments to tonal values, brightness and contrast, color, saturation, and curves settings.

Sometimes, we need to fine-tune or change earlier adjustments without destroying or undoing the subsequent steps that we have already performed, and adjustment layers make this possible. An adjustment layer is not like a pixel layer that has actual content, but rather it is an invisible layer that contains a set of operations that affect the pixel layer beneath it. As long as an adjustment layer exists, the adjustments it contains can be altered, deactivated (by clicking the show/hide icon 👁), or rejected by deleting the layer, all without affecting the image data contained in the pixel layer below. The values used to perform the adjustments made in an adjustment layer can be altered at any time, but they cannot be edited using conventional Photoshop tools. The effect of an adjustment layer can also be applied selectively using a layer mask (a highly popular processing step), or its intensity can be adjusted by altering its opacity setting. You can also change it's blending mode.

[1-8] Many of Photoshop's standard adjustment tools are also available as adjustment layers

Many of Photoshop's conventional adjustments are also available as adjustment layers (see the CS6 Image ▸ Adjustments menu in figure 1-8), and we will go into more detail on many of these later on. Earlier Photoshop releases do not have all of the options offered by the latest version.

Depending on the settings you make in the Panel Options dialog, the Layers panel labels an adjustment layer using either a generic icon or a more complex one that indicates the type of layer being used – for example, for a Curves adjustment layer, for a Levels layer, or for a Hue/Saturation layer.

Shadows/Highlights and HDR Toning are two of a few adjustments that are not available as adjustment layers. Such adjustments can be applied only directly to a pixel layer, although you can work around this limitation with Smart Filters.

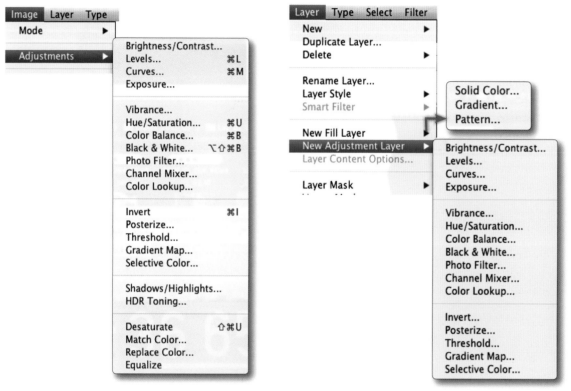

[1-9] On the left are the options available in the **Adjustments** menu, and the right illustration shows the options available in the CS6/CC **New Adjustment Layer** menu

Fill Layers

In principle, a fill layer is a pixel layer that you fill by using either a solid color, a gradient, or a pattern. The effect of a fill layer can be fine-tuned using its blending mode and the degree of fill (i.e., its opacity). The greater the fill value, the stronger (i.e., darker) the fill will appear. Fill layers have blending modes and opacity settings just like regular layers and can be manipulated in the same ways.

Gradients created on an otherwise empty layer using the Gradient tool can be applied selectively, whereas a new (gradient) fill layer is generated at the same size as the current canvas.

Fill layers are rarely used in a photo processing context, although gradients with reduced opacity are sometimes useful for selectively darkening or brightening a layer (see the example in section 1.8).

Vector and Shape Layers

If you create a text object using the Text tool **T**, the resulting layer will be a vector (or shape) layer. Any new shapes you produce or adjustments you make to such a layer will be made using vectors rather than by adjusting the pixels directly.

An editable text layer is a special type of vector layer that, since the release of Photoshop CS6, can be formatted using custom paragraph and character formats covering multiple image areas and layers.

The Shape tools (figure 1-10) automatically create a shape layer consisting of vector-based elements to which you can add your own shapes. Vector shapes can be losslessly scaled and edited as long as you don't rasterize them. In this respect they are similar to the shapes produced by Adobe Illustrator, although you cannot manipulate them as freely.

[1-10] There is wide range of shape tools available. If the are not rasterized, the shapes can be edited.

Vector shapes have their own stroke width, stroke type, color, and fill color, which you can adjust in the tool's options bar.

We don't often use vector layers in the course of our photo workflow, although it is sometimes necessary to use the drawing tools to create complex masks. In this case we use the Paths tool 🖋 to create a path. (The Paths tool is explained in detail in section 3.16.) For the purposes of this book, we won't be dealing with vector masks in much detail.

[1-11] The options bar for a Shape layer

Text on text layers and graphics on shape layers can be adjusted later, just like the steps in an adjustment layer. To do this, activate the layer in question, select the Text tool (**T**), and click the text you want to change. This sometimes takes several attempts until you find the right place within your image.

1.4 The Layers Panel Icons

The left column in the Layers panel displays the current status of a layer: 👁 indicates that a layer is being shown (i.e., not hidden). Clicking the 👁 icon hides the layer and cancels its effect, a state indicated by the missing eye icon ▢. Clicking on the empty box again makes the layer visible and switches its effect back on. Toggling a layer on and off enables you to check the effect of an adjustment to see how various versions of a multi-layer image look. To activate a layer or layer element, click its icon in the right portion of the layer entry in the Layers panel.

➡ From CS2 onward, color highlighting is used to indicate the active layer.

The columns to the right of the eye icon contain important information regarding the name, type, and functionality of the layer in question:

* See section 8.3, page 221.

 This thumbnail displays the contents of a regular (pixel) layer in the appropriate place in the active layer hierarchy. The size of the icon can be set to one of several levels in the Layers panel options menu.*

 Instead of the contents thumbnail (see above), this icon displays the operation represented by an adjustment layer. Each adjustment layer type has its own icon. If you select the *None* option for the thumbnail display in the panel options menu, the panel will display the generic for all layers.

 The chain icon indicates that the layer and its layer mask are linked, so layer and its layer mask (if present) are always moved together when you use the ▶⊕ tool. We rarely change this setting.

 If you are working with pixel layers or Smart Objects, you might want to undo the link. To do this, simply click the 🔗 icon, which will then disappear. You can then move the pixel layer and its mask separately. A repeat click on the place where the icon was reestablishes the link and makes the icon visible.

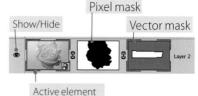

Show/Hide Pixel mask Vector mask

Active element

[1-12] The black-and-white dotted frame indicates which elements of a layer are currently active and therefore editable

This icon indicates that the active layer has a layer mask, shown here in miniature. We will go into layer masks in more detail later. Theoretically, a layer can have two layer masks: a conventional pixel mask like we often use in a photo workflow, and a vector mask. Vector masks are generally used only for graphics applications and are seldom used in a photographic context.

 If a layer has a white (i.e., empty) layer mask, this can be deleted without affecting the image. To do this, select the mask, and press the ⌈Del⌋ key or drag the mask to the 🗑 icon.

 This icon (located at the far right of a layer entry) was introduced with Photoshop CS6 and indicates that the *Hide* function has been applied to the layer styles (see section 5.4, page 169).

The Lower Tool Bar in the Layers Panel

Many of the steps we perform on a layer can be initialized using the buttons at the bottom of the Layers panel:

 Links multiple layers. We seldom use this function during the photo workflow.

 Allows you to define a new layer *style* or to edit the current style. We seldom use this function to process photos.*

* There is an example of how to do this in section 1.8 on page 37.

 Creates a new *Layer Mask*, which is white by default. If you press the ⌈Alt⌋ key while clicking the button, the new mask will be black. If you have a currently active selection, it will automatically be transformed into a layer mask when you click this button; ⌈Alt⌋-click inverts the selection in the new mask.

⬤ Adds a new adjustment layer to the stack. The layer type is selected using the new layer's drop-down menu.

▢ Creates a new *Layer Group* (called a *Layer Set* in versions up to CS2). See section 8.4 for more details.

▣ Creates a new layer or duplicates the selected layer if you drag a layer to the active layer icon.

🗑 Deletes the selected layer or any layer you drag here.* This function can be used to delete a complete layer or a layer mask (select just the mask before clicking 🗑 or dragging the layer to the icon).

* You will see a confirmation dialog.

Layer Filtering

Photoshop CS6 introduced the layer filtering function at the top of the Layers panel. This enables you to display subsets of layers based on name, kind, effect, mode, attribute, or color label. It makes working with complex, multi-layer images much simpler. By default, the filter is inactive. If, for example, you have selected *Kind* in the drop-down menu, the icons displayed allow you to filter for adjustment layers (⬤), text layers (**T**), shape layers (▣), and Smart Objects (▤). You can make multiple selections, and the switch at the right (▮) toggles the filter on and off. If no icon is active, the filter is automatically deactivated.

Menu Ⓐ is used to select the filter type (figure 1-13). The options offered in the right-hand portion of the filter bar vary according to the filter type you select. The tool enables you to quickly find a layer with a particular name, blending mode, or color label (section 8.5, page 224), or you can find layers with specific attributes (*visible, locked, empty, layer mask,* etc.).

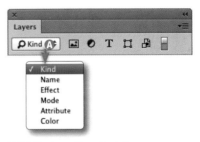

[1-13] The layer filter criteria list

➜ See section 8.7, page 228, for more on the layer filter.

1.5 Changing Layer Opacity

New layers have a default opacity setting of 100% (i.e., lower layers are completely invisible). You can change this to make a layer partially or completely transparent (i.e., an opacity setting of 0%).

100% The layer completely obscures the layers below

 0% The layer is completely transparent and has no effect

 n% The layer is semitransparent, and the opacity corresponds to the selected value

We often alter opacity values during the workflow. This setting allows us to start out by applying high-strength effects and then fine-tune them by reducing the opacity.

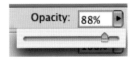

[1-14] Clicking the arrow in the upper-right corner of the Opacity value pops up a slider that you can use to change the value

In addition to altering the opacity using the slider or by entering a numeric value in the box, you can also alter the opacity by activating the layer you want to affect and pressing one of the number keys. ⒈ sets opacity to 10%, ⒉ to 20%, all the way up to ⓪, which sets it to 100%. Combinations of keys pressed quickly, one after the other, result in more precise values. For example, pressing ⒉ ⒊ selects an opacity value of 23%.

You can also use his method specify opacity settings for the Brush, Eraser, and Stamp tools. Make sure the correct layer or layer element is activated before you make this type of setting!

1.6 Blending Modes

Blending modes determine how the pixels and other adjustments on the active layer are sampled and merged with pixels on the lower layers, and how the effect appears in the final image. The following are the most important modes for use in the photo workflow:

Normal selects only the pixels in the active layer and applies the current opacity value.

Darken, Multiply work in a similar way to the Burn tool. White areas on the top layer have a neutral effect, darker areas show moderate effects, and black applies the maximum darkening effect.

Lighten, Negative Multiply are the opposites of the effects described above (equivalent to the Dodge tool). Black areas on the top layer have a neutral effect, brighter areas show moderate effects, and white applies the maximum brightening effect.

Overlay selectively brightens or darkens specific image areas. A 50% gray value has no effect. Values below 50% gray brighten the relevant areas in lower layers, while higher values darken lower layers. This is one of our favorite modes.

Soft Light/Hard Light allows you to increase color saturation. The effects of white/black/gray values in the top layer are similar to those produced by the *Overlay* mode. The white, gray, and black effects produced by the uppermost layer are similar to those produced by the *Overlay* mode, while *Soft Light* mode has a softer, more subtle effect. *Hard Light* is visibly harder and more extreme.

Luminosity is important for reducing unwanted color shifts. Only pixel luminosity (i.e., brightness) is affected. This mode is perfect for sharpening layers and reduces the artificially high saturation that sharpening produces at object edges (see the example on page 28).

Color affects only the color (not luminosity) for most details.

Saturation changes the color saturation but not the luminosity or hue.

Hue affects the hue without affecting the luminosity or color saturation.

Difference, Exclusion, Subtract and **Divide** are used for special purposes (see the example in section 4.6, page 143).

The individual modes are explained in detail in chapter 4 using hands-on examples.

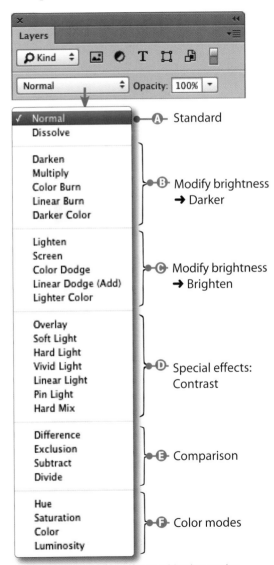

[1-15] The effects of various blending modes

Now, let's see a simple example in which we will use some of these features.

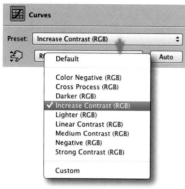

[1-16] Photoshop CS6 Curves presets

The image in figure 1-18 lacks contrast, but we can improve things using a *Curves* adjustment on a new adjustment layer, created using the Layer ▸ New Adjustment Layer ▸ Curves command.

To increase contrast in the mid-tones, we apply an S-shaped curve. More recent versions of Photoshop include a range of Curves presets to which you can add your own.

The *Curves* presets are shown in figure 1-16. To optimize the image shown in figure 1-19 we applied the *Increase Contrast (RGB)* preset (figure 1-17).

The disadvantage of this approach is that applying an S curve to the mid-tones also increases saturation, especially in colors that are already well saturated.

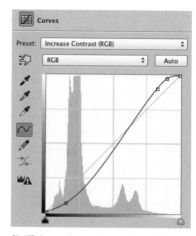

[1-17] Increasing contrast using an S curve

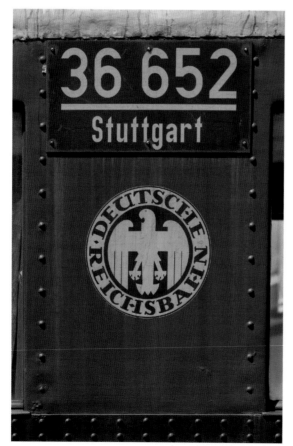

[1-18] The original image (of an old railroad wagon)

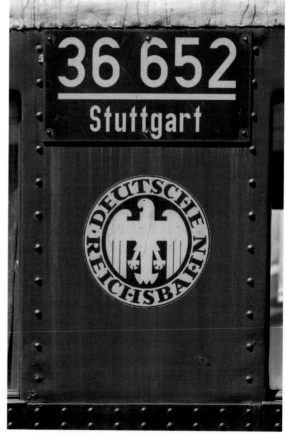

[1-19] The same image with increased contrast

This effect can have welcome benefits, but they are unwanted in our case. Figure 1-20 shows the preview image with the Gamut Warning function activated. The magenta areas indicate where output color clipping (in a print, for example) will probably occur if we use the current settings.

The warning function can be activated via View ▸ Gamut Warning. It applies a user-selected color to indicate which image areas are likely to contain clipped colors if they are outputted using the currently active color profile. Such areas usually lack detail. To select a different profile, navigate to View ▸ Proof Setup ▸ Custom. You can choose a warning color under Preferences ▸ Transparency & Gamut. Be sure to use a color that you can easily distinguish from the colors in your image.

You can largely prevent unwanted increases in saturation by selecting *Luminosity* blending mode for your Curves adjustment layer, as shown in figure 1-21 (including the layer stack). The difference may be subtle, but it's effective.

Switching to *Luminosity* mode is often quite useful – such as for sharpening layers – to prevent increased saturation (and some other effects, depending on the correction).

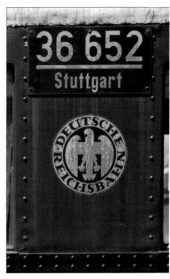

[1-20] The preview image from figure 1-19 with activated gamut warning

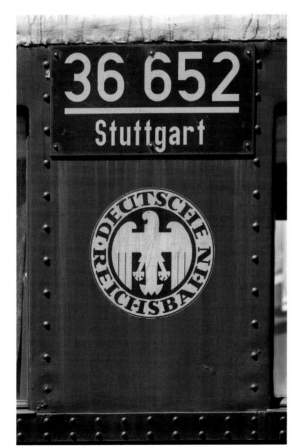

[1-21]
The image in figure 1-19 switched to Luminosity mode

1.7 Sample Layer-Based Processing Workflow

This is probably not going to be the first additional layer that you create. Most photographers have at some point created multilayer images or added text to a photo. Nevertheless, we will approach layers systematically from the ground up, even if this approach may at first appear a little uninspiring.

Figure 1-22 is our original image, shot at a reenactment of a medieval joust. Various aspects of this image can be improved, although the processing steps you take for a particular image will always depend on your personal taste.

Step 1: Basic Retouching

After you have leveled the horizon and cropped an image to an appropriate size, the first major editing step is deflecking. This involves removing obvious blotches caused by dust particles on the camera's sensor or spots that simply show up against a dark background in a closeup shot. This is also the phase during which we generally remove other major distractions, such as distant birds that aren't recognizable and muddy the sky, or a cigarette butt that spoils a street scene. In the case of our medieval knight, we want to remove the scratches on the side of the helmet.

The tools of choice for this task are either the Clone Stamp (🔨) or the Spot Healing Brush (🖊). Both tools have their own advantages, but in situations like this, we usually begin with the Spot Healing Brush.

But why mention this technique in a section dealing with layers? Simply because it is always a good idea to create a new layer to perform your adjustment on. This approach enables you to cleanly separate your original image from any edited versions you create, and it allows you to undo any changes if they don't turn out the way you planned without altering the original image data. You can simply erase local corrections or adjust their opacity, allowing details of the original image to show through at full strength.

We begin by creating a new layer (by clicking the 🔲 button at the bottom of the Layers panel). Give the new layer a meaningful name – in our case, *Retouch Scratches*. Use the Ⓙ key to activate the Spot Healing Brush 🖊 (or Ⓢ for the Clone Stamp 🔨). Use a size that is large enough to cover the imperfection with a little room to spare. If you are removing single specks, it is usually sufficient to just click on each one with the brush. Larger flecks require you to paint over them and follow the direction of any textures.

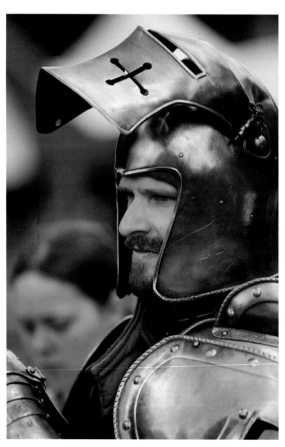

[1-22] The original image …

Because we are working on an empty layer, we have to activate the *Sample All Layers* option in the tool's options bar (figure 1-23).[*] This ensures that the tool includes the content of the lower layer(s) and applies the results of the corrections before saving it on the active layer.

[*] Without this option, Photoshop would only register the content of the empty layer.

Since the release of CS5, the 🖌 tool includes the *Content-Aware* option, which you should generally activate for this type of adjustment. This option analyzes the area you have selected for correction and automatically replaces any anomalies it finds – for example, a bright dust spot on a dark or textured background, or, in our case, the bright scratches on the otherwise darker flank of the helmet – with matching data from the surrounding areas. This function is extremely capable and even goes so far as to replace a dirt-smeared edge with a similar edge taken from nearby. The results are not always perfect, but they are often very good. The trick is learning to select the right size for the tool. The setting you select has to be large enough to cover enough of a detail's surroundings but small enough to miss other less interesting details. You also have to paint in your correction in a direction that matches the texture of the detail you are correcting. With a little practice, you will soon produce usable results; if you don't like it, you can undo the previous step by using the Ctrl/⌘-Z keystroke.

[1-23] Always use the *Content-Aware* option when you use the Spot Healing Brush. If you are working on a separate layer, remember to activate the *Sample All Layers* option too.

Like with other brush-based tools, Photoshop allows you to select start and end points for a straight-line correction by clicking and shift-clicking with the mouse.

Make sure the scratches you have just removed are still present in the original (background) layer by hiding the adjustment layer (click the 👁 icon in the new layer's entry in the Layers panel).

If you are happy with your results so far, try reducing the opacity of your deflecking layer. This will often produce more realistic-looking results, especially if you are retouching skin imperfections, such as scars, moles, rashes, freckles, and laugh lines.

If you use the Clone Stamp tool, you first have to select source pixels for your adjustment by Alt-clicking a reference area that contains the image data you wish to copy. You can then paint the copied pixels into the area you wish to adjust. Again, activate the *Current & Below* or the *All Layers* option for the Clone Stamp tool (figure 1-25). Again, set the opacity of the adjustment layer to produce the effect you are looking for.

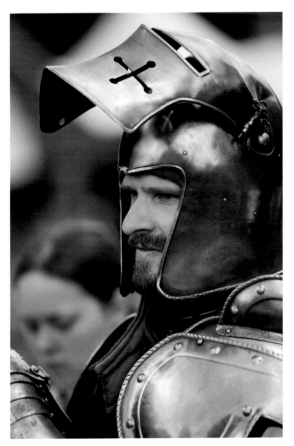

[1-24] … and the retouched version (without scratches)

[1-25] You have to select one of the lower two modes if you want to apply the Clone Stamp tool to a separate adjustment layer

→ The efficient use of Photoshop brushes is explained in detail in section 3.17, page 121.

Here too, it takes a little practice to get a proper feel for the tool and the way it works. In most cases, it is best to use a soft-edged brush (i.e., with a Hardness setting of 0). If you are copying soft textures, reduce the Flow setting to about 30% and repeat the action until you produce the right effect. If you are sure you want to completely cover a detail, you can set Hardness and Flow to 100% from the start.

Again, you can correct a larger area by selecting start and finish points by clicking and shift-clicking with the mouse. Using this technique with an appropriately small brush size allows you to work precisely along the edges of selected objects. To limit the effect of these types of corrections (for example, along sharp edges), use the Lasso tool to select the area you wish to adjust, switch to the adjustment layer, and use the ✏ or 🖌 tool to perform the correction. Your selection will automatically limit the area to which the correction is applied. However, you can still copy source data from outside the selection for use with the Clone Stamp tool.

Step 2: Darkening the Left Side of the Image

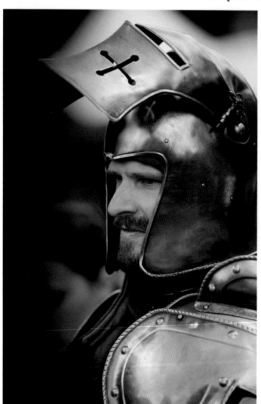

[1-26] The image with a superimposed color gradient

The knight's face would look better if we darken the left side of the image. There are various ways to perform such an adjustment, but we decided to go for superimposing a color gradient.

Once again, we created a new layer (⬆-Ctrl-N) and activated the Gradient tool ▮ (using the G key or clicking the ▮ icon in the *toolbox*). Make sure the foreground color is set to black before you draw the gradient. The quickest way to do this is to use the D key, which automatically sets the foreground color to black and the background to white. We then selected the ▨ (angle gradient) type and dragged the gradient from the left edge to the middle of the frame.

The initial result in figure 1-26 is too dark, so we switched the layer mode (Blending mode) from *Normal* to *Soft Light*, giving us the improved look shown in figure 1-27. *Soft Light* uses soft transitions to darken image areas in which the upper layer is darker than 50% gray and to lighten areas that are brighter. Because our gradient stretches only to the middle of the frame, it has no effect on the right side of the image.

The downside of the gradient we applied is that it darkened some areas we don't want to adjust, such as the helmet's visor.

The solution is to use a layer mask to protect the areas we don't want to change.

Step 3: Creating a Layer Mask

This step creates a mask that protects the knight's face and helmet from the effects of the previous adjustment. If a layer mask wasn't automatically created with the new layer, click the ⬛ button at the bottom of the Layers panel to create one. To make adjustments to the mask, you have to activated it by clicking its icon – the active mask is then indicated by a black-and-white dotted border. Generally, you can use a fairly large, soft black brush to paint in a layer mask. However, we are going to use a slightly more sophisticated technique based on the Quick Selection tool ✓ that was introduced with CS3 and replaced the older Extract function.

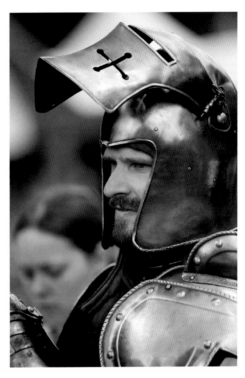

We use the Quick Selection tool to roughly draw the outline of the face and helmet, taking care to stay within the confines of the area we wish to adjust. The smaller the size you use, the more precisely you can trace your desired outline. Don't work too quickly! The tool's algorithm requires a lot of processing power, and the program sometimes takes a quick break (indicated by a progress bar) while it updates a selection. Quick selections are indicated by a running dotted line – also called *marching ants*.

If the tool selects too much of your image, press the Alt/⌥ key (with the tool active) and erase the parts of the selection you don't need. (The Quick Selection tool ✓ is discussed in detail on page 98.) To add to your selection, press the ⇧ key and continue to paint until you have the basic selection you are looking for. You can fine-tune the details later.

[1-27] The color gradient set to *Soft Light* mode

As with selections made using the Marquee, Lasso, and Magic Wand tools, a quick selection has a hard edge by default, which is not appropriate for our mask. There are various ways to soften mask edges and make the transitions between the image and the mask less obvious. The simplest way to do this to use the *Feather* setting in the selected tool's options bar. The radius you use will depend on the image resolution and the degree of detail in your selection. Between 3 and 8 pixels are good starting values. Earlier versions of Photoshop offer similar adjustments in the dialog located under Select ▸ Modify ▸ Smooth.

We now have to transform the selection into a mask that we apply to the gradient layer. If the gradient layer already has an empty mask associated with it, delete it (for example, by dragging just the mask to the 🗑 icon) and click the mask button ⬛ at the bottom of the Layers panel to create a new one.

A selection is automatically transformed into a layer mask if it is active at the moment the mask is created. In the resulting mask, the selected areas will be white, the nonselected areas will be black, and any partially selected areas (such as the soft transitions) will be gray.

However, the effect this produces is the opposite of the one we want to achieve. The gradient currently has its strongest effect in the white areas of the mask (i.e., the knight's head and helmet), and there is no effect where it is black. To invert the mask and its effect, select the mask and use the Ctrl-I shortcut or Image ▸ Adjustments ▸ Invert command. Alternatively, you can invert the selection before you create the mask. As ever, Photoshop offers a number of different ways to achieve the same effect.

The final image is shown in figure 1-29. The left side of the image is darker, and the woman in the background is now less distracting to the main subject, while the knight himself appears more striking. Figure 1-28 shows the Layers panel as it looks after we have finished making our adjustments.

Now you know how to perform a complex correction involving a layer mask and multiple layers with different layer modes. Adjusting the opacity of the gradient layer enables us to fine-tune its overall effect.

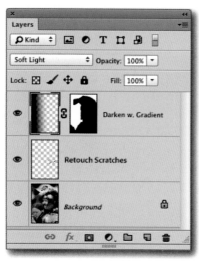

[1-28] The layer stack for the finished image shown in figure 1-29

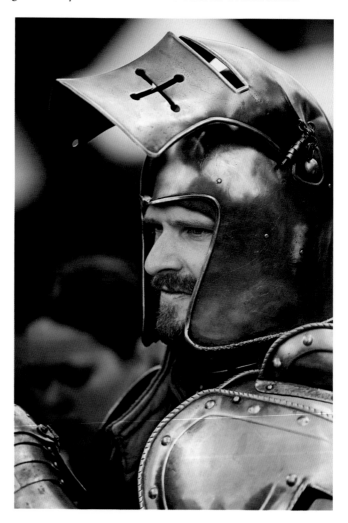

[1-29]
The finished image, with the freshly accented subject

1.8 Using Fill Layers

This example inserts a fill layer into the lower portion of the image shown in figure 1-30 to liven up the rather dull background. Use the Select Background Color button in the toolbox ![icon] to select an appropriate color from the color picker (in our case, a subtle green) and then create a new fill layer using the Layer ▸ New Fill Layer ▸ Gradient command.

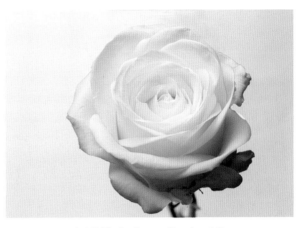

[1-30] The background is rather dull.

The Gradient Fill dialog enables you to select the direction and type of gradient (*Linear, Radial,* etc.) as well as a number of other settings (figure 1-31). *Scale* determines where the color center of the gradient lies, while the *Gradient* drop-down gives you a choice of different gradient types. We selected one that progresses from full opacity to full transparency.

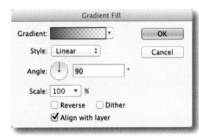

[1-31] Gradient Fill dialog

Instead of using a fill layer, we could have created an empty layer and filled it using the Gradient tool (![icon]), which would have allowed us to draw a gradient over just part of the frame. Whichever method you choose, be sure to select a gradient that changes from opaque to transparent.

Our gradient was initially too obvious and spoiled the image of the rose (figure 1-32), so we adjusted the strength of the effect by reducing its opacity to 50% (figure 1-33). Figure 1-34 shows the corresponding layer stack.

As mentioned earlier, opacity can also be adjusted using the keyboard instead of the slider.

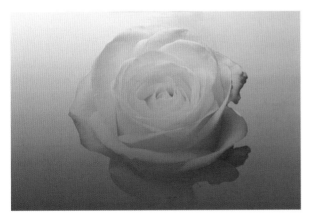

[1-32] The green gradient overlay is too prominent.

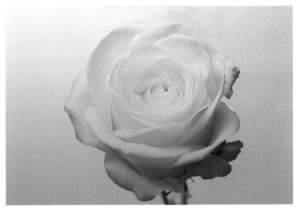

[1-33] Here, the opacity of the gradient is reduced to 50%

All you have to do is activate the appropriate layer and press ⌑ for 10%, ⌑ for 20%, and so on. ⌑ is equivalent to 100% opacity, and combinations of keys entered in quick succession result in two-digit values. This approach is often quicker and more precise than using the slider.

[1-34] The layer panel for the image shown in figure 1-33

To further optimize our image, we can exclude the rose itself from the effect of the gradient by using one of three methods (more on this later):

1. Erase the gradient in the area covered by the flower. This saves memory and disk space but is prone to imprecision that has to be painstakingly corrected. If you later want to increase or decrease the size of the gradient, you will have to erase and correct the flower all over again.

2. Create a layer mask on the gradient layer and use a soft black brush to paint over the rose. The gradient will then have no effect in the areas where the mask is black, allowing the underlying image to show through.

3. Use the Quick Selection tool (🖌) to create a selection (as described on page 33) and invert the mask to exclude the rose from the gradient's effect. The resulting layer mask can easily be edited, moved, or scaled, for example by using the Transform command.

After you have gone to the trouble to create a custom mask, you can apply it multiple times to an image – either in its conventional form or inverted – to adjust contrast, sharpness, color saturation, or any one of a number of image attributes. To apply an existing mask to a different layer, simply drag it with the [Alt] key pressed. If this layer already has its own mask, Photoshop will ask you to confirm that you want to replace it.

The duplicate mask is a separate copy that can be inverted and edited as you please.

➜ Masks can be adjusted and fine-tuned using a wide range of techniques, including virtually all Photoshop brush tools, many filters, and a number of other tools that are described in detail in chapter 3.

To illustrate the use of shape layers, we will also add a text layer to our rose image. Select a suitable color by double clicking the foreground color icon in the toolbox (▉). You should always do this **before** you create a text object. Now activate the Text tool (**T**), either directly in the toolbox or using the [T] key, and select a font in the tool's options bar. A smaller font often makes it easier to keep track of the text you enter. Don't worry too much about the exact position or font size when you type your text because both can be altered later. Remember, we are working on a separate text layer.

[1-35] You can select a text color either by double clicking the foreground color picker in the toolbox or using the color picker in the Text tool options bar.

We selected a subtle green for our text. To create a custom color, use the eyedropper (🖋) to sample a color from your image and use the color picker to fine-tune it – for example, by increasing the black component to darken it a little.

After you have typed your text, use the Move tool ▶⊹ (temporarily activated via [⇧]-[Ctrl]) to position it.

The text content, size, style, alignment, and color can be altered later using the tools in the options bar. To make alterations, the text itself has to be selected in addition to the layer it is on. This takes a little practice, and at first you might end up creating a new, empty text layer instead of selecting the one you have already made. To select text, activate the text layer,

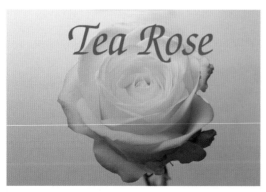

[1-36] Our image with its additional text layer

select the Text tool, and position the cursor precisely at the start or end of your text. If the text is underlined, you have succeeded in selecting it. You can now drag the cursor to select the parts of the text you want to adjust (e.g., using the ⬛ and ⬛ keys). You can now select new attributes for your selection (e.g., change the font size). This way, you can format various parts of a single line of text using different attributes.

Photoshop CS6 includes functionality for creating custom character and paragraph styles that you can then apply to single or multiple text objects. The dialog is activated using the Window ▸ Paragraph Styles command. If you edit a style, all text elements in the current document that use that style are automatically altered, similar to most desktop publishing programs.

[1-37] The Character panel showing character and paragraph styles

Text layers, too, have their own opacity, which you can adjust to allow the image beneath to show through (figure 1-38).

If you need to accentuate the text element to help distinguish it from the background, you can add a Layer Style, such as a border or a drop shadow. Open the Layer Style dialog by selecting text and clicking the 𝒇𝒙. button at the bottom of the Layers panel. There is a further text example (with explanations) in section 7.2 starting on page 208.

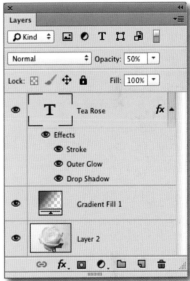

[1-38] The layer stack that corresponds to figure 1-39. The effects applied to the text layer are shown.

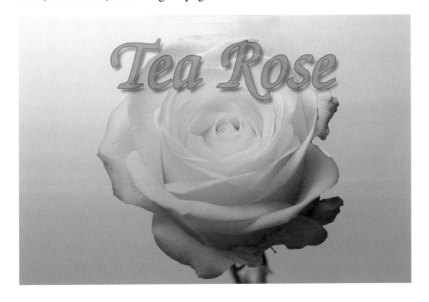

[1-39]

Here, we have reduced the text's opacity and added Stroke and Drop Shadow effects

1.9 Understanding Different Color Models

The color correction tools used by Photoshop are based on various color models, so it is a good idea to familiarize yourself with the basic principles as well as the advantages and applications of the models involved. A color model determines how a color is expressed in mathematical terms that can be interpreted by a computer, and the components are visible in the individual color channels in the Channels panel. The following sections offer an overview of the most important color models.

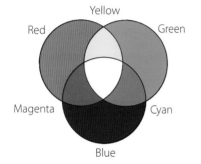

[1-40] The RGB color model

RGB · All colors in the RGB color model are created from three primary colors: red, green, and blue. RGB is the most commonly used color model in digital photography, and we will perform our workflow mainly in this mode. RGB is an *additive color model*, meaning that the sum (addition) of all three basic colors at full strength (100%) adds up to pure white.

Black is defines as 0, 0, 0 and pure white is defined as 255, 255, 255. Pure white is rarely present in photos – or at least it shouldn't be.

Photoshop works best with theoretical color spaces such as sRGB, Adobe RGB, and ProPhoto RGB. These color spaces are 'gray neutral', which means that mixing the three basic color components in equal parts results in a neutral gray tone.

RGB is the standard mode for processing digital photos, and virtually all Photoshop tools are capable of processing RGB images. Other color modes are less universal, and many Photoshop filters cannot process CMYK or Lab-mode image data.

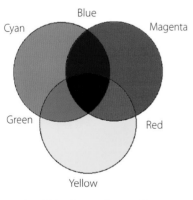

[1-41] The CMYK color model

CMYK · The CMYK color model uses four primary colors to define a color: cyan (C), magenta (M), yellow (Y), and black (K). CMYK was designed for print applications in which incoming light is reflected by the print.

CMYK is a *subtractive color model* because each of the colored inks absorbs (subtracts) a certain component of the incident light. Figure 1-41 shows that mixing cyan and magenta gives you blue, and when you add magenta to yellow you get red. In theory, the combination of cyan, magenta, and yellow should be sufficient to produce black, but due to certain impurities in inks, they produce a dark muddy brown instead. To solve this problem, a fourth color (black) is added, which is called the *key color* (K for short).

Although CMYK is an important color model for industrial printing processes, it is not used much in digital photography. Although inkjet printers are technically CMYK printers (most are CcMmYK, with additional light cyan and light magenta inks), they provide the user with an RGB interface. The conversion from RGB to CMYK is performed by the printer driver as a background process.

In the color wheel model (figure 1-44), the complementary color pairs R, G, B and C, M, Y are arranged opposite each other. CMY(K) is not a

gray-neutral model; instead it uses special device-specific color spaces, such as *ISO Coated V2 (ECI)* – used in Europe – or *US Web Coated (SWOP) v2* – used in the US – for printing on coated papers. Generally speaking, it is best to avoid unnecessary conversion to and from CMYK color spaces, and you should limit yourself to a single conversion only if it is absolutely necessary.

The six primary and secondary colors contained in the RGB and CMY models are the ones used by Photoshop color correction tools such as Color Balance and Hue/Saturation as well as in the color sliders in the Black & White adjustment panel.

Lab · The CIE L*a*b* *color model* (or Lab Color, as Photoshop calls it)separates colors (chroma, a + b) from the detail and brightness (luminance, L) in images. As with the RGB model, the L*a*b* model uses three basic components to describe a color: L (luminance), ranging from black (0, or no light) to white (100); and two color axes, *a* and *b*. The a-axis represents shades ranging from green to red (or magenta), and the b-axis represents blue to yellow shades.

A method that used to be used common for sharpening digital images involved converting an RGB image to the L*a*b* color space, sharpening the L channel, and then converting the results back to RGB. You can achieve similar (although not identical) results by applying a sharpening adjustment layer set to *Luminosity* mode. Lab mode is great for increasing color contrast in otherwise dull images without producing an oversaturated look.

Technically speaking, Lab mode is an important part of the Photoshop arsenal, and it is used for most color space conversions. It is not an intuitive color model, but it is available in Photoshop as a direct working mode for those who understand it well enough.

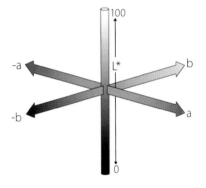

[1-42] The L*a*b* color model

HSL · The *Hue, Saturation, Lightness* model is not explicitly supported by Photoshop, but it is used in various tools, such as the Color Picker and the Hue/Saturation tool. Hue is expressed in terms of an angle from 0 to 360 degrees. Zero and 360 degrees correspond to red, 90 degrees to green, 180 degrees to cyan, and 210 degrees to blue. The saturation ranges from 0% (white) to 100%, while Lightness runs from 0% (black) to 100% (white).

In the Hue/Saturation and Saturation dialogs, saturation values are given in a range from –100 to +100. The same is also true for the Lightness slider. Zero then implies no change.

HSL and HSB (*Hue, Saturation, Brightness*) modes are not supported directly by Photoshop with a standard installation. You will have to install the appropriate plug-ins (available either on your Photoshop disk or as download from the Adobe website) if you want to work in these modes.

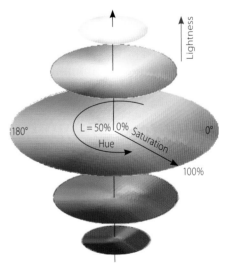

[1-43] The HSL/HSB color model

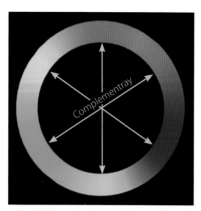

[1-44] The color wheel with examples of
complementary colors

The Color Wheel

We will encounter the color wheel (figure 1-44) in various places while work-ing with Photoshop, most prominently in the Color Picker. It is useful to get to know the color wheel and to keep it in mind (or on a crib sheet) while you process images because neighboring or complementary colors are the bread and butter of many color corrections. For example, when you counteract a color cast, instead of reducing the strength of the color of concern (perhaps by using a Curves adjustment), you can increase the intensity of its comple-mentary color to achieve the same effect. Complementary colors lie on op-posite sides of the color wheel, and the basic component colors of the RGB and CMYK models lie at 90 degrees to one another.

1.10 Some General Thoughts on Image Optimization

These considerations are independent of whether you edit your images using drawing tools, direct adjustment tools in the Image ▸ Adjustments menu, or adjustment layers, modes, and filters:

1. The first step is to analyze your image and consider whether it is worth cor-recting at all. Is the composition good enough? Does it need to be cropped? Are the main elements sharp enough? Is the exposure adequate?

2. If you decide to go ahead and edit the image, you then have to think about which adjustments are necessary. Consider how to accentuate the photo's good points and cover up its weaker points. Will an individual color, the brightness, or the sharpness (or lack thereof) irritate the viewer? Might a black-and-white conversion be more striking?

Section 9.1 addresses which adjustments to perform in Photoshop and which to do in a Raw converter.

3. The next step is to consider which adjustments to perform using a Raw converter (provided, of course, that you are shooting in Raw) and which to perform in Photoshop.

4. You can now plan the order of your adjustments and consider which tools to use, even if the finer points of each step only become apparent while you are working.

 Start by performing basic adjustments that affect the entire frame, such as aligning the horizon, adjusting the overall color temperature, reducing distortion, or correcting converging lines. Once these corrections have been made, you can perform retouching steps using the Clone Stamp, the Healing Brush, the Spot Healing Brush, the Patch Tool, or (with CS6 and later versions) the Content-Aware Move tool. Once you have done this, you can begin to fine-tune your image.

5. What follows can be considered the real image processing stage, which is divided into phases covering global and local adjustments.

It is important to keep individual adjustments simple. This reduces the amount of effort involved, minimizes any losses in image quality, and keeps the editing process clear and manageable.

Some of our tips regarding efficient working methods require practice. Everyone has their own personal working style, and not all of our methods will suit all users. You will develop your own techniques using our tips and the tools we mention. Different images will require the use of different tools to achieve similar effects.

Experience and practice will help you find your own direction. As we have already mentioned, there is a huge range of tools available for editing digital image data. Try to start each project with a fresh view and work out which tools are best for the job at hand. The quickest method isn't always the best, and you will also have to find the right compromise between the amount of effort you are prepared to make and the quality of the results. Part of this process will include considering the intended use of an optimized image and the output format. The larger the final print, the more effort you will need to put in to optimizing it.

This image was optimized in Adobe Camera Raw mostly. We adjusted the white balance and exposure, slightly brightened the shadows, and darkened the highlights. We used the Healing Brush tool to selectively reduce the exposure, and we finished up by slightly increasing the local contrast and sharpening the entire image in Photoshop.

1.11 Best Practices When Working with Layers

You should always duplicate the background layer and work on the duplicate when making corrections to an image. The quickest way to duplicate the active layer is to use the Ctrl-J/⌘-J keystroke. If you need to copy parts of the original image later, you can always use pixels from the unmodified background layer.

We recommend that you keep the Layers panel active because this will help you to see why a particular step doesn't have the expected effect or why the effect isn't immediately visible – for example, if the layer you are working on is hidden or if you are mistakenly working on the layer's pixels rather than its mask (or vice versa).

You can open the Layers panel either by using the **Window ▸ Layers** command or using the F7 key.

If you are working with a relatively small number of layers on a large monitor, you can increase the size of the icons in the Layers panel (see section 8.3, page 221, for instructions). If you are using large numbers of layers, smaller (or generic) icons are often preferable.

The layer filter introduced with Photoshop CS6 (see page 25) is extremely useful but can cause confusion if you forget to deactivate it, because you won't be able to see any layers that you have filtered out. Usually, the red switch (▮) will remind you that the filter is in use.

Working with layers requires discipline. For simple images with just a few layers, the generic layer names suggested by Photoshop are usually sufficient. However, if you are using multiple layers (and these will often be the same type), it is better to name each layer individually according to its particular function. We often include the settings values we have used in a layer's name, especially when we don't use Smart Filters.

Keyboard Shortcuts

Keyboard shortcuts are a great aid to efficiency when working in Photoshop, and you can either learn the most important ones by heart or keep a copy of page 43 handy. The more you work with the program, the more shortcuts you will use. If you use Photoshop only occasionally, you are more likely to evoke tools via the various menus.

Tools that belong to groups with similar functionality can be opened using a single key – for example, all three lasso tools (♀, ⤴, and 🔗) are accessible via the L key, either alone or in combination with the ⇧ key. This behavior is regulated by the *Use Shift Key for Tool Switch* option in the *General* section of the program's preferences.

Useful Keyboard Shortcuts

Tools	Keyboard Shortcut	Comment
Activate the Move tool (⊹)	V	⇧-Ctrl activates the tool temporarily
Activate Path/Direct Selection tool (⬏, ⬏)	A	⇧-A cycles through the available tools
Activate the Marquee tools (▭, ◯, ▬, ▯)	M	⇧-M cycles through the available tools
Activate the Lasso tools (◯, ⬠, ⬡)	L	⇧-L cycles through the available tools
Activate the Brush/Pencil tools (◢, ◢, ◢, ◢)	B	⇧-B cycles through the available tools
Activate the Eraser tools (◢, ◢, ◢)	E	⇧-E cycles through the available tools
Activate the Retouching tools (◢, ◢, ✕, ⊕)	J	⇧-J cycles through the available tools
Activate the Stamp tools (⬍, ⬍)	S	⇧-S cycles through the available tools
Activate the Rubber tools (◢, ◢, ◢)	E	⇧-E cycles through the available tools
Activate the Text tools (T, ↓T, T, ↓T)	T	⇧-T cycles through the available tools
Activate the Gradient/Fill tools (▭, ◆)	F	⇧-F cycles through the available tools
Activate the Quick Selection/Magic Wand tools (◢, ✳)	W	⇧-W cycles through the available tools
Activate the Paths tools (◢, ◢)	P	⇧-P cycles through the available tools
Editing a Selection		
Add to selection	⇧	Ctrl-A selects the entire layer
Subtract from selection	Alt	⇧-Alt uses the intersection
Invert selection	Ctrl-⇧-I	Ctrl-⇧-D deselects the selection
Layer Functions		
Activate the Layers panel	F7	or Window ▸ Layers
Create new layer	Ctrl-⇧-N	Ctrl-Alt-⇧-N new layer without dialog
Duplicate a layer	Ctrl-J	Copies the active layer and inserts the copy above
Delete layer	Drag panel entry to 🗑, drag masks and layer masks to 🗑	
Show/Hide layer	Click the 👁 icon. Alt-click toggles all but the active layer on/off	
Brushes and Masks		
Switch foreground/background colors to Black/White	D	
Switch foreground and background colors	X	
Set brush opacity to x% (in increments of 10)	1–9, 0	0 (zero) sets opacity to 100%.
Increase/decrease brush size	Ctrl-Alt + drag right/left with left mouse button pressed (⇧-ctrl-⌥ on a Mac)	
Increase/decrease brush hardness	Ctrl-Alt + drag up/down with left mouse button pressed (⇧-ctrl-⌥ on a Mac)	
Create a new (white) layer mask	Click ▣, ⇧-click creates a black mask	
Invert layer mask	Ctrl-I	

Editing Images Using Adjustment Layers

2

Adjustment layers enable us to make a wide rage of corrections to precisely define tonal values or color areas. These corrections are (initially) virtual and are not applied directly to the image data, making it possible to alter them at any stage, right up to the moment you merge the layers and apply your changes to the pixels that make up the original image. Adjustment layers are a wonderful editing tool and allow us to edit our photos completely non-destructively.

When it comes to fine-tuning corrections, masks are more flexible, easier to use, and require less processing power than the brush tools included with Adobe Camera Raw and Lightroom (and other Raw converters). As previously mentioned, layer masks can also be used to limit the area an effect is applied to.

Adjustment layers can not only be altered after they have been generated, they also provide a precise history of the editing steps you perform and can even be applied to other images.

[2-1] The CS6/CC Adjustment Layers menu

[2-2] New adjustment layers can also be created using the Adjustments panel

2.1 Adjustment Layer Basics

Adjustment layers are the main reason that photographers use layers so much when they edit images. An adjustment layer isn't a new image that is simply added to the layer stack, but rather a kind of invisible layer that is used to apply adjustments to the image layer beneath it. These adjustments are, initially, virtual – in other words, you can see the effect they have, but they are not actually applied to the pixels that make up the original image data until you are satisfied with the results and merge the layers, resulting in an image format such as JPEG (or a print) that is no longer layers compatible.

Adjustment layers are available for most (but unfortunately not all) of the adjustments offered in the Image ▸ Adjustments menu. Almost every new version of Photoshop introduces new adjustment layers, such as CS3's Black & White and the Color Lookup function included in CS6. (There is no new adjustment layer in Photoshop CC.) The great thing about adjustment layers is that their effects can be altered using not only the adjustment's own sliders, but also layer masks and layer opacity settings, enabling us to apply these effects partially and selectively.

A new adjustment layer can be created either via the Layer menu (Layer ▸ New Adjustment Layer ▸…) or via the ◔ icon at the bottom of the Layers panel. Photoshop CS3 also introduced a third method that involves use of the Adjustments panel that you can access via Window ▸ Adjustments. There you can simply click on the icon that represents the type of adjustment you wish to apply (figure 2-2). The icons you can see represent the adjustments listed in figure 2-1, arranged from top left to bottom right.

The seven adjustments marked in red in figure 2-1 are the most important in our everyday photo workflow, but you are sure to develop your own preferences in the course of your work.

With every new adjustment layer, Photoshop also creates an empty white layer mask by default, but you can change this behavior by deactivating the *Add Mask by Default* option in the ▤ menu in the Adjustments panel (figure 2-2). This can, however, cause some scripts to malfunction, so leave the option activated if you can.

If a layer's entry in the Layers panel is too narrow to display the layer type icon (▤ for example), or if you have selected the *None* thumbnail size option, the layers panel will display the smaller ◔ icon instead.

If, for example, we wish to apply a Curves adjustment to an image, we have to ask ourselves whether it would be better to apply it directly via Image ▸ Adjustments ▸ Curves or using an adjustment layer. The major difference lies in the ability of an adjustment layer to make changes to the appearance of the pixel (i.e., image) layer without actually altering the image data. Clicking the ◔ or ▤ icon in a Curves adjustment layer reopens the Curves dialog, enabling you to virtually (i.e., non-destructively) fine-tune

your adjustment. This type of subsequent fine-tuning is simply not possible if you apply an adjustment directly to the pixel layer.

Adjustment layers contain only parameters and, as a result, take up much less memory and disk space than a pixel layer filled with image data.

To retain compatibility with other applications, Photoshop's default settings save a merged (hidden) copy of layer-based images containing all current adjustments. This allows other applications to display the image as it is seen in the Photoshop preview window. In terms of disk space,this means that a single adjustment layer doubles the amount of space required to store an image.[*] Additional adjustment layers require only minimal additional disk space to save the new parameters the layer contains and the layer mask (if present).

The disk space used by an adjustment layer grows if the layer includes a layer mask, as detailed in chapter 3. However, layer masks consist exclusively of 8-bit grayscale values, so they take up less space than conventional RGB and CMYK pixel layers and are easy to compress.

> If you use a suitable file format, any layers an image contains – whether they are pixel, vector, text, or adjustment layers – will remain intact when you save your image. PSD, PSB, Photoshop Raw, TIFF, and PDF[**] are all layer compatible and are capable of saving alpha channels (usually saved selections). These formats also embed ICC color profiles by default. However, only more recent versions of Photoshop can reliably extract and interpret layer data.
>
> JPEG, PNG, and GIF files are not layer compatible. Saving an image to one of these formats automatically merges all visible layers. See section 8.15, page 236, for more details on layer-compatible file formats.

If you are saving an image that contains multiple pixel layers, you can save disk space by compressing your data. Photoshop has had RLE and ZIP compression functionality since the release of CS1 (see Figure 2-3). ZIP compression usually produces the smallest files, but they take longer to save and open.

[*] This extra layer is not visible during editing and can be suppressed if you set the Maximize PSB and PSD File Compatibility option in the File Handling section of the Preferences dialog to Never. If you select this option, many other applications (including Lightroom) will not be able to display your images properly, but it does effectively reduce the amount of disk space required to save images.

[**] We do not recommend saving photos as PDF files.

[2-3]
You can select different compression options for your image and any layers it contains

[2-4] The CS4 Levels adjustment dialog

[2-6] The CS5 Adjustments panel

Switching between Adjustment Layers

As of CS4, Photoshop includes largely nonmodal adjustment layer support. In earlier versions, we had to explicitly close one dialog (by clicking the *OK* button) before we could open or edit another. Now, dialogs such as the Levels settings can remain open, and the adjustment layer dialog no longer contains an *OK* button. There is, however, still a *Close* button to help you save desktop space (figure 2-4). Clicking a layer entry in the Layers panel automatically switches the dialog to that of the active layer – this functionality makes working with layers much simpler and smoother.

As of CS4, the dialogs activated by the commands in the Image ▸ Adjustments menu are slightly different than the ones found on adjustment layers. Adjustment layer dialogs are slightly smaller, but nevertheless offer all the same options. Each new version of the program includes a number of new refinements and functions, but the major adjustments remain largely the same, and you should be able to find your way around any version using our instructions.

The icons at the bottom of the dialog boxes have the following functions: resets all parameters to their default values, while displays the original (uncorrected) image and toggles your adjustments on and off. Clicking limits the effect of an adjustment to the layer directly beneath it, shifts the position of the thumbnails in the layers panel slightly to the right, and displays an arrow icon to signify the difference.

[2-5]
This adjustment layer affects only
the layer directly beneath it

This effect is particularly useful if the layer below doesn't completely cover the layers even farther down or is semitransparent (using an opacity lower than 100%).

The button switches between two different-sized settings dialogs (no longer present in CS6 and later versions). Further adjustment-specific settings are available in the menus like the one in figure 2-4 Ⓑ.

The drop-down menu icon shown in figure 2-4 Ⓒ reveals more operations related to the Adjustment layer (figure 2-7) – such as saving, loading, and deleting specific presets.

The arrow icon (no longer present in CS6) opens a different panel view (figure 2-6) that contains the icons Ⓓ for creating new adjustment layers and the list of adjustment presets Ⓔ. Each entry

[2-7] This drop-down menu offers
more operations

in the list contains various presets. For example, the *Curves* presets menu contains various predefined curves for increasing midtone contrast.

Clicking the individual adjustment icons of the Adjustments panel (figure 2-6 or figure 2-8, depending on your Photoshop version) creates a new adjustment layer with default settings, whereas selecting a preset creates a layer with the (fully adjustable) preset values already set. This approach makes it quick and easy to set up all the adjustment layers you need and to fine-tune the settings they contain.

Adjustment layers can also be created using the ⬤ menu at the bottom of the Layers panel or using the Layer ▸ New Adjustment Layer command. You can then select presets from menu Ⓐ shown in figure 2-4.

You can also save your current settings as a custom preset (with its own name) using the Save Preset command in the context menu ▾≣ at the top right of the adjustment panel (figure 2-7).

[2-8] Adjustments panel in
Photoshop CS6/CC

[2-9]

Most adjustments can be saved as custom presets for later use

Saved presets appear in the list Ⓐ in the Adjustments panel (figure 2-4), in the preset menu Ⓔ (figure 2-6), in the adjustment's own dialog window, and in the presets menu in the direct adjustment in the Image ▸ Adjustments menu.

The Save dialog (figure 2-9) automatically suggests saving presets to the appropriate adjustment, but you can also select another folder if you wish. This ensures that any custom presets you save won't be overwritten if you reinstall the program, but you have to manually set up the path to your own presets after reinstallation.

The adjustment layer context menu ▾≣ also contains the Load Preset command, which you can use to call up your own custom presets or others presets that you have downloaded or acquired elsewhere.

When you have familiarized yourself with adjustment layers and are used to working with them, you will most likely never want to work without them again.

[2-10] The Layers panel context menu located under ▾≣ contains a range of useful layer functions

2.2 Adjustment Layers Overview

The following sections provide an overview of the available adjustment layers. Later chapters include examples of how to use all these and more.

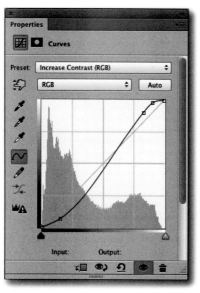

[2-11] A typical S curve for increasing image contrast

[2-12] Giving an image a warmer look

Levels Adjustments	
Brightness/ Contrast	Alters local brightness and contrast. Later versions of Photoshop (as of CS4) are much improved, and cause less banding. Global brightness in photographs is better corrected using *Exposure, Levels,* or *Curves.*
Levels	Used to set black, white, and gray points in individual or all three RGB color channels.
Curves	One of the most powerful and popular adjustments, although not entirely intuitive. Adjusts tonal values for individual or combined color channels. Can be used to increase contrast, reduce color casts, and alter color moods.
Exposure	As of CS3, increases midtone exposure without altering bright highlights or dark shadows.

Color Adjustments and Conversions	
Vibrance	As of CS4, offers the *Vibrance* and *Saturation* adjustments that are included in Adobe Camera Raw as adjustment layers. Vibrance adjusts saturation according to the level of saturation already present in a color and prevents clipping.
Hue/Saturation	Alters color hue and saturation, either globally or selectively.
Color Balance	Breaks image colors down into their CMY components and enables you to alter their color balance separately for shadows, midtones, and highlights. Enables you to correct color casts and optimize skin tones. Luminance can be protected during adjustments.
Black & White	As of CS3, allows finely adjusted conversion to black-and-white using six color sliders. Also includes tinting for finished images.
Photo Filter	Gives colors a warmer or cooler look using effects similar to those produced by analog lens filters.
Channel Mixer	Offers black-and-white conversion and subtle alterations to individual color channel input and output (also using colors sampled from other images).
Color Lookup	As of CS6, lookup tables determine which input tonal values correspond to which output values. Enables various effects but is most useful for optimizing video clips.
Vibrance	As of CS5, it increases or reduces saturation but adjusts already saturated colors less.

Special Effects

Invert	Inverts all color and tonal values. The same effect can be achieved using an inverted (negative 45-degree) curve.
Posterize	Breaks luminance values from 0 (black) to 255 (white) into a predetermined range of tonal values selected by the user. The finished image shows only the selected number of tones.
Threshold	Works like color separation, but has only black-and-white tones. The threshold level at which separation occurs is set by the user.
Gradient Map	As of CS4, maps the equivalent grayscale range of an image to the colors of a specified gradient fill. Enables, for example, split toning of shadows and highlights in monochrome RGB images.
Selective Color	Converts an image (internally) to CMYK mode without actually converting data and enables selective correction of process colors within primaries – for example, to increase the yellow component of red tones without affecting the other primary colors. This is a versatile adjustment but requires prior knowledge of color models. Can be used to remove or add color casts and optimize skin tones.

[2-13] The Gradient Map tool maps grayscale values to a color fill

Since the introduction of Photoshop CS3, most adjustment layers support 16-bit processing. This support was expanded to include 32-bit image data in CS4 – a real boon when it comes to producing HDR images. Sixteen- and 32-bit support has been further refined in CS5 and CS6 (figure 2-14). All adjustment layers offer 32-bit support from CS5 onward. Photoshop CC didn't add any new adjustment layers (though it did add some other goodies).

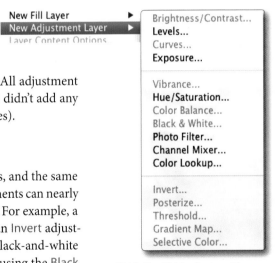

[2-14] The 32-bit adjustment layers in CS6 and CC.

More Ways Than One

Photoshop usually offers several ways to achieve most effects, and the same is true of adjustments made using layers. Most Levels adjustments can nearly always be produced using an equivalent Curves adjustment. For example, a curve with a gradient of –45 degrees has the same effect as an Invert adjustment layer. There are many ways to convert a color image to black-and-white using adjustment layers and blending modes – for example using the Black & White or Gradient Map tools, although in most cases, it is simpler to use the Black & White dialog and it is more intuitive to use the On-image adjustment tool ().

You need to develop a feel, through experimentation and practice, for which adjustment layer is best for the job at hand and which offers the most elegant solution in each situation.

2.3　An Example of a Curves Adjustment Layer

Before we go into more detail on the various types of adjustment layer, let's take a look at the basic elements they contain. This example uses a Curves adjustment – a powerful tool that is available both as a direct adjustment (via Image ▸ Adjustments ▸ Curves) or as an adjustment layer. Curves require some study if you want to get the most from their enormous potential, then you can use them to selectively (or globally) increase some tonal values and reduce others.

[2-15]
This French cheese looks delicious, but it is nevertheless a little too dark

[2-16]　The curve for figure 2-15

In figure 2-15 we see that the shadows are slightly swamped, but can be rescued. The midtones are a little too dark and the highlights could be brightened. To analyze an image objectively, it is always a good idea to have the Histogram window open (Window ▸ Histogram).

Now create a new Curves adjustment layer. A look at the histogram (figure 2-16) shows that there is still some leeway in the highlights (at the right end) – in other words, the tonal values don't use the entire available range.

We correct this situation the same way we would using Levels, that is, we shift the right slider Ⓐ carefully to the left, to shift the curve slightly to the left (figure 2-17).

To avoid clipping (which would cause parts of the image to become white and lose details), we temporarily press the Alt key while shifting the slider. This displays only the currently clipped pixels in an otherwise black preview window. In our example, the highlights (for example, in the plastic wrapping) are likely to be clipped. However, the amount of clipping you allow (if any) will always depend on your personal preferences and the type of subject involved. In case of doubt, it is better to move the slider to the right,

let go of the [Alt] key, take a break, and check to see how the image looks. In the end, the look of the image is more important than the subjective view offered by the clipping preview.

[2-17] Pressing the [⌥] key while shifting the white point slider activates the clipping preview (shown on the left)

Because our curve has become steeper in the middle, the midtones now show increased contrast. The steeper the curve in any area, the greater the difference in tonal values and the greater the contrast.

We can now raise the midtone section of the curve. To do this, we add a point to the curve and drag it slightly upward. Figure 2-18 shows the result of this change.

* Banding is indicated by obvious jumps in the curve and stripes in the image

[2-18]
The image with its new curve

Finally, we can brighten the shadows a little, although we need to make sure that black pixels remain black after we make our adjustment.

To do this, we activate the On-image adjustment tool () – also called the Direct Adjustment Tool – move the cursor to the area we wish to lighten, and drag the cursor upward. This automatically generates a new point on the curve at the luminance value that represents the current cursor position. This point is then shifted according to how we drag the mouse – moving the mouse upward brightens the corresponding pixels. The tool is intuitive to use and is available in various adjustment layers.

With a little more tweaking, our image now looks like this:

[2-19]
The medium-dark shadow areas have been lightened a little.

Take care not to make your curve too steep because this can quickly lead to banding, which causes obvious stepped tonal changes where smooth transitions should be.

Let's take a closer look at the settings in the Curves panel. The uppermost eyedropper is used to set the black point, and all pixels that are darker than the pixel you sample will end up pure black. The bottom eyedropper sets the white point; likewise, all pixels that are brighter than the one you sample will be pure white. The center eyedropper is used to set the gray point and can be used to regulate the white balance by sampling a point within the frame that represents medium gray. It often takes several attempts to find just the right point, but when you are successful, Photoshop adjusts all three RGB curves automatically so that the current cursor position becomes neutral gray (figure 2-20). You can also adjust the RGB curve manually by placing a new control point at the medium gray point on the curve and shifting it up or down.

In addition to the RGB curve, the color channels can be adjusted individually too. Simply select the channel you wish to adjust in the drop-down

menu in the Curves panel (figure 2-20). To delete an incorrectly set control point, click it and press the [Del] key.

To reset all the adjustments you have made and set the curve back to a straight 45-degree line, click ↻.

The *Auto* button does just what it says and performs an automatic adjustment that does its best to use the full tonal range available in each channel. In its default form, this adjustment allows some clipping in order to achieve the best possible effect.

You can, however, adjust the clipping limits yourself and set them as the default values for the *Auto* adjustment. To do this, select the *Auto Color Correction Options* entry in the ▪ menu at the top right corner of the Curves panel. You can then set your preferred algorithm, target colors and clipping levels (figure 2-21), and save them as defaults by checking the box at the bottom. We recommend using a clip value of 0.0, 0.0. The *Enhance Per Channel Contrast* algorithm tends to produce color casts, so take care when you use it.

[2-20] The curve for the cheese image with its new gray point

[2-21]
The Auto Color Correction Options window. The best Clip value to completely avoid clipping is (0, 0).

Photoshop CS6 offers four different algorithms, and you will have to try them to see which best suits your personal taste and the type of images you are processing. Checking the radio buttons in the options window shows the effect of each algorithm in real time in the preview window. You can also set your target black, white, and gray points to custom values that differ from the defaults, which are (0, 0, 0), (128, 128, 128), and (255, 255, 255).

If the ⚠ icon appears at the bottom left in the Curves panel or the top right of the Histogram panel, it means the histogram display is not current (figure 2-22). Click the icon to update the histogram that is displayed in the background of the Curves panel.

You can alter the panel display to show or hide the grid and switch between 4 x 4 or 10 x 10 views. The settings dialog (figure 2-23) can be opened

[2-22] The ⚠ icon indicates that the histogram needs to be updated

from the ▓▓ menu by selecting the *Curves Display Options* command. This is also where you can decide whether to display the histogram or just the baseline in the Curves panel.

[2-23]
The Curves Display Options dialog

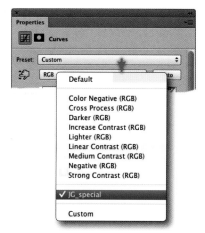

Most adjustment layers (here, *Curves*) contain a *Presets* drop-down menu (this menu has no name in earlier versions of Photoshop) in which stock and additional user-defined presets are stored. If you alter the settings of a preset, the menu entry switches automatically to *Custom*.

Figure 2-24 shows the presets provided with CS6 plus one of the author's own, called *JG_special*. Presets often save a lot of work – try them out and check out the effects they have on your photo's curve. You can save your own presets via ▓▓ ▸Save Curves Preset.

Figure 2-25 shows the functions associated with the icons at the bottom of the CS5 panel. The CS6 version (figure 2-26) is slightly simpler because some functions are now incorporated in the Properties panel.

These icons are the same in most adjustment layers. By default, Photoshop displays tool tips if you hover the cursor over an icon.

[2-24] Photoshop offers a rage of Curves presets

[2-25]
The icons at the bottom of the bottom of the CS5 Adjustments panel

[2-26]
The icons at the bottom of the CS6 and Photoshop CC Properties/Adjustment panel

For example, clicking the ● icon changes its appearance to ●, indicating that the current adjustment will be applied only to the next layer (or layer group) down. This creates a clipping mask, as described in section 8.6. Click ● to undo the switch. These icons look slightly different in CS6 (▼◻ and ↲■).

[2-27] The additional tool icons found at the bottom of most adjustment layer panels

Generally, Curves affect the entire image. However, if you wish to apply a Curves adjustment to selected parts of an image, you can do this using a layer mask. Chapter 3 goes into detail on masks and layer masks.

 If you use a steep curve (i.e., greater than 45 degrees) to increase contrast, it also increases color saturation. It is thus advisable to perform curves adjustments before you make any adjustments to saturation using the Hue/Saturation or Vibrance tools. If, however, you only want to selectively increase or reduce contrast without changing saturation, you need to switch the layer's blending mode from *Normal* to *Luminosity* (figure 2-28). This approach will, of course, nullify any color cast removal that you originally intended to perform using this Curves layer.

 Chapter 4 goes into more detail on the various blending modes and the effects they have. *Luminosity* mode is recommended only if you want to use an S curve to increase contrast without affecting saturation.

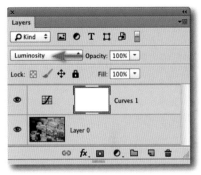

[2-28] Luminosity blending mode prevents Curves adjustments from increasing saturation

2.4 Selective Color Corrections Using Hue/Saturation

Cameras capture many colors differently than how photographers see them during a shoot, so we often need to emphasize or alter the influence of specific colors or tones in our images. In Photoshop, we can do this using the Hue/Saturation, Color Balance, and Curves* tools. A Hue/Saturation adjustment layer is often a good choice for this type of correction.

 The grass in the background of figure 2-30 (next page) is slightly too bright and diverts the viewer's attention away from the subject's face. To correct this, we create a new Hue/Saturation adjustment layer. This adjustment has sliders called *Hue*, *Saturation*, and *Lightness* (figure 2-29).** *Hue* shifts colors within prescribed limits, and *Saturation* increases or decreases saturation. Complete desaturation is one way to convert an image to black-and-white, although it is not always the most effective choice (see section 2.5).

* Individual RGB colors can be strengthened or weakened by shifting that color's curve up or down in the midtone area.

** See page 39 for more details on the HSL color model.

[2-29] The basic Hue/Saturation panel

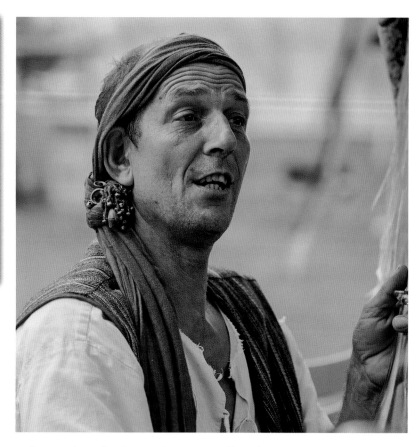

[2-30]
The bright green background spoils the
effect of this image

[2-31] The panel after selecting the green
background using the eyedropper

Lightness adjusts brightness, but it is usually only relevant if we have selected a specific tonal range using menu Ⓐ in figure 2-29. This dialog contains three eyedroppers tools, although they have different functions than the ones built into the Curves tool.

In most cases, we use the tool to alter one rather than all the colors in an image. The Vibrance tool is better for adjusting all colors at once. Here, we select the green of the grass using menu Ⓐ and fine-tune our selection using the eyedropper 🖊 to sample the green tone. The adjustment panel then looks like the one shown in figure 2-31. We see that our green tone is, in fact, a toned-down yellow, indicated by the name *Yellows 2*.

Looking more closely at the lower part of the panel (figure 2-32), we see a color scale with four sliders. The range covered by the two central sliders is regulated using the Hue, Saturation, and Lightness sliders, and the two end sliders regulate the amount of falloff (i.e., feathering) at each end of the adjustment range, enabling us to produce smooth transitions between tones. The narrower the gap between the central sliders, the narrower the range of colors that will be altered. The broader the feathering range, the softer the resulting transitions will be.

Main adjustment range

Feathering range

[2-32]

The sliders indicate which parts of the color range will be influenced by the adjustment

The plus eyedropper ![] (and clicking on some area with a suitable color in your image) is used for adding colors to the selection, and the minus eyedropper ![] subtracts tones. You can also add colors by using the ![] eyedropper with the ⇧ key pressed and subtract them by pressing the Alt key. This approach enables us to make extremely precise tonal selections.

In our example, we increased saturation and reduced brightness in the selected tones. Figure 2-33 shows the settings we used and the result of applying them to our original image.

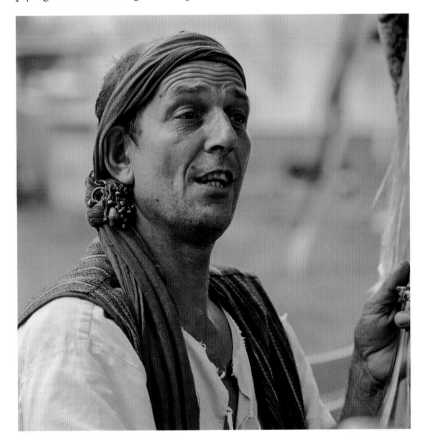

[2-33]

Here you can see the result of applying a Hue/Saturation layer. The setting shown above increases saturation and reduces brightness in the yellow and green tones.

Because the tones in the subject's face also include a yellow component, the adjustment has made it appear darker and more intense. The color of the bast fibers on the right have also increased in intensity. If necessary, we could have prevented the change in the face by applying a black layer mask to the appropriate areas.

In the hope that our subject (a liquor seller at a medieval market) doesn't mind, we will now increase the red tone in his lips to match his head scarf.

Again, we use a Hue/Saturation adjustment layer, but this time we select *Reds* in the drop-down menu. We then select the lip tone using the eyedropper in the Properties panel and increase the saturation while slightly reducing the brightness (figure 2-35).

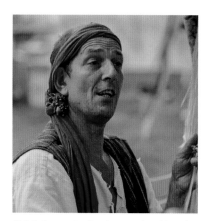

[2-34] A completely white mask reddens the subject's lips and also intensifies the colors in the rest of his face.

We will now use a layer mask on a new layer to preserve the look of the head scarf and the other surrounding areas. When you set layer masks, you have to consider in advance whether it will be more advantageous to start with a white mask and use a black brush to paint in the areas you wish to protect or, conversely, begin with a black mask and use a white brush to extract the appropriate areas. New layer masks are, by default, white. They enable you to see what you are doing while you apply brush strokes or other corrections, even if this isn't the effect you ultimately want (figure 2-34).

In our case, we create a layer mask, activate it in the Layers panel, invert it from white to black (Ctrl/⌘-I) and expose the desired details using a white brush. We recommend that you use reduced opacity (20–30%) and repeated brush strokes to achieve a precise effect. If you find you have applied too much of your effect, simply invert the brush color (by pressing the X key) and mask the overexposed detail in black.

After you have finalized the mask, you can fine-tune the strength of your Hue/Saturation effect by adjusting the opacity of the mask, so don't worry if your initial adjustment turns out a bit too strong.

[2-35] The settings we used for the lips adjustment

Figure 2-37 shows the final image and its accompanying layer stack, and figure 2-36 shows the layer mask we used (which is, in reality, the same size as the image itself).

The same effect can also be achieved by using one of the selection tools (with a feathered edge) to select the detail you wish to mask.

[2-36] This is the mask we used to ensure that our changes were applied only to the subject's lips. We used a white brush with a low hardness setting.

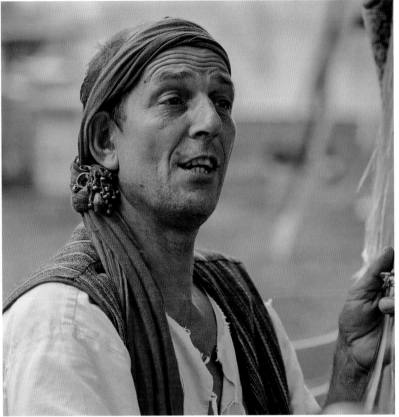

[2-37]

A **Hue/Saturation** adjustment layer was used to intensify the red of the subject's lips, and a layer mask excluded the rest of the image from the adjustment. The adjustment layer stack is shown above.

Make your selection on the pixel layer (in our case, the background). Now activate the top layer and add a Hue/Saturation adjustment layer. If the selection is active, the new layer automatically generates a layer mask in which the selection is shown in white and the rest of the image is black. The area you apply your correction to is now automatically limited to the area within the selection. This is often the most elegant way to approach this type of adjustment. Here, too, you can fine-tune the mask using the Brush tool.

Since CS4 was released, the Hue/Saturation tool includes its own On-image Adjustment tool(🖑), which can be used to increase or reduce saturation by dragging the cursor left or right from its current position. If you press the Ctrl/⌘ key while dragging (actually, before you start to drag), the tool adjusts hue instead of saturation. There is, as yet, no lightness adjustment available.

Hue/Saturation can be used to adjust single or multiple colors. All you have to do is activate different tonal areas one after another and then apply an adjustment to all of them. However, using a separate adjustment layer for each color means you can use layer masks to define the adjustment area more precisely for each layer.

[2-38] The six sliders in the Black & White adjustment layer are used to assign grayscale values to the various colors

➜ Moving a slider to the left darkens a color in the converted image, and moving it to the right has the opposite effect. This approach enables you to produce a completely different look in the converted image!

[2-39] The settings we used to perform the conversion shown in figure 2-43

2.5 Converting an Image to Black-and-White Using Adjustment Layers

Digital cameras cannot produce monochrome images the way analog cameras can. Even if your camera settings make it look like a captured image is black-and-white, the image data on the memory card will be in color. Nowadays, black-and-white conversion takes place at the image editing stage and offers a wide range of settings to help you get the right result. Up to CS2, the Channel Mixer was the tool of choice for converting images to black-and-white. Since CS3, the dedicated Black & White adjustment, with its wide-ranging customization options, has taken over.

Be sure to perform any other basic adjustments (alignment, lens corrections, retouching, optimizing contrast, etc.) before you convert an image to black-and-white.

The results delivered by the default settings in the Black & White dialog are usually quite good, but not perfect. The tool's sliders (figure 2-38) determine which colors are assigned to which grayscale values in the converted image. For example, if you want the green areas in your original to look bright in the converted image, you have to set the Greens slider to a high positive value. If, however, you want your greens to appear darker and more moody, you would use negative values. If you want to emphasize the contrast between a dark sky and white clouds, you would use negative Blues and Cyans values.

As with most other adjustment layers, Black & White includes a range of built-in presets. If you are familiar with analog shooting and darkroom techniques, you will recognize some of the preset effects. For example, the red and yellow filter settings produce the same type of dramatic landscape effect as the analog lens filters they are named after. Each preset offers its own particular combination of slider settings and can be used as the basis for further adjustments.

The original image in figure 2-40 ends up looking like figure 2-41 if we convert it using the default settings in a Black & White adjustment layer. The sky in the converted version is too bright, so we applied the *High Contrast Red Filter* preset, which gave us the result in figure 2-42.

However, the yellow stone of the wall is still too bright, so we reduced the Yellows value manually, followed by a further reduction of the blue value in the sky. To avoid having to guess how individual tones are composed, we once again used the On-image Adjustment tool 👆, to adjust the values directly in the image areas that require correction. This is a very intuitive tool that makes it simple to quickly achieve usable results. The final image is shown in figure 2-43, and the settings we used to create it are shown in figure 2-39.

[2-40] The original image

[2-41] Converted using the default Black & White settings

[2-42] Converted using the High Contrast Red Filter preset

[2-43] The finished image

Keep in mind that the look of a black-and-white image is defined by contrast and tonality, so don't be afraid to dial it up a little to get the effect you are looking for. But try to preserve smooth gradients.

Images converted this way are still RGB images, even if they look like grayscale images. Reducing opacity on the adjustment layer allows the color background layer to show through, which often produces very attractive results. Another effective technique (known as selective desaturation or color splash) involves using a layer mask to isolate a single high-color element within an otherwise monochrome image.*

* There is an example of this technique in section 2.6.

Tinting Black-and-White Images

The *Tint* option in the Black & White dialog enables us to produce effects like the ones we used to create using special chemicals in our analog darkroom days. Today's digital version of the same trick is simpler; it involves checking the *Tint* option and selecting a color from the neighboring picker. Figures 2-45 and 2-46 show two of the virtually endless possibilities. If you create a new tinted Black & White adjustment layer, you can use its opacity setting to fine-tune the strength of the tint effect without affecting the initial conversion.

The Split Toning technique for toning shadows and highlights separately is described in section 2.11 on page 76.

[2-44] If you check the Tint option, you can use the color picker next to the check box to select the color you wish to apply

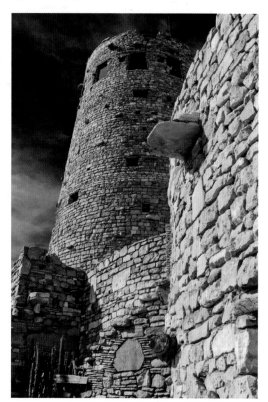

[2-45] A sepia tint

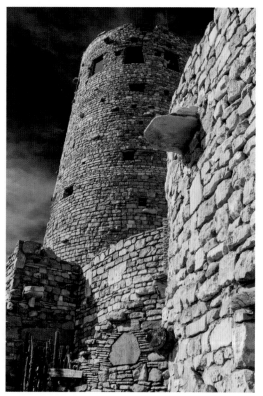

[2-46] A light blue tint

2.6 The Color Splash Technique

The term *color splash* refers to a technique that is used to emphasize a single detail in color while leaving the rest of an image in black-and-white. The trick to producing effective color splash images is to use a strong color limited to a small area within the frame. The lips in a portrait are a typical example of a color splash. The red of a person's lips can be intensified either in advance of conversion to black-and-white or later using either an adjustment layer, a mask, or both. We will describe the color splash process using the calla lily shown in figure 2-47 as an example:

1. Select the element you wish to isolate with a selection tool and, if necessary, fine-tune the selection using the Refine Edge tool (see section 3.9 for more details). In most cases, a feathered edge with a radius of 2–10 pixels should do the trick, although the settings you use will depend on the type of subject and the resolution of your image. Start by making a rough selection – you can always fine-tune the mask later. In our example, we used the Quick Selection tool and a 4-pixel radius.

2. Now create a Black & White adjustment layer. The active selection will be automatically converted into a layer mask on the new layer.

3. To make sure that everything except the chosen color detail is converted to black-and-white, activate the uppermost layer and invert the mask using the Ctrl/⌘-I keystroke.

4. It's now time to adjust the conversion settings. In this case, the default settings are pretty much ideal, so there isn't much to do. To darken the stem, we shifted the Yellows and Greens sliders to the left. Moving these sliders to the right has the opposite effect and lightens the stem.

 We used the On-image Adjustment tool for our fine-tuning. This revealed that the stem and the green parts of the calyx have a strong yellow component. Figure 2-48 shows the settings we used for our black-and-white conversion.

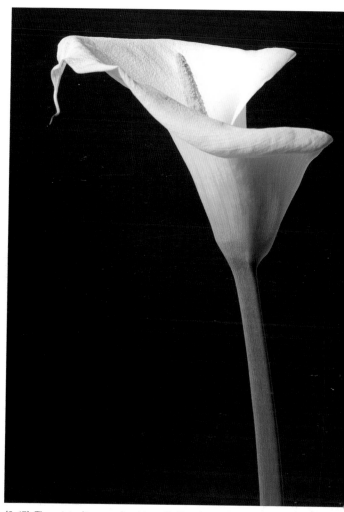

[2-47] The original image of a white calla lily in front of a black background

[2-48]
The Black & White settings we
used to produce figure 2-50

5. We then used a Hue/Saturation adjustment layer to intensify the orange of the spadix. For our first attempt, we selected *Reds* and sampled the spadix using the eyedropper. This took us automatically to the *Yellows* tonal range. Because the spadix has a prominent yellow component, we reduced the *Lightness* setting (an adjustment that is perhaps counterintuitive). The effect of a yellow tone as a component of orange is more intense if it is displayed slightly darker. Figure 2-49 shows the settings we used to produce the version of the image shown in figure 2-50.

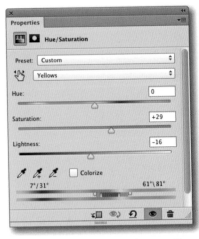

[2-49] The settings we used to intensify the color of the spadix

6. Once again, we had to invert the mask to apply a Hue/Saturation adjustment to just the spadix. To do this, we dragged the layer mask from the Black & White adjustment layer to the uppermost layer while keeping the Alt key pressed, and we inverted it using Ctrl/⌘-I. The layer stack for the finished image is shown in figure 2-51.

[2-50] The monochrome lily with its color splash spadix

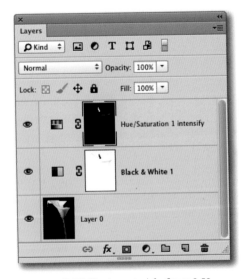

[2-51] The layer stack for figure 2-50

2.7 Adjusting Saturation Using the Vibrance Setting

If you wish to adjust color saturation without affecting tonal values and luminosity, you should use the Vibrance adjustment introduced with Photoshop CS4. This adjustment has two sliders called *Vibrance* and *Saturation* (figure 2-52). Just like its counterparts in Lightroom and Adobe Camera Raw (ACR), the Photoshop *Vibrance* slider is a smart setting that is usually very effective. It automatically increases saturation more in less saturated colors, thus reducing the risk of oversaturation and tonal clipping in the areas you are working on. The slider's effect works the other way around if you use it to reduce saturation.

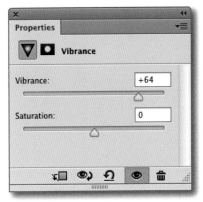

[2-52] Vibrance adjustment layers have two sliders

Clipping

The term *clipping* describes image areas that no longer contain any detail. Clipping can be caused by under- or overexposure, but it can also crop up during editing. It can occur in individual color channels or in any combination of channels.

Brightening light areas, darkening shadows, or increasing saturation in already highly saturated colors can cause clipping. It can also occur during color conversions if the output color space is smaller than the one embedded in the original image.[*]

Clipping can lead to a reduction in differentiation between areas that contain similar tones or levels of brightness, causing an image to look less dynamic.

* You can check whether clipping is likely to occur by using the Photoshop Soft Proof tool and the Gamut Warning command.

In contrast, the *Saturation* slider works in a linear fashion, like its counterpart in the Hue/Saturation adjustment – in other words, it increases or decreases saturation in equal amounts for all colors, right up to the level of complete saturation or desaturation. The smart *Vibrance* slider even takes skin tones into account and saturates them less than others. It is still nevertheless possible to oversaturate an image if you apply too strong a *Vibrance* adjustment, especially if you are outputting your work to a smaller color space. Vibrance can take only the working color space into account. You can often retain (or even intensify) colors that would otherwise be clipped during editing by increasing their luminosity – a trick that the Vibrance adjustment itself can't perform.

The tamarillos in figure 2-53 (next page) are already extremely colorful and immediately attract attention, but they could use a little more color to really make the scene pop.

[2-53]

The original image

We used a Vibrance adjustment layer to increase *Saturation* to 70%. The colors are now more intense, but switching on the Gamut Warning tool ([⇧]-[Ctrl]-[Y]) shows us that this adjustment runs the risk of producing serious clipping in the resulting image.

The areas marked in gray will be clipped if we output the image to the current target color space (in this case, for book printing)

[2-54]

Our tamarillo image with Saturation increased to 70%. The same image is shown above with the Gamut Warning tool active for the ISO Coated v2 (ECI) output profile.

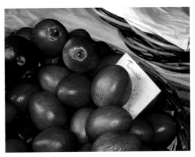

Clipping has been minimized.

[2-55]
In this version, we increased the *Vibrance* setting to 100% and reduced the Saturation to 0. The smaller image above shows that this approach almost completely eliminates clipping for the target color space.

Figure 2-55 shows the result of reducing the *Saturation* setting to 0 and increasing the *Vibrance* to +100. The smaller image on the right (once again, with active gamut warning), shows that this approach produces no significant clipping (except in a couple of highlights that don't affect the overall look of the image).

The colors in figure 2-55 look much more natural in spite of the high *Vibrance* value. The clipping warning color can be customized in Photoshop's main preferences dialog.

Soft Proofing and Gamut Warning

Soft proofing enables you to simulate the look of your image when it is outputted to another medium, such as a print or a different color space. To specify settings for the target (i.e., output) color space, navigate to View ▸ Proof Setup ▸ Custom. To view the resulting soft proof, use the View ▸ Proof Colors command or the Ctrl/⌘-Y shortcut.[*]

If you want to check which colors cannot be properly reproduced (i.e., will be clipped) in your target color space, activate the Gamut Warning function (View ▸ Gamut Warning or ⇧-Ctrl/⌘-Y). Photoshop then marks any areas where clipping will occur using the current profile settings. The default warning color is magenta, but this can be customized in the *Transparency & Gamut* section of Photoshop's preferences. In the case of our tamarillo image, switching the warning color to gray made the clipped areas much easier to see.

[*] Repeating the ⇧-Ctrl-Y keystroke returns Photoshop to its normal view. Active soft proofing is indicated in the title bar of the active image.

➜ If the active gamut warning distracts you while you are editing, simply deactivate it by pressing ⇧-Ctrl-Y.

2.8 Optimizing Skin Tones Using Color Balance

The Color Balance adjustment layer enables us to make separate, very delicate adjustments to shadows, midtones, and highlights. The adjustment's dialog (figure 2-57) offers three sliders with the primary colors from the RGB color model (i.e., red, green, and blue) positioned opposite those from the CMYK model (cyan, magenta, and yellow). Skin tones are a fine example of how to use this particular adjustment. Skin tones belong to the memory colors that are deeply ingrained in our subconscious and play a very important role in the success or failure of a portrait photo. If you are just starting out adjusting skin tones, it is a good idea to have a reference image with good skin tones as a comparison.

The right side of the baby's face in figure 2-56 looks much too pink due to the light reflected from the blanket.

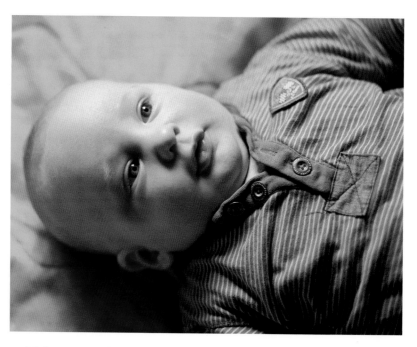

[2-56]

In our original image, the shaded half of the baby's face looks much too pink due to the light reflected from the blanket.

1. We began our adjustment by making a basic selection that generously surrounds the area of concern. We used the Lasso tool with a 10-pixel feathered edge.

2. We then created a new Color Balance adjustment layer with the selection active, which automatically sets the selection as a layer mask.

3. The best way to decide what to edit is to experiment. Experience will show that it is nearly always the midtones that require attention. In our image, the colors in the shadows are not very obtrusive, so a slight shift toward green (i.e., away from magenta, which is the root of the pink color) combined with slight shifts toward red and yellow (figure 2-57), makes a subtle

but sufficient change to the skin tones, giving us the result you can see in figure 2-59.

It helps to sample two reference colors using the Eyedropper tool 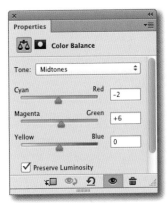. We used one from the baby's forehead, where the tones are correct, and one from the area we wanted to adjust. The values of the selected colors are displayed in the Info panel (Window ▸ Info). We used the Panel Options in the panel menu ▾☰ to activate the RGB and Lab Color value displays (Figure 2-58). The sampled tone in the baby's forehead has values of 181, 166, 159, so we need to adjust the values at the other point to have the same relative (not absolute) values. The differences are more obvious in the Lab values, although the red and blue components of the sampled shadow tone need to be a little higher.

Because we wanted to alter the tone but not the brightness, we activated the *Preserve Luminosity* option in the Color Balance panel.

[2-57] Increasing the green component reduces magenta, while increasing cyan reduces red

[2-58] The Info panel displays the tonal values of reference points that you set within the frame. In this case, we are more interested in the relationships among the individual colors than their absolute values.

[2-59]
The result of applying the setting shown in figure 2-57

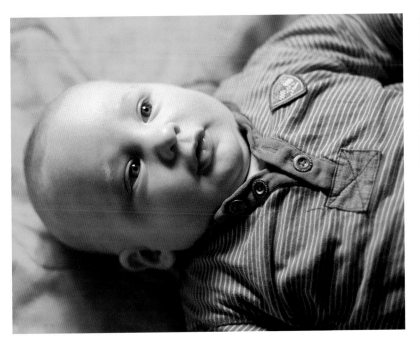

This adjustment confronts us with the base colors from both the RGB and CMYK color models. The colors at opposite ends of each slider are complimentary – in other words, they can be found on opposite sides of the color wheel (see section 1.9 and page 40 for more details on color models and the color wheel). Combining movements of all three sliders enables us to perform fine-tuned shifts in color balance separately for shadows, midtones, and highlights, which can be selected in the *Tone* menu.

[2-60]
The *Tone* option determines whether your settings influence the shadows, midtones, or highlights in your image.

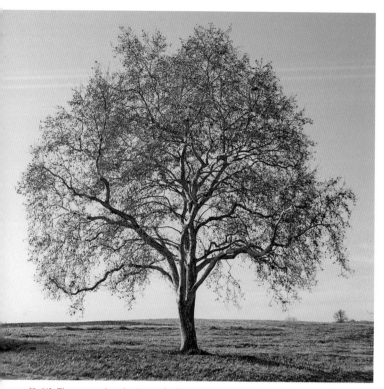

[2-61] The sun makes the image look warmer than my memory of the scene.

2.9 Adjusting the Mood of an Image Using Photo Filters

Figure 2-61 shows a tree that we photographed multiple times in the course of a year-long project. Although it was extremely cold when I captured this particular image, the sun has a much warmer tone than how I remember it. In this case, we used the Photo Filter adjustment to re-create the original mood.

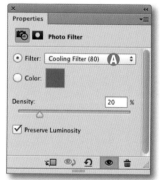

[2-62]

The tone of the Cooling Filter (80) effect is shown in the Color field. The *Density* setting determines the strength of the effect.

Photoshop's *Filter* menu Ⓐ includes a range of preset filter effects, some of which will be familiar to analog photographers. These include *warming* and *cooling* effects, as well as standards such as *Orange* and custom effects like the yellow-green *Underwater* filter.

We applied the *Cooling Filter (80)* preset (figure 2-62) to our original image to achieve the effect you can see in figure 2-63. The effect of the filter's default settings was too strong, but it can be toned down either by reducing the *Density* setting or by reducing opacity in the adjustment layer itself (Photoshop constantly confronts us with choices like this). A third approach is to activate the *Color* option and

[2-63]

Applying the Cooling Filter (80) preset with a density setting of 20% shifted the colors in our image toward blue, giving it a much cooler look

select a different filter color in the color picker – in this case, a slightly warmer tone such as a lighter blue. Remember, filter presets are nothing more than predefined colors that are used to blend an image. In most cases, activating the *Preserve Luminosity* option produces better results by preventing changes to brightness during color shifts.

Because of its soft effect, shady light is often advantageous for shooting portraits. The downside of shooting in the shade is that the colors often look rather cool because of the blue of the sky. Once again, a Photo Filter adjustment layer is the answer. It allowed us to give the baby photo from page 70 a warmer look. Figure 2-65 shows the original image and figure 2-66 shows the effect of applying the *Warming Filter (85)* preset with a density setting of 40%. This adjustment also softened the blue tone in the baby's T-shirt and gives it a look closer to that of the original scene.

This example raises the question of whether it would have been better to make the same correction by applying a different white balance setting. This is often a better solution if you are working with Raw image data. Photoshop CS6 (i.e., Adobe Camera Raw 7) and Lightroom 4 allow selective white balance adjustments.

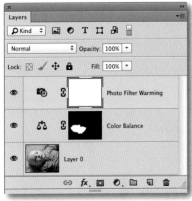

[2-64] The layer stack for figure 2-66

[2-65] This image was shot in the shade, so we wanted to give it a warmer look.

[2-66] The same image after applying the Warming Filter (85) preset

We then could have applied a global white balance adjustment to the entire image and a separate adjustment to the baby's face using the Adjustment Brush tool (in ACR or in Lightroom). Making corrections directly in the Raw converter interface (where you can also process JPEG and TIFF files) uses less memory. Adjusting white balance for JPEG and TIFF images in a Raw converter causes a greater loss of color quality than adjusting a Raw image white balance, but the JPEG will suffer no more than if you use an adjustment layer to perform the same steps.

➜ JPEG and TIFF files can be opened for processing in Adobe Camera Raw (via Bridge, for example) by selecting a file and using the Ctrl-R / ⌘-R shortcut. JPEGs and TIFFs can be processed directly in Lightroom.

2.10 Color Lookup

The Color Lookup tool was introduced with Photoshop CS6 and enables us to make systematic changes to colors and preset looks. The tool was originally designed for producing consistent color in video clips, but it can be effectively applied to still images too, provided you use the preset looks the tool provides.[*]

The original image in this case (figure 2-67) was captured handheld (without flash) at Chateau Carmatin in France using a Canon EOS 5D Mark III set to ISO 3200.

* Defining custom looks using Color Lookup is a complex process that is not well documented. We assume that a range of free and commercial looks will be available in the near future.

[2-67]
The original image was shot handheld without flash using a Canon EOS 5D Mark III. ISO 3200, f/6.3, 1/160 second.

[2-68] The layer stack for the image on the right

[2-69]
The same image with a **Color Lookup** adjustment layer applied. We used the *TealOrangePlusContrast.3DL* preset from the 3DLUT File menu

Color Lookup includes a wide range of retro and movie-style presets that you can apply without tweaking. All you have to do is create a new Color Lookup adjustment layer, select one of the three main menus (figure 2-70) and select one of the presets. The names may sound cryptic, but selecting a preset gives you a real-time preview of its effect before you apply it.

Like with most other adjustment layers, the strength of a Color Lookup effect can be regulated using the layer's opacity setting. It is rare that we use masks or blending modes other than *Normal* with Color Lookup. The mode options included in the dialog are generally of interest only to movie editors (these additional settings appear only when you select certain 3DLUT presets).

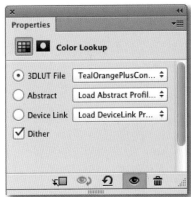

[2-70] The **Color Lookup** adjustment offers three categories, each with a broad range of preset looks

[2-71]
Our image with the **Abstract ▸ Sepia** preset applied

[2-72]
The **Abstract ▸ Gray Tone** preset produces a wonderfully retro look.

2.11 Split Toning Using a Gradient Map

The Photoshop Gradient Map tool is not particularly intuitive to use. It is based on a gradient that maps input tones to specific output tones. A simple black-to-white gradient can be used to convert a color image to monochrome, but it offers less color tuning options than the Channel Mixer and Black & White adjustments. The adjustment can, however, be used to separately alter the weighting of the shadow, midtone, and highlight tones in an image that has already been converted to black-and-white.

Start by converting your image using the Black & White adjustment (to get a monochrome RGB image) and then to tone it using a Gradient Map. (You can do the same in Lightroom and Adobe Camera Raw by converting your image using the *HSL / Grayscale* tool and then applying *Split Toning*.)

Figure 2-73 shows the image we will now process, which we converted from a color image as described in section 2.5.

Creating a new Gradient Map adjustment layer initially has no visible effect. The tool's default settings create a gradient that runs from the current foreground color to the current background color.

[2-73]
Our base image is a color shot of the monastery at Maulbronn in southern Germany that we converted to monochrome using a **Black & White** adjustment layer

To convert an image to black-and-white, press the ⬚D⬚ key to set the appropriate foreground and background colors. Setting a black-and-white gradient in the Gradient Map tool results in a monochrome image, perhaps with a slightly different distribution of grayscale values than those produced by the Black&White adjustment. Menu Ⓐ (figure 2-74) offers a range of preset gradients that can be inverted using the *Reverse* option. The *Dither* option helps to keep the transitions between colors smooth, but it is normally used only when you apply a gradient to 8-bit images.

Click the gradient icon in the Properties panel to open the *Gradient Editor* (figure 2-75), which we will return to quite often throughout the book. You can now select a preset gradient from the Presets icon list or the *Name* drop-down menu Ⓐ. The *Foreground to Background* gradient is selected by default. In our example, we wanted to give the shadows a blue tone and the highlights a sepia tone. Double click the left color stop Ⓑ to activate the color picker for the shadows, and double click the right color stop Ⓒ to select the highlight tone. We selected a deep blue for the shadows and a light sepia for the highlights, giving us the gradient shown in figure 2-75.

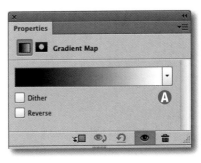

[2-74] The Gradient Map tool looks simple, but it is extremely powerful

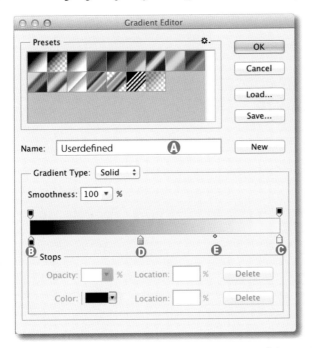

[2-75]

The Gradient Editor dialog can be used to save gradient settings using custom names. Custom gradients appear in the list of presets (usually at the end) and in the **Name** drop-down box.

The Color Midpoint slider Ⓔ is used to fine-tune the run of the gradient between its two end points. Click beneath the gradient indicator to insert one or more additional color stops and define the average input tonal value used by the Gradient Map tool. Photoshop shows the results of alterations in real time in the preview window as long as the *Gradient Editor* is still open.

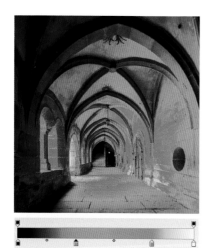

[2-76]
The result of applying dark blue/sepia split toning to our image using a **Gradient Map**

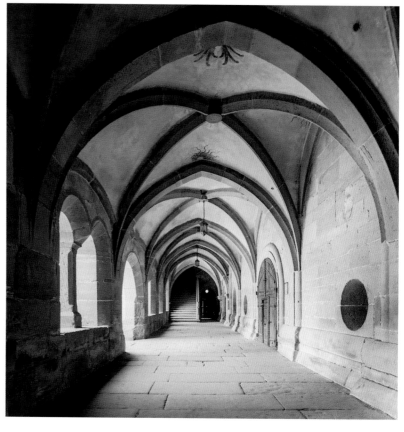

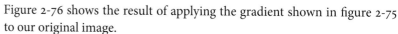

[2-77] You can use gradients to produce way-out effects too

Figure 2-76 shows the result of applying the gradient shown in figure 2-75 to our original image.

Gradient maps can also be used to produce way-out effects like the one shown in figure 2-77, although extreme effects like this are more likely to be used in a graphics environment than in a photo workflow.

Using the Gradient Map isn't the only way to apply split toning to black-and-white images. Photoshop's other options include using the Tint function in the Black & White adjustment to add separate layer masks for shadows and highlights (section 2.5, page 62) or using two separate Photo Filter adjustment layers (section 2.9, page 72).

A luminosity mask (section 3.13, page 108) can be used to tint highlights, and an inverted duplicate mask can be used to tint the remaining pixels (i.e., the shadows).

All these methods can be applied only to RGB black-and-white images. If your monochrome base image is not saved in RGB mode, convert it using Image ▸ Mode ▸ RGB Color before proceeding.

2.12 Image Analysis Using Adjustment Layers

It is often advisable to thoroughly analyze an image before making adjustments. Adjustment layers don't have to be applied to an image and can be created temporarily for analysis purposes. Hue/Saturation and Curves adjustment layers are particularly useful in this respect.

Image Analysis Using Hue/Saturation

Hue/Saturation is one of the adjustment layers that is most often used by photographers, and it's great for checking which tones are present in which areas of an image before you make corrections.

To do this, create a new adjustment layer and set the *Saturation* slider to its maximum value. The result will look terrible but will give you a clear view of the tones and color casts in your image. Color casts are then particularly obvious in areas that would normally contain neutral gray tones.

Figure 2-79 shows an example of this technique. The pink areas in the normally gray text in the background indicate that the image actually has a red color cast.

Reducing the saturation to 0 converts the image to a pure grayscale view, allowing you to clearly see the distribution of tonal values within the frame.

After you have analyzed of your image, you can either delete the Hue/Saturation layer, deactivate it, or use it to apply adjustments. In our example, we could use it to reduce saturation in the red and orange tones or increase it in the blue and green tones to achieve a similar effect. It is not really necessary to achieve absolute tonal neutrality for areas that contain neutral

[2-78] Setting saturation to its maximum value helps you to identify the colors present in an image

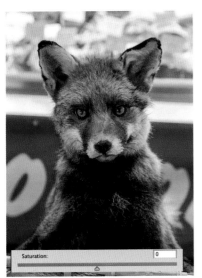
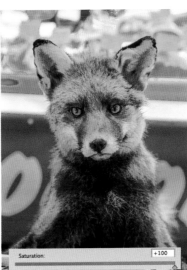
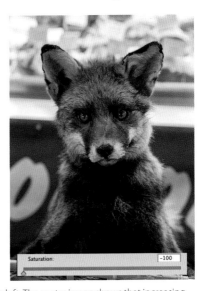

[2-79] The original image (a stuffed fox used for advertising at a French market) is shown on the left. The center image shows that increasing saturation to its maximum value reveals a red color cast in the gray background text. The image on the right shows the (grayscale equivalent) of completely desaturating the colors.

colors. Slight color casts, such as the blue in campfire or nighttime shots, often imparts a mood that identifies the true context.

Although we haven't used them here, there are a couple of other Hue/Saturation tricks you should know about. For instance, you can use an adjustment layer to adjust different colors separately. To do this, navigate to the color channel menu Ⓐ (figure 2-78) and select the color range you wish to adjust. You can do this as often as you like for each color channel.

If you are not sure exactly which tones an image area contains, select a non-*Master* tonal range in menu Ⓐ, activate the left eyedropper (), and click in the area you wish to correct. Photoshop then either selects the appropriate tonal range or creates a new one to match the selected color. You can then expand or limit the range of tones the adjustment affects using the Add and Subtract eyedroppers (or by pressing the ⇧ or Alt keys while using the standard Eyedropper tool). You can, of course, use the sliders in the color bar to directly regulate the tonal range affected by your adjustment (see pages 58–59). However, this option is available only if you have selected a non-*Master* tonal range in menu Ⓐ.

The best way to remove a color cast is either using a Raw converter (a virtually lossless process if applied directly to raw image data) or using a Color Balance adjustment layer.

You can also make corrections using a Curves adjustment layer by setting the gray point using the Gray Point Eyedropper (). Alternatively, you can shift the midtone curve for an over-strong color channel downward, or you can shift the curve for the complementary color of a color cast upward. There are various specialized plug-ins available[*] for removing color casts, but Photoshop's built-in tools are usually sufficient.

Removing color casts and correcting white balance are adjustments that you should make as early as possible in the workflow – ideally in-camera or directly after shooting. If you are shooting in Raw, you should adjust white balance at the Raw conversion stage. Adjusting white balance in Photoshop is a last resort and should be avoided if possible.

Using Curves to Identify Dust and Other Flaws

Just as we can use Hue/Saturation adjustments layers to analyze the colors in an image, we can also use a Curves adjustment layer to reliably identify dust specks and other minor flaws (a function, that has been available since ACR 8.1 and Lightroom 5 when you use the Spot Removal tool). Dust particles stuck to the camera's sensor often cause unsightly dark or bright specks in digital images.[*] Such imperfections can be difficult to see on a monitor and often become apparent after an image has been printed. Adding a steep curve on a Curves adjustment layer makes these types of flaws much easier to identify and retouch. The same applies to skin imperfections in portraits.

→ Don't forget to delete or deactivate your new Hue/Saturation layer after you have finished your analysis.

* For example, iCorrect Editlab Pro from PictoColor Software.

* The introduction of antistatic sensors and automatic sensor cleaning functionality has helped to alleviate the problem, but it is still an issue.

Figure 2-80 shows a typical portrait image, and figure 2-81 shows the same image with an additional Curves layer. The curve itself is shown in figure 2-82.

[2-80] The original image with its virtually invisible skin imperfections that become apparent in a large-format print

[2-81] A steep curve (figure 2-82, center) increases midtone contrast and makes flaws easier to identify.

This process reveals spots and flecks in the midtone range. Spots in the shadows are revealed in the left curve, and the ones in the highlights are reveled in right curve shown in figure 2-82. You can save curves as presets using the Save Curves Preset command in the ▇▇ menu in the Curves panel. If you use meaningful names such as *steep_shadows*, *steep_midtones*, or *steep_highlights*, you will quickly be able to find the right preset when you analyze and adjusting other images.

[2-82] The left curve shows spots in the shadows, the center curve reveals midtone spots, and the curve on the right shows blotches in the highlights (for example, in the sky).

The midtones are important in situations like this. Bright dust spots don't usually make a difference in highlight areas and are usually easy to find in shadow areas without the use of curves. Scanned negatives and slides often contain spots and scratches that you can identify using this method.

Switching the layer's blending mode to *Luminosity* prevents the strong saturation effect that steep curves produce and makes it difficult to judge its effect.

[2-83]
The sky appears dust-free in the outlined detail. However, using a steep curve for the highlights reveals the blotches that are actually present (above), caused by dust on the image sensor.

If you wish to remove the offending flaws, you can start by retaining the steep curve (as an adjustment layer) to help you identify the areas that require alteration.

The adjustment itself should be performed **below** this layer on an empty retouching layer, as described on pages 30–32, using the Clone Stamp (🖊), Spot Healing Brush (🖊), or Patch (🔲) tools. In this case, the tool must only pick up its source from the current layer and that one just below (not from layers below that).

2.13 **General Considerations when Working with Adjustment Layers**

As you can see, Photoshop usually offers more than one way to produce a specific result, especially when it comes to adjusting colors and tonal values. Curves are extremely versatile and can be used to adjust contrast, remove color casts, and colorize images. For example, you can use a negative 45-degree curve to produce the same effect as an Invert adjustment layer. However, other types of adjustment layers are often simpler or more intuitive to use than Curves. For example, Posterize provides a simple way to specify the number of tonal levels (or brightness values) in an image, producing a kind of comic book effect (figure 2-84).

Curves adjustments and nearly all adjustment layers affect individual pixels without taking neighboring pixels into account. This often makes the Shadows/Highlights a better choice for brightening shadows or increasing highlight detail. Shadows/Highlights (which is unfortunately not available as an adjustment layer) uses a *Radius* setting to determine the degree to which it affects the tonal values of neighboring pixels. It is a fantastic tool that often

[2-84] Here, we applied a **Posterize** adjustment layer (with nine levels) to the image shown in figure 2-76.

works wonders, although it can be applied only to pixel layers and is applied directly, making it impossible to make subsequent alterations to an adjustment. The same is true of the HDR Toning adjustment, which also merges all layers contained in an image to a single layer – an unforgiveable feature in our opinion.*

If you are using Photoshop CC (or a later version) there is a good workaround: merge your shots to a 32-bit HDR image in Photoshop (as described in section 5.5). With the resulting 32-bit image, call up Camera Raw Filter, and do your tone mapping in Adobe Camera Raw – the filter can handle 32-bit images!

However, a Shadows/Highlights adjustment can be readjusted later if you first convert the layer you are working on into a Smart Object and apply Shadows/Highlights as a Smart Filter. This technique is described in detail in chapter 6.

Even if you use relatively few adjustment layers in your daily photo workflow, it is still a good idea to try out all the variations. If you know what is available, it is much easier to pick the right tool when a situation demands an unconventional approach.

Adjustment layers are at their most powerful when they are used with layer masks, which are described in more detail in the next chapter.

* Because it merges all layers, this workaround cannot be used with the HDR Toning adjustment. The best approach is to apply the adjustment to a duplicate image and insert the result as a separate layer into the main image.

Working with
Layer Masks

3

*Alongside adjustment layers, layer masks are one of the most
important elements of layer techniques. They enable us to
hide selected parts of a layer by making them transparent or
invisible, and they make it possible to selectively apply the ef-
fects of adjustment layers. This capability is what makes ad-
justment layers so powerful. A mask enables us to paint an
adjustment into an image using a white brush on an other-
wise black mask or to hide selected parts of a layer using a
black brush on a white mask.*

*Adobe is continuously enhancing and extending layer
mask functionality. The introduction of the Quick Selection
tool in CS3 made creating masks much simpler, and the
Refine Edge and Refine Mask tools that appeared with CS4
make it much easier to fine-tune an existing mask.*

*You might find the following chapter slightly heavy going in
places, but it will equip you with all the basic knowledge you
need to get the most out of layers and layer masks. Feel free to
speed-read it now and refer back to the details mentioned in
later chapters as necessary.*

3.1 Making Selective Adjustments Using Layer Masks

Layer Mask Facts

The adjustment layer functionality that we have already described is extremely useful, but *layer masks* add a whole new dimension to their usefulness. They make it possible to determine exactly which parts of an image an effect is applied to and with how much intensity. Without the help of a mask, an adjustment affects the entire image. For this reason alone, masks are one of the most important components of layer techniques.

We have already shown you how to use simple masks, but the following sections go into much more detail. Masks can be complex and time consuming, but once you have learned the basics you will be able to quickly create and manipulate them. The basic principles of layer masks are as follows:

- When applied to a pixel layer, a layer mask controls the layer's visibility. When used with an adjustment layer, it determines which parts of the image the adjustment is applied to.

- Where the layer mask is pure white, the corresponding layer is fully visible – that is, the adjustment works at full strength. A mask's opacity also influences a layer and its adjustments.

 Where the layer mask is pure black, the corresponding pixel layer is invisible – that is, the adjustment has no effect.

 Where the layer mask has an intermediate gray value, this value determines the degree of visibility of the pixel layer and the strength of the layer's effect. The brighter the value, the stronger the effect, and the more visible the pixel layer will be.

→ All pixel layers in a Photoshop file have the same bit depth and the same color mode. The only possible exception is a layer mask, which always is an 8-bit grayscale object.

- Layer masks are treated as pixel images that are saved in 8-bit grayscale mode, regardless of the bit depth and color mode of the image being processed. (Well, there are also vector masks; they are vector objects, not pixel objects. But let's forget them for a moment.)

 If you paint a mask using a colored brush, the painted area takes on the grayscale value of the color you use.

 You can only insert content from the clipboard into a layer mask using trick 9 (explained on page 121).

 If you use the Eraser tool on a mask, the corresponding parts of the mask become white, not transparent (provided the background color is white).

[3-1] A deactivated layer mask

- A mask can be deactivated by ⇧-clicking the mask icon it in the Layers panel. The mask then remains intact but has no effect. A deactivated mask is indicated by a red cross in its panel entry (figure 3-1). Press ⇧-click on the mask to reactivate it.

[3-2] The pixel layer

[3-3] The layer mask

[3-4] The mask shaded red

- Alt-clicking the mask's icon displays the mask in the main preview window (figure 3-3). A repeat Alt-click returns the preview to its normal view.

- ⇧-Alt-clicking the mask's icon will superimpose the mask on the original image (figure 3-4). Once again, repeating the keystroke undoes the switch.

 The mask is colored red and is set to 50% opacity by default (the opacity setting doesn't work for adjustment layers). The default settings can be altered using the Layer Mask Display Options dialog in the mask's context menu (figure 3-6), which you can open by right clicking the mask.

 Showing the mask and the image simultaneously helps you judge the effect of the adjustments you make to the mask.

- In some cases, a mask can actually be smaller than its corresponding pixel or adjustment layer. If this is so, the overhang is treated as if it were white.

[3-5]
The image and the mask displayed together. The checkerboard pattern indicates transparency.
This mask was created using the Quick Selection tool and fine-tuned using the **Refine Edge** dialog.

[3-6] The Layer Mask Display Options determine the color and opacity of the mask as displayed in the preview window

[3-7] The pixel layer is active in the upper image, the mask is active in the lower one.

[3-8] The Masks panel was introduced with CS4 and serves as a useful control center for working with masks

[3-9] With CS6, mask information was moved to the Properties panel.

- A mask has to be activated before you can work on it. To do this, click its thumbnail in the Layers panel. An active mask is indicated by a dotted border (lower illustration in figure 3-7). If you don't activate the mask, any adjustments you make will be applied directly to the pixel layer.

- As of Photoshop CS4, it is possible to adjust the opacity of a layer mask, or *Density* as it is called in this context. The default Density setting is 100%. The mask Density can be reduced using the slider in the Masks panel, which you open using the Window ▸ Masks command (figure 3-8). Reducing the Density setting brightens the mask and weakens its effect. The Masks panel also contains a Feather slider for softening a mask's edges. Other options include the Invert, Mask Edge, and Color Range buttons. The advantage of using the Density and Feather sliders in the panel is that they are non-destructive (i.e., their effects are not actually applied to the mask).

 As of Photoshop CS6, the mask panel was moved to the Properties panel. When you click the mask icon of a layer, the Properties panel will show the mask icon and the mask controls, such as Density and Feather (figure 3-9).

- As of CS4, exisiting masks can be refined using the Select ▸ Color Range and Select ▸ Refine Mask functions (see page 100 and page 102). In CS6, some of these functions are directly accessible via the Properties panel.

- Layer masks can be adjusted using virtually all the tools and filters that are compatible with 8-bit grayscale images. For example, you can blur a mask using the Gaussian Blur filter or increase its contrast using the Image ▸ Adjustments ▸ Curves dialog. You can also use the Brush, Pen, Dodge and Burn tools. These include all the adjustments available in the Image ▸ Adjustments menu, but not adjustment layers.

 Whichever tool you choose, you will always end up performing a grayscale adjustment. You can use these tools to select, delete, and fill selected areas. The real skill lies in learning to use the right selection tool to create your mask and appropriate tools to refine it.

- Layer masks can be saved and applied to other images later on. To save a mask, make sure it is activated and navigate to the Select ▸ Save Selection command. As usual, make sure you choose a meaningful name for your selection. You can load saved masks using the Select ▸ Load Selection command.

- Layer masks can be merged with pixel layers (see section 8.8, page 228). This saves memory and disk space but means that you can no longer alter the mask's attributes.

Now that you know all about the theory of layer masks, let's take a look at some examples of how to use them.

3.2 Simple Masks

In many cases, a simple mask painted roughly using a brush is all you need to successfully edit an image. Figure 3-10 shows a fire salamander that, in spite of its bright coloring, is quite difficult to distinguish from its surroundings. The obvious solution is to reduce the saturation of the colors in the leaves while leaving the salamander's colors untouched.

1. We used a new Hue/Saturation layer with the settings shown in figure 3-11 to perform an initial desaturation, and the result is shown in figure 3-12.

[3-11]
The new layer
desaturates the image
and makes it slightly
brighter, thus reducing
the impact of the leaves

[3-10] In spite of its bright coloring, this fire salamander blends in with its surroundings too much.

2. If a new adjustment layer doesn't automatically generate a layer mask, create one by clicking the ▣ icon at the bottom of the Layers panel. This generates a white mask that can be adjusted using a black brush, in this case starting with a Hardness setting of 50%.

 To create our mask, we zoomed in to the preview image and used a large brush with a high opacity setting to roughly paint in the shape of the salamander's body. We then used a smaller brush to mask the details of its legs and tail.

 It took less than a minute to create the mask shown in figure 3-13. It helps to periodically check the precise shape of the mask in the preview window (Alt-click the mask) and its effect on the image (⇧-Alt-click).

 Minor errors can be quickly corrected using the white brush activated by pressing the X key.

 As long as you use a soft (feathered) edge, the mask doesn't have to be too precise. If you wish to use the composite mask/image view, make sure the brush is still set to

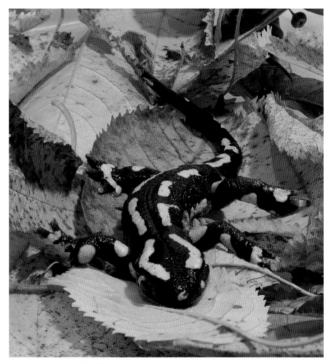

[3-12] The same image with reduced saturation

[3-13] This simple mask, created using just a few rough brush strokes, protects the subject from the effect of the adjustment layer applied to the rest of the image.

the right color. In this mode, the standard red rubylith color and the default 50% opacity setting can make it difficult to see exactly where the mask affects the image, so it can help to increase the opacity of the red color. If the default color isn't appropriate, open the mask's context menu by right clicking the mask thumbnail and switch the color to one that is easier to see. The color you use for the mask has no effect on the results of your adjustments.

Figure 3-15 shows the final result, and figure 3-14 shows the corresponding layer stack. The difference between figure 3-10 and 3-15 is quite subtle, but subtle adjustments are often the most effective.

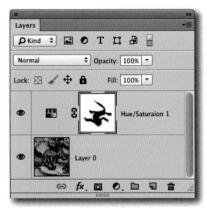

[3-14] The Layer stack for figure 3-15

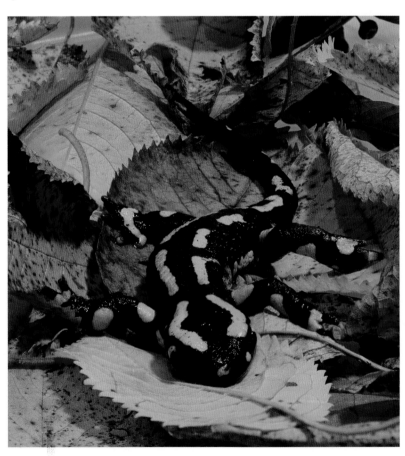

[3-15]
Protected by the layer mask, the salamander is now much more clearly defined against the background.

3.3 Using Masks Multiple Times

This simple example incorporates various aspects of working with layer masks. Figure 3-16 shows our original image, which is a relatively old JPEG file. The colorful house and the trees in the background have both turned out a little too dark, and the sky is too bright and lacks detail. We need to mask the various parts of the image if we want to process them separately.

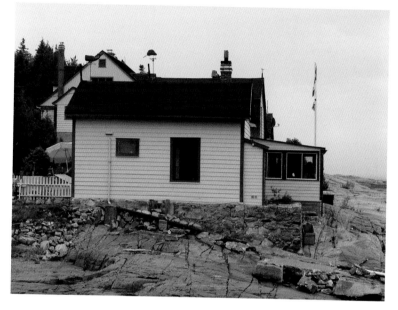

[3-16]
The original image

1. We create our first simple mask by clicking on the sky with the Magic Wand tool (🖌). In this case, we had to use the smallest possible Tolerance value that was still large enough to provide a usable selection, so we ended up using a value of 20. We activated the tool's *Contiguous* option to ensure that no pixels from the rest of the image were included in our selection. If an initial selection doesn't completely cover the desired area, you can ⇧-click in adjacent areas to add to a selection.

2. To adjust the parts of the image that do not include the sky, we inverted the selection. This can be done either by using the Select ▸ Inverse command or ⇧-Ctrl-I (⇧-⌘-I on a Mac).

 We then created a new Curves adjustment layer, which automatically generated a black mask to protect the sky. Applying the curve shown in figure 3-17 made the foreground brighter and less drab (figure 3-19).

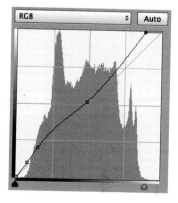

[3-17]
The curve we used for our initial adjustment

[3-18] The layer stack for figure 3-19 showing the layer mask that protects the detail in the sky

[3-19]
After applying a **Curves** adjustment and a mask to protect the sky

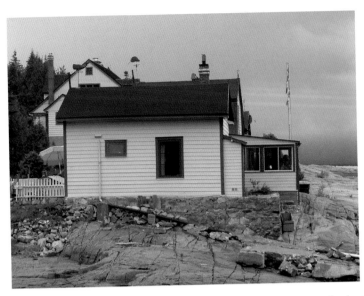

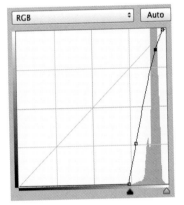

[3-20] A very steep curve for our sky. The rest of the image is protected by a mask.

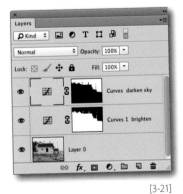

[3-21]
The results of our adjustments so far. The foreground is brighter, showing more contrast and color saturation. The corresponding layer stack is shown above.

3. Rather than replacing it, we decided to attempt to retrieve the lost detail in the sky. To do this, we used a steep curve to increase contrast and detail definition. The necessary mask was already part of our Curves layer, so all we had to do to apply it was right click on the mask thumbnail in the Layers panel, select the Add Mask to Selection command in the context menu, and use ⇧-Ctrl/⌘-I to invert it to cover the sky.

 We then created a new Curves adjustment layer using the new selection, allowing us to work on the sky without affecting the rest of the image.

4. Figure 3-20 shows the fairly extreme curve we used. The histogram in the background reveals that the curve adds some detail to the sky but also adds some unwanted noise, which we will remove during the next step. Figure 3-21 shows the results of the corrections we have made so far.

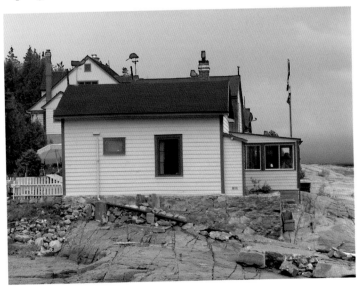

5. To remove the noise that the previous steps produced, we have a choice between using the Reduce Noise filter (Filter ▸ Noise ▸ Reduce Noise) or the Gaussian Blur filter, which is a good alternative in areas like the sky that contain little obvious texture.

 Because filters work only on pixel layers, we selected the uppermost layer and created a composite layer using ⇧-Ctrl-Alt-E (⇧-⌘-Ctrl-Alt-E on a Mac). The noise reduction is then applied to this new layer.

6. Because we wanted to blur only the sky, we activated the sky mask and selected the *Add Mask to Selection* command from the context menu, even though there was no selection to add it to. We then used the new selection mask to activate the composite layer and created a new mask using the ⬤ icon at the bottom of the Layers panel. This restricted the effect of the next step to the sky.

 We could have duplicated the sky mask by dragging it to the third layer with the Alt-key pressed. We then opened the Gaussian Blur filter dialog (figure 3-22). Now, we increased the Radius setting until the sky gained a suitably soft look with no visible noise.

 Remember to work slowly to give Photoshop time to update the preview image, and always work at the greatest possible magnification to help you judge the effect of your adjustments.

7. We decided to add a little color to the sky by applying the *Cooling Filter (80)* preset from the Photo Filter menu. We used a Density setting of 15%. To ensure that this change was applied only to the sky, we dragged the composite layer's mask to the Photo Filter layer mask with the Alt key pressed. Figure 3-24 shows the results of these adjustments, and figure 3-23 shows the corresponding layer stack.

[3-22] The Gaussian Blur filter dialog

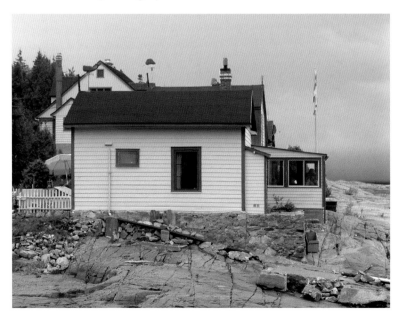

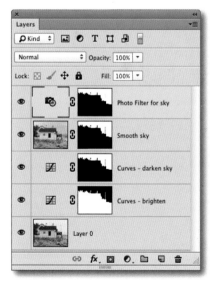

[3-23] The layer stack for figure 3-24

[3-24]

Using Photo Filter, we added some blue to the sky.

3.4 From a Selection to a Mask and Back

What We Have Learned So Far

→ In addition to the tips you have already seen, sections 3.5 to 3.8 go into more detail on selections and selection tools.

Selections and masks are easily interchangeable, and selections often form the basis of a mask. If a selection is active and you then create a new adjustment layer, the selection will automatically be transformed into a layer mask. The selected areas will be white (or gray, if the selection contains partially selected pixels). Nonselected areas are black.

If you wish to adjust only part of an image, it makes sense to select the appropriate areas before you create a new layer. If the selection represents the parts of the image you don't want to adjust, you can invert the mask in advance using the Select ▸ Inverse command* or by pressing the Alt key while you create the new layer. If a new layer has been created with an empty mask, the quickest way to produce a usable mask is to delete the empty one and proceed as described above.

* Or you can use ⇧-Ctrl/⌘-I.

You can also right click an existing mask and use the Add Mask to Selection command in the context menu, even if there is no currently active selection. This converts the mask to a selection. If you then create a new layer, it will automatically have the previously selected mask as its layer mask. A selection can always be inverted using ⇧-Ctrl/⌘-I before it is used to create a mask.

Selections can be saved for later use using the Select ▸ Save Selection dialog (figure 3-25). The default settings save a selection as a new channel in the current document. The dialog enables you to give a selection a meaningful name, and it names selections sequentially as Alpha 1, Alpha 2, and so forth if you forget. If necessary, you can alter these default names manually in the Channels panel.

[3-25]
Saved selections/channels can be given appropriate names.

Saved selections are loaded using the Select ▸ Load Selection command or in the Channels panel (Window ▸ Channels), where you have to select the appropriate channel – provided, of course, that the selection is saved with the current image file – and then click the ⚙ icon at the bottom of the panel.

Replacing a Layer Mask with a Selection or Another Mask

If you need to use a saved selection or mask to create a new mask, all you have to do is create a new, empty mask and select your existing mask/selection using the Image ▸ Apply Image dialog (figure 3-26).

The dialog might appear complex at first glance, but it is quite easy to use. The current document is automatically entered as the Source Ⓐ, but you can select other open documents too. You then have to select the layer with the content you wish to process in menu Ⓑ, which contains all layers contained in the document selected at Ⓐ. The first entry in the list is *Merged*, which represents the grayscale equivalent of all currently visible layers, giving you a kind of luminosity mask (see section 3.13 for more details).

Use menu Ⓒ to select a channel or mask/selection. The menu contains all channels and masks contained in the layer selected at Ⓑ. If the selected layer is an adjustment layer, only the layer mask will be available for selection.

The *Blending* menu Ⓓ is used to select the blending method, and *Normal* is usually the best choice in situations like this. The default *Opacity* setting of 100% is usually the best starting point. And that's it! In essence, all you have to do is select a layer and a channel and click *OK* to have a channel set as a new mask.

It is possible to blend a mask with itself using a blending mode that brightens or darkens the mask or gives it more contrast.[*]

Activating the *Mask* option Ⓔ displays additional options (figure 3-27) and enables you to blend your results with an additional mask. We hardly ever use this option, but it can be useful if you want to merge the mask you have just created with an existing one.

[3-26] In addition to blending pixel layers with other layers, the Apply Image command can also be used to load layer masks and merge them with other layers and masks. The resulting mask will always be an 8-bit grayscale image.

[*] See chapter 4 for more details on blending modes.

[3-27]

Activating the *Mask* option in the **Apply Image** dialog enables you to blend the results with an additional channel or mask

Right clicking an active mask reveals the context menu with its range of useful commands (see figure 3-28). For example, the mask can be deleted, applied to a pixel layer, or intersected with a selection. The Refine Mask command is discussed on page 104, and the Mask Options dialog is discussed on page 87.

[3-28]

The context menu for an active layer mask

3.5 Selection Tools Overview

The creation and fine-tuning of selections is one of the basic skills you need to master to be able to work effectively with Photoshop. Therefore, you should take some time to learn them.

You will often need to use selections, and you need to create them quickly. However, this is only possible if you are familiar with all the available tools and you know which ones to use in a particular situation. In addition, you need to know how to combine multiple selections and fine-tune the results.

Current versions of Photoshop offer a broad range of selection tools. These include the Rectangular, Ellipse, Single Row, and Single Column Marquee tools, as well as the various Lassos, the Magic Wand, and, since the CS3 release, the Quick Selection tool. Each has its own special capabilities, and it is often necessary to use a combination of tools to create the right selection. They can all be used to make selections for creating masks, and they can also be used to edit a layer mask to make a selective adjustment.

The Color Range dialog is a useful extension to the selection tools and can be accessed either via the Select menu or the options bar of the selection tool you are using. We plunge deeper into the Color Range tool in section 3.8.

In a Quick Mask, you can use a brush to make a selection (see section 3.7).

If you need to make an extremely precise selection with multiple edges and curves, Paths are your best choice. The Paths tools enable you to create a path (i.e., a spline curve) and transform it into a selection, a pixel layer mask, or a vector layer mask. See section 3.16 for more details.

Additionally, existing selections can be saved, loaded, and combined with other selections.

Selections can also be moved, transformed, added to, subtracted from and fine-tuned using the Select ▸ Refine Edge command (see section 3.9).

The art of successful selection lies in learning to choose the right tool or combination of tools for the job at hand. Again, experience and practice are the best teachers, and you will soon set up and refine your own personal tool set.

The four buttons (◻ ◻ ◻ ◻) in the selections tools' options bar allow you to create a new selection, add to or subtract from an existing selection, and intersect a new selection with an existing one. Instead of using the mouse, the keyboard shortcuts shown in the margin are another quick way to temporarily switch modes.

Sometimes, the blinking selection border – also called *marching ants* – disturbs your concentration. Therefore, you can hide and show the borders using the [Ctrl]-[H]/ [⌘]-[H] shortcut. Toggling the border on and off doesn't affect the selection itself.

Selection shortcuts:

Add:	[⇧] (Shift key)
Subtract:	[Alt]
Intersection:	[⇧]-[Alt]
Inverse:	[⇧]-[Ctrl]-[I]
Deselect:	[Ctrl]-[D]
Select All:	[Ctrl]-[A]
Refine Edge:	[Alt]-[Ctrl]-[R]

3.6 Making Selections Using the Magic Wand, Magnetic Lasso, and Quick Selection Tools

Magic Wand ✨ · This tool is an old favorite and a good choice for selecting areas with relatively homogeneous colors, such as the bright sky in our example. The trick with this tool is finding the right Tolerance value. The *Contiguous* option ensures that only pixels adjacent to the cursor with colors matching its current position are selected. If you don't use this option, the tool selects all matching colored pixels in the image.

[3-29] The Magic Wand options bar

[3-30]

In this case, we used the Magic Wand tool with a Tolerance setting of 20 to select the sky.

As with other selection tools, you can add to a Magic Wand selection by holding down the ⬆ key or subtract from it by holding down the Alt key while selecting. You can intersect two selections using the ⬆-Alt shortcut. If you need to smooth a selection's edges, you can either check the Anti-alias option or use the options included in the *Refine Edge* dialog (see section 3.9 for more details).

Magnetic Lasso · This tool is great for selecting complex shapes. It snaps to the edges of well-defined areas when you trace the outline of an object with the cursor. The tool looks for high-contrast edges and selects segments and fastening points along the outline. You can click the automatically produced outline to add your own fastening points, which we recommend you do in all places where an outline makes a sharp change in direction. The Del key undoes your last action.

➡ The buttons in the selection tools' options bar () can be used instead of the shortcuts listed on the previous page to switch the mode of the next selection you make.

[3-31] The Magnetic Lasso options bar

Similar to the *Tolerance* control with the Magic Wand, the *Contrast* setting determines the degree of tonal contrast necessary between pixels to define them as an edge, and *Width* determines the distance (in pixels) from the

cursor within which the tool searches for appropriate pixels. *Frequency* determines the rate at which the tool sets fastening points.

You can reduce the *Frequency* setting for less complex shapes, and you complete a selection either by clicking the first fastening point or double clicking the last one.

In more recent versions of Photoshop, you can also select a *Feather* value to soften your selection's edges and activate the *Anti-alias* option, if necessary.

Quick Selection ✎ · Introduced with CS4, this is a versatile selection tool that replaces the Extract filter that was part of earlier versions of Photoshop. The tool works by tracing the inside outline of the area you wish to select. Make sure you select a *Size* setting that fits the type of detail you are selecting. You can make a rough selection using a large brush and then select the edges and details using a smaller one.

[3-32] The Quick Selection tool options bar

The tool's automatic functionality is effective but often makes large additions to a selection when it thinks it finds more details similar to already selected ones. If an automatic addition is too large, use the Ctrl/⌘-Z to move one step backward while retaining the rest of the selection you have already made. If you let go of the mouse button at regular intervals, the tool will automatically select smaller additional areas, so you can work more accurately.

After you have made a rough selection, check the *Auto-Enhance* option (in the options bar) before you fine-tune your selection. This helps to narrow the selection down to pixels that are similar to those at the current cursor position.

Work slowly while fine-tuning to give the program time to analyze the neighboring pixels and update the preview image. The tool analyzes color and brightness values and sometimes takes a quick break before updating the border around a selection, so you might find that you have to stop selecting until it catches up.

If you have made a selection that is too large, pressing the Alt key and retracing the unwanted areas subtracts them from the selection. You can then release the Alt key and continue selecting. This technique requires a little practice, but it quickly becomes intuitive.

To make the final touches to your selection, click the *Refine Edge* button in the options bar and proceed with Refine Edge. Section 3.9 explains how to use the dialog.

The Quick Selection tool often produces extremely good results, but it has problems detecting soft edges and low-contrast transitions. In such cases, you can fine-tune a rough selection using other tools, such as the Brush or Pencil (see the next section for more details).

3.7 Quick Mask Mode

Quick Mask mode allows you to adjust a selection directly using the Brush tool. After you have made a rough selection, double click the ⬚ icon in the toolbox to activate the Quick Mask Options dialog shown in figure 3-33. This is where you can decide whether to display the masked or selected areas in color, as well as the color and opacity of the overlay.

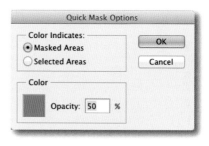

Quick Mask mode is then activated by pressing the ⬚ key. This grays out the ⬚ icon in the toolbox. Photoshop now displays your selection (or the mask, depending on the settings you have just made) as a colored overlay. If you have chosen to display *Selected Areas*, you can now use the Brush tool ✐ set to black to make a new selection or add to the existing one. The Hardness and Opacity settings of the brush influence the nature of the selection. If you have selected too much, use a white brush to subtract the unwanted areas.

[3-33] This dialog contains options for setting the mask color and opacity as well as for switching the color overlay between masked and selected areas.

A repeat press of the ⬚ key returns the program to normal selection mode and displays the altered selection with the usual blinking dashed border instead of the red mask.

[3-34] In this example, we selected the roof. The left image shows the preview window with Quick Mask mode set to Selected Areas, and the right image shows the result of selecting the Masked Areas option.

If you choose the *Masked Areas* option in the dialog shown in figure 3-33, the mask (i.e., the inverse of the selection) will be displayed with a colored overlay. You can then add to the selection using a white brush or subtract from it using a black brush. If you want to give your selection really hard edges, you can use the Pencil tool ✐ instead of the Brush.

Quick Mask mode takes a little getting used to, but it is a useful tool for fine-tuning selections.

3.8 Selecting and Masking Using the Color Range Command

The Color Range command (Select ▸ Color Range) was introduced with CS3 and enables us to make selections based on colors. The command is continually being developed, and the CS6 version includes the new *Detect Faces* option. Depending on which Photoshop version you use, the command can also be accessed via the *Masks/Properties* panel or directly via the selection tool options bar.

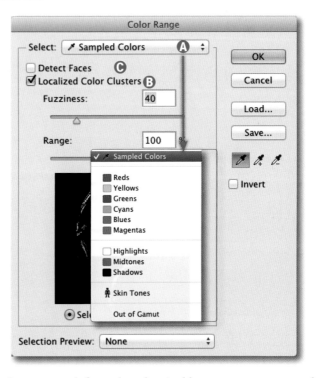

[3-35]
The Photoshop CS6 *Color Range* dialog

To apply the command, first select the pixel layer you want to sample from, then choose a Select option from the drop-down Ⓐ (*Sampled Colors* is selected and the ✎ eyedropper is activated by default). Now select an area that contains the color you wish to sample. The radio buttons beneath the preview image allow you to choose between displaying the selection or the image.

The *Fuzziness* slider determines the degree to which sampled colors can differ from the color at the cursor position. Additional clicks with the plus eyedropper ✎₊ add colors to the selection, and clicking with the minus eyedropper ✎ subtracts colors. A faster way to achieve the same effect is to use ⇧-clicks to add colors and Alt-clicks to subtract them.

Activating option Ⓑ *Localized Color Clusters* limits the area around the cursor that is sampled and helps to produce precise multiple color range selections. The *Range* slider determines the radius of the sampled area. Low

values enable you to select colors locally, even if the same color appears elsewhere in the image. The best way to build up a selection is using multiple ⇧-clicks and Alt-clicks to correct any errors. As always, experimenting is the best way to get a feel for the way the tool works.

If you select the *Skin Tones* option – introduced with Photoshop CS6 – in menu Ⓐ, the *Range* slider is grayed out (figure 3-36) because the color range is already selected. Often, it's more practical to use the *Sampled Colors* selection option and activate *Localized Color Clusters* before you select one or more skin tones manually using the 🖉 eyedropper.

The *Detect Faces* option Ⓒ (introduced with CS6) attempts to find faces within the frame using an algorithm that is influenced by the *Range* and *Fuzziness* sliders, as shown in figure 3-38. This is a great option for working with portraits in which the subject's face and skin tones are the main details that require editing. *Skin Tones* and *Detect Faces* can be combined, but you usually need to fine-tune the mask with a brush when you use this technique.

The resulting selection can be inverted and saved. The *Load* button enables you to add a saved selection to or subtract it from the current one, or you can create an intersection of the two (figure 3-49).

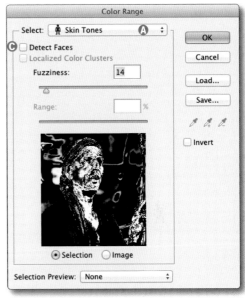

[3-36] With Skin Tones, there is no Range control

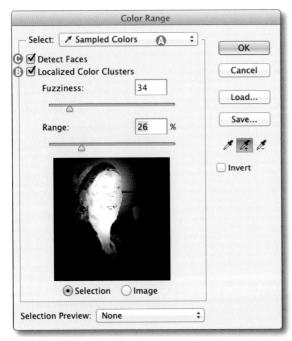

[3-38] The *Color Range* mask using the *Detect Faces* option

[3-37] The original image

3.9 Refine Edge

You will often need to refine a rough selection that you made with the Quick Selection tool or Color Range command by using the Select ▸ Refine Edge dialog (or a mask using Select ▸ Refine Mask). The former was introduced in CS3 and the latter in CS4, and both have been continually developed since then. The two dialogs are virtually identical and are important tools for fine-tuning masks and selections. The following sections explain them in detail. The selection we made in figure 3-38 is shown in the Refine Edge dialog (figure 3-39).

The first step is to select an appropriate *View* Ⓐ. There are various options that you can change at any time using the *View* menu or the F key.

As its name suggests, the dialog's main function is to fine-tune the edges of a previously made selection. The areas that are affected by the radius, detected by the *Smart Radius* function, can be shown by selecting the *Show Radius* option.

The *Smart Radius* option looks for contrasting pixels and color transitions within the selected pixel range and adjusts the selection accordingly. You should select a *Radius* value that suits the resolution and texture of the image content. Experiment to find out which value best suits the image you are working on.

The Refine Radius tool 🖌 Ⓑ enables you to extend or reduce the radius range. Tracing the selection's edge with the Alt key pressed reduces the range, and you can use the Zoom and Hand 🖐 tools to check your changes in detail.*

In the *Adjust Edge* section of the dialog, a setting of just a few pixels is usually sufficient for the *Smooth* option, although if the edge includes very fine details, such as hair, it is better to leave it set to zero.

If the rough selection has hard edges, it is usually beneficial to select the *Feather* option. Once again, the pixel value you select will depend on the resolution and content of the selection.

The *Contrast* value determines the abruptness of soft-edged transitions along the border of the selection. In most cases, 0 is the best value to use.

Positive *Shift Edge* values shift the border of the selection outward, and negative values shift it inward. The best value to choose will depend on the nature of the selection and the surrounding pixels.

If you are isolating an object from its background, you will often find that odd pixels with the background color are still part of the selection and its semitransparent edge, which produces a slightly dirty effect. The *Decontaminate Colors* option combats this effect and goes a long way toward removing the background color from a selection, although there is no way to explicitly select a tone that you wish to remove.

* The Hand tool can be temporarily activated by pressing the space bar.

➜ Adobe offers a video tutorial on how to use the **Refine Edge** dialog at: http://tv.adobe.com/watch/learn-photoshop-cs6/selecting-soft-edge-objects-with-refine-edge/.

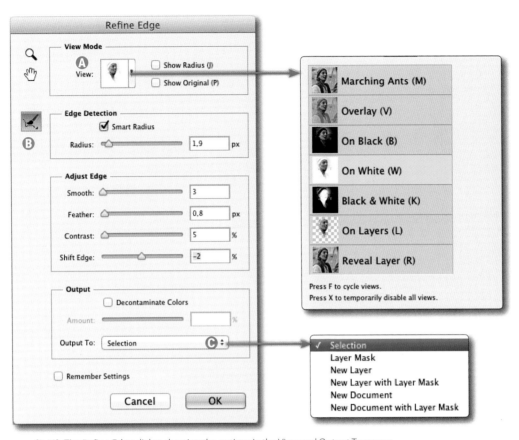

[3-39] The **Refine Edge** dialog showing the options in the View and Output To menus

Selecting a different view in menu Ⓐ (figure 3-39) often helps you get a clearer picture of complex masks and selections.[*]

Finally, use the *Output To* menu Ⓒ (figure 3-39) to choose the output type for your refined selection.

If you use your selection to create a layer mask, you have to create a new layer, delete the automatically created layer mask (if necessary), make your selection and refine it, and then select the *Layer Mask* option in menu Ⓒ.

All layers and masks can be used to make a selection that serves as the basis for a layer mask. After you finish the selection, you can activate the layer where you want to apply the mask.

Alternatively, you can create a selection and use the *Selection* option in the *Output To* menu. You can then create a new adjustment layer with the selection active. The selection then automatically becomes a mask, which you can invert if necessary.

[*] Press the F key to switch views.

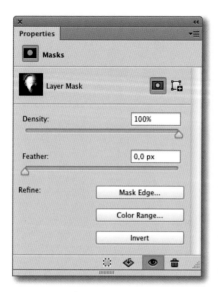

[3-40] The **Refine Mask** dialog includes the same options as Refine Edge

Refine Mask

If you want to refine an existing mask, activate it and then navigate either to Select ▸ Refine Mask or go directly to the Mask Edge function in the *Properties* panel. The same dialog appears as it did for the Refine Edge function, but it is now used to refine the active mask rather than an active selection.

These two dialogs contain powerful tools that are self-explanatory in most simple editing situations. However, in more complex cases, it pays to look at the way they work in more detail and to practice. It is not uncommon that a mask will have to be further refined using some of the other tools we have already introduced. Don't be afraid to pull out all the stops: zoom in and out, switch views, use all the edge adjustment sliders, and don't forget the Refine Radius tool . Using Quick Selection (or other selection tools) in combination with the Refine Edge and Refine Mask dialogs usually provides all the selection tools you need and makes most specialized third-party selection plug-ins redundant. Plug-ins have to be learned too!

3.10 Saving Masks

* If necessary, you can then invert the mask using Ctrl/⌘-I .

If you want to apply an existing layer mask to another layer, drag it to a layer (or layer mask) with the Alt key pressed.* If the layer already contains a mask, Photoshop will ask if you want to replace it. Confirm by selecting Yes. If you drag a mask without pressing the Alt key, it will be deleted from the original layer.

You can drag a mask to another (open) image in a separate Photoshop window using Alt-drag, and you can perform the same maneuver for entire layers. However, Photoshop doesn't automatically adjust the size of dragged layers to fit one another.

You can load a saved selection into a new layer or image using the Select ▸ Load Selection command. You can use any open file as your source (figure 3-41), and you have to specify the channel that contains the selection you wish to use.

[3-41]
When you load a selection, you can specify the source document, the channel that contains the selection, and the operation you want to use to combine the loaded selection with an existing one.

3.11 Selections and Channels

Color channels are the result of splitting an image into its RGB components (if your image is in RGB mode). Each color has its own channel. The color mode of an image is reflected in the way the channels look and function. An image in RGB mode (which we usually use) contains red, green, and blue channels. For an overview of the various color modes and models, see section 1.9, page 38.

You can view channels in the Channels panel (figure 3-42). If you are working in CMYK mode, the panel will contain cyan, magenta, yellow, and black channels, where black represents the Key (K) channel. If you use the Image ▸ Mode ▸ Lab Color command to convert an image to Lab mode, the panel will contain a channels labeled *Lightness* (**L**, equivalent to the luminance component of the HSL model), plus **a** and **b** color channels (figure 3-43). But why are we looking at channels and the Channels panel at all?

One reason is that individual channels often make great ready-made masks – for example, the *Lightness* channel in Lab mode can be used as a luminance mask. Additionally, Photoshop temporarily saves masks (and, with a little help, selections) as channels. They then appear in the Channels panel (like the *Face mask* shown in figure 3-42). Such temporary channels are, however, usually deactivated and are thus invisible (figures 3-42 and 3-43), even though they take up additional disk space and memory.

You can check out how this works by making a selection on a pixel layer and opening the Channels panel. Using its default settings, Photoshop numbers such selection (or alpha) channels sequentially starting with *Alpha 1*, but you can change the name of an alpha channel in the Channels panel. If you use the Select ▸ Save Selection command, you can select a name for your selection in the dialog that follows.

If a selection is active and you click the 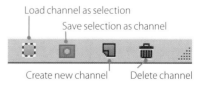 icon in the Channels panel, the selection will be saved as a channel. The saved selection can then be loaded by selecting its channel and clicking the ⚙ icon.

The Channels panel displays only the channels and layer masks contained in the current layer and any newly created channels.

Clicking the 👁 icon shows and hides a channel, and an Alt-click on the 👁 icon shows or hides all other channels. This is the same functionality that we have already seen in the Layers panel, where the 🔲 and 🗑 icons have the same functions.

The layer icons in the Channels panel can be displayed in their native colors or as luminance icons (figure 3-42), which are often more useful, especially if you are on the lookout for the channel that contains the most image data. Choose the setting in the Interface ▸ Options ▸ *Show Channels in Color* option in the Preferences dialog. It is usually best to deactivate it.

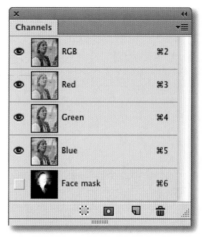

[3-42] The Channels panel for an RGB image with a mask called *Face mask*

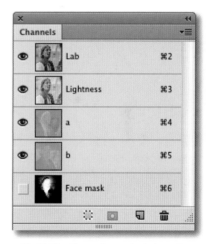

[3-43] The Channels panel in Lab mode

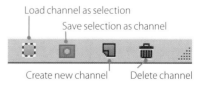

Load channel as selection
Save selection as channel
Create new channel Delete channel

[3-44] The icons at the bottom of the Channels panel

Luminance mask

→ The quickest way to create a luminance mask is to Ctrl/⌘-click the RGB channel in the Channels panel. This converts the luminance of the image to a selection that you can then use as a layer mask.

If you need to save the luminance (i.e., the distribution of brightness values) of an RGB image as a mask, select the RGB channel in the Channels panel by clicking it (or using the Ctrl/⌘-2 shortcut), load the selection as a channel (🔲), save it as a new channel (🔲), and give it a new name. You can, of course, save this sequence as a Photoshop Action. (For more details on how to create luminance masks, see section 3.13.)

You can use the same procedure to load one of the other channels as a selection or a mask.

As with layers, Photoshop gives new channels generic names, so we recommend that you give your selections and channels new, meaningful names as soon as you create them.

3.12 Using Channels to Optimize Images

Denoising the Blue Channel

The blue channel often contains the most noise – for example, if images are shot with high ISO values. Instead of reducing noise in all three channels and running the risk of losing image detail, you can reduce noise in just the blue channel:

[3-45] Click the blue channel to display it alone

1. Copy the background layer (Ctrl/⌘-J) or, if you have already applied adjustment layers, create a new combined layer using the Ctrl/⌘-Alt-⇧-E shortcut.

2. Activate the uppermost layer and then activate the blue channel (figure 3-45), to make sure it contains the most noise.

3. If it does, you have to blur the blue channel by, for example, using Filter ▸ Blur ▸ Gaussian Blur. Make sure that you zoom in far enough to adequately judge the effect of your adjustments. The Radius value you use will depend on the nature of the image you are editing, but values between 2 and 6 pixels will probably do the trick. Keep an eye on the detail image in the dialog window and the main preview image while you work.

4. That's all there is to it. Click the RGB layer in the Channels panel to see the result of your changes.

* Start by ⇧-clicking the appropriate channel.

It is also a good idea to exclude the noisiest channel from any final sharpening you apply to an image,* because sharpening existing noise tends to accentuate it. To avoid this effect, hide the noisy channel in the channels panel before you sharpen the others. When you are done with sharpening, you should show the hidden channel(s). Another way to achieve the same effect is to create an inverted mask from a selection in the noisy channel and use it as a layer mask during sharpening.

Sharpening Using the Luminance Channel

An effective way to sharpen an image is to sharpen just the luminance channel, not the color channels. Sharpening should usually be the last step you perform before you output an optimized, scaled image:

1. Duplicate your edited image (Image ▸ Duplicate) and merge all visible layers to the background using Ctrl/⌘-⇧-E.

2. Convert the image to Lab mode using the Image ▸ Mode ▸ Lab Color command (figure 3-46).

[3-46] Switching an image to Lab mode

3. Sharpening should always be performed on a separate layer, so duplicate the new background layer and activate it.

4. Now activate the *Lightness* channel (Ctrl/⌘-3 or Alt-click the channel entry). This channel contains the grayscale brightness values that make up the image, and the preview image displays a grayscale version.

5. Now sharpen the L channel using the Unsharp Mask filter. Note that this adjustment is destructive – that is, it is applied directly to the image pixels!

6. Finally, switch back to RGB mode using the Image ▸ Mode ▸ RGB command, this time making sure that Photoshop doesn't merge the visible layers to the background.

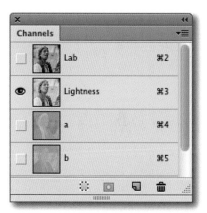

[3-47] A Lab mode image with the L channel selected

Using a Color Channel as a Mask or the Basis for an Adjustment

It is often helpful to use the channel with the most image data or greatest range of texture or contrast as the basis for an adjustment. Which channel this is will vary from image to image, and a quick look at the Channels panel will help you find the right one:

1. If you have found the right channel, hide the others and take a closer look.*

2. One option is to increase the channel's contrast using a Curves, Levels, or Brightness/Contrast adjustment selected from the Image ▸ Adjustments ▸ … menu (i.e., not a separate adjustment layer). This increases detail throughout the image and usually increases local contrast, giving the image more impact. But take care: this method can cause color shifts.

3. To check the results of your changes, display the entire image by clicking the RGB channel entry.

An alternative way to achieve a similar effect is described section 4.12, where we use the *Overlay* blending mode to merge the luminance values in the blue channel with the original image.

Most images contain one or more channels that have more contrast than the others, and you can use this difference when you create selections. Activate the channel with the highest contrast, make a selection,** then reactivate the RGB channel before you create a mask from the selection you have just made.

* The preview image will then show only the selected channel.

** Use, for example, the ✏ or ✒ tools.

3.13 Luminance Masks

If you want to make an adjustment to an image based on the luminance (i.e., the brightness) of a particular area, a luminance mask is the tool of choice. A luminance mask – which can be inverted if necessary – can be created in a number of different ways; on page 106 we described a method that uses the Channels panel.

Creating a Luminance Mask Using the Color Range Dialog‹

The dialog for the Select ▸ Color Range command has been available since Photoshop CS3 and offers the three basic luminance zones – *Highlights*, *Midtones*, and *Shadows* – in menu Ⓐ. What exactly these three definitions entail is not described in the dialog, but because most masks are comprised of multiple selections, these criteria are usually sufficient for most adjustments based on luminance masks.

For example, if you want to select the midtones and the shadows, first make a midtone selection and save it using the Select ▸ Save Selection command, then open the Color Range dialog and make a shadow selection. You can now combine the two selections by navigating to the Select ▸ Load Selection command and activating the *Add to Selection* option (figure 3-49). You can even load selections from other (open) image files using the *Document* drop-down. The dialog's default selection is the currently active image.

[3-48] The Color Range dialog offers three luminance selection criteria

[3-49]
The Load Selection dialog, set up to add a saved selection to the current one. If you want to load a selection from a separate file, you have to open it first.

You can now save the combined selection or use it to create a mask, as previously described. Figure 3-49 shows the additional options for subtracting, intersecting, and inverting selections during the loading process.

Creating a Simple Luminance Mask

If you want to use the luminance values from the entire image as a mask, select the layer mask and navigate to the Image ▸ Apply Image command (see page 95 for more details).

The default Layer, Channel, Blending, and Opacity settings are as shown in figure 3-50 and deliver a luminance layer mask for the current image when you click *OK*. If you want any resulting adjustments to affect only the shadows, you can use the *Invert* option.

An alternative way to create a luminance mask is as follows:

1. Navigate to the Channels panel and click the RGB entry Ⓐ (if you happen to be in RGB mode).*

2. Click the Load Channel as Selection icon 🔲 at the bottom of the Channels panel. The result may look a little unsharp, but this is normal for a luminance selection.

3. Now click the *Save Selection as Channel* icon 🔳 to create a luminance mask in the form of a new channel (Ⓑ in figure 3-51). The mask can then be used in the normal way or as a selection.

4. Alternatively, if you navigate to the Layers panel in step 3 and click the 🔳 icon to create a new layer mask, the luminance mask will be converted into a layer mask.

You can use the same procedure to create luminance masks for any individual channel simply by selecting the desired channel in step 1. Don't forget to reactivate the RGB channel in the Channels panel. If you are working in a different color mode (for example, Lab or CMYK), the same steps apply.

[3-50]

If you select a layer mask and then open the Image ▸ Apply Image dialog, the default settings create a luminance mask for the whole image

* See section 1.9, page 38, for more information on color modes and models.

[3-51] The new RGB luminance channel is shown at the bottom of the stack

Editing a Luminance Mask

If you want to adjust a particular luminance zone (midtones, for example) using an adjustment layer, you need to refine the luminance mask using any of the regular Photoshop tools (but not adjustment layers).

First, Alt-click the mask to display it in the preview window and then apply whichever brush-based or Image ▸ Adjustments tool you like.

3.14 Saturation Masks

In a similar way to luminance masks, saturation masks can be used to selectively increase or reduce saturation. Unlike using a conventional Hue/Saturation adjustment, the following procedure prevents already highly saturated colors from becoming even more saturated, thus preventing potential loss of detail or color errors:

1. Create a new, temporary Selective Color adjustment layer and activate the *Absolute* option in the Selective Color Properties panel.

2. Set the Black slider to –100% for each color channel separately (figure 3-52) and to +100% for the *Blacks*, *Whites*, and *Neutrals* channels. The result is a pure grayscale representation of the saturation levels in the image, which is already a kind of saturation mask.

3. Use a Ctrl/⌘-click to select either the Red, Green, or Blue channel and make a selection.

4. You can now delete the temporary Selective Color adjustment layer.

5. Load the corresponding luminance channel as a selection by activating it and clicking the ⊞ icon at the bottom of the panel, and use the selection to create a new Hue/Saturation adjustment layer. Your saturation mask will now be a layer mask on the new layer.

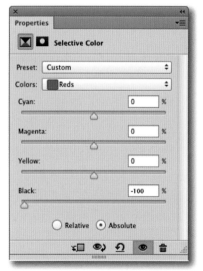

[3-52] Select the Absolute option and set all color channels to –100%.

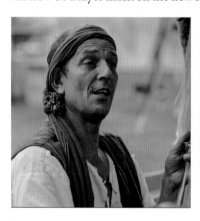

[3-53]
The original image is shown on the left, and the corresponding saturation mask is shown on the right.

6. Use the Hue/Saturation dialog to increase saturation. Due to the saturation mask, this adjustment affects the less saturated colors in the image almost exclusively. If you wish to adjust the highly saturated colors, invert the mask (Ctrl/⌘-I) and use the Hue/Saturation dialog to reduce the saturation.

7. If the mask is too dark (the effect of the adjustment is not strong enough) or too bright (the effect is too strong), you can use the tools in the Image ▸ Adjustments menu to increase the contrast or make it darker or lighter. The best tools to use are Brightness/Contrast, Curves, or Levels.

 Instead of brightening the mask itself, you can adjust its Density setting in the Properties panel (Window ▸ Properties) to achieve a similar effect, albeit with a slightly less marked differentiation between the saturation of the individual colors.

Another way to create a saturation mask is to download and install a dedicated plug-in from the Adobe website, which is easier than using the previous steps.

You can install optional Photoshop plug-ins either from a CD or from the Adobe website. The following example uses the HSB/HSL plug-in, which is part of the *Optional Multiplugin.plugin* package available from the website shown in the margin.* After you have downloaded and unzipped the package, install it in the *\Plug-ins\Filters* folder and restart Photoshop. HSB stands for the *Hue, Saturation, Brightness* color model. The filter will then be available in the Filter ▸ Other menu. You can now create a saturation mask as follows:

* The Windows plug-in can be downloaded from www.adobe.com/support/downloads/detail.jsp?ftpID=4688. The Mac version is available from www.adobe.com/support/downloads/detail.jsp?ftpID=4965.

1. Select the layer you wish to use to create your saturation mask and duplicate it.

2. Navigate to Filter ▸ Other ▸ HSB/HSL and select the *RGB* input mode option (figure 3-54) or the mode in which you are currently working. Select the *HSB* option for *Row Order*. After you apply this operation, don't let the unusual appearance of your image put you off.

[3-54]
The HSB/HSL filter dialog

3. The red channel of an RGB source images represents the *Hue* value, while green represents *Saturation* and blue represents *Lightness*. Now use the green channel to create a saturation mask (as described for the luminance mask on page 109) by clicking the ⚙ icon at the bottom of the Channels panel. Then click the ▣ icon to give the new channel a meaningful name.

4. You can now delete the uppermost (HSB) layer and use the saturation mask (or its inverse) from the Channels panel.

[3-55] The original image of a toy steam engine

The following sections describe a practical way to use a mask like the one we have just described. The original image (figure 3-55) contains a number of colors that are already highly saturated. Increasing the *Saturation* setting (for example, using Hue/Saturation) would oversaturate these colors, and cause them to lose detail. This is where a saturation mask comes in:

1. Create the mask:

 a. Use Ctrl/⌘-J to duplicate the background layer.

 b. Use the HSB *Row Order* option in the Filter ▸ Other ▸ HSB/HSL Parameters dialog to transform the uppermost layer to HSB mode (figure 3-56).

[3-56] The HSB/HSL filter dialog

 c. Select the Green channel (i.e., the saturation channel) in the Channels panel.

 d. Click the ✺ icon to turn the green channel into a saturation selection. You can now delete the HSB layer.

2. Keep the selection active and create a new Hue/Saturation adjustment layer. The saturation selection you have just made will become a saturation mask (figure 3-57) in which saturated colors look bright and less saturated colors look dark.

[3-57] The saturation mask for figure 3-55

[3-58] The inverted saturation mask

[3-59] The inverted mask with increased contrast

3. Make sure the mask is still active, and use Ctrl/⌘-I to invert it (figure 3-58). The less saturated areas will be bright and the more saturated areas will be masked.

4. Use a Levels adjustment (figure 3-60) to increase contrast in the mask. The resulting mask is shown in figure 3-59.

5. Increase the *Saturation* setting in the Hue/Saturation dialog to +45. The mask ensures that only the less saturated colors are affected.

6. Figure 3-63 shows the result of applying these steps, and figure 3-61 shows the corresponding layer

[3-60] Increasing contrast in the mask

[3-61] The layer stack showing the inverted increased-contrast mask

stack. The blue shimmer in the metal looks just right, and the brass funnels have a brighter look without being oversaturated. Figure 3-64 shows the result of applying a direct saturation increase without using a mask. In this case, the brass elements are much too bright.

We could have reduced the saturation in the more saturated colors by applying the mask to the Hue/Saturation layer and reducing the saturation, and we could have used a slightly steepened curve for the mask.

[3-62] The original image

[3-63] Inverted saturation mask and a *Saturation* setting of +45

[3-64] Saturation increased with a Hue/Saturation setting of +45 but no mask

3.15 Other Masking Techniques

If a mask's edges are too sharp, you can blur them using the Gaussian Blur filter (among others). When you use the Gaussian Blur filter, make sure the mask, not the image, is activated.

Alternatively, you can add a non-destructive feathered edge via the Masks /Properties panel (described later on this page).

To use an existing mask on a new layer, select it in the Layers panel and Alt/⌥-drag it to the desired layer. This automatically duplicates the mask and copies it to the new layer.

To delete a mask, drag it to the 🗑 icon at the foot of the panel (or simply press the Del key). Deleting empty (white) masks saves disk space when an image is saved with its layers.

Because masks are a kind of selection, they can be saved and loaded just like selections. To save a mask, right click it to activate the context menu and select the *Add Mask to Selection* option. If a selection is active, the context menu will include the *Save Selection* command. Alternatively, you can use the Select ▸ Save Selection command.

To load a saved selection, navigate to the Select ▸ Load Selection command and click the 🔲 icon in the Layers panel to turn it into a new mask.

If you click the 🔲 icon without loading a selection, Photoshop creates an empty white mask. To create a new black layer mask, Alt-click the 🔲 icon. This can be useful when you need to apply an adjustment layer effect to a selected image area. Initially, a black mask negates the effect, allowing you to use a white brush to paint in the areas you want to modify.

If you want to apply a single mask to multiple layers, group the layers (section 8.4, page 222) and apply the mask to the group (the layer entry with the 🗀 icon).

As previously mentioned, layer masks (which are really just grayscale images) can be edited using most Photoshop tools and adjustments, including Curves and the Gaussian Blur filter. If a mask is part of a pixel layer, it can be applied to the pixel layer via the context menu, which transforms the layer's pixels into transparent pixels according to the maks's degree of blackness. Applying this operation deletes the mask itself.

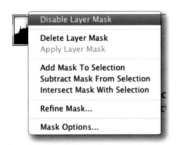

[3-65] Right clicking a layer mask opens the context menu, with its various masking options

The Masks Panel

The Masks panel (Window ▸ Masks) was introduced with Photoshop CS4. The panel contains the most important functions for creating and editing masks. The *Invert* button does just what it says, and the *Color Range* button opens the Color Range dialog. Clicking ⦿ loads an active mask as a selection, which can be useful if you want to create a new mask on an existing layer. Clicking ⦿ temporarily deactivates an active mask, and clicking 🗑 deletes it.

As mentioned before, in Photoshop CS6, the contents of the Masks panel have been transferred to the *Properties* panel (figure 3-67).

The *Density* slider (available since CS4) enables you to directly reduce the strength of a mask's effect.

Clicking the ◈ icon applies an active mask to the corresponding pixel layer – in other words, the mask is blended with the pixel layer and then deleted. We never use this function because we prefer to edit our masks later. However, using it can save disk space when you save complex images.

In the Properties panel, you can switch between the mask's properties and the properties of the image or adjustment (when you use an Adjustment Layer) by clicking on the corresponding (▥, ◉ or the adjustment) icon.

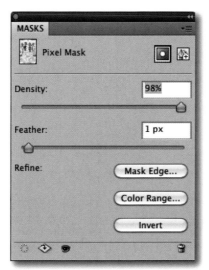

[3-66] The CS4/CS5 Masks panel contains all the most important mask functions

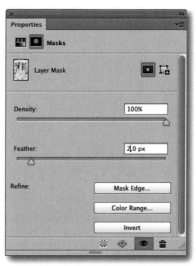

[3-67] As of CS6, the basic Mask functions can be found in the Properties panel

3.16 Paths, Shapes, and Vector Masks

The Pen/Paths tools ✎ (figure 3-68) are seldom of much interest to photographers, although the Pen tool is quite versatile when it comes to creating paths and vector-based shapes. Like masks, paths and vector graphics can be transformed into selections (and vice versa). Masks created this way are vector masks that can be rasterized to turn them into pixel masks. Pixel masks cannot, however, be transformed into vector masks.

In contrast to pixel-based shapes, vector-based shapes can easily be edited, scaled, and transformed without any loss of quality. A vector-based element can, for example, be reduced in size and later enlarged without running the risk of blurring its edges or altering its original precision. Simple vector shapes also use less disk space than equivalent pixel-based shapes.

Photoshop builds vector shapes from *splines*. Splines consist of anchor points and segments and describe complex shapes in mathematical terms. Each anchor point has two *tangents* (or direction lines) that determine the form and direction of the segment that connects it to the next anchor point. This might sound complicated, but it is quite simple after you practice a little. The Photoshop Paths tool uses two basic types of anchor points called *Smooth Points* and *Corner Points*.

Corner points have two independent direction lines and enable you to draw corners (figure 3-69). Clicking on a path with the ✎- or the ⁺✎ tool creates a new corner point. Initially, the segment that connects two corner points is straight.

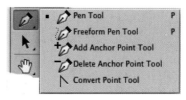

[3-68] The Pen/Paths tools

➔ As of CS4, you can feather a path's edge non-destructively using the tools in the Layers or Paths panels (figure 3-65).

[3-69] Corner points on a path

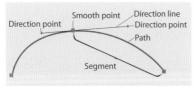

[3-70] Elements of a path

Smooth points are anchor points on a straight or curved path segment (figure 3-70). The two direction lines that you can drag out from a smooth anchor point move symmetrically to the anchor point, and the further you drag their ends (the direction points), the shallower and longer the curve at that point will become. Direction points can be moved separately by Alt-dragging them, thus allowing you to form acute corner angles or transform smooth points into corner points. To make the direction lines for a new anchor point visible, keep the mouse button pressed and drag it away from the path while you create a new anchor point.

Tangents are generally visible only for active anchor points and their two immediate neighbors. If you are using multiple active anchor points, only the most recently edited point and its neighbors will be visible. The following sections give you an overview of how to use paths to make a selection.

[3-71] The vase we are going to select

This example uses a path to select and extract the vase shown in figure 3-71.

Figure 3-72 shows the CS6 Paths options bar. Use the *Path* menu to select the type of object (in this case, *Path*) and check the *Rubber Band* option that is revealed when you click the ⚙ icon. This allows you to preview path segments as you move the pointer between clicks.

Select the Pen tool and click on your image to begin a path. You can start a path anywhere, but it is usually a good idea to use a corner of the object you are working on. We recommend that you zoom in to your image while you draw paths and shift the preview detail as necessary using the Hand tool (press the space bar to temporarily activate it).

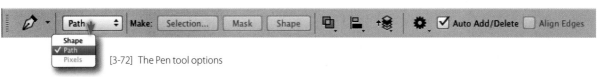

[3-72] The Pen tool options

[3-73] Suitable anchor points are marked in red

Now look for other suitable anchor points and set them by clicking with the mouse. Generally, anywhere the path changes direction is a good place to set an anchor point. Figure 3-73 shows suitable points in red. Practice will teach you where best to set anchor points, and simple shapes can usually be outlined using relatively few. To set suitable anchor points, you can either of the following:

- Set suitable corner points and transform them, where necessary, into smooth points (or back) using the Convert Point ⊢ tool. You can then either keep the mouse button pressed or use the Direct Selection tool ▷ to drag out suitable direction lines.

- Set suitable corner and smooth points by clicking and click-dragging, and then optimize the direction lines using the Direct Selection tool ▶. This approach requires more practice but is faster when you are up to speed.

You can close a path by clicking once again on the initial anchor point. Press Esc to finish a path. If you don't explicitly close a path, Photoshop automatically joins the first and last anchor points with a straight line when a path is used as a mask, a clipping path, or a shape.

You can select paths using either the Path Selection ▶ or the Direct Selection ▶ tools. Using ▶ activates all points on a path, indicated by their black color. If you then use the Move tool ▶ or the arrow keys, the entire path will be moved as one.

Clicking on a path segment with the ▶ tool activates the path but not the anchor points. You can then use the same tool to activate individual anchor points, enabling you to shift individual points or alter their direction lines. You can also ⇧-click with the Direct Selection tool to activate multiple anchor points, which can then be shifted at the same time.

Pressing the Ctrl/⌘ key while using one of the path selection tools temporarily switches modes.

Our finished path is shown in figure 3-75.

[3-75]
The finished path for our vase

Stroke path with brush
Load path as a selection

Fill path with
foreground color

Delete path

Create new path

Add vector mask (from path)

Make work path from selection

[3-76] The Paths panel icons and their functions

For the subsequent steps, we need to take a look at the Paths panel and the tools contained in its icons and menu (figure 3-76 and figure 3-77). The first step, however, is to give your path a suitable name by double clicking the *Work Path* label in the Paths panel.

[3-77] The Paths panel menu contains variable entries depending on the current context

To select and extract the vase, click the *Add vector mask* icon at the bottom of the Paths panel or use the Create Vector Mask command in the context menu to add the path as a mask on the current layer. This mask can then be edited like a normal path. The preview image now looks like figure 3-78.

[3-78] The selected and extracted vase. The checkerboard pattern in the background indicates transparent (i.e., masked) areas.

[3-79] The panel entry showing the pixel mask (center) and the vector mask (right). The result of applying both is shown above.

If we had clicked the icon (to load the path as a selection) before clicking the icon, our path would have been transformed into a pixel mask. However, vector masks are a much more flexible and elegant way to edit complex, rounded shapes. Because vector masks have sharp edges, the mask thumbnail in the Paths panel shows the nonmasked areas in white and the masked areas in gray (they are black in a pixel mask, as shown in figure 3-79). If a single layer has two masks, the effects of both are added together to produce the final effect.

There are a number of operations that you can perform on a path, and they can be accessed with the context menu, keyboard shortcuts, or Paths panel (figure 3-76):

* **Load Path as a Selection**. Photoshop can convert a selection into a path using the command in the Select menu. The resulting selection can then be saved as a mask or an alpha channel.*

* **Fill Path with Foreground Color.**

* Alpha channels are saved selections or masks.

- **Stroke Path with Brush.** This traces a path with a selected tip-based tool (the Pencil tool ✏, for example) using the parameters set in the tool's options bar. This function makes sense only if you want to use a path as a shape (see page 120).

- **Make Work Path from Selection.** The new path is then available as an additional vector shape.

- **Create Vector Mask.** This function works only for nonbackground layers and masks the areas outside the path. Pixel masks can also be created using paths.

- **Free Transform Path.** Can be used with all the usual transformation tools and transforms either the entire path or selected segments only.

- **Save Path.** For later use in other images.

- **Align Path**. Complete paths or selected path segments/anchor points can be aligned the same way as layers.* To align a path object, select it and use the appropriate commands in the 🖫 menu in the Paths options bar.

Paths can be further edited at any time by moving, adding, or deleting anchor points or adjusting a point's direction lines.

At the beginning of the book we mentioned that – in addition to pixel, adjustment, gradient, and text layers – Photoshop also supports shape layers. These contain shapes (i.e., vector objects) that have been created using either the Shape tools (figure 3-80) or the Pen tools.

In earlier versions of Photoshop, you have to select Shape mode 🔲 in the Pencil tool options bar to create a shape using the ✒ tool (figure 3-81, where 🔳 indicates Path mode). As of CS6 and CC, you have to select the *Shape* option in menu Ⓐ (figure 3-82).

Since the release of Photoshop CS6, the Pencil tool options bar is set up as shown in figure 3-82. To create a shape, you have to select the *Shape* mode option in Menu Ⓐ.

Photoshop automatically creates a new shape layer when you draw a shape. You can select the stroke type, thickness, and color (figure 3-83), as well as a fill that can also be a gradient.

* To do so, click, ⬆-click or Ctrl/⌘-click the corresponding layers, activate the Move tool ▶⊹, and use the Align icons in the options bar

[3-80] The Shape tools

[3-81]
The CS5 Pen tool options

[3-82] The Pen tool options when a shape is created in CS6

[3-83] Photoshop offers various configurable stroke options for fine-tuning shapes

Shapes are really vector graphics, and if you are serious about using them in your work, you are better off using a dedicated vector-based program, such as Adobe Illustrator, to create them. Vector graphics that you have created elsewhere can be inserted into Photoshop files as Smart Objects using the File ▸ Place command. Nevertheless, the Photoshop Shape tools enable you to create and edit simple vector graphics without having to leave the program's interface.

The path we created in the previous example can be simply transformed into a shape like the one shown in figure 3-84. If you are drawing a shape into an image file, it is usually best to make the shape itself transparent (⧄) and to use a thin stroke to draw the initial outline. You can fine-tune the settings for fill, stroke, and so forth after you create your outline.

[3-84]
Our vase as a shape with a gradient fill

You will rarely need to use pure shape elements in a photographic context, although they can be quite useful if you are creating greeting cards or other decorative graphics. They can also be used to create previously nonexistent shadows in photos. Shapes can be freely transformed and edited to create realistic-looking perspective and shadow gradients. Such artificial shadows are particularly useful if you need to insert a shape or a cropped object into a new background.

3.17 Tricks and Tips for Selections and Masks

❶ A selection created using one of the lasso tools can be added to an existing selection by pressing the ⇧ key, subtracted by pressing Alt, and intersected using ⇧-Alt.

❷ ⇧-Ctrl-I inverts the current selection, and Ctrl-I inverts a currently selected mask. Pressing Alt while creating a new mask automatically makes it black.

❸ It is often a good idea to begin a new selection afresh. Ctrl-D deactivates an existing selection.

❹ Entering a number with the Brush tool active sets its opacity value to the equivalent tenfold value (1 → 10%, 0 → 100%). Hit two keys in quick succession to produce intermediate values.

❺ Entering ⇧-number adjusts the hardness of the Brush tool to the equivalent tenfold value (⇧-1 → 10%). Hit two keys in quick succession to produce intermediate values.

❻ Tips 4 and 5 work the same way for the Pencil, Eraser, Dodge, Burn, Sponge, Blur, and Sharpen tools.

❼ When using the Brush tool, press D to set the foreground and background colors to black and white and the brush to black. Press X to reverse these settings.

❽ If the blinking dotted border of a selection annoys you, press Ctrl-H to temporarily deactivate it and again to reactivate it.

❾ To insert the contents of the clipboard into a mask, Alt-click the preview to make it visible and press Ctrl/⌘-V to insert it.

❿ The tools in the Masks/Properties panel can be used to give a mask a non-destructive soft edge and reduced density.

⓫ Always zoom in as far as possible when creating and editing selections and masks (see the navigation shortcuts listed below).

⓬ Use the Edit ▸ Keyboard Shortcuts dialog to save shortcuts for functions and commands you use regularly or to customize existing shortcuts.

Learning to Navigate Efficiently

You will often need to zoom in and out when you work with masks or other tools. Using menu commands to zoom in and out is clumsy and inefficient. It is much quicker to use the following shortcuts:

Zooming in and out using the keyboard:

Ctrl-+	zoom in	Ctrl--	zoom out

Ctrl-0 (zero) zooms in to fit the current image to the window
Ctrl-1 zooms in to the 100% view

➡ As previously mentioned, Mac users use the ⌘ (or cmd) key instead of the Ctrl key.

Zooming with the mouse: This works either using the scroll wheel alone or the scroll wheel and the Alt key, depending on the settings you have made in the program's preferences.[*]

Shifting the preview detail: Temporarily activate the Hand tool 🖐 using the space bar. The tool remains active until you release the space bar.

* See the Zoom with Scroll Wheel options in the Options section of the General Preferences page.

Using the Brush Tool and Other Tip-Based Tools

→ The Eraser tool ✐ has almost all the same settings as the Brush tool, but it works in the opposite fashion, deleting instead of adding pixels.

Graphic artists often use both the Pencil ✐ and Brush ✐ tools, whereas photographers tend to use the Brush almost exclusively, mostly for creating and fine-tuning layer masks. If you have a mask with gray areas, and you would like to darken or brighten those parts, you could also use the Burn and Dodge tools, respectively. Most often, however, it's better to stay with just a few tools – and the Brush tool is one of the best for masking.

The following sections describe the most important features of the Brush tool for photographers – graphic artists use additional features (e.g., different brush shapes).

Brush Tool Settings

[3-85] The Brush tool options bar

[3-86] The Size, Hardness, and Shape of a brush tip can be set using the fly-out menu in the options bar

[3-87] Since CS5, you can display the brush settings on-screen and adjust them using mouse pointer movements.

The most important brush parameters for photography are *Size*, *Hardness*, *Opacity*, *Flow*, and airbrush mode (✐). These all need to be adjusted according to the job at hand – for example, to fit the size and resolution of the image you are working on. Other parameters include the brush shape (figure 3-86) and its mode. The most commonly used settings for creating masks are a circular brush tip and *Normal* mode. Other modes, such as *Darken* or *Lighten,* can be useful if used with the ✐, ✐, and ✐ tools, while *Midtones*, *Shadows*, and *Highlights* are the choices for the ✐ and ✐ tools.

The *Size* setting is self-explanatory. *Hardness* determines the size and softness of the transition surrounding the hard tip of the brush. A setting of 100% works like a pencil, and produces clear, hard-edged strokes, whereas 0% produces soft, diffuse strokes.

Since CS5, pressing the Alt key and the main mouse button in Windows (Ctrl-⌥ plus mouse button on a Mac) displays the brush settings as shown in figure 3-87. Keeping the mouse button pressed, and moving the cursor left or right decreases or increases the brush size. Moving the cursor up or down increases or decreases the Hardness. Any changes you make are simultaneously visible in the brush preview window, while the actual cursor position is not affected by the operation. The same function can also be used with the Pencil, Eraser, Clone Stamp, Healing Brush, Dodge, Burn, and Sponge tools.

You can also increase or decrease the brush size using the [and] keys, and you can adjust the brush hardness using the ⇧-[and ⇧-] keys.

The *Opacity* setting is self-explanatory. A setting of 0% reduces the effect of the brush to zero, while intermediate values (below 100%) apply the selected color with corresponding strength. We often use reduced opacity to apply masks in a series of finely-tuned strokes. The disadvantage of this

technique is that it can produce unwanted runs between mask layers (figure 3-88).

Flow determines how the selected color flows from the brush tip (i.e., the rate of application). In its default state, color ceases to flow when you stop moving the pointer. However, if you select the airbrush option (by activating the ![icon] option in the tool's options bar), the tool continues to add color at the current cursor position for as long as you keep the mouse button pressed. This continues until the area covered by the current brush size is completely filled.

If you use a graphics tablet instead of a mouse, you can alter the brush size, hardness, and opacity using differing amounts of stylus pressure. The exact parameters are determined by the preferences settings you make for Photoshop and your tablet.

You will usually have to adjust the brush size, hardness, opacity, and flow several times while you fine-tune a mask, depending on the nature of the current detail.

We generally recommend that you use a 100% black brush with 100% opacity and a reduced Flow value of about 20–30%, again varied according to the job at hand. (We recommend using the same settings if you are painting with a white brush in a black mask.) This approach means you will have to paint over some areas several times to achieve the desired opacity, but this approach provides more precision. If you need to paint large areas black, it might pay to begin using a large brush with 100% opacity and 100% Flow. Then switch to reduced values to mask finer details.

If, for example, you are working in normal (i.e., non-airbrush) mode with 25% opacity and 100% Flow, a particular image area will remain 25% gray no matter how often you paint over it. The opacity value of the brush only begins to function additively when you release the mouse button (or lift the stylus from your tablet) and paint over an area again. If, however, you work with 100% opacity and 25% flow, you can paint back and forth over a particular area to increase the overall opacity without having to keep releasing the mouse button or lifting your stylus.

Flow values can be entered using the ⇧-number keyboard shortcut. The ⇧-⓪ (zero) key combination results in 100% Flow.

If you paint in short bursts and release the mouse button between strokes, you can use the Undo command (Ctrl/⌘-Z) to undo the previous stroke without having to undo an entire outline or other complex action.

Working with reduced opacity or Flow can lead to unwanted areas of overlay, but it allows you to progressively build up an effect.

You can limit the area that the brush affects in a mask using a selection; you can then use a soft brush to produce a hard edge and prevent adjustments from spilling over into other areas.

[3-88] This figure shows various brush strokes: top left is a hard (100%) brush, and the top center has 20% hardness – both are set to 100% opacity. The lower strokes have 50% opacity. The two crossed strokes at the bottom right show how colors can run when you use lower opacity values.

3.18 Other Considerations When Working with Selections and Masks

As with all Photoshop tools, practice makes perfect, so the best thing is to simply experiment with all the available tools. Don't be afraid to combine different tools and use the *Add*, *Subtract*, and *Intersect* functions. Remember to periodically save complex selections, and get used to using temporary Brightnesst/Contrast, Levels, or Curves adjustment layers to assist you in fine-tuning your masks. It often helps to select the parts of an image you don't want to keep and then invert your selection.

There are three basic approaches you can use when creating layer masks. The one you choose will depend on the situation at hand, and you will soon learn which is best in various situations. You can always combine aspects of one approach with those of another:

1. Perform an adjustment with (or without) a white mask, concentrating hard on the areas you wish to edit. You can then mask the areas you don't want to affect using a black brush.

2. Begin by creating a black mask and paint a rough mask using a white brush. Now set your adjustment parameters and fine-tune the mask.

3. First select the area you want to adjust, and then use the selection to create a new adjustment layer. This automatically creates a layer mask from the selection. You can then set your adjustment parameters, view the results in real time in the preview window, and fine-tune the mask as necessary.

Learn to use combinations of channels and masks. Masks can be merged with individual channels to create new masks. For example, blending a luminance mask with the blue channel* limits the effect of the mask to that channel only. The same approach can be taken using saturation masks, as described in section 3.14. You will often find that you only need to adjust the content of a single channel to improve detail rendition in a highly saturated image.

Photoshop pixel and vector masks offer many advantages over the selective adjustment tools available in most Raw converters. The flexibility these tools offer absolutely justifies the extra disk space that layer-based images require.

→ Don't forget to clean up any unwanted channels before saving a file. Selections and channels that you have already saved use extra disk space if you save them with a file.

Using a Graphics Tablet

A graphics tablet is a worthwhile investment if you use Photoshop regularly. A tablet makes it simpler and less demanding to work precisely. Settings such as Opacity or Flow can even be adjusted by altering the stylus pressure, and the top end of the stylus can be set up to work as an eraser. Using a tablet requires practice and a two- or three-day learning period.

* See the description of the replacement operation described in section 3.4 on page 95. In this case, activate the *Mask* option in the *Apply Image* dialog and select the blue channel in the *Channel* drop-down.

Useful Shortcuts[1, 2]

Editing Selections

Add to selection	⇧	
Subtract from selection	Alt	
Intersect selections	⇧-Alt	
Invert selection	Ctrl-⇧-I	
Undo selection	Ctrl-⇧-D	
Select all	Ctrl-A	
Show/Hide selection edge	Ctrl-H	
Open the Refine Edge dialog	Ctrl-Alt-R	
Activate Quick Mask mode	Q	Pressing Q again returns you to normal mode
Select highlights (luminance values 162-255)	Ctrl-Alt-2	(Ctrl-Alt-~ up to CS5), soft edge, selects luminance values for RGB images

Brushes and Masks

Set foreground/background colors to black/white	D	X switches foreground/background colors
Switch foreground/background colors	X	
Adjust brush opacity to x% (in increments of 10)	1…9, 0	0 (zero) sets opacity to 100%
Adjust brush flow to x% (in increments of 10)	⇧-1…⇧-9, ⇧-0	⇧-0 (zero) sets flow to 100%
Reduce/increase brush size	[/]	(Square brackets)[1]
Increase/reduce brush hardness	> / ' (apostrophe)	Each click adjusts value by 25%
Adjust brush size and hardness (Windows)	Alt+main mouse button, move the cursor left/right or up/down	
Adjust brush size and hardness (Mac)	ctrl-⌥ +main mouse button, move the cursor left/right or up/down	
Create white layer mask	Click the ◐ icon. Alt-click the ◐ icon to create a black mask.	
Temporarily deactivate a mask	⇧-click the mask thumbnail, ⇧-click again to reactivate	
Invert mask	Ctrl-I	
Show mask in preview window	Alt-click mask thumbnail, repeat ⇧-click returns to image view	
Show mask in overlay mode	⇧-Alt-click mask thumbnail, repeat ⇧-Alt-click returns to normal view	

Channels

Show channel in preview window	Click channel's panel entry
Select channel luminance	Ctrl-click channel entry in Channels panel
Save selection as alpha channel	With selection active, click the ◐ icon in Channels panel
Save channel as alpha channel	With channel selected, click the ⬛ icon
Load channel as selection	Select channel and click the ✦ icon

[1] Mac users press ⌘ in place of Ctrl and ⌥ in place of Alt.
[2] Shortcut key assignments can be changed using the **Edit ▸ Keyboard Shortcuts** dialog.

Blending Modes

4

Alongside adjustment layers and masks, blending modes – also known as layer modes – are another of the powerful tools that Photoshop provides for working with layers. They are often underrated by digital photographers but can be extremely useful in a multitude of situations. Blending modes determine how the pixels in separate layers are merged, or blended. We have already touched on blending modes in previous chapters and we will encounter them at various points in the rest of the text. Photoshop offers a wide range of blending modes that are useful to photographers and graphic artists, but this chapter concentrates on the modes that are of particular interest to photographers.

Some modes work like self-contained adjustments when they are applied to duplicate upper layers, and others are used to limit the effect of a layer to a change in hue, saturation, or lightness.

4.1 Photoshop Blending Modes

As mentioned in section 1.6, the mode that you select from menu Ⓐ in the Layers panel (figure 4-1) determines how the active layer is blended with the layer beneath it. The default blending mode is *Normal*, which completely covers the underlying layers with a nontransparent pixel layer, leaving just the uppermost layer visible. All other modes use more complex blending algorithms. Blending modes work in tandem with a layer's opacity and the effects of any active layer masks.

For example, *Overlay* mode brightens underlying pixels in areas that are lighter than 50% gray (in the upper layer) and darkens them where the pixels of the upper layer are darker than 50% gray. This mode has no effect on areas that are precisely 50% gray in the upper layer.

The other modes in group Ⓓ of figure 4-1 use various algorithms to achieve similar (and sometimes quite extreme) effects. *Soft Light* usually produces a slight brightening effect with a small increase in contrast, and *Hard Light* produces a much more obvious increase in contrast, as its name suggests. The tonal values in the uppermost layer play no role in blending when you use the modes in group Ⓓ, whereas in modes such as *Hue*, the tonal value is highly relevant to the effect the mode produces.

Figure 4-1 recaps the mode overview we introduced in section 1.6. Different applications for various modes are mentioned throughout this book. Note that the effectiveness of a particular mode depends a lot on the content of an image, as well as the hue, color, and saturation values in the underlying layer, and the settings you have made in any adjustment layers. As usual with any new tool, you will have to experiment to find out exactly which settings work best for you.

Standard

Modify brightness
Ⓑ → Darker:
White → No effect
Gray → Positive effect

Modify brightness
Ⓒ → Brighter:
Black → No effect
Gray/white → Positive effect

Special effects
Ⓓ Contrast:
50% gray → No effect
< 50% gray → Brighten
> 50% gray → Darken

Ⓔ Comparison

Ⓕ Color modes
Transparent → No effect

[4-1] Blending modes overview

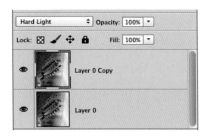

[4-2] The layer stack for figures 4-3 to 4-8, each of which was created using a different blending mode

Sometimes all that's needed to optimize an image is duplicate it and apply a suitable blending mode to the uppermost layer. Figure 4-3 shows an image that we corrected using various modes from group Ⓓ, and the results are shown in figures 4-4 to 4-8. Some of these direct corrections might look a little extreme, but they can all be modified by reducing the opacity of the uppermost layer. Figures 4-9 to 4-11 show the results of applying blending modes from groups Ⓑ and Ⓒ.

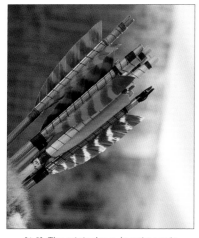

[4-3] The original two-layer image in Normal mode

[4-4] Overlay mode → brighter areas lighter, darker areas darker → more contrast

[4-5] Soft Light mode → slight increase in contrast, colors more intense

[4-6] Hard Light mode → medium increase in contrast

[4-7] Linear Light mode → greater contrast, stronger colors

[4-8] Hard Mix mode → extreme contrast and color intensity

[4-9] Screen mode → entire image becomes lighter

[4-10] Multiply mode → entire image becomes darker

[4-11] Color Dodge mode → lightens individual color channels

4.2 An Overview of the Main Blending Modes

The following tables contain brief explanations of how the most important
blending modes work. However, you can combine layers in many ways when
you use blending modes, so experimentation is still the best way to answer
any questions you may have. Modes not mentioned here (such as *Dissolve*,
for example) are generally not applicable in a photographic context. Here,
the term *blend color* refers to the pixel value of the uppermost layer, and *base
color* refers to the pixel value of the underlying layer or layers. Not all modes
mentioned here are available in earlier versions of Photoshop.

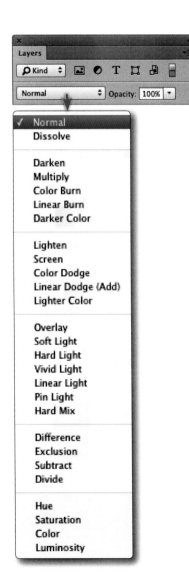

Normal	This mode calculates its effect pixel by pixel. The nontranparent pixels on the top layer cover those below without having a further effect. This mode is most often used for pixel layers and is the only practical choice (in most cases) for adjustment layers.
Adjustments to brightness – darker (white → neutral effect)	
Darken	Looks at the color information in each channel and selects the base or blend color – whichever is darker – as the result color.
Multiply	Looks at the color information in each channel and multiplies the base color by the blend color. The resulting color is always darker. Multiplying any color with black produces black. Multiplying any color with white leaves the color unchanged.
Color Burn	Looks at the color information in each channel and darkens the base color to reflect the blend color by increasing the contrast between the two. Blending with white produces no change. Similar to *Multiply* but more intense.
Linear Burn	Similar to *Color Dodge*, looks at the color information in each channel and darkens the base color to reflect the blend color by decreasing the brightness. Images become darker and better defined.
Darker Colors	Compares the total of all channel values for the blend and base color and displays the lower-value color. The resulting image is usually darker than the darkest of the two originals.
Adjustments to brightness – lighter (black → neutral effect)	
Lighten	The opposite of *Darken,* looks at the color information in each channel and selects the base or blend color – whichever is lighter – as the result color. Pixels darker than the blend color are replaced, and pixels lighter than the blend color do not change. Enables selective brightening using a white brush in a black blending layer.
Screen	The opposite of *Multiply*, looks at each channel's color information and multiplies the inverse of the blend and base colors. The result is always a lighter color. The results is additive, so screening with white produces white. Blending two identical layers with this mode produces usable results for dark originals, but bright originals tend to burn out in the highlights.

Color Dodge	Looks at the color information in each channel and brightens the base color to reflect the blend color by decreasing contrast between the two. Blending with black produces no change. Works like *Screen*, but is more intense and can produce blooming effects. Dark base colors tend to become heavily saturated.
Linear Dodge (Add)	Looks at the color information in each channel and brightens the base color to reflect the blend color by increasing brightness. Blending with black produces no change. Otherwise similar to *Color Dodge*.
Lighter Color	The opposite of *Darker Color*, compares the total of all channel values for the blend and base color and displays the higher value color.

Special effects (50% gray → neutral effect)

Overlay	Mostly affects only midtones and preserves the highlights and shadows of the base color. A great mode for producing dodge and burn effects.
Soft Light	The effect is similar to shining a diffused spotlight on the image, brightening lighter areas and slightly darkening shadows. Blending two identical layers makes the contrast more luminous, but it reduces shadow details, which need to be masked.
Hard Light	Multiplies or screens the colors, depending on the blend color. The effect is similar to shining a harsh spotlight on the image. Can reduce fine midtone and shadow detail.
Vivid Light	Burns or dodges the colors by increasing or decreasing contrast, depending on the blend color. If the blend color (light source) is lighter than 50% gray, the image is lightened by decreasing contrast. If the blend color is darker than 50% gray, the image is darkened by increasing contrast. Results are harder than with *Overlay*.
Linear Light	Similar to *Vivid Light*, but produces more obvious edge effects.
Pin Light	Replaces colors in midtone areas.[*]
Hard Mix	Adds the red, green, and blue channel values of the blend color to the RGB values of the base color. Changes all pixels to primary additive colors (red, green, or blue), white, or black, producing extreme effects like the one shown in figure 4-8 on page 129. Can usually be used only with strongly reduced opacity.

[*] *Pin Light* mode is rarely useful in a photographic context.

Comparison modes

Difference	Looks at the color information in each channel and subtracts either the blend color from the base color or the base color from the blend color, depending on which has the greater brightness value. Very useful when aligning layers.
Exclusion	Creates an effect similar to but lower in contrast than *Difference* mode. Blending with white inverts the base color values. Blending with black produces no change (matte).
Subtract	Looks at the color information in each channel and subtracts the blend color from the base color. In 8- and 16-bit images, any resulting negative values are clipped to zero.

Divide	Looks at the color information in each channel and divides the blend color by the base color. Can be used to produce interesting effects, as shown in section 4.6.

Color modes (transparency → neutral effect)

Hue	Creates a result color with the luminance and saturation of the base color and the hue of the blend color. Enables you to colorize selected areas, convert them to monochrome, or decolor a layer.
Saturation	Creates a result color with the luminance and hue of the base color and the saturation of the blend color.* Black, white, and gray values in the blend layer result in complete desaturation.
Color	Creates a result color with the luminance of the base color and the hue and saturation of the blend color.** Can be used to colorize black-and-white images or decolor a blend layer (with reduced opacity).
Luminosity	Creates a result color with the hue and saturation of the base color and the luminance of the blend color. This is useful for blending the gray pixels on a sharpening layer or a *Curves* adjustment layer with the base layer. The color saturation remains unchanged.

* Enables you to apply a kind of dodge or burn effect to the color saturation.

** Can be used to apply makeup to portraits using the Brush tool in a separate, empty layer. Skin texture (defined by its luminance) remains unchanged.

4.3 Using Overlay Mode to Brighten an Image and Increase the Contrast

[4-12] The original image of the Frauenkirche (Church of Our Lady) in Dresden

The photo in figure 4-12 lacks contrast and is too dark in several places. Both of these weaknesses can be corrected using layer copies, blending modes, and a couple of other tweaks:

1. Copy the background layer (Ctrl/⌘-J) and activate *Layer 1*.

2. Select *Screen* blending mode for *Layer 1* (figure 4-13). The image then becomes a lot lighter (figure 4-14).

 However, the center of the image is now too bright due to the light from the window.

3. How do we selectively correct a layer effect? You guessed it: by using a mask! If no mask is present, click the 🔲 icon at the foot of the layers panel to create a new one.

 We could use a brush instead, but in this case a gradient that starts in the center of the frame and becomes lighter toward the top and bottom is a better option.

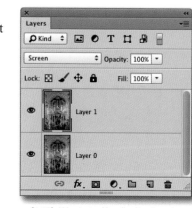

[4-13] We started by duplicating the Background layer

This effect of this gradient also has to be limited to the center vertical area of the frame. To do this, use the Rectangular Marquee tool ░ to select an appropriate area.

4. Activate the Gradient tool ▰. If there is no preset for a gradient that runs from white to black and back to white again, you can define your own. Click the main menu at the left side of the Gradient tool options bar to open the *Gradient Editor* (figure 4-15). Start by selecting the *Foreground to Background* option in the Presets box. Press ⌨D ⌨X to set the foreground to white and the background to black.

[4-14] After applying *Screen* mode

[4-15]
The *Gradient Editor* dialog, with the selected preset outlined in red.

5. Click beneath the center of the gradient bar to insert a new color stop (figure 4-16). You can enter a precise location (in terms of a percentage of the total gradient length) in the *Location* box.

 Now assign appropriate colors to the various color stops. In this case, the colors are white for the left stop, black in the center, and white on the right (which is already set).

 To alter the color of a stop, double click the color field beneath the stop marker ⬓ and use the color picker dialog to select a color.

 Clicking in the preview image automatically samples the color at the current cursor position, using the eyedropper ✎, and assigns it to the active color stop.

 Assigning white and black to the left and center color stops gives us the gradient bar shown in figure 4-17. The diamond-shaped midpoint markers between the color stops can be used to adjust the run of the gradient between each pair of neighboring color stops.

[4-16] Clicking beneath the center of the gradient bar adds a new color stop – in this case, white

[4-17] The white, black, white gradient

[4-18] Applying the new gradient as a layer mask has too strong an effect on the center of the image

[4-20] Reducing mask density to 50% makes the effect of the gradient mask less obvious

We can now give our new gradient a name and save it as a preset, which is added to the end of the Presets list.

6. Now apply the gradient (to the mask) using the selection made in step 3 above. This produces the result shown in figure 4-18 and the layer stack shown in figure 4-19. At this stage the mask darkens the center portion of the image too much.

[4-19]
The layer stack showing our gradient as a layer mask

7. To counteract this effect, we reduce the density of the mask (not the layer), either in the Window ▸ Properties panel (in CS6 and later) or in the Window ▸ Masks panel (CS3 to CS5). In older versions of Photoshop, you will have to brighten the mask using the Image ▸ Adjustments ▸ Brightness/Contrast command (this adjustment cannot be fine-tuned later).

 A different way to achieve the same effect is to reapply the gradient to the mask with a lower opacity setting (which you can adjust in the Gradient tool's options bar).

8. To give the adjusted image a final polish, we increase the contrast by merging our current layer stack and selecting *Overlay* blending mode or, as an alternative, one of the other modes from the same group, such as *Soft Light*.

 Use the ⇧-Ctrl-Alt-E / ⇧-⌥-⌘-E command to combine the layers (see page 160 for more details on performing this step). Using this keystroke produces a flattened layer while preserving the content of the lower layers.

9. If the resulting look is too extreme, you can adjust the opacity of the mask layer to fine-tune it. Figure 4-22 shows the result of using *Overlay* mode and 40% opacity – some details now have an intensity that is reminiscent of HDR effects.

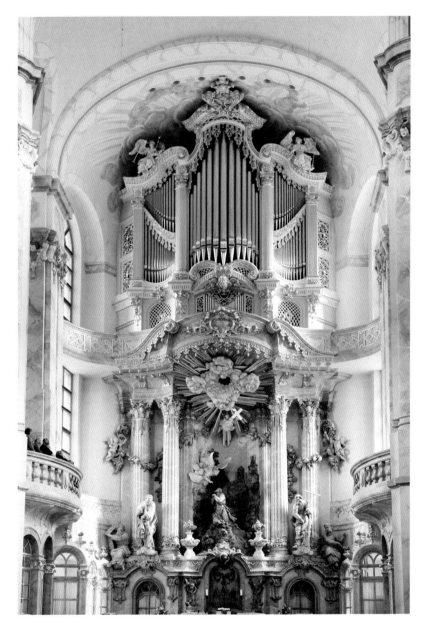

[4-21] The layer stack for figure 4-22 showing the two adjustment layers. The bottom layer shows the mask in Screen mode that brightens the image, and the combined upper layer in Overlay mode increases the contrast

[4-22]
The finished image

Reducing the layer mask's Density – introduced with Photoshop CS4 – is often overlooked by Photoshop users. When you create a layer mask by first creating a selection using any of the Marquee or Lasso tools, feathering the selection (or the mask) is another useful technique. You can also feather the mask in the Mask or Properties panel.

4.4 Dodging and Burning Using Layers

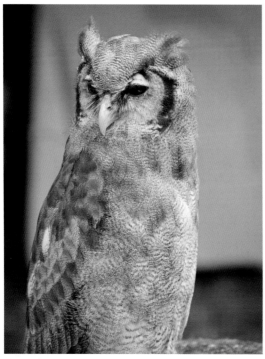

[4-23] The original image

A popular use of *Overlay* mode is to apply selective brightening (dodge) and darkening (burn) effects.

Figure 4-23 shows our original image. Certain areas – such as the bright green perch – distract us from the main subject and could do with a little tweaking. Brightening the bird's eye and darkening some of its feathers would also give the image a more balanced overall feel:

1. Start by creating a new layer using the Layer ▸ New ▸ Layer command. Name the new layer *Dodge & Burn* and select *Overlay* mode, in which Photoshop automatically gives you the option to fill the layer with a neutral color (in this case, 50 % gray, as shown in figure 4-24). So far the look of our image has not changed.

[4-24] Creating and naming a new layer in
Overlay mode with the 50% gray fill option activated

[4-25] The layer stack showing the 50% gray
layer

2. We now add some adjustments by selectively altering the grayscale values in the new layer. The adjustments have the following effects:
 - 50 % gray No change (which is why we begin at this point)
 - Values > 50 % Darken the affected area (black is darkest)
 - Values < 50 % Brighten the affected area (white is brightest)

 The method you use to alter the grayscale values is a matter of personal taste. We prefer to use soft black and white brushes, with Size and Opacity settings that we constantly alter using keyboard shortcuts. It is usually better to use low opacity values between 20% and 30%, and build up effects gradually. Pressing the D key switches the foreground and background colors to black and white, and the X key toggles between them.

 Instead of using the Brush tool, you can use the Dodge tool (🔍) to brighten the gray layer or the Burn tool (✋) to selectively darken it. Select the *Midtones* option in the *Range* menu in the options bar. We generally use a soft-edged brush tip and activate the ✒ option when we work this way. *Exposure* values of 5-15% are a good starting point.

[4-26] The Dodge and Burn tools

[4-27] Recommended Dodge and Burn tool settings

If you darken or lighten an area too much, you can use the opposite tool to correct your adjustment. As with other tools, remember to zoom in far enough to concentrate on the detail you are adjusting and use the Hand tool (press the space bar to activate it) to shift the preview detail as necessary. And don't forget to zoom out regularly to check the overall effect of your changes.

If you [Alt]-click the eye icon in the grayscale layer, all other layers will be hidden, and the adjustments you made will be revealed in the preview window (figure 4-29). The areas that are darker than 50% gray will darken the original image (here, the bright-colored feathers), and the brighter areas will lighten the image (such as the eyes).

Figure 4-28 shows our adjusted image; we also darkened the upper-right corner a little. The bird's eyes, face, and beak now show more detail. Figure 4-30 shows the layer stack for the adjusted image.

[4-28] Our owl image after dodging and burning

[4-29] The Overlay adjustment layer showing the dodged and burned areas

[4-30] The layer stack for the adjusted image

3. The changes we have made have brightened the perch too much (figure 4-31), so we use another layer to correct this. We could use a *Hue/Saturation* adjustment layer with a mask that covers everything except the green surface, but in this case it is simpler and more effective to use Saturation blending mode to desaturate the color.

[4-31] The green perch in the bottom right corner is too bright.

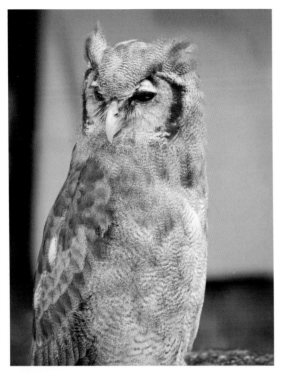

[4-32] The green perch in the bottom right corner is too bright

There is no neutral fill color available in *Saturation* mode, so instead we create a new, empty (i.e., transparent) layer in which any application of color or opacity reduces saturation.

Once again, we use a black brush set to about 30% opacity to paint in the area we wish to desaturate. Black is simpler to use because it is easier to see while we work. If you need to reduce the degree of desaturation, use the Eraser tool with a low opacity setting to increase transparency – or simply reduce the Opacity of the layer.

[4-33] Layer stack for figure 4-35

[4-34] Desaturation layer using *Saturation* blending mode

The result of this step is shown in figure 4-35; figure 4-33 shows the layer stack and 4-34 shows the adjustment layer. As usual with such adjustments, you can apply a thicker brush effect and fine-tune it by reducing the opacity of the layer.

Darken is a suitable alternative to *Saturation* mode, although in this case it would make the lower-right corner of the frame too dark and distracting.

4. A more effective approach for this image would be to change the color of the perch using a Color Balance or a (more flexible) Hue/Saturation adjustment and a mask to limit its effect to the surface of the perch.

 To do this, discard the uppermost layer shown in figure 4-33 and create a new Hue/Saturation adjustment layer.

5. Switch to the Greens view and sample the color of the perch using the eyedropper. Here, we use a *Hue* value of -41 to match the color of the perch to the background color (figure 4-36).

 The *Saturation* and *Lightness* sliders can then be used to fine-tune the result.

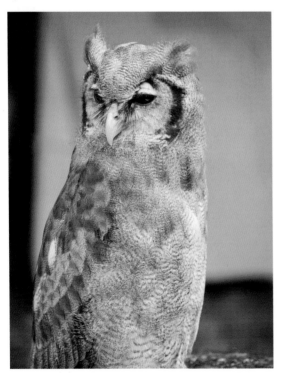

[4-35] The result of desaturating the perch

[4-36]
Our Hue/Saturation settings

6. Finally, invert the white layer mask to black (Ctrl/⌘-I) and fine-tune the adjustment using a white brush. Figure 4-38 shows the final result.

 In this case, the *Hue* adjustment was so successful that the mask wasn't really needed at all.

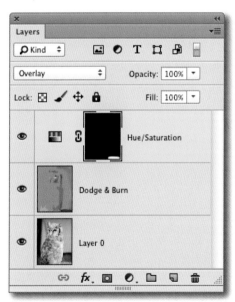

[4-37] The layer stack for figure 4-38, showing the Hue/Saturation adjustment layer

[4-38] The color of the owl's perch has been altered, slightly desaturated, and darkened to blend it with the background

Once again, you can refine overdone effects by altering the opacity of the adjustment layer. We often find that deliberately applying an exaggerated effect gives us the headroom we need to get the fine-tuning just right.

4.5 **Sharpening without Altering Colors**

Sharpening for output is usually the last editing step, and varies in strength according to the chosen output medium. Presentation on a monitor requires little sharpening, an inkjet print requires more attention, and magazine or book printing requires the most sharpening. Ideally, sharpening should be applied to a finished, scaled image.

[4-39]
The original image

The Unsharp Mask filter (often abbreviated to USM) is the sharpening tool of choice for many photographers, although some prefer to use the Smart Sharpen filter introduced with CS2 and enhanced in CC.

Both filters have be applied to a pixel layer – and we recommend that you use a separate layer. If the uppermost layer of your image is an adjustment layer or a mask, you will need to create a new, combined pixel layer (as described in section 4.3, step 8) to perform this type of sharpening:

1. Use the ⇧-Ctrl-Alt-E / ⇧-⌥-⌘-E shortcut to create a combined layer containing all visible layers,* or, if you are working on an image that contains just one layer, duplicate it using the Ctrl/⌘-J shortcut before proceeding. We applied the following steps to the image shown in figure 4-39.

2. Activate the Filter ▸ Sharpen ▸ Unsharp Mask filter. In this example, we will be sharpening high frequency and low frequency areas separately, while keeping a careful eye on the detail and the entire preview image.

* See section 5.1, page 160, for more details on how to perform this type of layer merge using older versions of Photoshop.

High-Frequency Sharpening

3. Areas that contain fine textures, such as grass, leaves, hair, or animal fur, are known as high-frequency areas. Such patterns contain finely differentiated tonal values with poorly defined edges that need to be rendered more clearly.

 This can be achieved using a low Amount setting (10–20%) and a high Radius value (in this case, 200 pixels) for the Unsharp Mask filter. The Radius value you choose will depend on the content and the resolution of the image you are editing.

 In this example, we use a *Threshold* value of zero. It is important to check the look of the entire image, not just the detail you are working on when you apply these values, although you do need to use a 200–300% detail view to ensure that you don't produce unwanted noise while you make your adjustments.

 Figure 4-40 shows sample settings, and figure 4-41 shows the result of applying them to our original image. The circular details on the right underscore the differences between the two versions.

[4-40] High-frequency sharpening settings

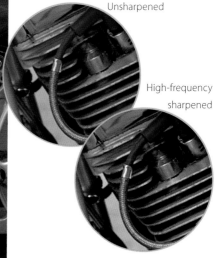

Unsharpened

High-frequency sharpened

[4-41] High-frequency USM sharpening using the values shown in figure 4-40 has given the details in our image better definition (see the enlarged details on the right). We prevented the increased saturation that often results from sharpening by using Luminosity blending mode.

Once again, you can attenuate the final effect by altering the filter layer's opacity (provided, of course, that your settings produce a strong enough effect in the first place).We often find it useful to write the name of the filter and the settings we used in the name of the layer.

Increasing edge sharpness often increases saturation too, but you can prevent this from happening by using *Luminosity* blending mode (see figure 4-42).

[4-42] We used the filter name (USM) and settings in the layer name.

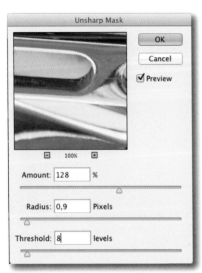

[4-43] Low-frequency sharpening settings

Low-Frequency Sharpening

4. This technique is most often used to sharpen prominent edges and is usually performed using the Unsharp Mask filter (often referred to as *USM*). To set the opacity and blending mode separately, begin by duplicating the current state of the image.

 This time we use a low *Radius* setting (typically 0.8-1.2 pixels) and a higher *Amount* setting (100–200%). We recommend starting at 100% to sharpem monitor output. 160–180% is better suited to output on an inkjet printer or for a third-party print service, and 180–220% can be used for printing on matte papers. If you are sharpening for book printing or for printing on highly absorbent paper, you can use even higher values. However, if you have already performed high-frequency sharpening, it is advisable to use a slightly lower *Amount* value or reduce the *Radius* setting accordingly. Keep an eye on high-contrast edges because they are particularly prone to sharpening artifacts. Higher *Threshold* values (around 3–6 levels) help to prevent artifacts in single-color areas and at soft transitions. Set the USM zoom level to between 50% and 100%, and keep an eye on the effect of your changes in the preview image, which should be zoomed to at least 50%.

5. Finally, we select *Luminosity* blending mode to give us the result shown in figure 4-45 and its layer stack in figure 4-44. The slight increase in edge saturation that sharpening in *Normal* blending mode produces can provide better results for images with weaker colors.

[4-44] The layer stack for figure 4-45 [4-45] The result of applying high- and low-frequency sharpening to our original image

We will look at other low-frequency sharpening techniques later, but high-frequency sharpening can be effectively performed at the Raw conversion stage using the *Clarity* slider built into Adobe Camera Raw and Lightroom.

4.6 **Simulating a Pencil Drawing Using Divide Mode**

Divide mode was introduced with CS5. It divides the pixel value in the blending layer with that of the base layer. The following example is based on the high-contrast image shown in figure 4-46 and demonstrates how the effect works:

1. Begin by duplicating the background layer using the Ctrl/⌘- J shortcut.

2. Now select *Divide* mode for the uppermost layer. The result will initially look like a pure white image, but don't let that put you off!

3. Now convert the upper layer into a Smart Object using the Layer ▸ Smart Objects ▸ Convert to Smart Object command (see chapter 6 for more details on Smart Objects). We could perform this example without using a Smart Object, but its effect is particularly useful here, so please bear with us for now.

4. Applying the Filter ▸ Blur ▸ Gaussian Blur filter to the upper layer once again makes the original image visible. The Radius setting in the Gaussian Blur filter dialog determines the degree of blur and should be selected according to the resolution of the source image

[4-46] The original portrait

[4-47]

The Radius setting in the Gaussian Blur filter dialog determines the degree of blur.

The result looks like a lightly colored pencil drawing. What the filter actually does is blur the pixel-based image. The *Radius* setting determines the degree of blur and is best selected by observing its effect in the preview image. The setting you choose will depend on the resolution of the original image and the types of textures it contains. Settings of 50–200 pixels work well with high-resolution images. But let's not spend too much time on this now – we'll go into more detail on the subject later. The initial result is shown in figure 4-48.

[4-48] The result of applying **Gaussian Blur** in *Divide* blending mode

5. The next step is to remove the remaining colors and, as usual, there are various ways to do this – for example, using a Hue/Saturation adjustment layer, the *Vibrance* control, or a Black & White adjustment layer (which offers greater flexibility when you fine-tune color shifts, as described in section 2.5 on page 62). The Channel Mixer can also be used as an alternative to Black & White, which produced the image shown in figure 4-49.

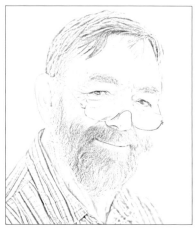

[4-49] The **Black & White** conversion

6. The result is still a little too pale, so we now adjust the contrast using a Levels adjustment in which we shift the black point and midtone sliders quite a long way to the right. In cases such as this, it is worth experimenting with the position of the white point slider too. Our settings are shown in figure 4-50.

[4-50]

Clipping the blacks, using the black point slider, and shifting the midtone slider to the right produces a steep curve; the result is shown in figure 4-51.

7. Figure 4-51 shows the current state of our image, and figure 4-52 the corresponding layer stack.

[4-52] The layer stack for the image in figure 4-49

8. Why did we use a Smart Object in step 3? Simply because it allows us to later reactivate the Gaussian Blur layer and fine-tune its effect.

 To do this, click the *Gaussian Blur* filter entry in the layer that contains the Smart Object and, if necessary, click the triangle Ⓐ at the right side of the entry to show the Smart Filters view. You can then try out different Radius settings while retaining all the other changes you have made.

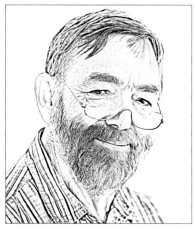

[4-51] The result of our **Levels** adjustment

[4-53] Applying a filter to a Smart Object. Clicking the triangle Ⓐ shows the filter view.

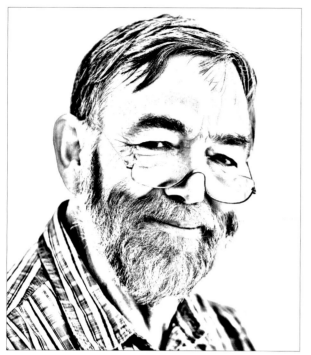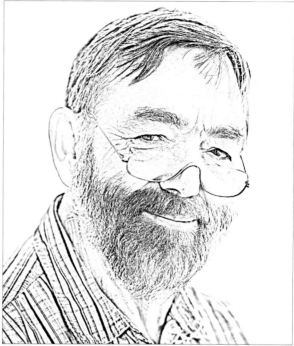

[4-54] Applying Gaussian Blur with a Radius setting of 6 pixels (left) and 40 pixels (right)

9. We can now separately adjust the degree of blur, the Black & White conversion parameters, the Curves settings, and the opacity of each individual layer. In other words, this technique offers us plenty of opportunities to experiment. Figure 4-54 shows two possible results.

10. The final step involves either merging all the layers to the background or producing a combined layer using the Ctrl/⌘-Alt-⇧-E shortcut.* Any artifacts that remain in the new merged version can then be removed using the Eraser tool or a white brush.

 * See section 5.1, page 160, for more details on flattening layers.

11. The resulting drawings shown in figure 4-54 have little to do with a real photo, but they can nevertheless be used as an accent layer. To do this, create a combined layer using the Ctrl/⌘-Alt-⇧-E shortcut (not necessary if the uppermost layer is already a pixel layer), create a copy of the background and place it beneath the new layer, and then select *Overlay*, *Luminosity*, or *Soft Light* blending mode for the top (combined) layer. The result is an image with accented edges that appears to have been subtly sharpened. You can also adjust the opacity to fine-tune the overall effect.

4.7 Dull + Lifeless × Blending Mode = Powerful Image

The idea of using blending modes to pep up simple adjustments can often be expressed in terms of the formula quoted above. If your images lack contrast or color, a quick way to liven them up is to duplicate the pixel layer and apply a new blending mode to the uppermost layer. If you want to increase the color contrast, *Color Dodge* is a great mode to use, as shown in figure 4-56. In this image, the new layer causes the sky and the rainbow to really glow and gives the trees on the horizon a much clearer profile.

If, however, you want to increase the light and dark contrast in an image, *Overlay*, *Soft Light*, and in some cases *Hard Light*, are the modes of choice, although you will usually have to reduce the opacity of the top layer to avoid producing over-the-top effects. This technique can be used additively, and you can create three or four duplicate layers and apply your chosen blending mode to each. Layer masks are seldom useful if you use this technique.

[4-55] The layer stack for figure 4-56

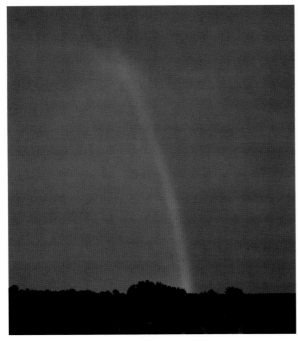
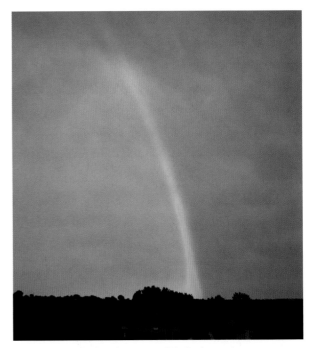

[4-56] The original image is shown on the left. The right image has a duplicated top layer set to *Color Dodge* mode.

4.8 Adding Clouds to a Landscape

Poor detail and color definition in the sky often spoil otherwise acceptable landscape images (figure 4-57). In such cases, adding a few well-defined clouds from another image is a quick way to make such an image more effective.

The method is as follows: Begin by selecting suitable clouds (with plenty of surrounding sky) from a separate image using the Lasso tool, and copy the selection to the clipboard using the Ctrl - C shortcut. You can then copy the contents of the clipboard to the working image (Ctrl - V) and move it into position. If necessary, you can also scale your selection (Ctrl - T). Clouds can usually be scaled without any obvious side effects.

We can now apply a suitable blending mode. In our example, we used clouds from a similar scene that looks suitably dramatic, but the landscape itself was fairly dull. Figure 4-58 shows the new image, and figure 4-59 the new layer stack.

Because the new sky is darker than the original, we use *Darken* blending mode. The layer mask in our illustration shows how rough the selection for such an operation can be. We enlarged our inserted sky selection to fit the original image and removed any unwanted overlaps using the Eraser tool.

[4-57] The original image with its humdrum sky

[4-58] Our original image with its new, dark sky applied using *Darken* blending mode

[4-59]

The layer stack for figure 4-58

If the clouds you use are particularly dark, we recommend using *Darken* mode; *Lighten* is better for blending brighter clouds.

You don't need to make a precise selection with this technique, and the blending mode ensures that the new selection blends into the original image. Figure 4-60 shows a bright cloud with a dark outline from a different image inserted using *Normal* mode. Inserting the same cloud using *Lighten* mode produces a smooth, authentic-looking result (figure 4-61).

[4-60] This bright cloud with a darker outline is much too obvious if we use *Normal* blending mode

[4-61] We used *Lighten* mode (with 70% opacity) to integrate the bright cloud into the sky

4.9 Merging Multiple Images Using Blending Modes

Blending modes are a great tool for merging multiple images without having to create complex, custom masks for the job. This technique is particularly effective if all the source images are similarly exposed and are shot from the same position using a tripod. *Darken* and *Multiply* modes are best for merging high-key images, while *Lighten* and *Screen* are good choices for low-key merges.

Figures 4-62 through 4-64 show our three source images, which were captured at a light show in Wolfsburg, Germany, in the summer of 2012. They were captured using a Nikon D80 mounted on a tripod with the mirror locked up and set to 1/6 second at ISO 400.

[4-62] Original 1

[4-63] Original 2

[4-64] Original 3

1. Begin by loading the source images as a stack, either from Bridge or Lightroom using the Open as layers in Photoshop command or in Photoshop itself using the File ▸ Scripts ▸ Load Files into Stack command. Alternatively, you can open the three images individually and select (Ctrl/⌘-A), copy (Ctrl/⌘-C), and paste (Ctrl/⌘-P) the second and third images into the layer stack.

2. Now select *Lighten* mode for the upper two images, and that's it! The brighter parts of the upper layers are automatically superimposed on the corresponding parts of the bottom layer.

3. In cases like this, it is worth trying out *Lighten* and *Screen* modes to see which produces the best result. We used *Screen* in our example to produce a lighter result, and the finished image is shown in figure 4-65. The corresponding layer stack is shown in figure 4-66.

We could have used a long exposure to capture a single photo of this scene, but that would have produced an image with a lot more noise and the other unwanted details that always turn up in exposures. The background lighting would have been recorded during the entire exposure and would have turned out disproportionately bright. The technique described here enabled us to capture the most interesting parts of the show and merge them into a single, well-exposed image.

This approach (using a tripod-mounted camera and mirror lock-up) is an effective way to capture photos of fireworks.

[4-65] The merged image, with the two upper layers set to *Screen* mode

[4-66] The layer stack for figure 4-65

4.10 Applying Makeup Using Color Mode

Blending modes can also be used to apply digital makeup to portraits without affecting the texture of the subject's skin, which is mainly defined by the luminosity of the area that contains it. *Color* and *Hue* are the best modes to use for this type of adjustment, as demonstrated in the following example.

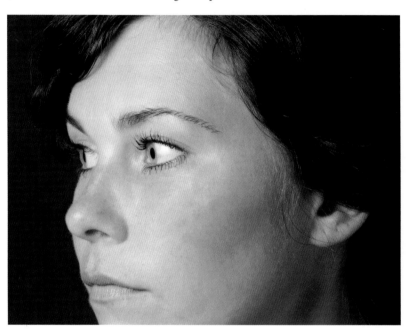

[4-67]
The original image without makeup

1. Begin by creating a new, empty layer (⇧-Ctrl/⌘-N) and set it to *Color* mode.

2. Zoom in to the eyes and select a soft brush of appropriate size and color. As usual, you can begin with a color that might at first appear too dark because you can always moderate the effect by adjusting the layer's opacity. We recommend starting with the following values: 25% Opacity, 50% Flow, and 5% Hardness.*

 * For more details on how to use brushes, see section 3.17 on page 122.

3. You can now apply makeup using repeated brush strokes. The low Opacity and Flow values ensure that you can't overdo things, and they allow you to work up slowly to your desired effect.

4. Using separate layers for different colors and different subject areas enables you to adjust the opacity and set different modes for each layer without affecting the others.

5. Figure 4-69 shows the makeup layer. We could have applied our effects directly on the image layer using a brush in *Color* mode or on a separate layer with a brush in *Normal* mode (set in the brush tool's options bar), but the method described here gives us more control over the final effect.

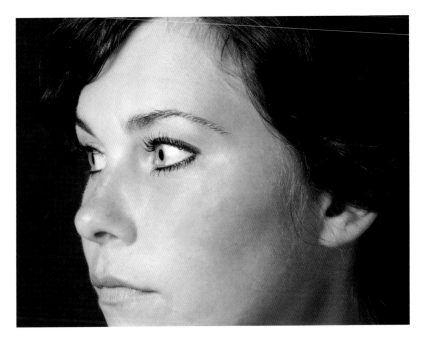

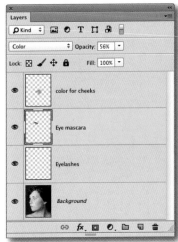

[4-68]

The same image with digital makeup applied in *Color* blending mode. Figure 4-69 shows the makeup layer on its own.

[4-69]

Our eye and cheek makeup adjustments combined in a single layer.

The black accent that we applied to our model's eyelids (in *Overlay* mode) is not included here.

[4-70] The original image

[4-72] The original image with an additional
upper texture layer in *Overlay* mode

4.11 Adding Texture

Many images can be effectively en-
hanced by adding texture. There are
countless texture files available com-
mercially and for free on the web, and
you can always photograph your own.
This example combines a portrait with
a plain background and a separate
texture file chosen to suit the nature
of the original image. The steps re-
quired to perform the merge are as
follows:

[4-71] The texture image
(from Flypaper Textures [11])

1. Open the image and the texture
 files individually.

2. Select the entire texture and drag
 it to the image while you press
 the Alt key.

3. Scale it (Ctrl/⌘-T) to completely cover the subject's face. The loss of
 quality involved in enlarging or distorting a texture file is usually negli-
 gible in cases like this.

4. *Lighten, Darken, Overlay,* and *Soft Light* are all suitable modes for add-
 ing textures. In our example, *Overlay* produced the best result (figure
 4-72).

5. In this case, the chosen texture makes the background more interesting
 and isn't too obvious in the subject's clothing. However, we don't want it
 to show in the face, which we need to mask.

 To create an appropriate mask, activate the portrait layer and open the
 Color Range dialog using the Select ▸ Color Range command. Select the
 Skin Tones option in menu Ⓐ and set an appropriate fuzziness value (the
 Detect Faces option has no effect here). This automatically creates a mask
 like the one shown in figure 4-73). Such a mask is not a perfect face mask,
 but it is sufficiently precise for our purposes here.

6. With the selection active, activate the texture layer, delete the layer mask
 (if present), and create a new layer mask by clicking the ⬛ icon at the
 bottom of the Layers panel. The active selection is then automatically in-
 serted into the mask.

7. Invert the mask (⌃Ctrl/⌘-I) so it masks rather than reveals the face. You can achieve the same effect in step 5 by selecting the *Invert* option in the Color Range dialog.

 The mask can be fine-tuned using a black or white brush, although this is not necessary in our example.

 The result of these steps is shown in figure 4-74 and the corresponding layer stack in figure 4-75.

Overlay isn't always the best mode to use for adding textures. You should select the mode that best suits the texture, brightness, and color of the original image. Generally speaking, the more extreme blending modes, such as *Color Dodge*, *Darker Color*, *Lighter Color*, and *Hard Mix*, and all modes in groups Ⓔ and Ⓕ (see page 128) are not suitable for adding texture.

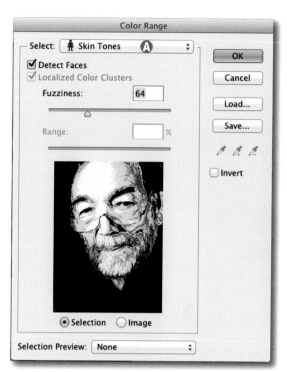

[4-73] The Skin Tones selection option in the **Color Range** dialog automatically produces a usable mask

[4-74] The finished image with its mask and overlaid texture

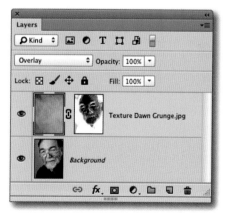

[4-75] The layer stack for figure 4-74

4.12 Enhancing Texture Using Individual Channel Luminosity

In RGB images, one color channel often contains more detail and texture than the others (section 3.11). This tendency can be used to enhance the overall look of an image, as the following example shows.

[4-76]

The original image

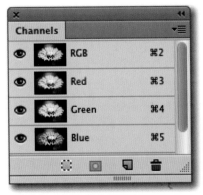

[4-77] The Channels panel for figure 4-76. The blue channel contains the most contrast and detail.

The image shown here depends on shallow depth of field for its effect, but it could use an increase in detail rendition. The following steps present an extended version of the *Overlay* or *Soft Light* blending technique that we have already described and can be varied by inverting the luminosity image or using it as a luminosity mask:

1. As usual, the first step is to duplicate the background layer using the Ctrl/⌘-J shortcut.

2. Now switch to the Channels panel and look for the channel with the best detail rendition. In our example, this is the blue channel (figure 4-77), although in portraits it is usually the red channel. The purpose of this process is to blend the original image with the luminosity of the most detailed channel.

3. Click the blue channel to activate its (grayscale) luminosity image.

4. Select the luminosity image using the Ctrl/⌘-A shortcut and copy it to the clipboard using Ctrl/⌘-C. Activate the Layers panel and insert the copied luminance channel[*] into the uppermost layer using the Ctrl/⌘-V shortcut. The new layer is initially the only one that's visible.

* I.e., its grayscale representation

5. Setting the luminosity layer to *Soft Light* or *Overlay* mode provides us with much more detail. *Luminosity* mode produces a similar effect.

6. Finally, fine-tune the strength of the effect by adjusting its opacity. The result is shown in figure 4-78.

 If necessary, you can strengthen the effect of the luminosity layer by duplicating it again and reapplying *Soft Light* or *Overlay* mode.

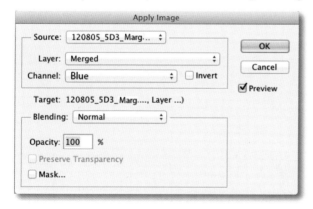

[4-78]

Our image blended with the luminosity of the blue channel

Another way to achieve a similar effect is to use the Apply Image command, starting at step 2 from the previous page:

2. Activate the copied background layer and navigate to the Image ▸ Apply Image command. The resulting dialog (figure 4-79) may appear complex, but it actually consists of just Source and Target settings.

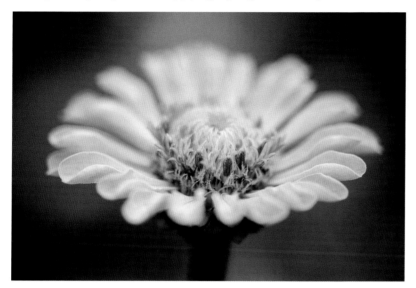

[4-79]

Apply Image is a powerful tool that is often neglected or ignored

By default, *Source* is set to the currently active image and layer (in this case, the virtually flattened layer made up of all currently visible layers). We select the Blue channel, whose luminosity image we want to blend with the original.

The currently active image is also set as the default target, where the result of the blend and the selected blending mode will be applied. The

→ Photoshop shows the effect of the
selected blend in the preview window
before you click OK, enabling you to check
the effects of various modes without
committing to a change.

opacity of the blend (not the layer) can also be adjusted at this stage. (The effect can be fine-tuned later using the layer's opacity setting.) The result is that the uppermost layer now contains the luminosity image of the blue channel, and the preview image appears in black-and-white. Rename the resulting layer to reflect the applied blend and set it to *Normal* mode, regardless of the blending mode you use to make the blend.

3. Switching the upper layer's mode to *Overlay* and setting 100% opacity gives us the result shown in figure 4-80. The effect produced by *Overlay* mode is stronger than that produced by *Soft Light*. The overall effect can also be adjusted using a layer mask – for example to prevent the background from becoming too dark.

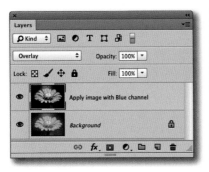

[4-80]
The result of our **Apply Image** blend.
Here, we blended the blue channel in
Overlay mode at 100% opacity into
the active layer. The steps are
documented in the name of the layer.

We could have applied our chosen blending mode in the Apply Image dialog, but then we would be unable to experiment with other modes later. This method allows us to document our changes more accurately and adjust the effect after the blend has taken place – which is the whole point of non-destructive editing.

The Apply Image command is a little known but extremely useful tool. Photoshop also includes the similar Calculations command that enables us to select two sources (see figure 4-81) and save the result as a new channel, a new document, or a selection. Here too, the blending mode determines the look of the result.

[4-81] **Calculations** enables us to blend individual channels
and save the result in a new channel

4.13 General Thoughts on Blending Modes

Blending modes are an extremely useful tools and that are often neglected by photographers. There are five basic ways to use them:

1. Set a blending mode in the upper of two identical image layers to independently adjust color, contrast, or saturation. Appropriate modes include *Overlay*, *Soft Light*, *Lighten*, *Multiply*, *Darken*, and *Screen*.

2. A specific blending mode is used on a neutral interim layer that contains selective brightness or color corrections. In this context, *Overlay* can be used to brighten or darken selected areas, while *Soft Light* is better for adjusting contrast and color saturation. Other modes that can be used with this technique are *Darken*, *Lighten*, *Color Burn*, and *Multiply*.

3. Use blending modes to limit the effect of the upper layer to the application of a particular color or tone characteristic. For example, if the upper layer is a Curves layers, the increase in contrast it produces also increases saturation in some colors. If, however, you set the upper layer to *Luminosity* mode, this effect will be largely avoided. This procedure is also useful when used with sharpening layers.

 Color and *Hue* modes can be used to superimpose selected colors or hues, while *Luminosity* and *Saturation* modes can be used to selectively adjust their corresponding characteristics. Transparency is neutral in this group of modes.

4. Comparison blending modes can be used to underscore the differences between two similar image layers. Appropriate modes include *Difference*, *Exclusion*, *Subtract*, and *Divide*. *Subtract* and *Divide* can also be used to accent individual details.

5. Blending modes can be used to superimpose a texture onto an existing image. A mask is often required to protect critical image areas from the blend effect. *Soft Light* is the best mode for this type of blend, although, *Overlay*, *Lighten*, *Screen*, *Darken*, and *Multiply* can be used too, depending on the nature of the image and the texture you use.

It is often possible to achieve similar effects using adjustment layers, which use less disk space and can be more selectively adjusted. Blending effects are generally best adjusted using the opacity setting. Both types of adjustment can be fine-tuned using additional layer masks.

➜ If you want to try various blending modes (on a Mac), activate the Layers panel and the top layer. Now, cycle through the mode list using the ⇧-⊟ shortcut.

➜ In addition to layer blending techniques, blending modes can also be used to alter the effect of the brush tools and the **Apply Image** and **Calculations** commands.

Merging and Blending Layers

5

There are many reasons to merge multiple layers into one – first and foremost, to save disk space when you no longer need to work on separate layers. Sometimes it is useful to temporarily merge edited layers into an interim pixel layer to which you can apply a filter or any other operation that can only be applied to a pixel layer.

Other forms of layer merge include smart merges that enable you to create new images with extended dynamic range or enhanced depth of field.

This chapter introduces basic merging techniques and uses hands-on examples to illustrate how they work.

5.1 Merge or Flatten

There are many cases in which we no longer need some layers and, if the upper layer completely covers an unwanted layer, we can simply delete it. In other cases, it makes more sense to merge multiple layers into one – for example, using the Layer ▸ Flatten Image command (which has no default keyboard shortcut, but under Edit ▸ Keyboard Shortcuts, you can create new shortcuts or customize existing ones).

The Layer ▸ Merge Visible command (shortcut: ⇧-Ctrl/⌘-E) has a similar effect, but it ignores hidden layers.

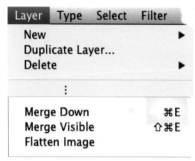

[5-1] There are several ways to merge layers

Flattening layers can save a lot of disk space, and you should always flatten an image before you share it with others or send it to a print service. If you need to scale an image for printing, it makes sense to flatten it first – but be sure to flatten a copy.

In some cases, such as when you have used a separate layer to make an adjustment, you will need to merge a layer with the one beneath it. The command is Layer ▸ Merge Down (shortcut: Ctrl/⌘-E).

Creating a Combined Layer

Another common use for merging is to combine all lower layers into a single interim pixel layer, which is useful if you need to apply an adjustment that cannot be applied using a separate adjustment layer (such as Shadows/Highlights or Replace Color). You can also generate a single pixel layer by flattening all layers to the background, but this discards all separate layers and therefore the history steps too, making it impossible to fine-tune any adjustments you have made. A combined layer is more practical and retains all the characteristics and parameters contained in the lower layers.

➡ This shortcut works only if no adjustment layer dialogs are currently open and no adjustment layers are active.

To create a combined layer, activate the uppermost layer that you want to include in the combination and use the ⇧-Ctrl-Alt-E/⇧-⌥-⌘-E shortcut. Hidden layers are not included in this type of merge.

Earlier versions of Photoshop require you to take the following steps to achieve the same effect:

1. Use ⇧-Ctrl/⌘-N to create a new, empty, transparent layer.
2. Execute the Layer ▸ Merge Visible command with the Alt key pressed to create a combined layer on the new, empty layer created in step 1.

When you are done, there will be a new pixel layer at the top of the stack (or above the top layer of the ones you selected for the merge). You can now apply filters or adjustments to this layer as you would to a normal pixel layer.

If you then need to adjust one of the combined layers, you have to undo the combination, apply your adjustment, and recombine. This is definitely a more efficient approach than starting over with the entire editing process.

5.2 Blending Layers

We often need to merge two images of the same scene that have perhaps been differently exposed or differently developed at the Raw conversion stage. Photoshop offers various ways to do this:

1. Using layer masks, as previously described.

2. Using blending modes, as described in sections 4.7 to 4.11.

3. Using HDR Merge (File ▸ Automation ▸ HDR Merge) or the HDR Toning tool (Image ▸ Adjustments ▸ HDR Toning). Although both of these tools are very good at aligning source images and preventing the ghosting artifacts that occur when moving objects enter the frame, Photoshop's native tone mapping module is not particularly effective. Tone mapping is used to reduce the much larger 32-bit tonal range produced by merging multiple source images to an 8- or 16-bit color depth image that can be correctly displayed on a monitor or printed.

 Third-party tone mapping programs and plug-ins still have the upper hand over Photoshop's own functionality, and we can recommend HDRSoft's Photomatix Pro plug-in [13] or the HDR Efex Pro filter from Nik Software [16]. Section 5.4 explains how to use Photoshop to perform simple HDR processing and section 5.5 goes into more detail on the same topic.

 As of Photoshop CC (which comes with Adobe Camera Raw 8.x), you can also tone map by applying the Camera Raw Filter to a 32-bit HDR image (in Photoshop). The filter does not actually tone map, but it allows you to tune the white balance, exposure, tonality and colors, achieving a the look of a tone mapped image. When this is done, you can reduce the 32-bit image to 16-bit data and retain the look of the image. In many cases this approach achieves much better and more natural-looking results.

4. Using panorama stitching techniques to align and merge multiple source images. Photoshop's stitching module is called Photomerge, and section 5.6 explains how it works.

5. Using the Edit ▸ Auto-Blend Layers command. This tool enables you to merge multiple images of a single scene that were captured using various focus settings, thus producing an image with enhanced depth of field. The process is described in section 5.3.

6. Using layer (blending) modes or the *Blend If* options in the layer styles dialog. This technique is explained in section 5.4.

5.3 Loading, Aligning, and Blending Layers

Loading and Aligning Layers

Since the release of Photoshop CS3, the program includes functionality for automatically loading multiple images as layers and (optionally) aligning them. This is useful for cases in which we need to blend or merge multiple, differently exposed images of a single scene. The tool can be started using the File ▸ Scripts ▸ Load Files in Stack command,* and its dialog is shown in figure 5-2.

* Lightroom includes functionality for handing over multiple images to Photoshop and loading them as layers. All you have to do is select your images in the Filmstrip and use the **Edit in ▸ Open as layers in Photoshop** command from the context menu.

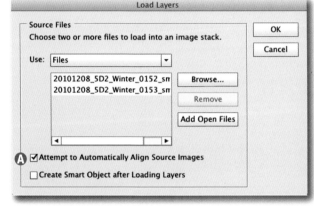

[5-2]
The **File ▸ Scripts** menu in CS3 (and later) includes functionality for loading multiple images as a layer stack and (optionally) aligning them.

Click the *Browse* button to select your images. As soon as you have selected two or more images, the auto-align option Ⓐ becomes available. You can also opt to create a Smart Object from your source images.** Activating the auto-align option opens the dialog shown in figure 5-3, which is the same as the one that is part of the Photomerge feature.

** For more information on Smart Objects, see chapter 6.

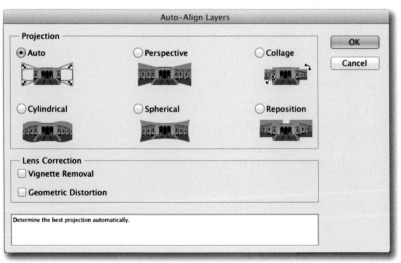

[5-3]
The CS6 and CC Auto-Align Layers dialog

The *Auto* projection type option usually works very well, and *Reposition* is a good option if your source images are framed almost identically.

If necessary, auto-aligning also scales, rotates, and even adjusts perspective in the source images, making it unnecessary (and virtually impossible) to perform manual alignment later on.

Blending Layers

The following example uses the described functionality to merge the two images shown in figures 5-4 and 5-5. A light wind caused focus to lock on the tip of the leaf in the first image, but the focus is on the top of the leaf in the second one.

[5-4] Here, the tip of the leaf is in focus.

[5-5] The focus here is on the top half of the leaf near the branch.

[5-6] The loaded layer stack

1. We loaded the images from Lightroom using Edit in ▸ Open as Layers in Photoshop, and figure 5-6 shows the resulting layer stack.

2. The source images were shot handheld, so the next step is to align them. To do this, select both layers and navigate to the Edit ▸ Auto-Align Layers command.

 Alignment can take a second or two, depending on the size of the images involved and the amount of computing power you have.

3. The aligned layer stack (figure 5-7) shows the transparent edge areas that the process creates. We crop this using the ◳ tool.

[5-7]
The aligned layer stack

4. Now merge the layers using the Edit ▸ Auto-Blend Layers command (available in CS4 and later), making sure that all layers you wish to blend are selected. In the dialog that appears (figure 5-8), select the *Stack Images* option and check *Seamless Tones and Colors*.

[5-8]
The Auto-Blend tool offers *Panorama* and *Stack Images* blend options.

Photoshop now looks for the areas with maximum sharpness and the best contrast, and it masks the stacked images so that unsharp areas are not included in the final blend. If both images contain blurred areas, the tool masks them in one of the two layers. Figure 5-9 shows the layer stack with the automatically created masks. The blended image now has enhanced depth of field.

5. This technique is known as *focus stacking* and was introduced with Photoshop CS4. The tool is continually being developed; it is still not perfect, even in CS6 or Photoshop CC. However, the results are often very good, as figure 5-10 shows. If necessary, the blended image can be further fine-tuned using the masks generated by the process.

6. If you no longer need the separate layers and layer masks, you can flatten the blended image as described in section 5.1. If the alignment process has created transparent edge areas, use the tool to remove them.

[5-9] The blended layer stack

[5-10]
The blended, cropped image

7. Photoshop doesn't always detect and select the best pixels in the source images. If this happens, duplicate the aligned and masked layers and insert the copies at the top of the layer stack. You can then replace the automatically generated masks with completely black masks to reveal the blended image and make the upper layers transparent.

8. You can now use a white brush to manually edit the new masks and create your own improved blend.

The technique we have just described doesn't just work with two layers, and it can be applied to stacks that contain a large number of source images. This is particularly useful for macro photographers, who wage a constant battle with limited depth of field.

You need to use a tripod when you shoot multiple source images for focus stacking, and you have to use manual focus to shift the focus from shot to shot. Ideally, you should deactivate all automatic exposure settings (shutter speed, aperture, ISO, etc.) to ensure that exposure and depth of field remain constant throughout the sequence.

* Our book *Photographic Multishot Techniques* [5] goes into much more detail on focus stacking.

Helicon Focus [14] is a dedicated application with appropriate features that is better at focus stacking then Photoshop. If you work regularly with multiple macro source images, the program can be a worthwhile investment.* Zerene Stacker [21] is another useful focus stacking application, as is the (free) Windows-only CombineZP [12], which is very popular among macro photographers. Enfuse [22] is also worth a look.

This function of Photoshop can also be used to merge differently exposed images to produce a kind of dynamic range increase (DRI) effect. The procedure is largely the same, and the tool automatically looks for the image areas with the best exposure. However, it has no fine-tuning options and is therefore less flexible than the HDR Pro module introduced with Photoshop CS3, although it does save you from having to perform a separate tone mapping step. The tool works very well if the total dynamic range of your source images isn't too great. Another way to use this concept is to blend two Raw source images that were individually developed to accentuate shadows and highlights. Section 5.5 describes an example of this approach.

Note that the rotation, scaling, and distortion effects applied by the auto-align process make permanent changes to the source image data. This is not a genuine non-destructive editing process and should be performed only on copies of your original material.

5.4 Creating DRI Effects Using Blending Techniques

Figures 5-11 and 5-12 show two differently exposed images of Lower Antelope Caynon near Page, Arizona. They are part of a handheld Raw bracketing sequence and are four stops apart. The shot in figure 5-11 was exposed for the sky, and the one in figure 5-12 was exposed to best depict the sandstone walls of the canyon. In this example we will blend the two images so the blown-out sky in figure 5-12 is replaced by the well-exposed sky from figure 5-11.

[5-11] f/9, 1/640 second, ISO 1600 [5-12] f/9, 1/40 second, ISO 1600

The steps required are as follows:

1. Load the images in a layer stack as described in section 5.3 on page 162. The darker image is loaded beneath the brighter one.

2. Because the images were shot handheld, we apply the Edit ▸ Auto-Align Layers command using the *Auto* projection type option.

3. As described in section 5.3, any remaining transparent edge areas need to be cropped using the ⬚ tool.

4. The simplest way to perform the blend is to mask everything except the sky in figure 5-11. However, because figure 5-12 contains other ares that are also too bright, we will use a faster, more practical technique that makes use of Photoshop's Blending Options dialog.

Activate the upper (highlight) layer and open the Blending Options dialog, either via the context menu or the Layer ▸ Layer Style ▸ Blending Options command.* Here, we will concentrate on the *Blend If* options at the bottom of the dialog window (figure 5-13).

* An alternative method is to select the Blending Options command in the Layer Style menu by clicking the *fx.* icon at the bottom of the Layers panel.

[5-13]
The Blend If options determine which tonal values from each of the two source images are used in the final image.

The sliders Ⓐ through Ⓓ determine which tonal values from the upper and lower layers are hidden in the final image. Because the upper layer in our example is exposed for the highlights, we shift slider Ⓐ to the right to hide the darker parts of the upper image. This reveals the corresponding ares in the lower image. You will need to experiment to find the right mixture of settings for your particular source images.

[5-14]
The sliders can be split by dragging them with the Alt key pressed. The area between the two halves represents the transition between the two blended layers.

To prevent a hard transitions between the two sets of pixels, press the Alt key and move the right half of slider Ⓐ to the right (or move the left half to the left). The split sliders create a transition zone, indicated by Ⓐ₁ and Ⓐ₂ in figure 5-14. The other sliders in the dialog can be split the same way.

The icon in the layer entry (figure 5-15) indicates that a Layer Style has been assigned to it – in this case, the Blend If settings. Clicking the icon opens the corresponding settings dialog.

Gray is the default setting in the *Blend If* drop-down, and it is the correct choice for our example. The options can be set separately for each individual color channel, although this capability is rarely useful in a photographic context.

Figure 5-16 shows the result of applying the settings shown in figure 5-14. They not only blend in the correctly exposed sky, but also the darker portions of the canyon walls in the lower part of the frame.

[5-15] The ▣ icon in the upper layer indicates that a Layer Style has been assigned to it

Using the (splittable) slider Ⓑ for the upper layer, you can also precisely determine which midtones from the upper layer remain visible in the blended image. You can apply the same technique to stacks with more than two layers, although it rarely makes sense to do so.

Other Uses for the Blend If Options

It is always preferable to avoid sharpening shadows because this amplifies any noise in them. If you use the Unsharp Mask or High Pass filters to sharpen an image, you can reduce their effects in the shadows either by using a luminosity mask or by using the *Blend If* options to partially mask the shadows in the upper layer. This technique can also be used to limit the effects produced by adjustment layers or duplicate blended layers to selected tonal areas. As ever, a little practice will help you to find out which settings work best.

[5-16]
Our result when we blended figures 5-11 and 5-12 using the Blend If technique with the settings from figure 5-14

5.5 HDR Merging Techniques

→ HDR imaging is a complex topic, and there are many books dedicated to the subject. For the purposes of this book, we will stick to describing only Photoshop's built-in HDR tools.

Introduced with CS3 and constantly improved ever since, Photoshop's built-in tools can be used to merge a sequence of differently exposed images into a single high dynamic range (HDR) image. The technique is primarily used to capture scenes in which the tonal range is too great to be captured in a single shot. To overcome this limitation, we shoot a sequence of images of the same subject using different exposure times. For the procedure to work properly, the brightest image (i.e., the one with the longest exposure time) should not contain any clipped shadows, and the darkest image (with the shortest exposure time) should have no clipped highlights. The number of images necessary to capture a scene will depend on its total tonal range and the camera's own dynamic range and the size of the exposure increments between each shot. Use two-stop increments if your camera allows – if not, one-stop increments will do (but you might need more shots).

Using a tripod ensures the best possible framing congruence and makes it easier for the software to merge the resulting images.*

* Using a tripod is a good way to avoid producing unwanted blur during long exposures.

Moving objects within the frame – such as people, vehicles, waves, or leaves blowing in the wind – make it difficult to produce cleanly merged images and should be avoided at the shooting stage if possible. Quickly shooting sequences in burst mode can help you avoid these types of issues, but all artifacts that remain have to be eliminated by the software.

The steps to perform HDR merging using Photoshop's *HDR Pro* module are as follows:

1. Phase 1 involves aligning the source images (if necessary) and merging them into a single image with extended tonal range. If the scene contains a moving object, you have to select the frame in which you want it to be visible and eliminate it from the others. The result is usually an image with 32-bit color depth and a range of tones that is too great to be correctly displayed on a monitor or printed.

2. Phase 2 involves reducing this extended tonal range to within an 8- or 16-bit range that can be reproduced using conventional output devices. This part of the process is called *tone mapping*. There is no single, universal tone mapping algorithm; they have a wide range of user-controlled parameters. Photoshop's four tone mapping methods are called *Exposure and Gamma*, *Highlight Compression*, *Equalize Histogram*, and *Local Adaptation* (figure 5-17). Our experience has shown that *Local Adaptation* is the only one that produces usable results.

[5-17] Photoshop CS6 offers four tone mapping methods

Figure 5-18 shows our three source images and their corresponding histograms. Due to the scene's extremely high contrast range, we captured them as a bracketed sequence with three-stop (3 EV) increments and the camera set to Av (aperture-priority) mode. We shot in Raw mode because Raw formats can capture a greater dynamic range than JPEG. The histograms show

that the highlights are not clipped in the darkest image and the shadows are still intact in the brightest image. The middle image is clipped at both ends of the scale.

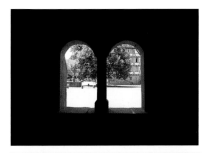
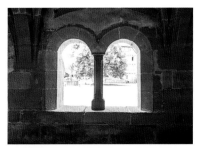

[5-18] The three images in the original bracketing sequence, captured at three-stop intervals

We processed the images as follows:

1. We straightened the first image using our Raw converter and synchronized the others to match. We also slightly increased the microcontrast using the *Clarity* slider, and we slightly reduced the overall dynamic range.*

2. After you have prepared your source images, load them into Photoshop and activate the HDR Pro module using one of the following methods:

 2a. In Bridge: Select your source images using the Tools ▸ Photoshop ▸ Merge to HDR Pro command

 2b. In Lightroom: Select your source images using the Photo ▸ Edit in ▸ Merge to HDR Pro in Photoshop command

 2c. In Photoshop: Use the File ▸ Automate ▸ Merge to HDR Pro command and select your source images in the dialog shown in figure 5-19

* We accomplished this by shifting *Lights* toward the negative end and *Darks* toward the positive end of the scale.

[5-19]

The image selection dialog in the Photoshop HDR Pro module

It usually makes sense to check the *Attempt to Automatically Align Source Images* option (figure 5-19). Click *OK* to proceed to step 3.

Methods A and B above automatically align the source images.

3. Photoshop now analyzes the selected images and opens the dialog shown in figure 5-20. The differences in exposure are read from the EXIF data and displayed at Ⓐ.

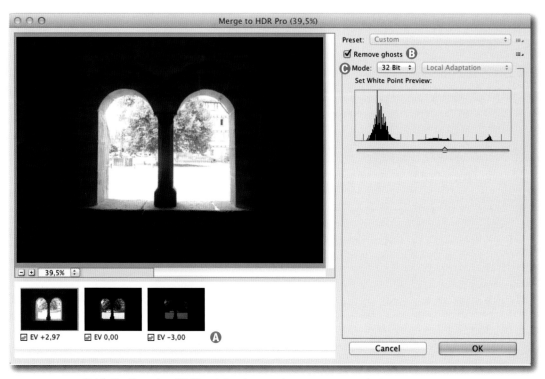

[5-20] The Photoshop HDR Pro dialog showing the source image and HDR image previews

It generally helps to check the *Remove ghosts* option Ⓑ because bracketing sequences nearly always contain some moving objects, however small. The program then detects the areas that vary from image to image and selects the appropriate pixels from the one with the best exposure.*

Instead of selecting the *8 Bit* or *16 Bit* option in the *Mode* menu Ⓒ (which would immediately open the tone mapping dialog), we select the *32 Bit* option so we can check the 32-bit interim version of our image.

* Specialized HDR plug-ins, such as Photomatix Pro by HDRsoft [16], allow the user to select which source image specific details are taken from.

4. Figure 5-21 shows the preview HDR image, which is, at first glance, somewhat disappointing. However, the odd look of the 32-bit image is primarily due to the inability of a conventional monitor to display all the tones it contains. You can adjust the brightness of the preview image using the 32-bit Exposure command in the fly-out menu at the bottom of the window.

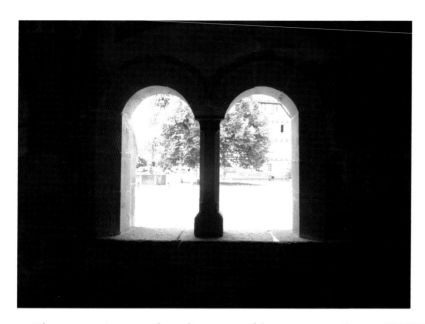

[5-21]
Because the monitor cannot correctly reproduce the range of tonal values it contains, the HDR preview image produced by Photoshop is dull and lacks detail

5. The next step is to save the 32-bit version of the image using the File ▸ Save As command and the settings shown in figure 5-22. Phase 1 is now complete.

 You can now edit your HDR image with the software or plug-in of your choice. We recommend the Photomatix Pro plug-in from HDRsoft [13] or the HDR Efex Pro filter from Nik Software [16]. Examples of how to use both tools can be found in our Book, *The Digital Photography Workflow Handbook* [7].

6. Our experience has shown that Photoshop's merging technology produces perfectly acceptable results, but its tone mapping functionality is often quite tricky to apply successfully. For this reason, we recommend that you use either Adobe Camera Raw or Lightroom for any additional processing steps. Adobe Camera Raw (version 7.1 and later) and Lightroom (version 4.1 and later) are both great for processing HDR images saved in 32-bit TIFF format. They include tone mapping functionality that is implemented much better than Photoshop's.

 If you open the Photoshop HDR Pro module from the Lightroom interface, Photoshop hands the image back to Lightroom so you can save it and continue to process it in Lightroom's *Develop* module. If you open HDR Pro from Bridge or Photoshop, you need to select your image in Bridge and use the ⌃Ctrl/⌘-ⓡ command to open it in Adobe Camera Raw for further processing.

 The following steps demonstrate a processing sequence performed using Lightroom 4.3, although the same tools are available in Adobe Camera Raw.*

[5-22] Recommended settings for saving an interim 32-bit HDR image

* As of Photoshop CC, you could also apply the Camera Raw Filter to a 32-bit image in Photoshop.

* The improvement began with Lightroom 4.
The same has been true for Adobe Camera
Raw sind version 7.1.

7. Like Photoshop, most Raw converters have problems producing usable previews for 32-bit HDR images, although Lightroom* copes better than Photoshop (figure 5-23). For this reason, it is important to keep an eye on both the histogram and the preview image while you edit HDR images.

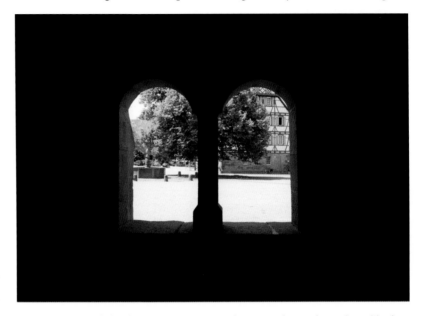

[5-23]

The preview of our HDR image in Lightroom looks much better than it did in Photoshop.

[5-24] The Lightroom 4 settings we used to produce the image shown in figure 5-25

The extremely high contrast range in the image has to be reduced before it can be successfully exported, printed, or displayed. Ways to do this include shifting the *Highlights* slider a fair way into negative territory and shifting the *Shadows* slider a long way to the right. In our example, the details on the inside of the sandstone wall become visible with Shadows set to +100. If you are using Adobe Camera Raw, using the *Blacks* slider (available since version 7.1) to set an appropriate black point will help you fine-tune your results.

Setting a *Clarity* value of +40 further accentuates the textures in the stones.

The *Vibrance* slider is the best tool for adjusting saturation, and less overall saturation helps to reduce the typical over-the-top HDR look of our image.

Note that using a 32-bit supporting Raw converter enables you to apply just about any tool or effect to your image, including the selective color corrections and Black & White conversion offered by the HSL panel's tools. You can even apply local corrections using the Adjustment Brush, the Graduated Filter, or the Radial Filter in Lightroom 5 (see section 9.2 for more details on how to use these tools). We used the Adjustment Brush (with *Highlights* set to –1.4 and *Clarity* set to +20) to reduce contrast in some of the elements in front of the window, thus adjusting the image away from the version captured by the camera and toward how the scene actually looked.

To achieve this effect, we used the Targeted Adjustment tool ⬍ in the HSL panel to reduce the luminance and saturation in the green of the tree.

The result is shown in figure 5-25, and figure 5-24 shows the *Basic* adjustment settings we used.

[5-25]
Our image after processing in Lightroom (or Adobe Camera Raw)

Figure 5-25 shows one possible interpretation of our HDR image, while figure 5-30 on page 177 shows one of the many others.

Using Photoshop to create HDR images and Lightroom or Adobe Camera Raw to process them produces photos with a natural look and a pleasing lack of HDR grunge.

> Our Tip: If you want to apply HDR Toning to a single layer without discarding your other layers, convert the layer you wish to alter to a Smart Object, double click it to activate the Editor window, and apply HDR Toning there.

Tone Mapping in Photoshop

If grunge is what you are after, you can produce it by tone mapping your image in Photoshop (to 8-bit or 16-bit data) and applying HDR Toning (Image ▸ Adjustments ▸ HDR Toning).

This tool can be used to tone map 8-bit, 16-bit, and 32-bit HDR images, and its 16-bit capabilities are particularly useful if you want to give a conventional image a bit more energy or an HDR-style look.

HDR Toning is not currently available as an adjustment layer or a Smart Filter. It automatically flattens all existing layers, including any layer-based adjustments you might have made. The tool offers the same tone mapping

functionality as Photoshop's HDR Pro module, and Photoshop also opens the dialog shown in figure 5-26 when you convert a 32-bit image to 8- or 16-bit mode.

The *Method* menu at the top of the dialog window (figure 5-27) offers four options, although we have found that *Local Adaptation* is the only one that produces acceptable results.

[5-27] Photoshop offers four tone mapping methods

The *Shadow, Highlight, Vibrance,* and *Saturation* sliders produce slightly different effects than the ones produced by the sliders with the same names in Adobe Camera Raw and Lightroom. As in Adobe Camera Raw, the *Exposure* slider adjusts the overall brightness, while *Details* can be used to produce a typical grunge-style HDR look.

Radius and *Strength* are the other two most important sliders for producing HDR effects. Similar to its effect in the Shadows/Highlights tool, the *Radius* setting determines the number of pixels that are included in the mapping effect the tool produces. It is generally advisable to find a suitable *Strength* setting and then experiment with different *Radius* settings to achieve the effect you are looking for. High *Radius* settings can produce obvious areas of brightness at high-contrast edges (figure 5-28), although the strength of this effect is also influenced by the nature of other details in the image.

[5-26] The Photoshop **HDR Toning** dialog

[5-28]
A detail from figure 5-30, adjusted using Strength and Radius settings of 2.2 and 21 (left), and 2.2 and 61 (right)

The Toning Curve, which displays a histogram, at the bottom of the HDR Toning window can be edited. It shows the tonal value at the current cursor position in the preview image as a point on the curve, which you can then shift to alter the curve's shape the same way you can in the Curves dialog.

In CS6 and CC, the individual sections of the dialog can be shown or hidden (only the histogram could be hidden in previous versions), and settings you have made can be saved as presets. To save a preset, click the ⚙. icon next to the Preset menu at the top of the dialog window (figure 5-29).

[5-29] You can save, load, and delete tone mapping presets

Setting a high *Details* value can produce a grunge look, as shown in figure 5-30. This version of our image was created using the settings shown in figure 5-26.

[5-30]
We created this version of our image using the **HDR Toning** tool and the settings shown in figure 5-26. It contains a number of typical HDR artifacts.

Tone mapping is an iterative game that needs to played on the basis of a stable Strength setting. After you have found a suitable value, you can then go on to experiment with the *Exposure, Shadow,* and *Highlight* sliders before you adjust the *Detail* setting, and finally, fine-tune the *Strength* and *Radius* settings.

The Photoshop HDR process combines multiple source images in a single-layer HDR image, to which you can add new adjustment layers. Most of Photoshop's adjustment layers work in 32-bit mode, but only a few filters share this capability. The original source images still exist outside of the Photoshop environment, but they are not visible, and you can't manipulate them in the layer stack.

The Camera Raw Filter was introduced with Photoshop CC. To achieve a natural-looking image, we recommend that you convert your 32-bit layer to a Smart Object (in Photoshop). Then call up this filter and use the Camera Raw controls (as described for Lightroom on page 174). In most cases, this yields much better results than using the Photoshop tone mapping techniques. This way, you don't have to save your image and open it again in Adobe Camera Raw. As previously mentioned, Adobe Camera Raw can handle 32-bit images (starting with version 7.1).

This way you have your image and any optional Adjustment Layers, that you can use for later corrections, in a single file.

Having tuned the tones in Adobe Camera Raw – actually a kind of tone mapping – you can reduce your image to 8- or 16-bit data.

5.6 Merging Layers in a Panorama

Another common way to merge layers is using *Stitching* techniques. These are most commonly used to create panoramas from multiple source images, but they can also be used to create ultrahigh-resolution images from multiple shots of a single scene. Stitching involves performing a sequence of steps:

1. Placing the source images to form a single image (with overlaps).

2. Rotating, scaling, and distorting the source images as necessary so that they fit together perfectly.

3. Blending the overlapping areas as invisibly as possible, which usually involves adjusting brightness in the corresponding areas.

When you shoot source material for stitching, make sure you capture all your source images using the same aperture and, if possible, the same exposure time. You also need to make sure that each image in the sequence overlaps with the next by about 25–30%. Stitched images usually need to be cropped along all four edges after stitching has taken place, so you also need to shoot with plenty of space surrounding the main subject. Always try to rotate the camera around the optical center of the camera/lens assembly when you take the shots.*

* For a detailed look at panorama photography, see Harald Woeste's book on the subject [8].

There are many specialized stitching programs available, including Autopano Pro [10], PTGui [18], and the open source Hugin package [17]. However, as long as you stick to fairly basic stitching tasks, Photoshop's built-in Photomerge Pro module produces perfectly acceptable results. The following sections give a rough idea of how the process works. For more detail, see our Workflow [7] or Multishot [5] books.

The source images for this simple example are shown in figure 5-31. They were captured handheld in manual exposure mode to ensure even lighting throughout the sequence. We used a Nikon D700 (full-frame) camera with a 16 mm lens.

We brightened the shadows and removed vignetting, chromatic aberration, and distortion artifacts using a Raw converter. If you perform these types of adjustments in advance of stitching, it is important to make sure you perform exactly the same adjustments on all your source images if you want the resulting panorama to look authentic and balanced. The Synchronize function built into Adobe Camera Raw and Lightroom makes this simple to do.

1. There are various ways to load source images into Photomerge:
 a. Select the appropriate images in Bridge and use the Tools ▸ Photoshop ▸ Photomerge command. You can then proceed directly to step 2.

[5-31] Our original landscape sequence was captured in Krakaw, Austria, with plenty of overlap between the individual shots

b. Select your source images in Lightroom's Library module and use the Photo ▸ Edit in ▸ Merge to Panorama in Photoshop command. You can then proceed directly to step 2.

c. Use the Photoshop File ▸ Automate ▸ Photomerge command.

All three of these commands open the dialog shown in figure 5-32.

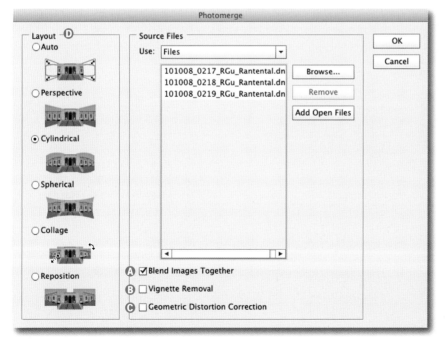

[5-32]
The CS6 Photomerge dialog

With a click on the *Browse* button, you can add additional images to the ones you have already selected.

In most cases, it is advisable to check the *Blend Images Together* option Ⓐ. This ensures that Photoshop automatically compensates for differences in brightness in the overlapping areas between images. Options Ⓑ and Ⓒ were introduced with Photoshop CS4 and are self-explanatory. They are useful only if you haven't already removed any unwanted vignetting or distortion using other tools.*

* These options are grayed out if you select the Collage or Reposition layout options.

2. The options in the *Layout* section Ⓓ determine the projection type the tool uses to merge the source images. *Auto* usually produces great results, but it's worth experimenting with the other options. If your source images cover a total angle of view of less than 120 degrees, then *Perspective* is a good choice, whereas *Cylindrical* is a better option if your material covers a larger angle of view (as our example does). *Spherical* is the best option if you are stitching a 360-degree or spherical panorama, and *Collage* and *Reposition* are useful if you are merging source images shot using a tilt/shift lens or a microscope. You will quickly see that the various projection types produce very different results.

→ If you are working with high-resolution source images, it makes sense to experiment on reduced-size versions to save time and processing power while you find the right settings.

3. Click *OK* to start the stitching process. The more source images you have and the higher their resolution, the longer the process will take. Be patient!

 Figure 5-34 shows the result of the stitching process. The curvature at the top and bottom of the merged image is due to our use of the *Cylindrical* Layout option. Figure 5-33 shows the stitched layer stack and illustrates how Photomerge automatically loads the source images into individual layers and orders, and aligns and masks them.

 The layer masks themselves are produced by the merging process, although no actual merging takes place. Instead, Photomerge simply masks the parts of the source files that are not required in the final image. Photomerge also automatically rotates, scales, and (if necessary) distorts the source images to ensure a perfect fit during merging.

 Note that this part of the process irreversibly alters the source layer's data.

[5-33] The stitched layer stack

4. The transparent parts of the canvas (in figure 5-34) that result from stitching using Photomerge can be dealt with in various ways:

 a. They can be cropped
 b. They can be filled using the method described below
 c. The image can be corrected using the Adaptive Wide Angle filter before further editing using methods a or b

 All three methods require the use of a combined layer created using the Ctrl/⌘-Alt-⇧-E shortcut. After you have created this new layer, either hide or delete the lower layers because they hinder the steps that follow.

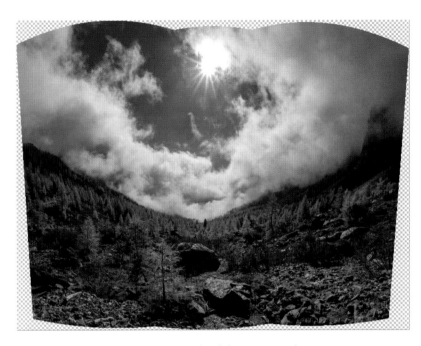

[5-34]
The initial results of merging our source images using Photomerge

4b. Begin by cropping as much of the unwanted transparent areas as possible and select the remaining pixels using the Magic Wand . You can now use the Edit ▸ Fill command with the *Content-Aware* option (available since CS5) to fill the empty areas (figure 5-35). This tool attempts to fill the transparent pixels using pixels that match the neighboring ones. This smart process can take some time to complete and usually produces very good results, as you can see here.

 You can then edit any obvious transitions or blur using the Clone Stamp and Healing Brush tools.

[5-35] Set the *Use* option to *Content-Aware*

4c. Photoshop CS6 includes the Adaptive Wide Angle filter (figure 5-36). In our example, we use the filter's *Perspective* correction type option, which automatically corrects the image and smooths its edges to a certain degree.

 Now shift the *Scale* slider until the image fills the preview window. The next step involves activating the Constraint tool located in the toolbar at the top-left corner of the filter window, which can be used to straighten the warped vertical and horizontal edges.

 To straighten an edge, click on an image corner (top left, for example), draw a line to the bottom left corner with the ⇧ key pressed, and click again to complete the line. Pressing the ⇧ key tells the program that the line you have drawn is vertical. Now repeat the same step for the other three edges of the image.

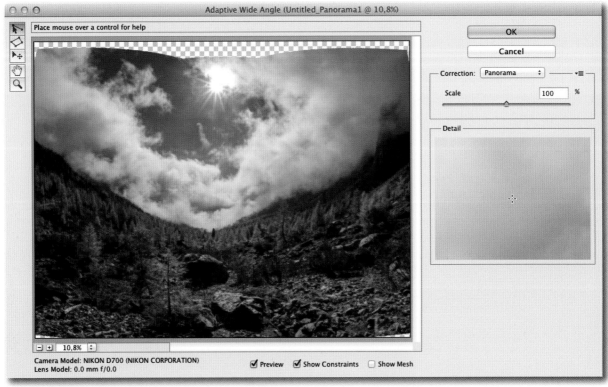

[5-36] Using the **Adaptive Wide Angle** filter is a quick and easy way to remove (or add) lens distortion

Click *OK* to apply the distortion (or correction) using the lines you have drawn. The result of our changes is shown in figure 5-37. You can remove any remaining transparent pixels using method 4b, or the Clone Stamp tool.

[5-37]

The image following our **Adaptive Wide Angle** adjustment. It still needs some cropping

Adding this kind of postmerge distortion is sure to reduce the overall image quality in some places, and Adaptive Wide Angle is not yet available as a Smart Filter in CS6,[*] so we always work on a copy of the image layer so we have a copy of the original image data to fall back on if necessary.

[*] As of Photoshop CC, it can be applied as a Smart Filter.

5. After these steps, a final crop using the ⊠ tool is often necessary.

6. To give our image a final polish, we slightly increased the local contrast. This step can be performed using the High Pass filter (as described in section 10.1 on page 264) or our DOP EasyD Plus DetailResolver script (as described on page 272). Figure 5-38 shows the finished, stitched image.

[5-38] The finished, cropped image with slightly increased microcontrast and sharpening for printing

Photo by Rainer Gulbins, processed using Nik Color Efex Pro as a Smart Filter

Smart Objects and
Smart Filters

6

It is often extremely handy if we can access and alter the original file for an edited image. In the case of Raw files, this means retracing our steps to the Raw conversion stage and applying changes there. All this and more is possible if the base file in question is opened – or handed over from Lightroom or Adobe Camera Raw – as a Smart Object.

Smart Objects can also be very useful if we need to copy a detail from an image to reinsert and rescale it somewhere else – for example, to enlarge the lips in a portrait. If we use a Smart Object to perform this task, the original image data is used in place of the previously edited detail.

One of the drawbacks of Photoshop filters is that after they are closed (applied), they cannot be reopened in their previous state, which means that we have to create a new pixel layer and start over if we want to alter a completed filter-based adjustment. In contrast, filter steps applied to Smart Objects can (in most cases) be reopened and edited.

This chapter shows you how to open files as Smart Objects, how to convert existing layers into Smart Objects, and how this wonderful technology works in general.

6.1 Smart Objects

Smart Objects were introduced with Photoshop CS3. A Smart Object is an object such as a pixel layer, a Raw file, an Illustrator graphic, or a PDF that Photoshop embeds in a file as a complete unit without (at first) making any changes to it.

Even if you apply a filter or other operation to a Smart Object, the object itself is not altered. Instead, Photoshop creates a new interim layer and applies the operation there, leaving the original material unchanged and ready to be used again. In the layer stack, Smart Objects have the same general appearance as conventional pixel layers, but they are labeled with an extra icon to remind you of their special nature.

If, for example, you import a Raw file as a Smart Object, it initially looks as if you opened a converted file that you can then edit in the normal way.

[6-1] In Lightroom, Smart Objects can be handed over to Photoshop using the command shown here or its equivalent in the context menu

Opening a File as a Smart Object
When editing Raw files in Lightroom, the context menu includes the Edit In ▸ Open as Smart Object in Photoshop command. In Adobe Camera Raw, press the ⇧ key and click the *Open Object* button to hand over a file to Photoshop as a Smart Object.

Earlier versions of Bridge include the File ▸ Open File as Smart Object command, which has been replaced by File ▸ Place ▸ In Photoshop since the release of Bridge CS5. This command is also included in the context menu. Photoshop includes the Open as Smart Object command in the File menu.

Any file type recognized by Photoshop (Raw, PSD, JPEG, TIFF, PDF, Illustrator files, etc.) can be opened as a Smart Object.

Any object opened as a Smart Object initially remains unchanged and is embedded – as a hidden object and as a visible layer – in the active Photoshop file.

[6-2] This layer is a Smart Object

In many cases, Smart Objects can be treated just like normal pixel layers, and you can use adjustment layers to alter the way they look. You can also copy, delete, and show or hide them. Other conventional layer-based operations are possible too, such as adding layer masks, switching blending modes, and even performing transformations. Image data can be copied from, but not directly to, a Smart Object.

Direct alterations using tools, such as the Brush, Eraser, or Dodge tools, cannot be applied to Smart Objects, and the same is true for the commands listed in the Image ▸ Adjustments menu. There are two ways to alter the content of a Smart Object:

1. Use the Layer ▸ Smart Objects ▸ Rasterize command to transform the Smart Object into a conventional pixel layer. The object is then no longer smart and behaves like a normal pixel layer within the layer stack. If no other copies of it are present in the stack, the embedded file is then deleted.

2. Double click the smart layer. Photoshop then opens the editing software appropriate to the type of object (Adobe Camera Raw for a Raw file, for example) and any corrections you have made will be embedded in your file along with the object. The same thing happens if Photoshop finds an associated XML settings file when it opens an external file. Photoshop itself acts as the editor for TIFF, JPEG, PSD, and conventional pixel layer file types, but editing takes place in a new, separate window. Adobe Illustrator is automatically activated for '.ai' files, and PDFs activate Acrobat. In all cases, the results of the editing operation replace the original Smart Object.

 You can even steal the entire layer stack (complete with all its corrections) from a Smart Object and replace it with a modified or new file – any layer-based corrections you have made will then be applied to the new object.

[6-3] Photoshop issues a warning if you attempt to apply a pixel-based operation to a Smart Object

[6-4] Use the **Save** command rather than **Save As** to save files that you have altered using a separate editor

This procedure is a perfect way to encapsulate an edited Raw file and save and share it as a Photoshop file. The price you have to pay for this convenience is a large file size, because the modified file includes the original Raw file plus a TIFF file with all its layers packed in a TIFF or PSD container. This principle only works for file formats that are layer compatible, but not for conventional formats such as JPEG and PNG.

If you open a Raw file as a Smart Object and double click its Smart Object icon in the Layers panel, the Raw file will be reopened in Adobe Camera Raw, complete with any changes you have made embedded in it. You can then continue to edit the file, and any changes you make will be automatically applied to the object in Photoshop when you close it by clicking the Adobe Camera Raw *OK* button. (The object doesn't have to be reconverted into a Smart Object in Photoshop.)

➡ Smart Objects embedded in image files are only recognized by Photoshop and Photoshop Elements. Other image processing software simply ignores them.

Smart Objects are equally well suited for use as complete layers or extracted details that you insert into an existing image. This approach is particularly suitable for cases in which you need to scale, rotate, or transform an inserted detail because you can return to your adjustments and fine-tune them later. Normally, if you re-edit a transformation that you have applied to a pixel layer, Photoshop retransforms the already transformed object, and the rounding errors produced by each transformation accumulate. If, however, you use a Smart Object to perform your edit, Photoshop edits only the embedded object.

→ Rounding errors and a corresponding loss of image data are particularly prevalent when you scale or distort an object

This functionality is often used to enlarge the subject's eyes in fashion shots and portraits. Here's how:

1. Make a rough selection surrounding the eyes using the Elliptical Marquee ⬭ or the Lasso ◉-tool, and give the selection a 5–10 pixel soft edge using the Select ▸ Modify ▸ Smooth* command (use a higher value if you are working on a high-resolution image). Copy your selection (⌃Ctrl/⌘-C) and re-insert it (⌃Ctrl/⌘-V).

* Using ⇧-F6 is quicker.

2. Before you proceed, select the copy and apply the Layer ▸ Smart Objects ▸ Convert to Smart Object command.

3. Now use the Transform tool (⌃Ctrl/⌘-T) to enlarge the eye. Stretching eyes slightly more vertically than horizontally opens them a little and adds to the effect. Be careful not to scale people's features too much – an enlargement of 5–10% is usually plenty.

 If you are not happy with the results, all you have to do is adjust the transformation. Any loss of detail is limited to those produced by the last transformation you performed, and is less noticeable in 16-bit files than in 8-bit files.

4. Symmetry and good proportions are important in beauty shots, so if both eyes in a portrait are the same size and similarly lit, you can even use a mirror image of the best eye. To do this, copy your favorite enlarged, transformed eye using the Layers ▸ Smart Objects ▸ New Smart Object via Copy command. This gives you two independent objects that you can edit separately (see section 6.2).

5. Insert the copied eye in roughly the right place and use the Edit ▸ Transform ▸ Flip Horizontal command to mirror it. You can then place the flipped copy precisely where you need it.

6. Use a layer mask to soften the transition between the copied eye and its surroundings. The layer masks are clearly visible in the layer stack shown in figure 6-6.

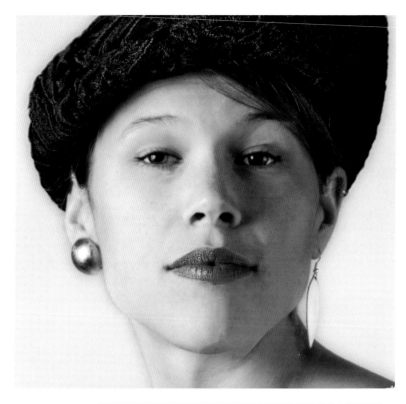

[6-5]
The original image

[6-6]
The eyes were selected separately using the Lasso tool (with a feathered edge), reinserted, converted to Smart Objects, enlarged, and opened slightly by stretching them vertically. The transitions were fine-tuned using a mask. The result is a more lively looking portrait.

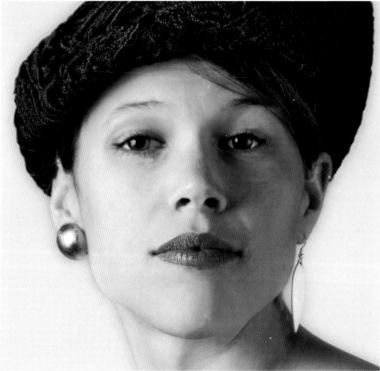

* In the example shown in figure 6-6, we also had to flip the reflection in the copied eye to match its twin.

7. If the eyes are not identically lit, you will have to selectively correct brightness in the appropriate places – for example, using the procedure described in section 4.4. This type of feature copy only makes sense if the original eyes don't look similar enough to make a balanced portrait, and you might have to flip any reflections, to make the result look authentic.*

6.2 Copying Smart Objects

Copying a Smart Object layer the conventional way (using Ctrl-J or by dragging the ⬛ icon at the bottom of the Layers panel) simply creates a new reference to the embedded object. If you then edit such an object (such as the copied eye in our example), all copies will be altered accordingly.

If you need a genuine second copy of an object, use the Layer ▸ Smart Objects ▸ New Smart Object via Copy command. This creates a second, independent copy that you can edit without affecting the original object.

[6-7] This command embeds a second copy of the same Smart Object in your file

6.3 Smart Filters

Our aim is always to work as non-destructively as possible – in Photoshop, this means using adjustment layers that we can fine-tune at any time during the editing process. However, this type of adjustment cannot be used with tools and filters that only work on pixel layers. Sharpening is a good example of an operation that we apply to virtually all our images, but it cannot be applied using an adjustment layer. Since the introduction of Smart Filter functionality with Photoshop CS3, you can work around this limitation as follows:

1. If the uppermost layer is an adjustment layer, begin by creating a temporary combined layer using the ⇧-Ctrl-Alt-E / ⇧-⌥-⌘-E shortcut (section 5.2, page 161). If the uppermost layer is a pixel layer, ignore this step.

2. Use the Convert to Smart Object command (in the ▾≣ menu in the Layers panel or in the Layer ▸ Smart Objects menu) to convert the new layer into a Smart Object (figure 6-8).

[6-8] Since CS3, the Layer menu includes the Convert to Smart Object command

3. Now apply your chosen filter to the new Smart Object. Not all filters can be used this way, but Unsharp Mask and Smart Sharpen can. The Layers panel will then look like the one shown in figure 6-9. Now you can apply more filters to your Smart Object, and you can add a layer mask – but only one per Smart Object.

This approach enables you to reactivate a filter and alter its settings without having to discard the settings you have already made and create a new layer to start a fresh edit. To reactivate a filter and its dialog, double click its entry in the Layers panel (in this case, the line named *Unsharp Mask)*.

Not all Photoshop and third-party filters are compatible with smart functionality (but with almost every new Photoshop version, Adobe makes more of its filters Smart compatible). However, there is a work-around for noncompatible plug-ins.

The installation media for Photoshop CS3 (and later versions) includes a script called *EnableAllPluginsForSmartFilters.jsx* that you can copy to the scripts folder *…/Adobe Photoshop CS6/Presets/Scripts* (replace "CS6" with your version number). The plug-in will then be available in the File ▸ Scripts menu, and you only have to execute it once for it to take effect. Not all filters are affected by the script, but it nevertheless makes a large range of filters and scripts Smart compatible. Note that this forced compatibility can cause software instability, so check to see if the filter you want to use is Smart compatible before you attempt to apply it to an important image.

Third-party software manufacturers are producing increasing numbers of filters and plug-ins that are Smart compatible from the ground up. For example, nearly all of the filters manufactured by Nik Software are now Smart compatible without applying *EnableAll*.

It is generally a good idea to convert all filtered layers into Smart Objects, even if it uses additional disk space. This approach not only gives you the opportunity to alter your filter settings later on, but it also enables you to check which settings you used.

Many specialized filters (Photoshop plug-ins) are much easier to use than their equivalent Photoshop functions and often save you from having to use multiple layers, masks, and modes. All in all, Smart Objects and Smart Filters represent a dramatic improvement in handling editing tools.

[6-9] In this example, the USM filter was applied as a Smart Filter. A mask was added to protect selected areas from sharpening.

6.4 Sharpening Using the High Pass Smart Filter

Sharpening digital images is an art in itself that we cannot really cover adequately within the scope of this book. Because it is often difficult to find just the right sharpening settings, creating a smart layer for use with a sharpening filter is a really useful option. Alongside the popular Unsharp Mask and Smart Sharpen filters,* the High Pass filter is a frequently used alternative. The following example demonstrates the principle on a photo taken in the Jewish cemetery in Obergrombach, Germany.

* They are located in the Filter ▸ Sharpen menu.

1. If the uppermost layer is a pixel layer, duplicate it using the Ctrl/⌘-J shortcut and give it a suitable name. Otherwise, use the Ctrl/⌘-Alt-⇧-E shortcut to create a new pixel layer from the underlying layers.

2. Use the Layer ▸ Smart Objects ▸ Convert to Smart Object command (or Convert to Smart Object from the context menu) to convert the new layer into a Smart Object. You can now apply Smart Filters to the new layer.

3. Switch the new layer's blending mode to *Soft Light* (or *Overlay* for a slightly harder effect).

4. The High Pass filter is located in the Filter ▸ Other menu. Its basic function is to look for high-contrast edges. *Radius* is the filter's only user-adjustable parameter (figure 6-9). It creates a gray layer on which high-contrast edges show up more clearly. This layer also amplifies the effect of the blending mode, which also strengthens the sharpening effect.

 The trick when using this filter is to find a Radius setting that works well with the resolution and degree of detail in the original image. Start with a value between 1 and 6 pixels and use 100% preview magnification to help track the effect your settings have. The ideal Radius value is one that just begins to accentuate detail outlines against the gray of the preview frame.

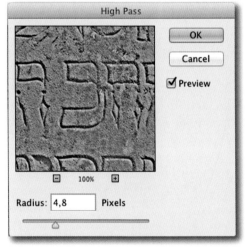

[6-10]
The High Pass filter looks for high-contrast edges

5. As usual, we recommend that you apply a strong filter setting and regulate its effect via the opacity of the Smart Object layer.

6. If the adjustment you have made is simply wrong, or if you want to re-sharpen your image for a different type of output, double click the High Pass filter entry in the Layers panel and adjust the Radius setting.

 It is worth experimenting with the various blending modes in group Ⓓ, as shown in figure 4-1 on page 128. *Overlay, Soft Light, Hard Light,* and *Linear Light* are all worth a shot. If you do switch blending modes, you should re-open the filter to select an appropriate Radius setting.

7. Mask any areas that you don't want to sharpen using a black layer mask, and mask areas that you wish to sharpen moderately using a gray mask. Such a mask can usually be created using fairly rough strokes with a soft black brush.

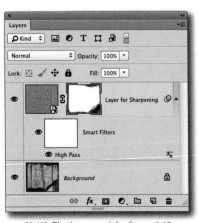

[6-11] The layer stack for figure 6-13

[6-12] The original image

[6-13] Our image following High Pass sharpening with a Radius setting of 5 pixels. The inscriptions are now much clearer.

The result of our adjustments are shown in figure 6-13 and the corresponding layer stack in figure 6-11.

6.5 Converting Smart Objects

Smart Objects take up a lot of disk space, so you might occasionally need to convert a Smart Object into a normal pixel layer after you are sure that you no longer need its special capabilities. To do this, apply the Layer ▸ Rasterize ▸ Smart Objects command. (This function is also available as the Rasterize Layer command in the Smart Object layer's context menu.)

If an image contains multiple copies of a Smart Object, you have to convert them individually.

If you want to copy a detail from a Smart Object layer, use the selection tool of your choice and the Ctrl/⌘-C shortcut to copy and the Ctrl/⌘-V shortcut to paste your selection into its own layer. You cannot, however, paste such a selection directly into a Smart Object. If you copy from a simple pixel-based Smart Object, the contents of the clipboard can, however, be pasted into a Smart Object layer in the Smart Object editor window.

You can even copy nonpixel data from a Smart Object, although the copied data is automatically converted into pixel form and no longer possesses smart functionality.

Another way to convert a Smart Object is to export its contents using the Layer ▸ Smart Objects ▸ Export Contents command. This copies the embedded object into a separate, external file while the active image remains unchanged.

6.6 Replacing Smart Objects

Smart Objects are easy to replace. The easiest way is to double click the object in question and alter its content in the separate editor window that opens – for example, via copy and paste. You can, however, swap out an object for a completely new image.

* This command is also available in the Smart Object layer's context menu.

To perform a swap, activate a Smart Object and use the Layer▸ Smart Objects ▸ Replace Contents command,* navigate to the new content in the browser window that results, and click *Place*. If the new content isn't the same size as the old content, Photoshop doesn't automatically resize it, so you have to do this yourself. If the new content isn't a simple pixel-based file, Photoshop automatically opens the appropriate editor (Adobe Camera Raw for Raw files, for example).

And what is the point of all this? If, for example, you want to apply the corrections you have made to a similar image from the same shoot, all you have to do is duplicate the edited image and swap the smart base image for the new one (making sure, of course, that you give the resulting image a new name). The following section details another useful application for this function.

6.7 Using Smart Objects to Create Multiple Borders

This example inserts multiple borders into a single image and fills them with images taken from separate files. The images themselves are converted to Smart Objects to make it easier to rotate, scale, and crop them without sacrificing too much quality. The combined images and borders can be saved as a kind of preset, enabling us to replace the images with others later on.

[6-14] Start with a photographed or scanned border, or one created using Illustrator or Photoshop

1. Our starting point is the photo of a mount, shown in figure 6-14, with the center deleted and filled with transparent pixels. Any border will do; we could have used a scan of a vintage photo with the content cropped out.

2. Convert the border into a Smart Object and copy it twice using the Ctrl/⌘-J shortcut.

3. Create a new white background layer (⇧-Ctrl/⌘-N) and enlarge it using the Image ▸ Canvas Size command to give yourself plenty of space for all three images and borders.

4. Position (Ctrl/⌘-T), rotate, and, if necessary, scale the borders, leaving room on the canvas for any Layer Styles that you apply later. Figure 6-15 shows the interim result.

5. Now import the image content using the File ▸ Place command. This command automatically converts the selected files into Smart Objects. Position the images below the borders by inserting them beneath the appropriate layers in the Layers panel. Rotate and scale them as necessary. Don't be concerned if they are larger than the borders because you can crop any excess later.

6. Give the borders a 1-pixel dark gray outline and a drop shadow using the Layer Style settings shown in figure 6-16. You can, of course, use other values, depending on the size and resolution of the images you use and your own personal taste.

 After you have defined the style for one border, you can save it under an appropriate name and apply it to the other two border images.*

[6-15] The borders in their new positions

* Layer Styles are covered in chapter 7.

[6-16]

Detail of the *Drop Shadow* section of the Layer Style dialog. The Opacity, Angle, Distance, and Spread settings you choose will depend on the size and resolution of each image

7. Select each image/border pair and link them by clicking the icon at the bottom of the Layers panel. This enables you to move, rotate, and transform them as units. Linked layers are indicated by the link icon in the upper of the two linked layers (not to be confused with the same icon that appears when an image is linked to a layer mask).

 In our final montage (figure 6-18) we placed three images of different types of roses beneath our previously copied and positioned borders. The corresponding Layers panel is shown in figure 6-17.

8. Save the file for use as a template.

9. If you want to replace one of the images, first select its border and click the link icon to unlink it (or use the Unlink Layers command in the border layer's context menu). In CS6 (and later), the link icon only becomes visible when its layer is activated.

 You can now select the image you want to replace and use the Layer ▸ Smart Object ▸ Replace Contents command to select the content you wish to import.

Freshly imported content automatically becomes a Smart Object and is automatically rotated and scaled to fit the existing file. If you do need to adjust the size of an image to fit the border, use the Transform tool (Ctrl/⌘-T).

10. Because they are embedded Smart Objects, the images can be edited individually to fit the overall composition. The original image that was imported into the composite image using the Place command remains unchanged.

For the sake of completeness, we could have adjusted the direction of the drop shadows for each image separately to give the impression of a light source coming from a single direction. We didn't bother to make this change in the version shown in figure 6-18, but we would have if we had rotated the images any further.

Compositions like this are rarely created for output as an individual print, but these design and editing options are great for creating individual pages for photo books.

[6-17] The Layers panel shows that the images and their borders are Smart Objects

[6-18] The finished composition. We added a border and a drop shadow to the canvas to emphasize it in print.

6.8 Merging Multiple Versions of a Raw Image

Many images (landscapes in particular) end up with too much contrast, which produces underexposed and overexposed areas within the frame. Figure 6-19 shows an image with swamped shadows, shot in the early afternoon under the merciless Arizona sun.

If you capture images using a Raw format, you can often rescue shadow detail or burned-out highlights, but rarely both at once. There are two ways to work around this particular challenge:

1. Start by opening the Raw source image as a Smart Object and create a copy using the Layer ▸ Smart Objects ▸ New Smart Object via Copy command (don't use the Ctrl/⌘-J shortcut). This way, you end up with two independent images.

2. Double click the upper copy to open it in Adobe Camera Raw and develop it so the highlights are no longer burned out. To do this, reduce the *Exposure* setting and, if necessary, reduce the *Fill Light* setting too. Figure 6-20 shows the result of these changes.

3. Repeat step 2 using the lower layer, this time using settings that reveal the details in the shadows – for example, by increasing *Exposure* and adjusting the *Shadows* and *Fill Light* sliders accordingly. Figure 6-21 shows the result.

There are now two ways to combine the properly exposed details from the two versions:

A. Mask all areas in the upper image that are too dark. Such masks can become quite complex and can be fine-tuned by masking in gray. In our example, the bright sky in the original image enabled us to use a simple gradient.

B. Apply Blending Options to the upper layer, as described in section 5.4.

These two approaches can be combined. Here, we use method B and combine it with a mask:

[6-19] The highlights are fairly bright but the shadows lack detail

[6-20] The version developed to show detail in the sky and highlights

[6-21] The version developed to bring out shadow detail

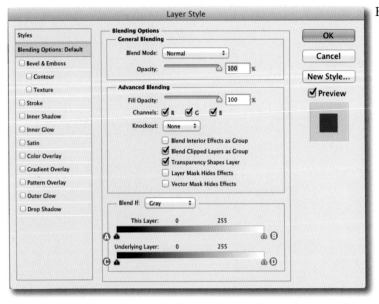

B1. Activate the upper layer (the one exposed for the highlight details) and open the Blending Options dialog, either via the context menu or using the Layer ▸ Layer Style ▸ Blending Options command. The following steps require use of the *Blend If* sliders (figure 6-22).

These enable you to determine the range of tones from each of the two layers that will be visible in the finished image. Because we want to hide the highlights in the upper layer, we shift slider Ⓑ to the left. This reveals the darker tones in the lower layer, which we have already adjusted specifically to show shadow detail. You will need to experiment to find the right mixture of settings. The interim result shown in figure 6-23 still shows some weaknesses.

[6-22] The Blend If sliders allow you to determine which tonal values from each of the two layers are used in the final image

[6-23]
The result of blending with the
B1 slider set to 102

B2. To avoid producing obvious transitions between tonal areas, press the Alt key and slide the right side slider Ⓑ to the right (or the left side to the left). The tonal range between points Ⓑ₁ and Ⓑ₂ (figure 6-25) represents the new transition area. The other sliders in the dialog can be split and individually adjusted the same way.

The 🔲 icon in the layer stack (figure 6-27) indicates that a Layer Style has been applied to the layer in question.

The *Gray* option is set as the default in the Blend If menu. You can also select blending ranges for individual color channels, although this is an option that is rarely useful in a photographic context.

[6-24] In addition to gray, the primary color channels can be individually blended, too

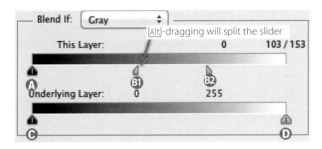

[6-25]

The *Blend If* sliders enable you to determine which tonal values from each of the two layers are used in the final image.

You can, of course, play the same game with more than two layers. For example, slider Ⓑ can be used to determine which of the midtones in the upper layer are actually visible in the final image.

Figure 6-26 shows the result of applying the *Blend If* settings shown in figure 6-22. The bushes in the foreground and the cliffs in the background still look a little colorless and lack contrast.

B3. Here, we use a simple layer mask applied to the upper layer to give the image a final polish.

Figure 6-28 shows the final result, and figure 6-27 shows the layer mask we used to achieve it. Shadow areas like the ones in this image often benefit from an increase in local contrast. See page 272 for a description of one way to do this.

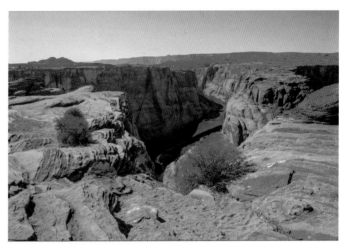

[6-26] The blended image with additional soft transitions

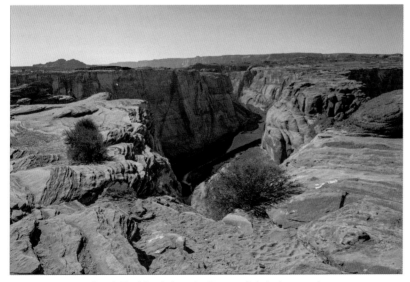

[6-28] The blended, masked image, slightly sharpened

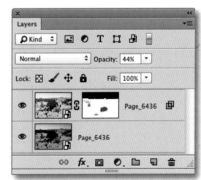

[6-27] The layer stack for figure 6-28. The 📄 icon indicates that a Layer Style (in this case, *Blend If*) has been applied to the layer.

Working with Smart Objects takes some getting used to – especially because they have to be edited in a separate window or application. However, after you have familiarized yourself with the technique, you will find there are many ways in which they enhance the Photoshop experience.

[6-29] You can apply several filters to Smart Object, but only one single layer mask

[6-30] In Photoshop CC, the Camera Raw Filter can be used as a Smart Filter, offering all the adjustments available in Adobe Camera Raw 8

6.9 General Information on Smart Objects and Smart Filters

Smart Objects and Smart Filters are a fantastic invention, but they remain largely unused by many Photoshop users. The invisible extra layer that they use takes up about twice as much disk space as a regular pixel layer, but offers a lot of benefits.

Some users always open their Lightroom or ACR-based Raw images as Smart Objects, enabling them not only to embed the file and its settings in a new Photoshop file, but also to open ACR directly from the Photoshop interface. The encapsulated Photoshop file that results from opening a file as a Smart Object is usually about two-and-a-half times larger than the original TIFF file, which can result in extremely large files, especially if the original file is large to start with.

If you no longer need the Raw capability in an object, you can rasterize it using the Layer ▸ Smart Objects ▸ Rasterize Layer command, thereby saving the extra disk space that smart functionality uses.

If you scale a file that contains Smart Objects, the Smart Objects themselves remain unchanged, and only the (invisible) virtual pixel layers are altered.

Multiple Smart Filters can be applied to a Smart Object and appear sequentially in the Layers panel (figure 6-29). These can be individually shown or hidden, deleted (context menu ▸ Clear Smart Filters), or temporarily deactivated (context menu ▸ Disable Smart Filters). The order in which the filters are displayed can be altered by dragging them, and it can take a second or two for Photoshop to update the preview when you do. In spite of containing multiple filters, such layers can only be adjusted using a single layer mask, a single blending mode, a single opacity setting, and a single fill setting, although there are rumors that this situation will change in future versions of the program.

Not all Photoshop filters are smart compatible (at least not in Photoshop CS6), and tools such as Field Blur, Iris Blur, Tilt/Shift, and all Distort filters have to be applied directly to a pixel layer (this shortcoming has been rectified in Photoshop CC for the filters previously mentioned). If you need to apply such a filter to a layer that has already been heavily edited (or to the background layer) always copy the layer first and apply the filter to the copy. This way, you still have access to the original image data in an emergency.

Recording the main parameters of an adjustment in its layer name is a great way to give yourself reference values for future adjustments. After you have achieved your desired results, you can hide or delete any safety layers.

The Camera Raw Filter was introduced with Photoshop CC. To produce natural-looking results for HDR images, first create a merged 32-bit HDR image (as described in section 5.5, steps 1 to 4). Now convert your 32-bit layer into a Smart Object, open the filter, and optimize your image as usual using the Adobe Camera Raw tools and controls. In most cases, this approach produces much better results than tone mapping, and it means you don't have

to save your image and reopen it in Adobe Camera Raw. As previously mentioned, Adobe Camera Raw 7.1 (and later) can handle 32-bit image data.

This way, the main image and any additional adjustment layers that you may want to fine-tune later are contained in a single file.

After you have tuned the tones (in effect, a kind of tone mapping) in Adobe Camera Raw, you can convert your image to 16-bit mode (in Photoshop or by exporting a 16-bit file from Adobe Camera Raw).

When your corrections are done, you can add a layer mask and reduce the strength of the layer's effect by reducing the opacity of the mask. You can also apply the Blend If adjustment described in sections 5.4 and 6.8, or use the various blending modes explained in section 4.1.

As previously mentioned, we recommend that you convert your pixel layer into a Smart Object and then apply Adobe Camera Raw as a Smart Filter.

The Camera Raw Filter has other benefits too, whether you apply it to a regular pixel layer or a Smart Object layer. For example, if you haven't already straightened the horizon or corrected perspective using your Raw converter, you can use the Upright function included in the filter's Lens Corrections tab to automatically perform these adjustments.

We used this functionality in the example shown in figure 6-32, and figure 6-33 shows the result. We used the *Full* (⊞) option to correct the perspective. Then we selected some of these areas using the 🪄 tool, and used content-aware filling to fill some of the resulting transparent pixel areas. Finally, we did some cropping.

[6-31] The Upright adjustment in Adobe Camera Raw 8.1

[6-32] The original image with its converging lines

[6-33] The same image, with perspective corrected using the *Full Upright* option in the **Camera Raw Filter**'s Lens Corrections tab

Smart Objects produce larger files, but they are nevertheless a powerful correction tool that you should definitely try out and use whenever possible.

But keep in mind that any correction you can do in your Raw converter (section 9.1) – prior to passing the image on to Photoshop – can save you the overhead of a Smart Filter in Photoshop.

Layer Styles

7

The main aim of this book is to help photographers find the best ways to optimize their images, but we nevertheless want to take a quick look at Layer Styles too. Layer Styles are generally more popular among graphic artists and designers than photographers, but they can be useful when you need to insert text or graphic elements, such as borders or text, into an image. Styles can also be used to fill text with a background image or create watermarks.

7.1 Creating Borders, Drop Shadows, and Bevels

A decorative border can help give an image a professional look, especially if it is part of a complex layout. This example uses the image shown in figure 7-1 to demonstrate how to create a border.

[7-1] The image that we are going to frame

1. If you don't want to sacrifice any image data, begin by using the Image ▸ Canvas Size command to extend the canvas.

 Because the background in our image is already very bright, the first step is to give it a 4-pixel dark gray border using the settings shown in figure 7-2. Figure 7-3 shows the result.

[7-2]
Creating a 4-pixel gray border
around the canvas

Double clicking the square icon next to the Canvas extension color drop-down menu activates the color picker, which you can use to select an appropriate color.

[7-3]
The image with a dark gray border

2. Now extend the canvas again to provide space for the drop shadow. To do this, select the lower layer and enter appropriate values. We used 0.2 inches on each edge (see figure 7-4) and used white as the fill color.

3. Select the layer you want to apply the Layer Style to and select either *Drop Shadow* from the *fx.* menu at the bottom of the Layers panel or select *Blending Options* from the ▪▪ menu at the top-right corner of the panel.

4. The Layer Style dialog (figure 7-6) contains a broad range of presets in the Styles menu Ⓐ and an even broader range of custom settings in the Blending options list Ⓑ. The same options are also listed in the *fx.* menu shown in figure 7-5.

 The settings for each style type are grayed out until you check the box next to its entry in list Ⓑ.

 The list offers various types of shadow. The options for the *Drop Shadow* type are divided into two sections called *Structure* and *Quality*.

[7-4] These settings add a 0.2-inch border to the canvas.

[7-5] Layer Styles can be selected via the *fx* drop-down menu.

[7-6]
The Drop Shadow settings in the Layer Style dialog. The preview gives a good impression of the effect the settings will have.

Most of the presets produce perfectly good results, so you will usually only have to fine-tune the results. The default blend mode (Multiply) and color (black) are well suited to our purposes, as is the preset opacity setting of 75%. Reducing the opacity makes the shadow effect more subtle.

The *Quality* settings rarely need to be changed from their defaults. If you are using a large shadow area, adding noise often makes the shadow appear more realistic (3–5% is usually sufficient). Changes to the Contour setting are very rarely necessary.

➡ Layer Styles cannot be applied to the background layer unless it is unlocked.

The settings in section © are self-explanatory. *Angle* determines the angle from which the artificial light source illuminates the image, and thus the angle of the drop shadow. For example, a setting of 135 degrees produces a shadow at the bottom right, 45 degrees at bottom left. *Distance* determines the distance of the light source from the center of the image. The greater the value, the longer the shadow. A value of 0 produces light from directly overhead. *Size* (together with *Distance*) determines the width of the shadow.

If you are working on a high-resolution image, work slowly to give Photoshop time to update the *Preview* window.

➡ Most Layer Styles require a bright background to make them visible. If necessary, such a background can be produced by extending the canvas and filling it with an appropriate color (figure 7-2).

[7-7]
Our image with its gray border and drop shadow cast on the extended canvas. Figure 7-9 shows the corresponding layer stack. The outer black border was added later to emphasize the edge of the image in print.

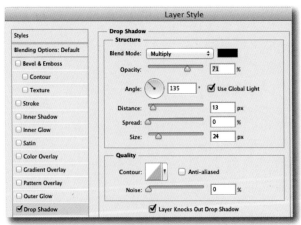

[7-8]
The Drop Shadow settings we used to produce figure 7-7.

5. Click *OK* to close the dialog. The *fx* icon in the layer's panel entry indicates that a Layer Style has been applied. The effect that was used is then listed beneath the layer thumbnail (figure 7-9).

Like adjustment layers, Layer Styles are not applied to the pixel layer of an image. To make changes to your Layer Style settings, double click the effect's name in the Layers panel to reopen the dialog.

Like layers, Layer Styles can be shown and hidden by clicking the 👁 icon (located next to the word *Effects*). Multiple effects are listed sequentially and can be individually activated and deactivated. Clicking the ▲ icon next to the *fx* icon shows and hides the Effects list.

If you flatten a Layer Style, its effect is applied directly to the image data and can no longer be adjusted. The Layer ▸ Rasterize ▸ Layer Style command (introduced with Photoshop CS6) has the same effect.

Layer Styles can be copied and applied to other images via the context menu. (Activate the layer and select Copy Layer Style from the context menu.)

A border like our thin gray one can also be added using the *Contour* setting, although this method superimposes the border on the image without increasing the canvas size, thus stealing pixels from the original image.

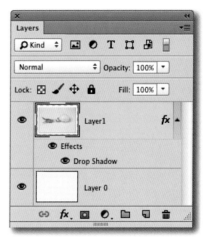

[7-9] Applied Layer Styles are indicated by the *fx* icon, and the effect name is listed in the layer's panel entry

Applying Effects to Irregular Shapes

If the layer to which a shadow is applied has an irregular shape, the shadow automatically follows the shape's edges, as demonstrated by the masked rose in figure 7-10.

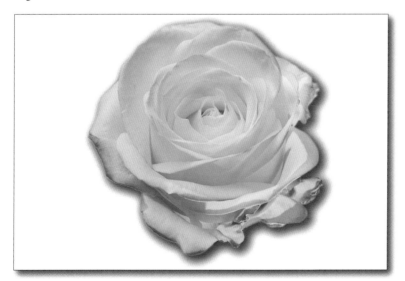

[7-10]

Layer Style effects automatically snap to the edges of a selection

We made this selection using the Quick Selection tool (🖌) and inverted it using the ⇧-Ctrl-I shortcut. We then added a 0.5-pixel feathered edge and increased the radius by 1.5 pixels using the Select ▸ Refine Edge dialog. We saved the result as a mask (rather than deleting the rest of the image) to enable us to fine-tune the selection later.

Drop shadows applied to irregular shapes only look good if the selection itself is well rounded and accurately selected.

7.2 Adding Bevels and Emboss Effects to Text

Bevel and emboss are graphic effects that photographers might need when producing photo books or greeting cards in which conventional text disappear into background details. If you use colored text with bevel or emboss effects, it will stand out much better. The following steps explain how:

1. Press the ⊤ key to activate the Text tool **T** and enter your text. Text is created on its own layer and should remain unrasterized while you edit, format, transform, and scale it. And because we are using layers, we keep text layers as long as possible.

2. In spite of its bright pink color, the text in figure 7-11 is difficult to read and lacks punch. To give it an extra edge, first select the text layer and once again select *Blending Options* from the **fx.** menu at the bottom of the Layers panel (or from the layer's own context menu).

3. Check the *Bevel & Emboss* entry in the options list to activate its settings (figure 7-13). As with other Layer Styles, the default settings usually produce great results. In addition to the standard effect, we will now give our font a more rounded look. But tuning the Styles settings a bit is always worth a try.

4. We won't go into detail on all of the available settings, and you will probably need only one or two of them.

 Start by selecting the *Inner Bevel* option in the Style menu (see figure 7-14) or experiment with the other options to see the effects they produce.

 Smooth is the default setting in the Technique menu and suits our image well. *Chisel Hard* would have worked too.

5. The roundness of the resulting text is controlled by the *Size* slider, and the correct value depends on the resolution of your image, the size of the font you are using, and the strength of the effect you wish to achieve. A *Size* setting of 7 works well in our example.

[7-11] In spite of its bright color, the text is not sufficiently obvious

[7-12] A *Size* setting of 7 gives the text a nice rounded look.

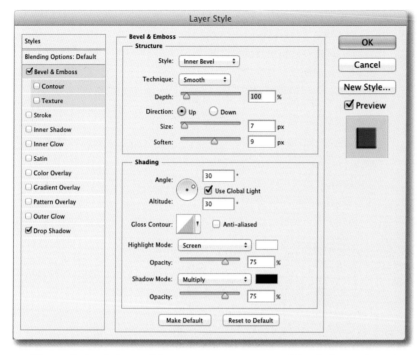

[7-13]
Selecting the *Inner Bevel* option

Play with the *Soften* and *Direction* settings to see if they help produce the effect you are looking for.

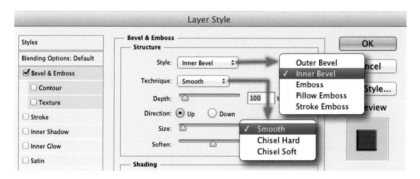

[7-14] The settings we used to produce our rounded 3-D text.

6. The *Shading* settings determine the angle of incidence and distance of the virtual light source that illuminates the text. The *Highlight Mode* is a kind of blending mode, and *Shadow Mode* enables you to choose a new color for the shadow. Once again, the default settings work fine for our example.

7. Activating *Bevel & Emboss* and using *Chisel Hard* for *Technique*, an almost cuneiform look is achieved for the text. The option you choose in the Contour menu (figure 7-16) determines the shape of the shadow the tool produces; again, the default setting is generally pretty good.

[7-15] Here, the *Bevel & Emboss* option has been activated, and *Chisel Hard* was used in the *Technique* menu

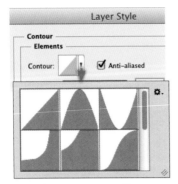

[7-16] The *Contour* menu offers various lighting gradient shapes

The *Range* slider enables you to define smoother transitions, and the *Anti-aliased* option enhances this smoothness. We recommend that you always use this option, even if it requires extra processing power.

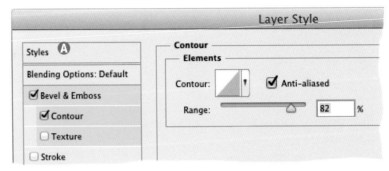

[7-17] Activating the Contour option gave our text an almost cuneiform look (figure 7-15).

8. After you have made all your settings, you can make them the default setting by clicking the *Make Default* button (figure 7-13).

 Alternatively, you can save your settings as a preset by clicking the *New Style* button (figure 7-13) and giving them an appropriate name. Your new style will then appear as the last entry in the *Styles* list in the Layer Style Dialog (Ⓐ in figure 7-17). Hover over a Style with the mouse to reveal its name (figure 7-18).

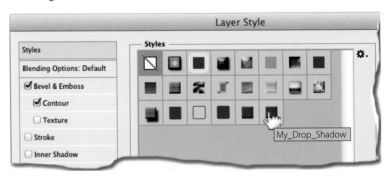

[7-18]
Hovering over a Layer Style preset reveals its name as a popup tool tip

9. When you are done, click OK to close the dialog.

Our finished image is shown in figure 7-19. In addition to the *Bevel & Shadow* effect, we also gave our text a drop shadow, as you can see in the layer stack shown next to the image. We used a *Distance* setting of 4 pixels to keep the effect subtle. We also increased the subject's local contrast on the background layer, and we used a mask to ensure that the adjustment didn't affect the background.

These types of effects can be applied to pixel layers too, although this rarely makes sense in a photographic context.

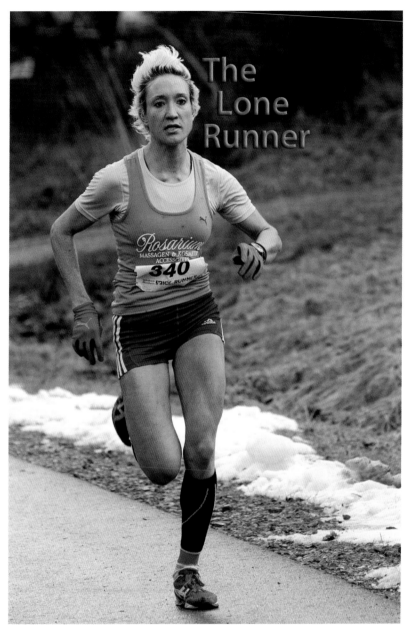

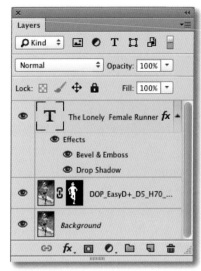

[7-19]

The result of applying our Layer Style settings to the text. The corresponding layer stack is shown above. We used a mask to increase local contrast on the image layer, thus giving the runner a more striking look.

As long as you don't flatten or merge the layer the effect is applied to, you can adjust the Layer Style parameters at any time by double clicking the *fx* icon or the name of the effect in the layer's panel entry.

Layer Style effects are great for creating buttons and other web graphics, but that is not what this book is about.

7.3 Filling Text with Image Data

[7-20] The original image

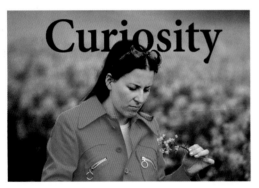

[7-21] The text that we are going to fill

[7-22] The linked clipping mask and
background copy

Although it isn't directly connected to photo editing, we want to introduce you to another interesting text effect. It involves filling text with image data, to create a kind of hole-punch effect. This effect is useful only when it's applied to very large typefaces. If it is applied to fonts that are too small, it looks like the text is full of random image artifacts. This is a good effect for greeting cards and photo book titles, but the content of the text needs to contrast with the main image to be truly effective.

Our example is based on the photo in figure 7-20:

1. Start by duplicating the background layer using the Ctrl-J shortcut. This example uses part of the original image for the text fill.

2. Add text to the image. We used 60-point Adobe Myriad Pro Semibold, initially colored black.

3. Use the Free Transform tool (activated via Ctrl-T) to position and scale the text to fit the frame and the subject. Dragging a corner handle with the ⇧ key pressed retains the original aspect ratio during a transformation. Figure 7-21 shows the interim result. The fact that the text is indistinguishable from the subject's hair is an issue that we will tackle later.

4. We used the lower half of the original image for our text fill. The first step in the fill process is to drag the background copy to the top of the layer stack and position its content using the Move tool ▸⊕. In our example, we moved the content upward and slightly to the right.

5. Now select Clipping Mask from the context menu (or use the Layer ▸ Create Clipping Mask command). This creates a clipping mask that shows only the parts of the upper layer that overlap the text layer beneath.

 Figure 7-22 shows the layer stack with the clipping mask, and figure 7-23 shows the effect this has on our image. The fill layer thumbnail has shifted to the right in the panel entry, and the ⬐ icon indicates that the layer is a clipping mask linked to the layer beneath.

6. If necessary, reposition the content of the fill layer using the Move tool ▶⊹. We enlarged the fill layer a little to completely fill the left half of the text with the red of the subject's jacket while preserving the yellow of the rapeseed flower on the right.

7. The final touches involved adding a 2-pixel black *Contour* and a 3-pixel, 135-degree *Inner Shadow* with a Distance setting of 2 pixels to our text layer. An additional *Drop Shadow* with a Distance setting of 10 and the Size set to 27 pixels helps to accentuate the text against the main image.

 Figure 7-25 shows the finished image, and figure 7-24 shows the layer stack.

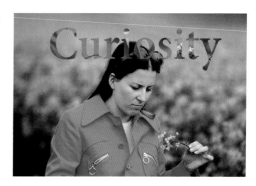

[7-23] Our image with the clipping mask activated

The use of these effects are, of course, highly dependent on the nature of the image, the fill content, the degree to which the fill contrasts with the main image and, most importantly, your own personal taste. Using a black or white contour is usually the simplest way to accentuate any kind of text in an image.

You have to adapt the style settings – especially those for the pixel borders – to your image content and resolution; when you apply them to text, you also need to consider the font size.

[7-24] The layer stack for the finished image

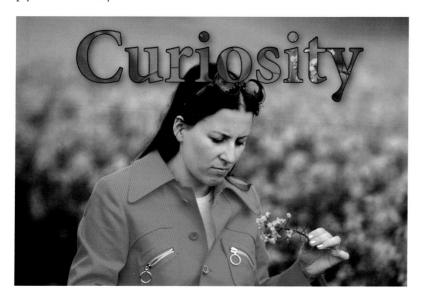

[7-25]
The finished image with its filled text

[7-26] The original image

[7-27] Plain text is too dominant

[7-28] Partial transparency helps to make the
text look more like a watermark

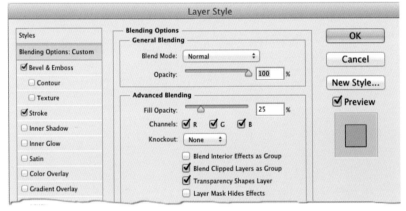

[7-30] The text is now transparent, but is
only visible against the dark background if
we give it a white outline

7.4 Using Layer Styles to Create Watermarks

Watermarks are an increasingly important way to avoid copyright abuse in published images. Layer Styles are ideal for creating watermarks, whether you use text, graphics, or both. You can combine stylistic elements to ensure that a watermark is sufficiently visible and use the opacity of the separate watermark layer to control its intensity.

This example adds a combined text and graphic watermark to the original image shown in figure 7-26. The font you use in a watermark needs to be large enough and bold enough to remain effective when it is partially transparent. Whether you select one with or without serifs is up to you.

For our 1500 × 1000-pixel sample image, we used 30-point Optima Bold font. However, the font size you use will depend on the size and resolution of your image. You can generate the copyright symbol (©) by typing Alt - G . The plain white text shown in figure 7-27 is not subtle enough to work as a watermark.

Simply reducing the *Opacity* to 45% produces the result shown in figure 7-28. The text is partially transparent and the background shows through.

You can use the *Contour* effect to take things a step further and give the text an outline while increasing its transparency using the *Fill Opacity* setting in the *Advanced Blending* section of the Layer Style dialog (figure 7-29).

[7-29] Adjust the text opacity using the Fill Opacity slider in the Advanced Blending section of the Layer Style dialog.

An appropriate contour size (in our case, 1 pixel) produces a usable result (figure 7-30). The problem here is that a white contour can still disappear where it intersects bright detail in the main image. In this case, use a black or colored contour.

To produce the final result shown in figure 7-33, we used the additional settings shown in figure 7-31. We used a black contour and an Opacity set-

ting of 25% (figure 7-29). Additionally, we added a scanned ginkgo leaf on a separate layer and applied the same settings (figure 7-33).

Finally, we saved our settings as a new style for use with other images.

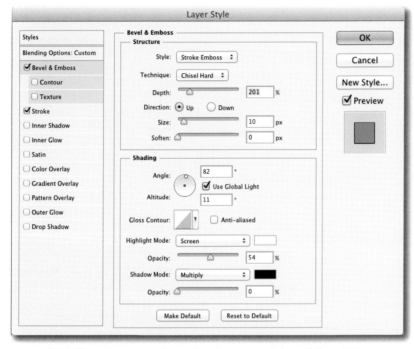

[7-31] The settings we used to produce the watermark shown in figure 7-33.

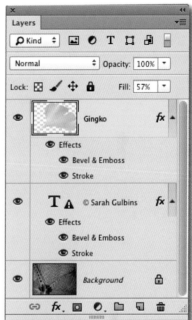

[7-32] The layer stack for figure 7-33 showing the combined text and graphics watermark. The intensity of the graphic element was adjusted by reducing *Fill* to 52%

[7-33]

The finished image. The watermark is clearly readable but doesn't dominate the image. The scanned ginkgo leaf was treated using the same effects as the text.

7.5 Copying Layer Style Effects to a Separate Layer

[7-34] The original image

Layer Style effects can be copied to a new layer for separate editing. Doing so destroys the direct link to the original layer, and the effect itself becomes a rasterized pixel layer.

Our example shows how to use this technique to distort the perspective in a drop shadow added to an object as a Layer Style. Begin by selecting the object to ensure that the shadow has the right shape.

1. Prepare your object by selecting it with the Quick Selection tool and refine your selection as necessary using the Refine Edge dialog. Now copy the object into a new layer (Ctrl/⌘-J) and hide the background layer (figure 7-35).

[7-35] The selected object

2. Create a drop shadow with a high Opacity setting, and use a large Distance setting to make it easier to see the effect of your changes. Figure 7-36 shows the result of performing this step.

3. Now use the Layer ▸ Layer Style ▸ Create Layer command. This separates the effect from its original layer, rasterizes it, and inserts it into a new layer while deleting the effect from the original layer. Depending on the effect you are using, Photoshop may issue a warning that not all aspects of the effect can be accurately reproduced on a new layer.

[7-37]
Photoshop warns you
that some Layer Style
effects cannot be
accurately rasterized

[7-36] The object with a drop shadow

The *Opacity* setting used for the shadow effect is represented by the *Fill* setting in the new layer. If the original shadow is black, the new one will be black too.

4. The shadow can now be edited independently. In our example, we transformed it (Ctrl/⌘-T) to produce a more realistic-looking perspective effect. Individual anchor points can be selected and

[7-38]
Following step 3, the shadow
resides on its own layer beneath
the subject layer

dragged by keeping the Ctrl/⌘ key pressed during the operation. Anchor points can even be positioned outside the canvas, but this makes them more difficult to manipulate later.

The result of the steps so far is shown in figure 7-39. When you manipulate shadows, it is important to ensure that the results match the direction of the light source in the original image. Our example is only partially accurate in this respect.

5. To give a shadow an even more realistic look, you can add a gradient that gets lighter toward the tip of the shadow. To do this, select the shadow on its own layer using the Magic Wand tool ✎ and drag a black-to-white gradient parallel to the direction of the shadow (i.e., away from the light source). Alternatively, you can create a gradient on a separate layer and limit its effect to the shadow area of the layer below using the Layer ▸ Create Clipping Mask command. The result of this step is shown in figure 7-40.

6. As a final touch, consider making the shadow blur toward its tip, perhaps using a graduated Gaussian Blur effect.

[7-39] The transformed shadow showing the anchor points we used

This technique may seem highly specialized, but it is often useful if you want to insert an element and its shadow into a photomontage in which the other details make it too difficult to isolate the shadow after insertion. A shadow created on its own layer can even be broken down into multiple elements that can be manipulated separately – for example, to enable a shadow to climb up a wall or fall on multiple complex objects.

[7-40] The transformed shadow with a gradient added

7.6 **General Thoughts on Layer Styles**

Layer Styles are versatile and use very little extra disk space (as long as you don't rasterize them). Photoshop offers a broad range of Layer Style presets, and it is simple to create and save your own styles for use later. If you take the time to experiment with the various effects and settings,you will be surprised at just how useful they can be!

Although they are not directly related to photo optimizing techniques, Layer Styles are often useful when an image requires tweaking that goes beyond purely photographic techniques.

Organizing Layers

8

Some images generate a large number of layers during editing, and 20 or more layers are not uncommon when you edit beauty shots. The tools available for organizing layers will help you retain a clear overview of your work and can also save disk space.

Layer handling has been greatly improved in Photoshop CS6. This chapter describes the changes involved and tells you when and how to use them effectively.

The Buddhist palace Punakha Dzong in Bhutan (Photo: Sandra Petrowitz)

8.1 Organizing Layers

After you have tried working with layers, you won't want to do without them. However, the problem with layers is that you can quickly end up using a great number of them to perform all the necessary adjustments – especially when it comes to retouching beauty shots. Large numbers of layers present three major challenges:

1. It is difficult to retain a clear overview.

2. Files become very large, requiring a lot of main memory during process-ing and a lot of disk space at the saving stage. It also takes longer to open and save large files.

3. If the main memory is full, Photoshop can slow down significantly or even hang.*

* This depends, of course, on how much memory your system has.

To retain a clear overview of your layers, you should:

- Use meaningful layer names

- Use appropriate Layers Panel Options (figure 8-2)

- Link and group layers, which can be shown or hidden as a unit

- Color code layers to group them visually or indicate their functions or status

- Use the layer filtering options introduced with Photoshop CS6 to show specific layer types and hide others

- Merge layers where possible and delete unwanted layer masks

8.2 Naming Layers

If you don't give a new layer a custom name when you create it, Photoshop will automatically name it according to its type or copy number.

If you are working with a small number of layers, generic names such as *Background Copy 1* or *Curves 3* are often sufficient and save you the trouble of thinking up and typing custom layer names. On the other hand, when the number of layers in an image begins to increase, it is advisable to use layer names to record their function – for example, Brighten or Increase Contrast. There are two basic ways to name layers:

1. Enter a name in the New Layer dialog when you create a layer. The dialog (figure 8-1) includes a color coding option. Color codes are a visual aid that have no effect on a layer.

[8-1]
Photoshop automatically gives new layers
a generic name that you can change in the
New Layer dialog

2. Change the layer name later by clicking first on the layer and then double clicking the layer name.

Alternatively (for Photoshop versions up to CS5), you can use the Layer Options command in the layer context menu. As of CS6, you can make changes directly in the Properties panel.

We generally use method 2 to give layers a meaningful name once we have completed a processing step. Always name layers before you close a file while the adjustments you have applied are fresh in your mind.

It is often useful to include filter settings in layer names – for example, USM 150/0.9/8 for a pixel layer that has been sharpened using the Unsharp Mask filter. This approach is particularly useful when you analyze the structure of a processed image or when you apply additional adjustments to a lower or new layer. This approach is, of course, not necessary for adjustment layers and Smart Filters.

8.3 Layers Panel Options

The pull-down menu revealed by clicking the ▾☰ icon at the top of the Layers panel includes the *Layers Panel Options* dialog, where you can select a thumbnail size and various other options that affect the look of the Layers panel.

If you have a lot of layers, use smaller thumbnails to avoid scrolling through the panel. Figure 8-2 shows the most commonly used settings.

The *Use Default Masks on Fill Layers* option ensures that an empty layer mask is automatically generated when you create a new fill layer, whether you need it or not.

The *Expand New Effects* option ensures that all effects you apply (usually using the *fx.* menu at the bottom of the Layers panel) are listed in full (figure 8-3). This can make the Layer stack longer and less comprehensible, but it ensures that you

[8-2]
The Layers Panel Options dialog includes
various thumbnail size options

[8-3] New effects are listed in full by default

can see all the effects you have applied. The effects list can be hidden or shown by clicking the 🔳 icon in the layer's panel entry.

Activating the *Add "copy" to Copied Layers and Groups* option adds the word *copy* to the generic names of copied layers. Multiple copies of a single layer are named generically and numbered sequentially: *Curves 1*, *Curves 2*, and so forth.

8.4 Layer Groups

[8-4] This image is the result of intense editing on a large number of layers

The image shown on the left was captured and processed by Matthias Matthai. This particular image required a lot of editing steps because encounters with vampires that look like this are rare in the wild. The final file contained 38 layers, and figure 8-6 shows some of them. The size of the complete layer stack is evidenced by the scroll bar on the right side of the Layers panel. It is easy to lose track of what you are doing with so many layers, and it can take some time to find a particular layer or adjustment.

In this case, the photographer used layer groups to separate the individual effects. Layer Groups are extremely practical and can be expanded as a unit, or hidden and shown using the ⊙ icon.

The layer stack for our sample image is much clearer if the layer groups are collapsed (figure 8-7). The various retouching stages, such as for the eyes, lips, teeth, and (in this case) blood, were assigned to separate layer groups. Always give layer groups meaningful names, as the photographer did here.

Matthias also added an alternative look to the uppermost group, giving him two versions of the image in a single file. To view the main look, all we have to do is hide the uppermost group by clicking the ⊙ icon, revealing the alternative look shown in figure 8-5.

[8-5]
An alternative look, activated by hiding the Look Variation layer group

We often group the adjustments we make to optimize an image for output on a specific printer or paper type. If we then decide to output the image on a monitor or a projector (i.e., output that requires less sharpening), all we have to do is hide the print-specific layer group.

To create a new layer group, click the 🔳 icon at the foot of the Layers panel. Layer groups can be named and renamed the same way as individual layers.

To create a group from existing layers, select them by ⇧-clicking their layer entries and use the 🔳 ▸New Group from Layers command.

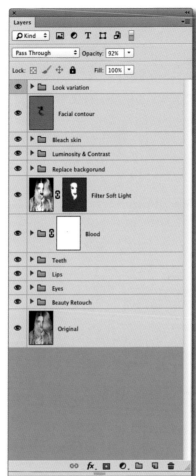

[8-6] A layer stack with 38 layers can be quite confusing, even if each layer has been carefully named.

[8-7] Using expanded and collapsed layer groups makes things a lot clearer.

[8-8] Here, the layer filter has been used to show only layers set to *Lighten* mode.

New layers are automatically assigned to the currently active group. Grouped layers are indented, and clicking the ● icon in the uppermost layer of a group hides the entire group. Clicking the ▢ icon shows a hidden group. The layers within a group can also be hidden or shown individually.

Another reason to group layers is to enable you to limit the effect of a layer mask adjustment on multiple layers. If individual layers within a group have their own masks, the final effect will be produced using the intersection of the layer and group masks.

 Click the triangular layer group icon ▼ to collapse the group view and see a simpler overview of the layer stack. Click the ▶ icon to expand the collapsed group view.

Like individual layers, layer groups can be deleted by dragging them to the 🗑 icon in the Layers panel.

Individual layers can be selected and dragged from one group to another or to a separate layer within the stack.

Applying layer effects to layer groups has been possible since Photoshop CS5, although we have yet to see a working example of how to use this functionality.

Grouped layers can be ungrouped using the Layer ▸ Ungroup Layers command.* Ungrouping destroys group masks, which are **not** applied to the individual layers that result!

* Oddly, this function is not available in the layer context menu.

Blending Modes in Layer Groups

The blending mode of a layer group is set to *Pass Through* by default, which means that the group has no blending properties of its own. Giving an entire group its own blending mode quickly leads to odd and unwanted effects, which we don't recommend.

Nested Layer Groups

Layer groups can be nested. This can be useful if, for example, you need to apply a single mask to multiple groups.

8.5 Color Coding Layers

Layers and layer groups can be color coded (figure 8-9). This feature can be used to indicate a specific processing phase or to visually group layers. To add a color code, select a layer and then select a color from the context menu. Alternatively, you can select a color in the Color menu when you create a new layer (figure 8-10).

[8-9] Layer and layer groups can be color coded for easy identification

[8-10]

You can select a coding color when you name a new layer.

If you use them systematically to indicate processing phases or adjustments types, color codes can be a useful alternative to layer group names.

Giving a layer group a color code automatically assigns the same color to all layers in the group, then you can manually assign different colors as needed.

The layer filter tool built into CS6 (and following versions) can be used to filter layers with a specific color code.

8.6 Limiting Layer Effects Using a Clipping Mask

We have already demonstrated how to use the opacity setting, blending modes, and Layer Styles to alter the effect of an adjustment layer on all underlying layers. If, however, you wish to affect only the next layer down (for example, if the next layer is smaller than those beneath it or is semitransparent), you can use the ⬤ or ⬛ button in the Properties panel (**not** the Layers panel).[*]

* Or you can use **Create Clipping Mask** from the context menu.

[8-11]
The background in the original image lacks contrast and punch

Figure 8-11 shows a scene in which the reflections in the water vapor in the air produce a blue cast that makes the background look rather dull. This helps accentuate the main subject, but we nevertheless want to bring out more background detail to give the image a more consistent overall look.

Increasing the contrast (e.g., using an S-shaded Curves layer) doesn't help because yields a foreground that is too harsh (figure 8-12).

[8-12]
Adjusting the contrast of the entire image produces an unusable result

Therefore, we have to take a more elaborate approach:

1. As with most layered optimizations, we started by duplicating the Background layer (using either Ctrl/⌘-J or Layer ▸ Duplicate Layer).

2. To achieve the desired effect, we used the Quick Selection tool 🖌 to select the background, and we refined the selection using the Select ▸ Refine Edge dialog (feathered edge 4 pixels, edge shifted by +2 pixels, activated *Smart Radius*). We then copied the result to a new layer that, because it is mostly transparent, takes up less disk space and can easily be compressed.

3. The image was then optimized using two adjustment layers. We used a Hue/Saturation layer to reduce saturation in the blue tones while increasing saturation and reducing brightness in the green tones. We then used a Curves adjustment set to *Luminosity* mode (figure 8-13) to increase contrast.

 The initial result (figure 8-12) looks terrible because the adjustments were applied to the entire frame.

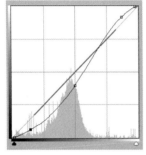

[8-13] Using an S curve to increase contrast

4. To attenuate the effect, we selected the two uppermost adjustment layers using the ⇧ key. To apply their effects to the background layer only, we used the Layer ▸ Create Clipping Mask command to create a clipping mask and produce the result shown in figure 8-14.

 The result is a balanced image with less of a blue cast in the background.

 The clipping mask is indicated by the indented layer entries and the ⌐ icon in the layer stack (figure 8-15).

[8-14]
The foreground and background are more harmonious.

5. We then assigned the top three adjustment layers to a group called *Improve background*. The adjustment can then be toggled on or off by showing or hiding the group using the ◉ button of the layer group.

6. Finally, we brightened the shadows under the roofs in the final image (figure 8-16) using a Shadows/Highlights adjustment on *Layer 1* (Shadows: *Amount 35, Tonal Width 50, Radius 30*).

 Before we applied Shadows/Highlights, we converted the layer to a Smart Object to make its effect repeatable. We also darkened the highlights slightly (*Amount 9, Tonal Width 50, Radius 20*) to reduce the stark contrast produced by the midday sun.

 The Shadows/Highlights adjustment produces astonishingly good results when used on non-Raw images, but it is not available as an adjustment layer, which is why we converted it to a Smart Object.

 We used a layer mask on *Layer 1* to protect the areas we didn't want to affect (mainly the wooded hill to the left of the building). As usual, we began this step by duplicating the background layer to document the original image and give us access to the original image data.

We could have produced a similar effect to that produced by the clipping mask by creating a black mask from the transparent parts of the Background mountains layer and linking it to the adjustment layers.

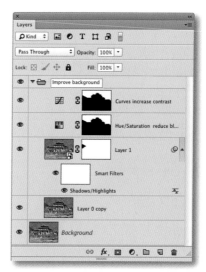

[8-15] The layer stack for the finished image. All adjustments are part of the Improve background group. The clipping mask only affects the Background mountains layer.

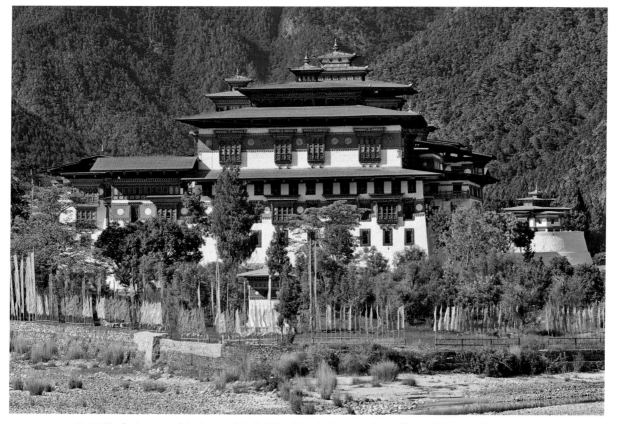

[8-16] The final version of the image of the Buddhist Punakha Dzong palace in Bhutan (Photo: Sandra Petrowitz)

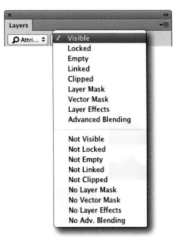

[8-17] The basic layer filter types

[8-18]
The options for the *Attribute* filter

8.7 The Layer Filter

If you are working with large numbers of layers, it is useful to be able to view just one layer type at a time – for example, all adjustment layers, all layers coded red, or all hidden layers. The layer filter introduced with Photoshop CS6 enables you to do just that. There are six basic filter types (figure 8-17), each with its own individual set of criteria. The *Kind* filter is selected by default, and allows you to select layer types using the icons beside the filter drop-down. The filter allows multiple selections.

An active filter is indicated by the red switch in the filter bar ▋, and clicking the switch temporarily deactivates (or reactivates) the current filter. If no criteria are selected, the filter has no effect. If the current filter doesn't match any layers in the current image, Photoshop issues an appropriate warning in the Layers panel.

The selectable criteria for the *Name*, *Effect*, and *Mode* filters are self-explanatory, and the *Attribute* filter offers a long list of potential criteria (figure 8-18). The *Color* filter enables you to filter layers according to their color codes.

Negative criteria, such as all layers without layer masks, are not yet available.

Don't forget to deactivate the filter when you are done – otherwise, you may find that some of your layers have suddenly disappeared.

8.8 Merge and Flatten Layers

→ Just as we often need to merge layers, we also need to duplicate a layer in order to have access to its content. The quickest way to do this is to select a layer and use the Ctrl-J/⌘-J shortcut or drag a layer to the ▣ icon at the bottom of the Layers panel. If you no longer need it as a functional layer, the original background layer can then be hidden.

We already addressed the concepts of merging and flattening layers in chapter 5, so we will only provide you with a summary here.

If you are working with a large number of layers, Photoshop might slow down or even hang. Merging several layers can help alleviate this effect. Merging layers makes it impossible to adjust them individually later on, but you can merge just the layers that you no longer need to change by selecting them and using either the Ctrl/⌘-E shortcut or the Layer▸Merge Layers command. Hidden layers are ignored.

If you are done editing and you want to scale an image for output or share it on the Internet, you can merge all of its layers to the background using the Layer▸Merge Visible command (or the ⇧-Ctrl/⇧-⌘-E shortcut). The image then uses much less memory and disk space.

Merging is also useful if you need to create an interim layer for applying pixel-based adjustments, such as sharpening or Highlights/Shadows. The shortcut ⇧-Ctrl-Alt-E (⇧-⌘-⌥-E on a Mac) creates a new pixel layer from the uppermost selected layer and all those beneath it. The lower layers nevertheless remain intact.

All merging operations incorporate any layer masks and Layer Style effects into the merged image, making it impossible to alter them later.

Deleting and Applying Layer Masks

Layer masks use a certain amount of disk space when an image is saved. Because pixel-based masks are 8-bit grayscale layers, they require less space than 8-bit or 16-bit RGB layers. Empty black or white layers use very little disk space, although it is not negligible.

You can therefore save some disk space if you delete the empty white masks that are often automatically generated when you create new layers.* To do this, drag the mask (not the layer!) to the trash icon 🗑 at the bottom of the Layers panel (or select the layer mask icon and press Del). Depending on the layer type (pixel or adjustment layer), Photoshop asks you to confirm deletion or application and also lets you to suppress the confirmation dialog in the future. You can always create a new mask later if you accidentally delete one that you need.

As of CS6, the confirmation dialog gives you the option to delete the mask. If you wish to apply the mask, select it and use the Apply Layer Mask command in the context menu. X

* Figure 8-22 on page 231 shows you how to suppress the automatic generation of a layer mask with each new adjustment layer.

[8-19]

In the top image (part of a Layer stack), the pixel layer has been optimized using a script and the effect is limited to the main subject using a mask.

The bottom image shows the layer entry following application of the mask. The checkerboard pattern indicates transparent pixels.

Applying a mask produces transparent areas where the mask is black and semitransparent areas where it is gray. Once a mask has been applied, retrieving missing pixels is no longer possible. The masks of Smart Objects, adjustment layers, and fill layers cannot be directly applied.

8.9 How to Adjust Corrections without Using Layers

There are many occasions when we need to use some layer functionalities – such as blending modes, opacity settings, and selective adjustments – without actually having to create a new layer. Additionally, some adjustments (Shadows/Highlights and Equalize, for example) are not available as dedicated adjustment layers, and adjustment layers cannot be applied to layer masks anyway. In such cases, we need functionality that combines completed adjustments with blending modes.

This is possible using the Fade command. We sometimes use *Fade* for output sharpening, but it can be used to perform a number of other adjustments, too.

As previously described, selective corrections can be performed by making a selection and applying an adjustment from the Image ▸ Adjustments menu or a filter such as Unsharp Mask to the selected pixels.

Make sure that **no other pixel-changing operations are performed in the meantime**, you can now select the Edit ▸ Fade command (or use ⇧-Ctrl/ ⌘- F). This opens the dialog shown in figure 8-20.

[8-20]
The **Fade** dialog enables you to reduce the strength of a previously applied effect using the Opacity slider and to apply a blending mode using the Mode drop-down.

Fade enables you to reduce the strength of a previously applied adjustment using its *Opacity* slider and also offers the familiar list of blending modes. If, for example, you have just applied the Unsharp Mask filter to an image, you can reduce the strength of the sharpening effect and check the result in real time by checking the *Preview* option. We have already seen how *Luminosity* mode can reduce the incidence of sharpening artifacts. Click *OK* to apply your changes. Fade thus allows you to use some of the major advantages of layers without actually using the memory-intensive layers functionality.

Fade can also be used after applying any of the Image ▸ Adjustments to a layer mask. This comes in handy sometimes.

The only drawback of Fade adjustments is they cannot be readjusted later, the way layer-based adjustments can. They also don't allow subsequent changes to the layer mask or the creation of an additional vector-based layer. As is often the case with editing, each approach has its own advantages and disadvantages.

8.10 Saving Disk Space Using Data Compression

To save disk space, we usually apply Lempel-Ziv-Welsch (LZW) or ZIP compresion to our layer-based TIFF images. LZW compression is named after the three mathematicians who invented it and is supported by a broad range of applications. ZIP compression usually produces slightly smaller files (on average, about 30% file size reduction, compared to 25% produced by LZW). Fine textures cannot be compressed as much as single-colored shapes, and a compressed file can sometimes end up being larger than the original.

Photoshop also offers Layer Compression options (figure 8-21). Again, we usually use ZIP compression, which produces about 30% file size reduction, compared to run-length encoding (RLE) compression, which produces an average compression rate of about 15% per layer.

Adjustment layers that don't include layer masks take up very little additional disk space, and layer masks (which are nothing more than 8-bit grayscale layers) can be highly compressed, especially if they are almost pure white or pure black.

Deleting pure white layer masks saves disk space too, although there is no command for automatically deleting all white masks in a file.

The *Add Mask by Default* option can be deactivated in the Adjustments panel menu �573 (figure 8-22). All new adjustment layers created thereafter have no default mask, which also saves disk space, but it can cause some third-party scripts to malfunction.

The File ▸ Scripts menu contains three further space-saving commands: Delete All Empty Layers, Flatten All Masks, and Flatten All Layer Effects.

Flattening layer effects rasterizes them and makes them virtually impossible to edit later, and it can even cause an increase in file size due to the reduction in compression efficiency that rasterizing causes. The resulting images are, however, compatible with a wider range of image editing software. The context menu for pixel layers also contains the Rasterize Layer Style command, which applies styles to pixel layers, thus saving further disk space.

[8-21] Various layer compression methods are available in Photoshop.

[8-22]

In the Adjustments panel menu, you can select whether new adjustment layers automatically generate an empty layer mask. Make sure that no layers are active when you select this command.

8.11 The Layer Context Menu

Right clicking an active layer opens the context menu (or `ctrl` click on a Mac with a single-button mouse), which contains a wide range of commands and options (figure 8-23). Using the context menu is usually the quickest way to apply all of the listed options, and the range of available commands varies according to the type(s) of the currently selected layer.

The commands that are available also depend on whether you have selected the layer thumbnail, the layer mask, or the layer name. It also depends on whether your layer has a layer style applied. In every case, non-applicable commands are grayed out.

8.12 Rasterizing, Exporting, and Replacing Layer Content

Smart Objects can be rasterized, exported (figure 8-23), and replaced via the context menu (or via Layer ▸ Smart Objects ▸ …).

The Rasterize Layer command uses the currently assigned editor to convert a Smart Object to pixel data at its currently displayed size and position. Further copies of the same Smart Object are not affected by this process, and changes made to them don't affect the rasterized copy. If the only copy of a Smart Object is rasterized, the Smart Object itself is then deleted.

The Export Contents command copies smart image data and writes it to a separate file. The command does not copy XMP sidecar data in Raw files unless you apply the Convert to Smart Object command first, which produces a PSD file that contains all Raw and XMP data associated with an image.

The Replace Contents command opens the dialog described on page 195, which you can then use to select replacement content.

Replacing Pixel-Based Image Data

If you need to replace the contents of a regular pixel layer, you need to convert it to a Smart Object before you replace the content. Alternatively, you can insert new content into a pixel layer using the File ▸ Place command before you delete the old content.

[8-23] CS6/CC layer context menu

8.13 A Recommended Layer Sequence

The layer sequence you use in an image plays an important role – for example, it makes a significant difference to the workflow if you perform a Levels adjustment before or after a Curves correction.

Our normal layer sequence is very similar to the one used in a typical photo workflow, as shown in figure 8-24. Applying this model results in the following sequence of layers (from the bottom up):

1. Background layer, if necessary, with copies.

2. Basic error retouching, such as sensor dust specks.

3. Basic global corrections, such as Exposure, Levels, Curves, and Hue/Saturation.

4. Basic local adjustments, usually via layer masks or color selections.

5. Fine global adjustments.

6. Fine local or selective adjustments (usually using layer masks).

7. Application of filters – for example, Shadows/Highlights followed by lens error corrections. We use additional interim layers to perform these steps.

8. Sharpening (on an interim layer, as described in section 4.5 on page 140). (When we are working on Raw files, we often apply slight sharpening at the Raw conversion stage to help us judge the overall image quality.) Additional sharpening can be applied to an interim layer that is first converted to a Smart Object.

9. Optimization for output, often applied to a copy of the edited image, especially if the image needs to be resized for output.

10. Final sharpening, with type and strength depending on the output method.

This is a typical workflow for use with TIFF and JPEG images captured using a camera or a scanner. If you are processing Raw images, you will have to consider which of these steps can be best performed using a Raw converter and which using Photoshop. Some images require only basic editing that can be performed exclusively using a Raw converter. To avoid image quality loss, white balance and basic exposure corrections should always be applied at the Raw conversion stage.

[8-24] The basic steps involved in Raw conversion and editing

➜ See the discussion in section 9.1 on the relative merits of using a Raw converter or Photoshop to perform certain tasks.

8.14 Tips and Tricks for Working with Layers and Masks

Adjustment Layers and Color Space Conversion

If you convert the color space of an image that contains adjustment layers – for example, to or from CMYK, RGB, or Lab – some of the adjustment layer attributes cannot be retained. These include Levels, Curves, and Color Balance adjustments.

Color space conversion should therefore be performed either as early as possible in the editing process or on a copy of the edited image (the copy should be flattened to a single layer). Conversion within a single class of color space (for example, from Adobe RGB to sRGB) doesn't cause any major issues but should still be kept to a minimum to avoid the unnecessary loss of image quality that results from multiple conversions. If you use the ProPhoto RGB color space, you should use 16-bit image data, especially if you plan to perform comprehensive Levels or Curves adjustments.

Preparing Images for Sharing and Presentation

Images with 16 and 32 bit are not suitable for presentation on a monitor (other than your own), slide shows, the Web, or sending to customers or an online print service, especially if they have been saved in a large color space like ProPhoto RGB or a less common color mode such as Lab or CMYK.*

* CMYK image files are used in prepress situations, but both parties have to agree in advance which color profile will be used for printing.

1. Begin by creating a copy (e.g., using Image ▸ Duplicate).

2. If you haven't done so as part of your Duplicate action, flatten all layers of this copy to the background (⇧-Ctrl/⌘-E). This makes the image file much smaller and easier to display, share, and output.

3. If necessary, switch the image to RGB mode (Image ▸ Mode ▸ RGB Color).

4. For commercial printing, convert the image to sRGB or, if it is still saved in the ProPhoto RGB color space, to Adobe RGB using the Edit ▸ Convert to Profile dialog. Here you can select your desired color profile using the *Destination Space* option (figure 8-25). Leave the *Engine* option set to Adobe (ACE) and activate *Black Point Compensation*. Select either the *Relative Colorimetric* rendering intent (or *Perceptual* to retain the original look of images with highly saturated colors).

 As soon as you have selected a target profile and one other parameter, Photoshop shows the results in the preview window; you don't have to click *OK* first. This helps you to find the right combination of settings before you commit to a change.

 If your settings produce large-scale changes – for example, if you convert an image from a larger color space to a smaller one – it is a good idea to selectively reduce the saturation for high-risk colors and activate the gamut warning function (with the new color space set as the target).

[8-25]
Convert to Profile dialog

This helps you identify which parts of the image will be subject to clipping when the target color profile is applied.*

If you are converting an 8-bit image from a larger to a smaller color space, always activate the *Use Dither* option.

* See page 69 for more details on soft proofing and gamut warnings.

5. Finally, convert your image to 8-bit mode (Image ▸ Mode ▸ 8 Bits/Channel).

Showing and Hiding Multiple Layers

Clicking the 👁 icon in a layer panel entry with the Alt/⌥ key pressed hides all other layers. Repeat the keystroke to show the hidden layers. This is a useful feature if you want to check the look of a single layer without the influence of the other layers in an image.

Copying Adjustment Layers

Just as Raw development settings can be saved and applied to multiple images, adjustment layers can be applied to other images too.

To do this, open the target image and the image that contains the adjustment layer you wish to apply in separate, tiled windows. Now, in the source file, select the layer (or layers) you wish to transfer and drag them to the target image with the Alt key pressed.* The cursor switches to a hand symbol ✋ during the drag operation. Instead of selecting and applying multiple layers, you can also group the appropriate layers and drag the group to the target image.

* Pressing the Alt key ensures that a copy is produced and that the corresponding layers are not deleted from the original image.

After they are applied, the new adjustment layers can be fine-tuned in the normal way. Pure adjustment layers function normally, regardless of the size and resolution of the target image, and layer masks may have to be adjusted to match the dimensions of the new image or the subject.

[8-26] Many adjustments include the Save
Preset command in the fly-out menu

→ Embed a color profile in your image file
whenever possible and avoid using formats
that don't support embedding (GIF, for
example).

→ To preserve the greatest possible
compatibility with other desktop publishing
programs, always save TIFF files in an 8-bit,
non-compressed format.

→ If you work exclusively with Photoshop,
you can safely compress TIFF files using
LZW or ZIP. Noncompressed TIFF files are
better (i.e., less prone to quality and attribute
loss) if you want to share them with other
applications.

→ TIFF files can include proprietary data.
Proprietary data segments can, however,
cause problems during processing.

Saving Adjustment Presets

Instead of simply dragging an adjustment to a new image, you can save adjustments as presets for future use alongside the default presets provided with the program.

To save an adjustment or adjustment layer, use the appropriate command in the adjustment's fly-out menu (figure 8-26). Note that some adjustment layers (such as Lightness/Contrast and Gradient Map) don't include the command.

8.15 Selecting the Right File Format

Photoshop supports a wide range of image file formats, but we will stick to describing the ones that are most useful in a photographic context. Some formats don't support 16-bit color depth and others don't allow you to embed color profiles or preserve selections and layers. It is important to select the right file format for your intended application.

TIFF ▪ *Tagged Image File Format* is a proven image file format that can be used to save 8-bit, 16-bit, and even 32-bit per channel image data. The 32-bit format is used for saving HDR images. TIFF is a lossless format, so you can open and save TIFF images as often as you like without any loss of image quality.

TIFF files can be compressed losslessly. Photoshop (and many other image processing programs) can open and process compressed TIFF images. However, some programs still have problems processing images that are compressed using certain algorithms.

Photoshop supports LZW and ZIP compression. Opening and saving ZIP files is slightly slower than using LZW, but both methods achieve similar compression rates, with ZIP achieving higher compression with 16-bit images. Photoshop also offers JPEG compression for TIFF images, but we never use it because very few programs support the JPEG-compressed TIFFs.

Photoshop can save multiple layers, color profiles, EXIF and IPTC metadata, transparency settings, and clipping paths in TIFF files, making TIFF the best choice for flexible, high-quality image processing.

Note: Canon calls the Raw files produced by the EOS-1D and EOS-1Ds cameras TIFF, although the format is actually proprietary and can only be handled by a few programs, such as Adobe Camera Raw. This has often been a cause of confusion among photographers and imaging software manufacturers.

JPEG ▪ This format allows high data compression rates. LZW and ZIP are capable of reducing TIFF files to 65–80% of their original size, but JPEG often reduces files to between 5% and 20% of their original size (depending on the amount of quality loss you are prepared to accept). JPEG is therefore the

right choice for web presentation and for transmitting images over slow connections or networks. A lossless version of JPEG does exist, but it is only capable of slight compression. Regular JPEG is the format of choice for applications where image quality loss is acceptable. The amount of quality loss increases with the compression rate and again every time an image is opened and saved. JPEG supports only 8-bit color depth and cannot be used to save layer-based images.

➜ JPEG saves exactly 8 bits of data per color channel (i.e., 24 bits per pixel) and cannot save layers or alpha channels. Images that contain layers and alpha channels must be flattened to a single layer before saving.

Note: To retain optimum image quality, don't use JPEG to save images that you wish to process in the future. Always use TIFF to save critical images, even if your camera natively captures JPEG files.

JPEG 2000 ▪ This is a relatively new format with a number of improvements over conventional JPEG. It includes a usable, lossless compression method that produces better compression rates than TIFF compressed with LZW or ZIP. Its lossy compression results are better than conventional JPEG results at similar image quality levels, and the format also supports 8-bit, 16-bit, and 32-bit color depth. Photoshop supports JPEG 2000 using a plug-in, and a few other programs support it too, although most web browsers don't recognize the format without a special plug-in. JPEG 2000 hasn't yet established itself on a broad basis, and it is still something of a niche format.

➜ Photoshop and Photoshop Elements are JPEG 2000 compatible if you install the free plug-in available from www.fnordware.com. Photoshop CS2 supports the format without a plug-in.

Photoshop PSD ▪ PSD used to be the format of choice for saving multi-layer images. Since the release of Photoshop CS, you can use TIFF for the same purpose because TIFF produces smaller files when you compress layer-based images using ZIP. This is especially advantageous when you process 16-bit images.

PSD means Photoshop Data.

Because Photoshop is the de facto image processing program on today's market, the PSD format enjoys a high level of compatibility as a transfer format between imaging applications. This is especially useful when you need to transfer and process layers, color profiles, and clipping paths (although some programs cannot recognize all of these image attributes).

Photoshop PSB ▪ PSB is designed for use with large image formats (up to 300,000 pixels wide or high), and it can be used to save image files that are up to 2 GB in size. This special format is not supported by any other mainstream programs and is of no practical use in the photo workflow.

PSB means Photoshop Big Data.

PNG ▪ The PNG format was invented for web-based use and to work around the (expired) LZW compression patent. It offers lossless compression and bit depths that range from 8 bits (per pixel) up to 3 × 16 bits per pixel. The format is supported by all popular web browsers. In spite of its inherent ability to do so, Adobe doesn't allow the format to embed color profiles. It can, however, recognize existing color profiles.

PNG means Portable Network Graphic.

Other Formats ▪ Photoshop supports a wide range of other formats, including HDR, although they are not included in this book.

→ Always ensure that your images have a suitable filename extension (.tif, .psd, .jpeg, etc.). A correct extension ensures that files can be seamlessly opened in other programs and that Photoshop interprets them correctly.

Compatibility Settings

To achieve better compatibility with Lightroom and other applications, we recommend that you set *Maximize PSD and PSB File Compatibility* to *Always* in the *File Compatibility* section of Photoshop's preferences. This setting is particularly effective when you save TIFF images because it creates an invisible virtual layer on which the detail from all other visible layers is saved. Other applications then use this additional layer to display the visual parts of the image file without having to be completely compatible with the complex Photoshop layers mechanism.

[8-27]
Set this option to *Always*

If you want to manage TIFF or PSD files that contain layers, channels, or other adjustment attributes in an asset management program such as Lightroom, it is essential to avoid making further adjustments in the asset management interface because the layers and other adjustment elements stored with the image files will be lost the next time you hand over your assets to Photoshop for processing. Always hand over the original TIFF or PSD file for processing.

The aspects and characteristics of various file formats make a difference to their practical applications; for instance, whether color profiles can be embedded or alpha channels can be saved*. Table 8-1 lists some file formats and their main characteristics.

* Alpha channels are used to save selection information (see section 3.11 on page 105).

Table 8.1: Image Formats and Their Options for Saving Information									
Format/File Extension	Compression	Color Depth (per Channel)	Meta-data	Trans-parency	Layers	Color Profile	Vector Layers	Alpha Channels	Notes
Raw Various	No/slight	10–16 bits	+	–	–	+	–	–	Most Raw formats are proprietary
TIFF .tif .tiff	Various: None / LZW/ZIP/ RLE/JPEG	Various, 1/8/16/32 bits	+	+	+	+	+	+	Highly versatile, but not all programs support all TIFF variants
JPEG .jpg, .jif, .jpeg	Lossy	8 bits	+	+	–	+	–	–	Size is optimized; high (lossy) compression is possible
JPEG 2000 .jp2, .j2c	Lossless and lossy	8/16/32 bits	+	+	–	+	–	+	As yet, little support in popular DTP programs. Very compact.
PNG .png	Lossless	8/24/48 bits total[c]	+[a]	+	–	+[b]	–	–	Compact, no CMYK
GIF .gif	LZW, lossy because of 8-bit limit	2–8 bits total[c]	–	+	–	+	–	–	Internet graphics with 8-bit indexed colors
PDF .pdf	Various methods LZW, JPEG, others	1–16 bits	–	+	+	+	+	+	There is a special Photoshop PDF variant
PSD .psd	LZW for layers	1/8/16/32 bits	+	+	+	+	+	+	Native Photoshop format, also recognized by other image editing programs
PSB .psb	LZW for layers	1/8/16/32 bits	+	+	+	+	+	+	Photoshop format for very large files

a. With limitations, for example, no EXIF data
b. PNG color profiles are not saved in Photoshop
c. This number of bits is not used per color channel but rather per pixel for all bits of the index-encoded data

Alternatives to Photoshop Layers

9

Photoshop layers are powerful and flexible tools, but there are nevertheless situations in which other technologies offer equivalent or better functionality. This chapter addresses some of these alternatives.

If you shoot in Raw format, you will have to deal with the question of which processing steps to perform using a Raw converter and which you are better off executing in Photoshop. Raw converter technology is developing fast, and most programs nowadays include editing functionality previously only available in Photoshop, such as lens corrections, vignette removal, or selective local corrections to colors, tones, and contrast. This chapter includes thoughts and tips on dealing with this aspect of the photo workflow, and discusses some alternative approaches to non-destructive image editing.

9.1 Choosing a Raw Converter or Photoshop

* Raw-to-JPEG conversion (as an explicit action) has been available in high-end cameras since about 2011.

If you shoot in Raw format and don't convert your images to JPEG in-camera* you will have to use a Raw converter to save them to a format that your editing software understands. Photoshop cannot directly process Raw image files, and instead opens the Adobe Camera Raw (ACR) processing module when you open a Raw image.

However, even if your camera produces JPEG or TIFF image files, you can still perform some editing steps using a Raw converter if it provides the functionality you need. We will go into more detail on this aspect of the process later. And, as of Photoshop CC (Photoshop 14), the Camera Raw Filter can be applied to any pixel layer as a filter. Start with the conversions of the layer to a Smart Object. This allows you to apply the Camera Raw Filter as a normal Filter or a Smart Filter. This gives you a very powerful correction tool that works like an adjustment layer.

** Some medium-format cameras capture 48 bits of data per pixel, and similar technology is sure to find its way into full-frame cameras in the near future.

Raw image files contain much more image data than JPEGs or camera TIFFs. JPEG images contain a maximum of 8 bits of data per RGB color channel (i.e., 24 bits per pixel), whereas Raw files contain a minimum of 30 bits and often as many as 36 or 42 bits per pixel.** This additional data enables us to perform more complex corrections without having a visible effect on the quality of the resulting image. JPEGs produced in-camera are subject to a more or less predetermined Raw-to-JPEG conversion process that can be adjusted slightly using bult-in style presets. Processing Raw files using a Raw converter gives you a lot more freedom to convert your images to your own taste using custom white balance, sharpening, saturation, contrast, and color balance settings.

You will be able to achieve the best editing results if you give Photoshop the maximum possible amount of data to play with. However, the program can process 8-bit (24-bits per pixel), 16-bit (48-bits per pixel) or 32-bit (to some extend) image data – but not 10-, 12-, or 14-bit image data – so you should make sure that (when you shoot Raw) your images are converted to 16-bit mode before you begin processing. The resulting files are twice the size of their 8-bit equivalents, but they are much more flexible when it comes to the types of editing steps you can apply. If you are running on limited disk space, you can convert your processed images back to 8-bit format, flatten any remaining layers and, if necessary, compress the JPEG file that results.

➜ The principle of non-destructive editing also applies to JPEG, TIFF, and PSD files that you process using a Raw converter.

The other major advantage of editing with a Raw converter is that it doesn't actually alter the original image data; it records the changes you make in a separate small sidecar file or in its own database. This approach ensures that you cannot unintentionally overwrite your original images. If you are processing camera JPEGs or TIFFs, you should **always** work on copies of your images.

[9-1] Lightroom 5 (above) and Adobe Camera Raw 8 (below) Raw converters have slightly different interfaces but offer the same functionality

Raw Converter versus Photoshop

If you are capturing in Raw, some adjustments should always be performed at the Raw conversion stage. They are listed in order of importance and execution:

1. **White balance** – can be adjusted losslessly in a Raw converter, whereas adjustments in Photoshop always involve a slight loss of image quality.

 → ACR and Lightroom are capable of selective white balance adjustments using the Adjustment Brush.

2. **Exposure**, that is, the overall brightness of the image, can be adjusted.

3. **Straightening** and perspective corrections can be made (if necessary). As of Lightroom 5 and Adobe Camera Raw 8, there is a function called Upright to automatically straighten the horizon and do some perspective corrections.

4. **Cropping** can be done at this point, if necessary.

5. **Setting the white and black points** is optional. Make sure that the points you set leave some room for maneuvering at both ends of the tonal scale, especially if you plan to perform further adjustments in Photoshop later on.

6. **Chromatic aberration** correction can often be performed at this stage. Nowadays, most Raw converters have very good built-in chromatic aberration correction functionality that also relies on essential EXIF metadata (lens model, aperture, crop, vignette, etc.).

 → Demosaicing is the process that converts the grayscale data captured by the camera's sensor into color pixel data.

7. **Basic sharpening** can be done to compensate for the blur caused by demosaicing. Most Raw converters provide a range of camera-specific presets. Try to minimize global sharpening to avoid accentuating sharp edges that result from many editing steps. Output sharpening should always be the final step in the editing process and will therefore usually take place in Photoshop – provided, of course, that you haven't performed the entire editing and output workflow within the Raw converter environment.

 → Lens error correction is not usually necessary in landscape images captured using standard or telephoto lenses.

8. **Lens distortion correction** should be performed only if it is really necessary – for example, in architectural or ultrawide-angle shots.

9. **Vignetting** correction can be done if desired or necessary.

10. **Noise reduction** is another step that many Raw converters can handle quite well. It's worth considering this at the Raw conversion stage.

11. **Lens softness and edge blur** could be performed at this stage. It's worth considering this. A few Raw converters (such as DxO Optics Pro) work on the basis of custom camera and lens profiles that enable them to automatically correct edge blur and lens softness based on the known characteristics of the lens and aperture settings used to capture an image.

12. **Removing dust spots** can easily be done in most Raw converters.

13. **Simple local corrections** can be made depending on the available tools.

Although Photoshop is capable of executing many of these adjustments, there are various reasons you should consider performing them at the Raw conversion stage:

* Raw converters often have full access to shooting and image data that is no longer present in an edited or cropped image. This is especially relevant for lens corrections, such as distortion, vignetting, chromatic aberrations, and perspective errors.

* Raw converters automatically apply all adjustments in the optimal sequence before handing an image over to Photoshop or saving it to a Photoshop-compatible format, such as TIFF, PSD, or JPEG. The optimal processing sequence is neither obvious nor automatic when you process images in Photoshop.

* All corrections applied using Raw converters are non-destructive and can be altered at any time without the use of additional layers and masks. The original image data remains unchanged and all alterations are saved in compact form, either as a separate sidecar file or in the program's own database. This approach saves a lot of disk space when sharpening, for example, which requires the use of memory-intensive Smart Objects if it is to be performed nondestructively in Photoshop.

* Virtual copies can be used to save multiple versions of images in the form of sidecar or database data, which also saves disk space. You only need to keep one copy of the original image.

* Some Raw converters enable you to perform multiple corrections using a single tool. For example, you can use the Lightroom Adjustment Brush tool to simultaneously apply reductions in brightness and sharpness while adding a slight color cast. Performing the same tasks in Photoshop requires the use of multiple layers and layer masks. Raw converters are often more efficient than Photoshop, and Adobe Camera Raw and Lightroom also include Auto Mask functionality that further simplifies the application of image adjustments.

* Some tools, such as Adobe Camera Raw's Graduated Filter or Lightroom's Parametric Curve, are more intuitive to use than their Photoshop counterparts (figure 9-3).

* Some tools, such as the Adobe Camera Raw and Lightroom Clarity slider (for adjusting midtones and microcontrast) aren't available at all in Photoshop and can only be emulated using complex work-arounds.

 As of Photoshop CC, you can apply the Camera Raw Filter as a standard filter or even as a Smart Filter. This allows you to use all of Adobe Camera Raw's controls to optimize your pixel layer (including the Clarity controls).

[9-2] Photoshop, Adobe Camera Raw, and Lightroom make use of these sidecar files and store them in XMP format. Other Raw converters use other formats.

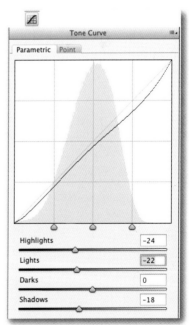

[9-3] Adobe Camera Raw's Parametric Tone Curve is intuitive to use and is highly fault-tolerant.

A. Single and multiple adjustments are simpler to save as presets and are therefore easier to apply to other images. This simplifies and accelerates the process of preparing large sequences of images or collections of photos with similar characteristics.

* Adobe Camera Raw and Lightroom are the only current offerings we know of with this functionality.

Some Raw converters can process 32-bit HDR images[*] in a way that is more intuitive than the tone mapping modules built into many HDR software packages. If you process a lot of HDR images, we recommend that you start by creating your HDR images using an external program such as Photoshop (using HDR Merge), Photomatix Pro [13], or HDR Pro [16] and save the results as 32-bit TIFFs before you edit them further in Adobe Camera Raw or Lightroom. You can then give your images their final polish in Photoshop in the form of 16-bit (or even 32-bit) TIFFs.

If you are not using HDR techniques, Raw images with a broad range of contrast are easier to tame in a Raw converter than in Photoshop. To achieve good results using the current versions of Adobe Camera Raw and Lightroom, use a negative *Fill Light* setting to rescue burned-out highlights and a positive *Blacks* setting to brighten the shadows. Burned-out highlights can be further attenuated by reducing the *Exposure* setting, and over-dark shadows can be moderated by raising the *Contrast* value. If your image still looks lifeless, a positive *Clarity* setting (figure 9-4) can improve the situation.

As of Photoshop CC, you can tone map by applying the Camera Raw Filter to your 32-bit layer.

The leeway you have for making these types of adjustments will depend on the dynamic range your camera is capable of capturing. High-quality cameras allow corrections of up to 1.5 f-stops in either direction. Raw converters use all the Raw headroom in an image, making adjustments possible that Photoshop simply cannot equal.

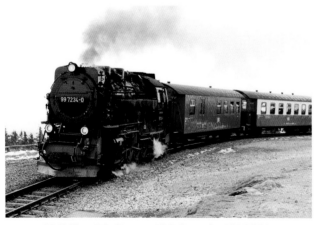

[9-4] The original image with its burned-out highlights and swamped shadows

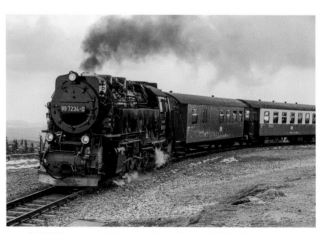

[9-5] The corrected image, adjusted using Adobe Camera Raw:
Exposure = -1.6, *Fill Light* = -60, *Contrast* = +90, *Blacks* = +50, *Clarity* = +36

Generally, global corrections (i.e., those that affect the entire image) should be made first using a Raw converter, followed by simple local corrections (which can also be performed using a Raw converter if necessary).

More advanced retouching steps, such as those you might perform using the Photoshop Clone Stamp, Patch, or Spot Healing Brush tools, should only be performed using a Raw converter if they are fairly simple – for example, removing dust specks from the sky. Otherwise, retouching – such as removing power lines – can usually be performed much more precisely and with more fine-tuning options in Photoshop.*

If you plan to increase contrast or sharpen your image, try to avoid using the entire dynamic range while you make adjustments in your Raw converter, and don't sharpen at all if possible.** Performing these types of adjustments in Photoshop helps to prevent banding and sharpening artifacts.

Contemporary Raw processing suites such as Lightroom, Apple Aperture, Corel AfterShot Pro, and the Capture One/Media Pro combo, generally combine processing and asset management functionality and also include specialized slide show, web, print, and photo book output tools. This combined functionality makes it tempting to perform all processing and editing steps from within a single interface, especially if the software's own image browser displays images using the same parameters as its editor. Using separate image browser and editing tools can lead to unwanted visual discrepancies.

* With Adobe Camera Raw 8.x and Lightroom 5, the Spot Removal tool was enhanced and now can be used like a brush. This is quite helpful for retouching.

** Even if you set your sharpening control to zero (in Adobe Camera Raw or Lightroom), some slight sharpening will be applied to your Raw file.

9.2 Making Selective Corrections Using a Raw Converter

If you shoot in Raw format, you will have to perform basic optimization steps and convert your images using a Raw converter before you hand your material over to Photoshop for advanced processing. At this stage, it doesn't matter whether you use Adobe Camera Raw, Adobe Lightroom, Apple Aperture, Nikon Capture NX2, or Capture One because they can all perform selective corrections. The handling of the correction tools varies slightly from manufacturer to manufacturer, but most use either a selection to limit an effect or a brush tool to paint it into the image. In contrast to Photoshop layer techniques, with their dedicated adjustment layers and masks, adjustment brushes and selections can usually be used to combine multiple corrections (such as brightness, saturation, local contrast, and even local white balance) in a single step, as we will demonstrate using Adobe Camera Raw.

The selective correction tools in Adobe Camera Raw and Lightroom are basically the same, even though they are embedded in slightly different interfaces. This functionality has been available since the release of Lightroom 3 and Adobe Camera Raw 6. Lightroom can perform selective corrections on all the formats it supports, while Adobe Camera Raw also supports JPEG, TIFF, and PSD files if it is configured appropriately.

[9-6] The Adobe Camera Raw Adjustment Brush (here in version 7.4) can be used to simultaneously apply various adjustments.

Adobe camera Raw's Graduated Filter █, and Adjustment Brush ✎ tools both use the sliders shown in figure 9-6, although the settings shown in section ⓑ (Brush Size, Flow, Density, etc.) are, of course, only available for the Adjustment Brush. The range of available settings was increased with the introduction of Adobe Camera Raw 7 but the techniques involved in applying them are still the same. The illustrations here show the Adobe Camera Raw 7 version that comes with Photoshop CS6.

Adobe Camera Raw 8.1 and Lightroom 5 also include the new Radial Filter tool (ⓞ in Adobe Camera Raw or ⬤ in Lightroom), which behaves in much the same way as the Graduated Filter tool, but with effects that are applied to circular or elliptical areas within or outside a selection's border. With the exception of the Flow and Density settings, the tool has the same controls as the Adjustment Brush and makes a great addition to Adobe's selective RAW adjustment tools. The Spot Removal tool has also been enhanced to include a brush option, so you can now cleanly replace the pixels that make up fine details such as power lines or facial wrinkles.

Combining multiple corrections in a single step doesn't always make sense, and you can apply multiple individual steps one after another if you need to. If you do decide to perform multiple adjustments in one pass, you can save your settings as a preset for later use with other images.

If you apply too many selective corrections to an image, it can slow down your Raw converter until you can no longer work effectively (depending on your RAM and CPU performance), so take care to use them sparingly.

Darkening the Sky

An over-bright sky (figure 9-7) is a regular feature of many landscape photos, but it can be mitigated by reducing the exposure value in the upper portion of the frame. To perform this step in Adobe Camera Raw (or Lightroom) we used the Graduated Filter █ with a negative *Exposure value*. Reducing the *Fill Light* setting further attenuated the highlights, and slightly increasing the *Saturation* (still within a single filter step) completed our adjustment. After you make a combined adjustment like this, you may have to slightly reduce the overall saturation to produce a realistic-looking sky.

The sky was still too bright following our basic adjustment (figure 9-7) and there was not enough contrast with the smoke coming from the locomotive, so we applied a gradient with an exposure value of –0.5 from the top of the frame to the roof of the train (figure 9-8). This technique, however, only works only if there is detail in the sky. Where no detail can be retrieved, you will simply produce dull gray.

In Adobe Camera Raw, the green pin indicates the start of the gradient, and the red pin represents the end. The black and white line between the pins indicates the direction of the gradient.

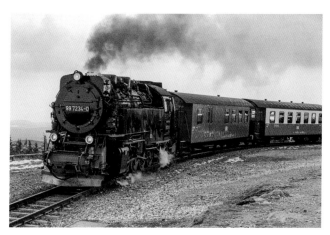

[9-7] Following basic adjustment, the sky in our image still requires additional tweaking

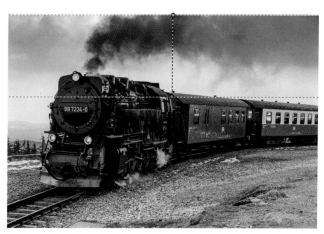

[9-8] The result of adding a gradient from the top of the frame to the roof of the train with *Exposure* set to −0.5

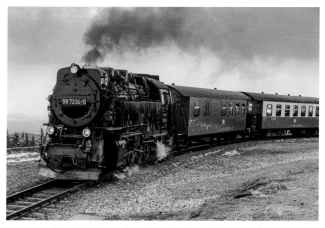

[9-9] The image from figure 9-8, with *Contrast* in the Graduated Filter set to −90

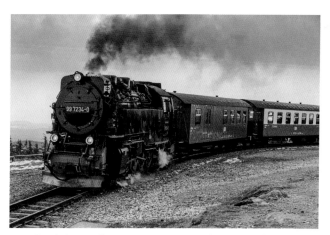

[9-10] Setting *Clarity* to +100 counteracts the unwanted loss of contrast produced by the previous adjustment.

This step unfortunately gave the sky an unnatural color, so we reduced the Graduated Filter's *Saturation* to −90 and *Contrast* to −85 to give it a more natural look (figure 9-9).

Local brightening and darkening effects, and alterations to saturation, can now be applied using the Adjustment Brush 🖌. Both tools also include color overlay functionality.

The Adjustment Brush even allows you to locally change the color *Temperature* and *Tint*. This comes in handy in mixed light shots.

Correcting Skin Imperfections and Adding Makeup

The Adobe Camera Raw Adjustment Brush ✐ (represented by the ⬤━ icon in Lightroom) can be used to perform local color corrections in portraits where global corrections cannot be effectively applied using the *HSL/Grayscale* adjustments. All you have to do is set the brush to paint in your desired color or reduce color saturation to lessen unwanted redness.

The hardness of the Adobe Camera Raw or Lightroom Adjustment Brush can be adjusted the same way as the standard Photoshop Brush tool.

The Adjustment Brush can also be used to deemphasize large pores that sometimes appear when a positive global *Clarity* adjustment is applied. Simply set a negative *Clarity* value and paint over the appropriate areas. Activating the *Auto Mask* option protects neighboring areas from being inadvertently affected by the adjustment. Positive *Clarity* values can be used with the Adjustment Brush to sharpen hair, eyelashes, and eyes.

Other skin blemishes can also be effectively removed using the Spot Removal tool ✐ (in *Heal* mode), although the Photoshop Spot Healing Brush ✐ with the *Proximity Match* option is even more effective.

[9-11] The original image in which we will use Adobe Camera Raw to redden the lips and smooth the pores

[9-12] The lower pin indicates the lip correction and the upper pin indicates the correction we applied to the pores using a *Clarity* setting of −74 and a *Sharpness* setting of −85. The pins are visible only if the tool is active.

The Adjustment Brush can also be used to apply blur by combining negative *Sharpness* and *Clarity* values.

Since the introduction of Lightroom 4 and Adobe Camera Raw 7, white balance, too, can be effectively adjusted at the Raw conversion stage. In Adobe Camera Raw, the *Temperature* and *Tint* settings can be adjusted using the Adjustment Brush, which is extremely useful if you need to balance an image shot using mixed light sources.

[9-13]
The corrected areas in figure 9-12 are shown in red when the mask overlay is activated.

The Adjustment Brush works in the same way as a black Photoshop layer mask adjusted using a white brush. You can make the mask visible by pressing the Y key in Adobe Camera Raw. In contrast to Photoshop, Adobe Camera Raw and Lightroom only display the white areas of the mask – the default in Adobe Camera Raw is gray; in Lightroom it is red (figure 9-13).

You can alter the mask's color in Adobe Camera Raw by clicking the color picker icon ☐ Show Mask ☐ (figure 9-14). Press the O key to show and hide the mask in Lightroom, where the ⇧-O shortcut cycles the mask color through red, green, gray, and white.

With a correction pin activated, pressing the Alt key enables you to reduce or undo your corrections. To delete a correction completely, activate the appropriate tool, followed by the corresponding pin, and then press the Del key.

Small blemishes and wrinkles can be removed using the Spot Removal tool in Lightroom or Adobe Camera Raw. As of Lightroom 5 and Adobe Camera Raw 8.x, it can be used like a brush.

[9-14] The Adobe Camera Raw Color Picker dialog with its masking options

Performing the local corrections we have described in Adobe Camera Raw or Lightroom is usually quicker than using Photoshop, is non-destructive, and uses little or no extra disk space. An image optimized this way can then serve as the basis for more detailed adjustments in Photoshop.

Our Recommendation

If you distribute your editing steps between a Raw converter and Photoshop, in addition to points 1–13 on page 244, we recommend that you also observe the following guidelines:

- Use a Raw converter to perform all basic global corrections that you wish to apply to all planned versions of an image. These include straightening the horizon (and other major lines), perspective correction, and cropping (if necessary).

- If you think you might need to adjust any of your basic Raw corrections later, hand over your image from Adobe Camera Raw or Lightroom to Photoshop as a Raw Smart Object. Otherwise, hand it over as a 16-bit TIFF or PSD file.* If you are working on JPEG images in your Raw converter, you will only be able to hand over 8 bits per color channel images.

* Section 8.15 includes detailed information on various file formats.

- If you are going to sharpen your image in Photoshop, sharpen it only slightly (or better still, not at all) at the Raw conversion stage. This prevents subsequent steps from producing obvious sharpening artifacts or amplifying any that may already be present.

- If you can avoid it, don't perform too many local adjustments in Adobe Camera Raw or Lightroom because this can quickly make the software unbearably slow (especially if you don't have much memory and still work on a 32-bit operating system).

9.3 Selective Corrections Using Viveza

The main purpose of Photoshop layers is to perform selective corrections – in other words, to limit the area to which we apply an effect, especially when we use layer masks. Like the combined corrections described in the previous section, Nik Software's Viveza plug-in [16] goes a long way toward making individual layers and layer masks redundant by combining multiple local corrections in a single editing step.

In its Photoshop plug-in form,* Viveza functions like a filter and requires a pixel layer on which its effects are applied. The plug-in can be set up to automatically create a combined pixel layer, or you can create one yourself using the Ctrl/⌘-Alt-⇧-E shortcut. We already explained the advantages of using Smart Objects in chapter 6, so to give yourself maximum editing and re-editing options, you should convert your new pixel layer into a Smart Object (Layer ▸ Convert to Smart Object) before starting the plug-in.

As well as selective local adjustments, Viveza can also apply global corrections (i.e, to the entire image) using the settings in section Ⓐ in figure 9-16. With the exception of the Curves tool, which is only available globally, all the plug-in's tools can be applied both globally and locally. It is always preferable to perform global corrections before you make local adjustments. In contrast to Photoshop layers, Viveza can be used to perform multiple corrections simultaneously, although they are nondestructive only if they are performed on a Smart Object layer.

The Loupe window at the bottom of the tools panel shows before and after views of your image (figure 9-16 Ⓑ), and the (zoomable) preview window can also be set up to show before and after views.

Viveza's powerful local correction functionality is controlled using *control points* governed by the program's patented U-Point technology. Each control point (in its basic form) offers individual *Brightness, Contrast, Saturation,* and *Structure* sliders (figure 9-15). *Structure* alters local contrast (also known as *microcontrast*), and increasing the setting increases definition in fine textures. The downside of using these slider is they can damage fine color gradients and increase noise artifacts (the Adobe *Clarity* adjustment built into Adobe Camera Raw 7 and Lightroom 4 is more subtle). Viveza analyzes the tonal value at a control point and corrects areas with the same (or similar) color and brightness values more than others.

The tone the tool uses is shown as a colored circle on the control point itself and in the settings panel at figure 9-16 Ⓒ.

The strength of the adjustment diminishes with increasing distance from the control point and can be adjusted using the *Radius* slider. The current radius is shown graphically around the control point (figure 9-15).

* Viveza is also available as a plug-in for Lightroom and Apple Aperture, which hand over TIFF or PDS files for correction.

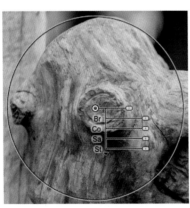

[9-15] A control point, showing the *Radius* slider (at the top, without a label) and the *Brightness, Contrast, Saturation,* and *Structure* sliders

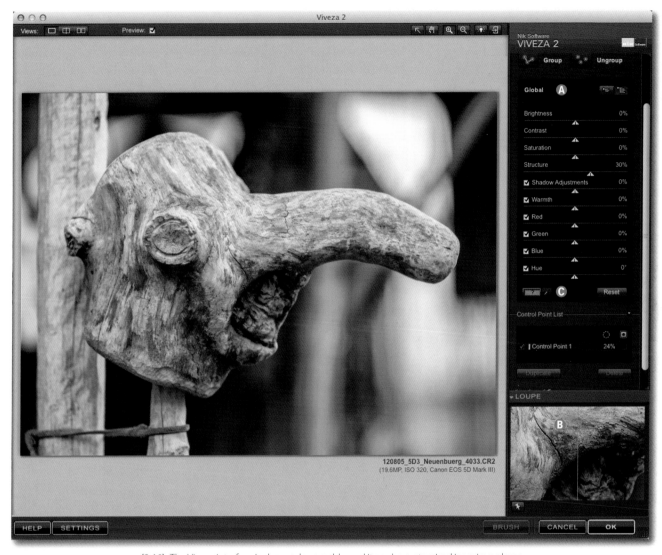

[9-16] The Viveza interface is clear and zoomable, and it can be customized in various places

All settings can be adjusted individually for each control point, although we usually end up using just one or two sliders (for example, *Brightness* and *Structure* to emphasize the texture in a subject's hair) while leaving the others at their default settings.

Additional sliders are shown when you click on the triangular icon ▼ below the main sliders (figure 9-17). They include *Shadow Adjustments*, *Warmth*, *Red*, *Green*, *Blue*, and *Hue*. All these sliders are set to zero by default, and setting their values to below or above zero weakens or strengthens each

[9-17]

Clicking the triangular icon shows and
hides additional settings sliders

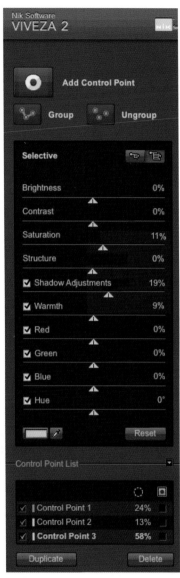

[9-18] Detail of the Viveza Control Point panel

effect accordingly. Slider adjustments you make in the preview window are automatically duplicated in the main tool panel. As an example, you can brighten shadow colors using the *Brightness* slider and then use the *Warmth* slider to shift the tones in your selected area away from blue to make them appear warmer. A similar effect can be achieved by reducing the *Blue* value and/or increasing *Red*.

As with Photoshop adjustments, you will have to simply play around with the options Viveza offers (figure 9-18) to get a feel for how they all work.

It is often easier to use multiple control points with the same settings to control an effect rather than risking using a single point with a large *Radius* value that can then affect areas you wish to leave untouched. To duplicate a control point, drag it to the desired position with the Alt key pressed.

A neutral control point (i.e., one with all sliders set to their defaults) can also be used to prevent the effect of another control point from spreading-any further by setting the radius of the neutral counter point to adjoin the area that the other point affects.

Control points can be altered right up to the moment when you click the *OK* button at the bottom-right corner of the plug-in window (see figure 9-16). Control points can be deleted, grouped, and activated (or deactivated) individually or, if grouped, as a whole group. When control points are grouped, all corrections you do to one control point are replicated to all other control points in the same group.

In order to better judge the effect of a control point, you can display the area it affects as a grayscale mask (figure 9-20) by checking the box (figure 9-19) beneath the mask icon in the Control Point List section of the tools panel. This is particularly useful if you have set multiple control points. Nevertheless, you should always deactivate this option to judge the overall effect before you commit to a change.

[9-19] The checkboxes used to activate the mask display.

[9-20] The current Radius setting displayed as a grayscale mask

The following example is based on the image shown in figure 9-21, which we cropped in advance.

1. We begin by converting our image to a Smart Object so that we can re-open and edit our Viveza correction later if necessary.

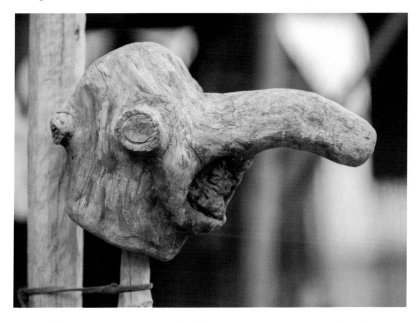

[9-21]
The original image

2. We then navigate to Filter ▸ Nik Software ▸ Viveza to open the plug-in.

[9-22] Our initial global correction

3. Before we make any local corrections, we slightly brighten the shadows and increase the local contrast for the entire image using the *Structure* and *Shadow Adjustments* sliders.

4. We now add a control point to the eye and reduce its *Radius* to encompass just this detail (see figure 9-15, page 252). We then increase the *Structure* and *Saturation* settings to give the selected detail better definition. Take care when you alter the *Structure* setting because it has a much stronger effect than the equivalent Adobe Camera Raw or Lightroom *Clarity* setting. The changes we make are automatically duplicated in the main tools panel (figure 9-22).

5. Because the viewer is automatically attracted to the brightest point in the frame, the blurred white shape in the background threatens to steal the show. To counteract this effect, we set a second control point with a small *Radius* and reduced *Brightness* to reduce the effect of the shape. We also reduce the *Saturation* and *Structure* settings to blur it even further (figure 9-23).

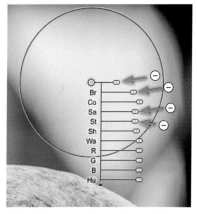

[9-23] The second control point darkens, desaturates, and blurs the texture

6. We repeat step 5 for the green area at the bottom right, and for the top and bottom of the wooden stake on the left. Because the two control points

on the stake require the same settings, we duplicate the upper one and place it at bottom left using the ⌥Alt drag keystroke.

7. A final control point increases the *Structure* setting for the detail in the mouth, thus compensating for the lack of texture in the original image.

In total, we used two global corrections and six control points. Figure 9-24 shows the areas they effect in the mask mode, and figure 9-25 the precise location of each control point.

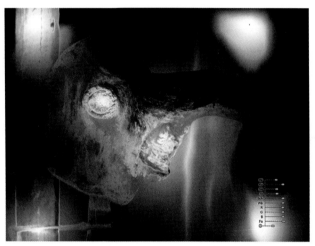

[9-24] The mask view, showing the areas affected by our corrections

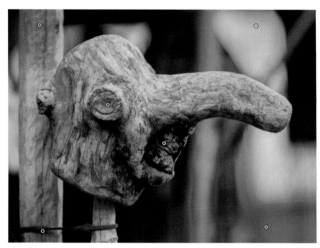

[9-25] The small buttons indicate positions of the control points within the frame

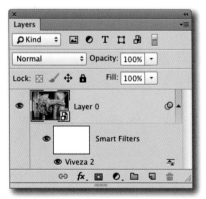

[9-26] The Viveza-corrected layer stack

➔ Some (but not all) Nik filters allow you to save settings as presets for later use.

As a comparison, figure 9-27 shows the original image, figure 9-28 the version corrected using Viveza, and figure 9-26 shows the corresponding layer stack.

Although these instructions might sound complicated, learning control point editing techniques is easier to do than it is to describe. The corrections we made took about three minutes, which is significantly faster than using Photoshop adjustment layers and layer masks.

Other Control Point-Based Plug-ins from Nik Software

Nik's U-Point control point technology is used in a range of filters, including Color Efex Pro 4, Silver Efex Pro 2 (a very nice black-and-white conversion filter), Sharpener Pro (a powerful sharpening tool), and the Define noise reduction plug-in. The settings for each tool are tailored to the specific needs of each application. Figure 9-29 shows a control point in Silver Efex Pro 2, and figure 9-30 one from Sharperner Pro.

[9-27] The original image [9-28] The image corrected in Viveza

Color Efex Pro 4 has its own *Opacity* slider that you can use to adjust the strength of the filter's effect from within its interface (the same as the opacity in a conventional pixel layer or Smart Object).

Once you are familiar with the concept, you will be able to use all control point-based filters quickly and easily to either limit or apply single or multiple effects. Even if they use more disk space, using these tools as Smart Filters means that you can adjust your changes at any time and still use less memory and computing power than the equivalent adjustment layers and masks.

[9-29] Here, in Nik Silver Efex Pro 2, a control point is used to darken the petal of the tulip.

Nik filters offer a number of advantages if you need to apply multiple adjustments in one pass; they can even be painted in to an image using an inverted layer mask.

Viveza offers a lot of creative leeway, but you need to have a good idea of the results you want to achieve if you are to apply it successfully.

Control points embody an elegant approach to editing but don't offer the same degree of precision as layer masks. You may find that you need to set quite a few neutral counter points to ensure that an effect is limited to just the area you want. Alternatively, you can set a large number of identical points with small radius settings to achieve the same limiting effect.

[9-30] Control points in Sharpener Pro have just *Radius* and *Sharpness* sliders. This illustration shows a before and after view.

9.4 Other Solutions

For Aperture and Lightroom users, there are a number of alternative solutions if you want to use layer functionality but don't want to go to the extra expense of purchasing Photoshop. The onOne Software [19] Perfect Layers plug-in offers multiple layers, a range of blending modes (although not as many as Photoshop), and layer mask functionality. At $80-100, depending on which version you choose, this is a good value solution, but it doesn't really offer a comprehensive alternative to Photoshop. It still lags behind when it comes to Smart Object functionality, the number of filters available, and the range of adjustments it offers. In addition to Perfect Layers, which is available as a plug-in for Lightroom and Aperture or as a stand-alone version, onOne offers a range of other Photoshop add-ons and plug-ins.

Topaz Labs [20] is another well-known manufacturer of Photoshop plug-ins with similar functionality to the Nik offerings but without the additional elegance of control point technology.

There is a wide range of third-party plug-ins available that either enable functionality that is simply not possible in Photoshop or offer simplified or more intuitive ways to perform familiar tasks. We recommend the DOP EasyD Plus DetailResolver script described on page 272 or AKVIS Enhancer [24] for increasing local contrast. Many of the Nik Software [16] solutions that we have already introduced are a useful addition to anyone's image editing arsenal – for example, HDR Efex Pro offers a much more intuitive approach to tone mapping than Photoshop's HDR Pro module. A good alternative is Photomatix Pro [13].* Both tools work as Photoshop, Lightroom, and Apple Aperture plug-ins or as stand-alone applications.

** HDRsoft's Photomatix Pro is one of the best plug-ins we know of for creating and tone mapping HDR images.*

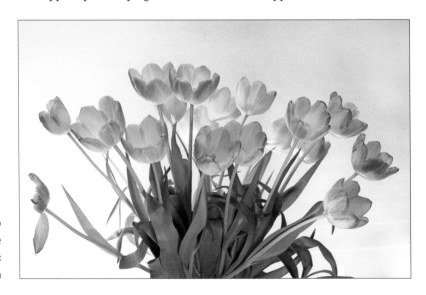

[9-31]
We edited this image in Photoshop in preparation for a black-and-white conversion using the Nik Silver Efex Pro 2 plug-in

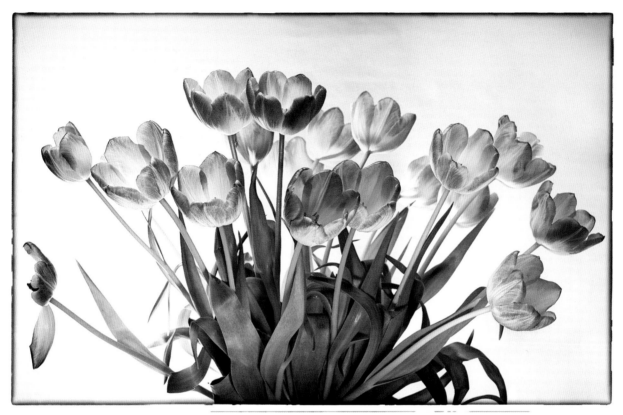

[9-32] The image from figure 9-31, converted using Nik Silver Efex Pro 2, which we also used to add the
vignette and border effect

Silver Efex Pro is a powerful black-and-white conversion module that is
widely used among wedding photographers and includes selective control
point editing functionality and a range of options for creating vignettes and
borders that are much easier to use than the equivalent Photoshop func-
tions. Figures 9-31 and 9-32 show an example of a Silver Efex Pro conversion.

Whichever filters or plug-ins you use, we recommend that you always
apply them as Smart Filters so you can alter the settings later if necessary.
When you are sure that you don't need to make any further corrections,
you can simply rasterize any Smart layers contained in your image file to
apply the effects.

Sample Edits

10

Optimizing an image is a complex process that often consists of multiple retouching steps followed by several further optimization processes. If your original image is correctly exposed, the initial aim of the optimization process is to remove blemishes and artifacts that you either didn't see while shooting or couldn't avoid capturing. Further optimization enables you to alter the image so it resembles the scene you remember as closely as possible. In other words, the data captured by the camera is manipulated to match the memory (or the fantasy) of the photographer.

This chapter details the complete optimization process for five selected sample images.

As discussed in section 9.1, you will need to consider which of these steps to perform using a Raw converter and which using Photoshop, regardless of whether you are shooting in Raw or JPEG format.

10.1 Railroad Car

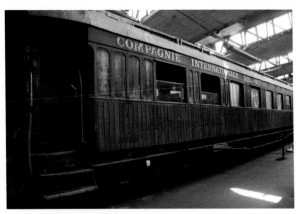

[10-1]The original image

[10-3] The corrections we made in the Lightroom
Basic panel

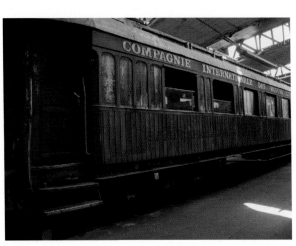

[10-5]
The initial Lightroom-based result

The original photo (figure 10-1) was captured in a railroad museum in southern Germany. The daylight entering through the skylights was weak, and the resulting contrast was high. We optimized the image as follows:

Using a Raw Converter

1. We used Lightroom 4.3 to develop this image, although we could have used Adobe Camera Raw. The first step was to crop the image sightly to bring us closer to the subject.

2. The original histogram (figure 10-2) shows obvious clipping in the highlights and shadows. We shifted the Highlights slider to rectify the highlight clipping.

[10-2]
The histogram for figure 10-1

3. We increased the *Blacks* setting to remove shadow clipping.

4. We also used the *Shadows* slider (formerly *Fill Light*) to slightly brighten the darker areas (figure 10-3).

5. We darkened the bright triangular highlight on the car's roof and its extension on the floor using the Adjustment Brush with the *Auto Mask* option activated. We set Exposure to –1.5 and Highlights to –47. Figure 10-5 shows the result of these steps.

6. We then reduced the chromatic aberrations (figure 10-4). We zoomed in to a 400% view to better judge the effect of our changes.

[10-4] Reducing chromatic aberrations

Chromatic aberrations are manifested in the form of green and magenta smears at high-contrast edges, and they are often only visible at high magnifications. If they are not removed at an early stage, such artifacts can produce unsightly blemishes in large prints.

7. We then handed over the resulting image (figure 10-5) to Photoshop as a 16-bit TIFF file (Adobe RGB (1998)).

In Photoshop

8. This is where the real retouching begins. We removed the irritating light spot at the bottom right using the Patch and Clone Stamp tools applied to a separate layer with the *Sample All Layers* option activated. We also lessened the effect of the light spot on the roof using the Clone Stamp tool with a reduced opacity setting. Removing the light from the letters in the wording was more complicated.

 It is often a good idea to use a selection to limit the area to which you apply Clone Stamp (and similar) corrections, thus preventing you from inadvertently adjusting surrounding pixels. The next interim result is shown in figure 10-6.

 In such cases, the decision as to whether to leave such details intact, darken them a little, or remove them completely is a matter of personal taste.

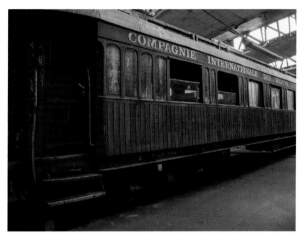

[10-6] Our image with corrected light spots

9. The Shadows/Highlights tool is perfect for situations like this and often works wonders. It enables us to subtly brighten shadows or darken highlights while taking the tones of neighboring pixels into account – an approach that is smarter than using simple Curves adjustments.

 Shadows/Highlights is not available as an adjustment layer, so we begin by creating an interim combined layer for the adjustment using the Ctrl/⌘-Alt-⇧-E shortcut and converting it into a Smart Object using the command in the new layer's context menu. When these steps are done, you can navigate to the Image ▸ Adjustments ▸ Shadows/Highlights command, which then opens the tool as a Smart Filter.

 To degree to which Shadows/Highlights integrates neighboring pixels into its effect is regulated by the *Radius* setting.

 Setting *Black Clip* and *White Clip* to 0 (figure 10-7) helps prevent shadow and highlight clipping.

 Once you have selected the *Amount* and *Tonal Width* settings, you can adjust *Radius* until you find the right setting. *Tonal Width* determines the range of shadows and highlight tones that are modified. *Amount, Tonal Width,* and *Radius* affect one another to differing degrees depending on their values, so it helps to work iteratively when you use this dialog.

[10-7]
The Shadows/Highlights values we used to produce the image shown in figure 10-8. The shadows have been slightly brightened and the highlights slightly (but broadly) darkened. Black Clip and White Clip have both been set to zero.

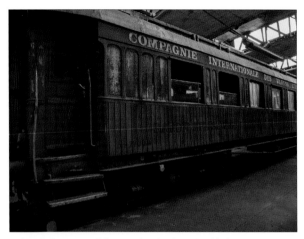

[10-8] Our image following the **Shadows/Highlights** correction

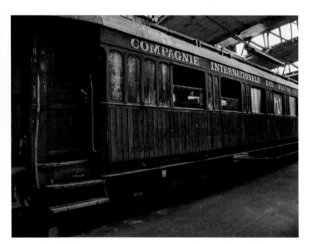

[10-9] Increasing micrcontrast using the High Pass filter

[10-11] Using **Apply Image** to create a mask

Shadows/Highlights can also be used to increase midtone contrast, although you should take care not to overdo this effect.

In our example, we slightly brightened the shadows within a narrow range and significantly darkened the highlights. Figure 10-7 shows the settings we used and figure 10-8 shows the results. The darker parts of the image now show more detail.

10. Our next step was to increase microcontrast to give the image more punch. We used the High Pass filter with a large Radius setting. Here too, we created a new combined layer (Ctrl/⌘-Alt-⇧-E) and converted in into a Smart Object (before we apply the High Pass filter).

11. We then switched the new layer's blending mode to *Soft Light*. Don't be put off by the unusual appearance of the result when you apply this step.

12. This is where we used Filter ▸ Others ▸ High Pass to increase local contrast (also known as microcontrast). In situations like this, a large Radius value of 200–1,000 pixels produces the best results (figure 10-10).

[10-10]
Check the main preview window and the filter's small preview window while you make an adjustment

The best Radius value to use will depend on the textures in your image and its resolution. Figure 10-9 shows our next interim result.

13. The previous step brightened some of the brighter areas too much. This effect can be counteracted in two ways:

a. Use an inverted luminosity mask as a layer mask
b. Use the blending technique described in section 6.8

In our example, we used method a. If the upper layer has no mask, create one by clicking the ◙ icon at the bottom of the Layers panel before proceeding.

We created our mask using the sharpening layer itself by opening the Image ▸ Apply Image dialog with the layer mask selected (figure 10-11). The source is the current layer, which we named *Microcontrast*. Because we wanted to use this layer's luminance values as a mask, we selected the *RGB* channel option. We also selected the *Inverse* option to increase the layer's effect on dark and midtones (figure 10-12).

[10-12] The Layers panel entry for our Microcontrast layer

14. This is where we began fine-tuning, using the Opacity slider for our Microcontrast layer, the layer's blending mode, and the High Pass filter's Radius setting. *Overlay* and *Hard Light* blending modes produce stronger effects than *Soft Light*. Since Photoshop CS4, a mask's Density setting can also be adjusted separately. (The setting can be found in the Window ▸ Properties panel once the mask has been selected.)

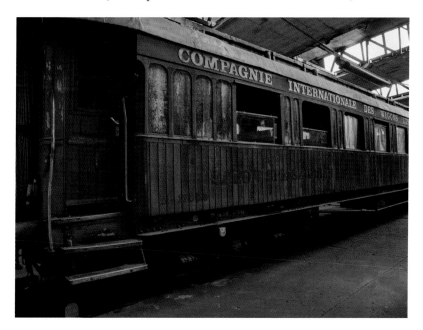

[10-13]
Our image with increased microcontrast and its new layer mask

15. If you are happy with the results and feel you don't plan to further adjust the filter settings, you can rasterize the Smart Objects to save disk space. At this stage, you can also delete any other layers that you no longer need.

16. The final step in most editing processes is sharpening, which you should only apply once you have cropped and scaled an image to its final size. To be on the safe side, it is a good idea to scale a copy of the processed image rather than the painstakingly edited image itself (Image ▸ Duplicate). The Duplicate Image dialog enables you to merge all layers to the background in the copy (figure 10-14). Always give image copies meaningful names so that you can identify them later.

[10-14] Don't forget to give your image copy a meaningful name

→ If an image contains multiple layers or masks, they will all be interpolated during scaling. If an image contains Layer Styles, be sure to select the *Scale Styles* option before proceeding.

17. Scaling (i.e., up- or downsizing) an image for output takes place in the Image ▸ Image Size dialog. Changing a file's size is a destructive editing step that reinterpolates (i.e., resamples) the image data. Use the Image Size dialog to enter your desired target resolution in pixels per inch (ppi), an shown in figure 10-15 Ⓐ. A setting of 75–100 ppi is usually sufficient for display on a monitor, and 300 ppi is adequate for printing using a third-party print service or offset printing. Use 300 ppi for most HP and Canon inkjet printers; 360 ppi works better with high-end Epson printers.

Enter the desired image size at Ⓑ by entering either the height or width. If you activate the *Constrain Proportions* option Ⓒ, Photoshop automatically enters the second setting and prevents the resized image from becoming distorted. If you leave the *Resample Image* option unchecked, the dialog displays the size the new image would be at the current resolution but without resampling.

Activate the *Resample Image* option Ⓓ and select a resampling method. Use *Bicubic Smoother* if you are enlarging your image, or *Bicubic Sharper* if you are downsizing. The *Bicubic Automatic* setting was introduced with Photoshop CS6 and automatically selects the correct method.

With Photoshop CC, *Preserve Details* was added to yield better results when you upsize an image, as was the *Reduce Noise* control (figure 10-16).

Click *OK* to start the resizing process.

[10-15] The Image Size (scaling) settings (using Photoshop CS6).

[10-16]
Use Resample *Preserve Details (enlargement)* for upsizing in Photoshop CC.

* See section 4.5 on page 140.

18. The best sharpening tools are the Unsharp Mask[*] and Smart Sharpen filters, or the High Pass filter described in section 6.4 (applied with a small *Radius* setting of 3-8 pixels). It is generally advantageous to sharpen shadows less than highlights if you want to avoid producing additional noise artifacts. You can use the Layer Style *Blend If* settings to limit the effects of the Unsharp Mask and High Pass filters using the techniques described in section 6.8.

The Smart Sharpen filter can be used to separately sharpen shadows, midtones, and highlights, making it ideal for use in our example (option-

ally as a Smart Filter applied to the Smart Object we created earlier, see figure 10-17). We checked the *Advanced* option and set the sliders in the *Sharpen* tab to sharpen the midtones.

Because we have already increased local contrast, we only need to sharpen a little at this stage. We used an *Amount* setting of 100% and set the *Radius* to 0.9 pixels.

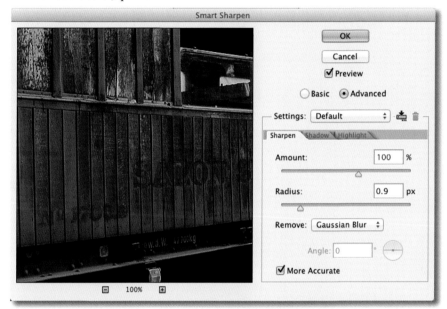

[10-17]

The *Advanced* options in the **Smart Sharpen** filter enable you to sharpen shadows and highlights separately (relative to the midtones)

We selected the *Gaussian Blur* option in the *Remove* drop-down. Activating the *More Accurate* option slows down processing but produces better results.

19. In the *Shadow* tab (figure 10-18), we used the *Fade Amount* slider to attenuate shadow sharpening (setting 100% means that the shadows are not sharpened at all). Once again, the *Tonal Width* setting determines the range of tones that are classed as shadows. Here too, you will need to experiment to find the right combination of settings while keeping an eye on the preview image to make sure that you don't produce additional noise.

[10-18]

The *Shadow* and *Highlight* tabs are only visible if you activate the *Advanced* option

20. Proceed as described in the previous step in the *Highlight* tab, although the settings here are less prone to producing noise and are generally less critical than the *Shadow* settings.

21. If you are working in 16-bit mode, the final optional step is to convert your image* to 8 bits for output or distribution to your customer or print service. If you are printing at home and your printer supports 16-bit images, skip this step. The final format – whether JPEG or TIFF, compressed or uncompressed – will depend on the file's intended use and the formats the recipient's system supports.

* Convert your image using the Image ▸ Mode ▸ 8 Bits/Channel command.

22. If you plan to print your image or publish it on the web (or distribute it to less technically-minded recipients), it is a good idea to convert it to the sRGB color space using the Edit ▸ Convert to Profile command.

Select the sRGB destination space and activate the *Use Black Point Compensation* and *Use Dither* options. The *Relative Colorimetric* rendering intent works well for most images (figure 10-19).

[10-19] Converting an image to sRGB is sometimes useful, depending on the intended use of the file

Figure 10-21 shows our finished image, sharpened for offset printing, while figure 10-20 shows the original image as it originally appeared in our Raw converter.

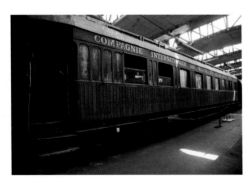

[10-20] The original image, as it appeared in Adobe Camera Raw

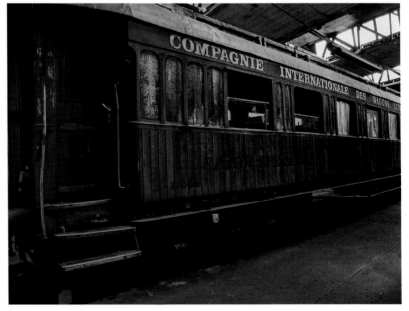

[10-21] The finished image, sharpened for offset printing

Figure 10-22 shows the layer stack following step 20 (before conversion to 8 bits).

In addition to the steps described, we also sharpened the optimized image, which we scaled to the appropriate output size in advance.

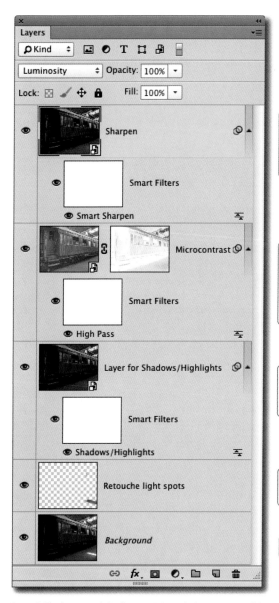

Ⓔ Final sharpening using the Smart Sharpen filter. To keep this step adjustable, it was applied as a Smart Filter to a separate combined Smart layer. The shadows and highlights were sharpened less than the midtones.

Ⓓ Increasing microcontrast using the High Pass filter applied as a Smart Filter to a combined layer, and using a large Radius setting (in this case, 950 pixels) and *Soft Light* for blending mode. An inverted luminance layer mask limits the adjustment's effect to the shadows and midtones.

Ⓒ Combined Smart Object layer used to apply non-destructive Shadows/Highlights adjustments. The highlights were darkened and the shadows were brightened.

Ⓑ Separate retouching layer used to remove the light spots using the Clone Stamp 🖌 and Patch 🩹 tools.

Ⓐ The original image as it appeared in Adobe Camera Raw.

[10-22] The layer stack for figure 10-21 with descriptions of the steps

10.2 Sunset in Monument Valley

[10-23] The original image as it appeared in our Raw converter

The photo shown in figure 10-23 was captured at sunset in Monument Valley, Utah. The dead tree in the foreground provides a perfect frame for the butte (called a Mitten) lit by the setting sun. To keep the foreground and background details in focus we shot at f/20 and ISO 640 using a 24–100 mm lens (set to 32 mm) mounted on a full-frame camera. The optimization steps we took were as follows:

Using a Raw Converter (Adobe Camera Raw 7.4)

1. The first step involved slight cropping to center the main details. This also removed some of the less interesting foreground.

2. Working in the *Basic* tab 🔘, we increased the *Exposure* setting slightly to +0.30 to lighten the foreground, and we set *Shadows* to +52 to brighten the shadows. A *Highlights* value of –10 reduced the intensity of the sky, while +20 *Clarity* increased microcontrast and emphasized the textures of the tree and the Mitten.

 Earlier Adobe Camera Raw versions have a slider called *Recovery* (now replaced by *Highlights*) and *Fill Light* (replaced by *Shadows*), both of which require different settings than their successors.

 Figure 10-24 shows the *Basic* settings we used for our example.

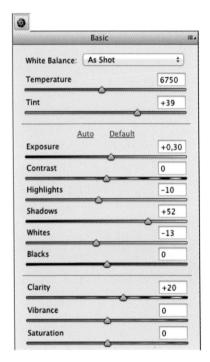

[10-24] Initial optimization using the ACR 7.4 *Basic* settings

3. The next step involved adjusting the color of the sky to match our memories. To do this, we switched to the *HSL/Grayscale* tab 🗒, then activated the *Targeted Adjustment Tool* 🔘 in the Adobe Camera Raw toolbar and dragged the cursor to the left in the upper portion of the sky to reduce luminosity. Then we activated the *Saturation* tab and dragged the cursor to the right to increase saturation.

 The slight vignetting effect that resulted works well in this particular image, and we decided not to adjust the lens distortion, which doesn't detract from the look of the image. Additionally, we activated the *Remove Chromatic Aberration* option in the *Lens Corrections* tab.

 Figure 10-25 shows the image (optimized in Adobe Camera Raw) that we handed over to Photoshop as a 16-bit TIFF file. Because we planned to further optimize our image in Photoshop, we didn't perform any sharpening in Adobe Camera Raw. The Raw converter's internal settings include compensatory sharpening anyway, which is designed to counteract the slight blur that it caused by demosaicing during Raw capture.

 (We could have done step 4 in Adobe Camera Raw 8 or Lightroom 5 because they allow you to use the Spot Removal tool like a brush.)

In Photoshop

4. The first steps in this phase involved removing smaller unwanted elements from the foreground. Steps like these are simpler to perform in Photoshop, where they can be more precisely executed than in a Raw converter. We used the Stamp and Spot Healing Brush tools on a separate layer (and with the *Content-Aware* option activated) to remove some wood fragments in the center and to the left.

5. We then applied a Hue/Saturation adjustment layer to lower the *Blues* value and match the intensity of the sky to our memory of the situation. We set Saturation to +64 and Lightness to –26. Because there are hardly any other blue tones in the image, we were able to perform these changes without a layer mask.

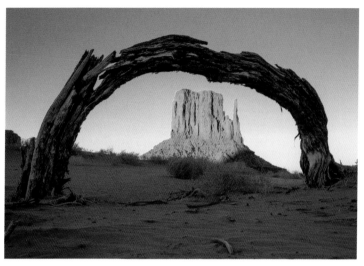

[10-25] Our image as handed over from Adobe Camera Raw to Photoshop

6. To brighten the tree, we created a new empty layer set to *Overlay* mode and filled it with 50 % gray (figure 10-26). We then used a white brush with a feathered edge and 25 % opacity to subtly lighten the tree and darken the lower portion of the foreground.

 Figure 10-27 shows the result, and figure 10-28 shows the adjustment's Layers panel entry.

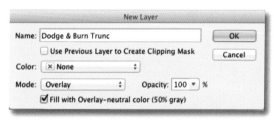

[10-26] Setting a new layer's name, mode and color

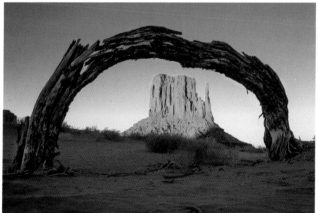

[10-27] The tree is brightened and the foreground is darkened.

[10-28] The adjustment layer in *Overlay* mode

7. We used a Curves adjustment to give the Mitten the more intense feel that we remembered. We selected the Mitten itself using the Quick Selection tool and fine-tuned the selection using the Refine Edge dialog before we created our Curves adjustment layer. The selection automatically

[10-29] This **Curves** layer darkens the butte using a layer mask.

became a layer mask. Figure 10-30 shows the curve we used. In situations like this, the Hue/Saturation adjustment can be used to produce similar results.

[10-30] By decreasing midtone luminosity, this simple curve will increase the illuminating power of the Mitten

8. There are various ways to increase microcontrast in the butte and the tree. They include the Unsharp Mask filter (with low Amount and high Radius settings) or the High Pass filter with a large Radius, as described on page 264. We could also have used a higher *Clarity* setting at the Raw conversion stage, but this would have required using the Adjustment Brush to apply it selectively to just the tree and the Mitten.

In situations like this, we prefer to use Uwe Steinmueller's script called DOP EasyD Plus DetailResolver, which you can purchase online [23]. This is one of my favorite scripts and is really easy to use. After you installed it, it is available under File ▸ Scripts ▸ DOP EasyD Plus DetailResolver.

The script automatically generates a new combined layer and records the parameters used in the layer's name. The script's only drawbacks are that it cannot be used as a Smart Filter and its lack of a preview window. It is great for enhancing the fine textures found in leaves, grass, cliffs, wood grain, and the like. It is also useful for emphasizing textiles and human hair, although you will need to mask skin areas to protect pores from unwanted emphasis if you use it to enhance portraits. Eyes and eyelashes usually benefit too.

To apply the script, simply select the uppermost layer in the stack, open the script, set your parameters, click *OK*, and wait patiently (without performing any further steps) while the script does its job.

The script's sliders and options function as follows (figure 10-31):

[10-31] The DOP EasyD Plus DetailResolver script dialog

Detail+ determines the strength of the microcontrast increase. The default value of 5 is often just right, and setting too high a value can cause unwanted noise in shadow areas. We recommend values between 5 and 12.

Light Halo suppresses the halos that some Photoshop tools produce at high-contrast edges and that can be caused by using high *Detail+* and *Definition* values. The *Light Halo* setting can be used to reduce the increase in microcontrast in brighter details, which is often a good idea for images that contain fine, high-contrast textures, such as tree branches captured against a bright sky.

Definition has a similar function to the *Detail+* slider. Higher values increase the effect but can lead to a lack of definition in single-color shapes.

Shadow Brighter brightens shadow areas. A zero value has hardly any effect, while higher values are more effective but can cause additional noise.

Noise Mask creates a mask that prevents additional noise from becoming overbearing. Always use this option if possible.

Clipping- prevents shadow and highlight clipping and should usually be left activated. (This option is particularly recommended for print output.)

Shadow Wide extends the range of shadow tones that are brightened in a similar way to the Shadows/Highlights adjustment. (This option is not recommended for images that already contain obvious noise artifacts.)

The script's effect is at its best when applied subtly. Try to use low *Details* and *Definition* settings to prevent the shadows from being brightened too much. If you do use higher values, be sure to zoom in and check for halos and noise in the shadows and at high-contrast edges. Unwanted artifacts can be reduced or eliminated by reducing the adjustment layer's opacity or by using a layer mask. If fine-tuning doesn't work, you can simply discard the layer and start again using different parameters.

9. To ensure that only the tree and the butte were affected, we dragged the Curves layer mask to the script layer (with the Alt key pressed) and enhanced it using a white brush (figure 10-32). Figure 10-33 show our (almost) finished image with its newly brightened shadows and improved local contrast.

Using too high a *Shadow Brighter* setting can increase noise and reduce overall definition.

[10-32] The layer entry for increasing microcontrast using DOP EasyD Plus. The parameters we used are recorded in the layer's name.

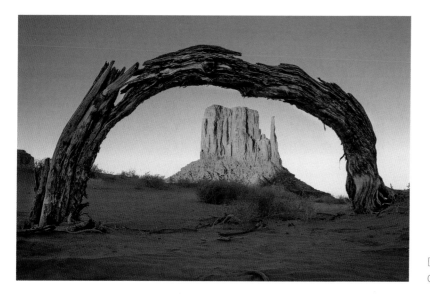

[10-33]

Our image with improved microcontrast

[10-34]
Detail view before and after applying the
DOP EasyD Plus DetailResolver script

As an alternative to using a mask as described, we could have increased microcontrast in the entire image while protecting just the sky with a mask, thus providing additional detail in the sand and the bushes.

As usual, there are various ways to achieve similar effects, and practice and experience will help you to decide which is the best option for a particular situation.

10. We have now optimized our image to a point at which we can save it for sharpening and output.

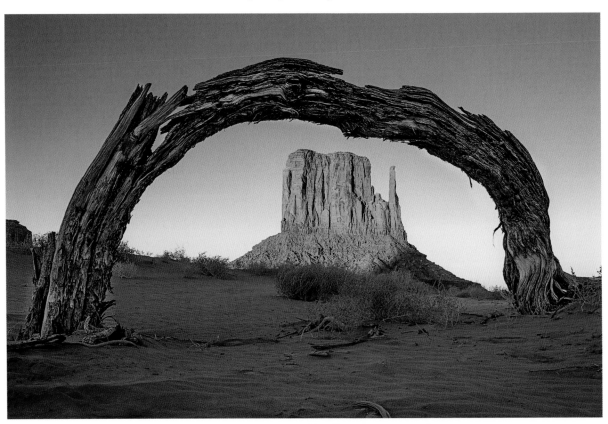

[10-35] The finished image, sharpened for offset printing on coated paper

11. We sharpened the optimized image directly without resizing it.* We created a new, combined layer using the ⌃Ctrl/⌘-⌥Alt-⇧-E shortcut, converted it to a Smart Object, and applied the High Pass filter with a low (4-pixel) Radius. In this case, the sharpening effect can be fine-tuned by adjusting its opacity or by altering the filter's Radius setting.

* We did not sharpen a scaled copy, as described on page 265.

Figure 10-36 shows the complete layer stack for our finished image.

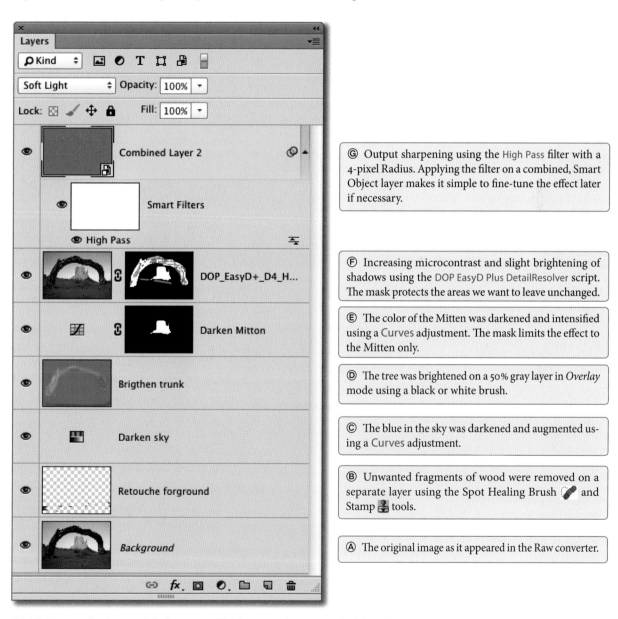

Ⓖ Output sharpening using the High Pass filter with a 4-pixel Radius. Applying the filter on a combined, Smart Object layer makes it simple to fine-tune the effect later if necessary.

Ⓕ Increasing microcontrast and slight brightening of shadows using the DOP EasyD Plus DetailResolver script. The mask protects the areas we want to leave unchanged.

Ⓔ The color of the Mitten was darkened and intensified using a Curves adjustment. The mask limits the effect to the Mitten only.

Ⓓ The tree was brightened on a 50% gray layer in *Overlay* mode using a black or white brush.

Ⓒ The blue in the sky was darkened and augmented using a Curves adjustment.

Ⓑ Unwanted fragments of wood were removed on a separate layer using the Spot Healing Brush and Stamp tools.

Ⓐ The original image as it appeared in the Raw converter.

[10-36] The complete layer stack for figure 10-35. The sharpening layer was applied directly to the optimized image.

10.3 Wilting Tulip

This example uses five shots from a sequence of a wilting tulip to perform layer-based focus stacking. This technique merges multiple source images with various focus settings to create a single image with enhanced depth of field. Such an image can be used to create really large prints. The tools used here have been available since the introduction of Photoshop CS3.

Our source images (shown in figure 10-37 and figure 10-38) were captured at f/11 using a 100 mm macro lens mounted on a full-frame camera. The session took place in a controlled tabletop studio situation using off-camera flash, so the images were well exposed from the start.

[10-37] The first of our five source images

[10-38] The four additional source images, captured using different focus settings

1. Apart from slightly darkening the highlights, we didn't perform any corrections at the Raw conversion stage. We selected our source images in Lightroom and handed them over Photoshop using the Edit In ▸ Open as Layers in Photoshop command.

 If you use Bridge, select your source images and use the Tools ▸ Photoshop ▸ Load Files into Photoshop Layers command.

 If you are working with Photoshop, select your source images and use the File ▸ Scripts ▸ Load Files into Stack command, as described in section 5.3 on page 162.

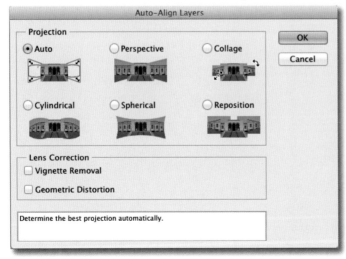

[10-39] The Auto projection type is best for this kind of merge

2. For our example, we then selected all five layers and applied the Edit ▸ Auto-Align Layers command and chose the *Auto* Projection option (figure 10-39). We left both Lens Correction options unchecked.

3. If necessary, crop any transparent space left over by the alignment process using the ◻ tool.

4. Keeping all five layers selected, we then used the Edit ▸ Auto-Blend Layers command in *Stack Images* mode with the *Seamless Tones and Colors* option activated (figure 10-40).

This gave us the layer stack shown in figure 10-41. While stacking images this way, Photoshop attempts to mask blurred image areas to leave only sharp details visible. The result of our Auto-Blend step is shown in figure 10-42. Because it is blurred in all the source images, the flower's stem remained blurred in the merged image.

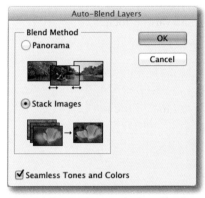

[10-40] Select *Stack Images* for Auto-Blending

[10-41] The blended layer stack

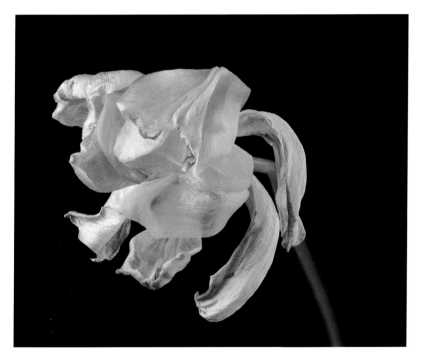

[10-42]

The composite image with enhanced depth of field that shows the original stem

5. The bent stem detracts from the look of the merged image, so we decided to edit it to exit the frame on the right. To perform an edit like this, the detail that is to be altered has to be selected as precisely as possible to keep the subsequent fine-tuning steps to a minimum.

We used the Magnetic Lasso tool 🔧 to select the stem because it gives us a better range of edge-tuning options than the Quick Selection tool (🖌). We also used the Lasso's Refine Edge dialog (located in the options bar) to fine-tune the selection.

6. There are at least two ways to reposition a selection:

 a. Using Copy and Paste followed by an appropriate transformation. The subsequent steps are the same as those described for method b.

 b. Using the Content-Aware Move Tool ✖ (available since Photoshop CS6).

 We used method b for our example. To begin, we created a new, empty layer and then, with the selection active, selected the Content-Aware Move tool ✖. We used *Move* mode, set Adaptation to *Strict*, and checked the *Sample All Layers* option.

[10-43]
The ✖ tool's options

[figure: toolbar — Mode: Move, Adaptation: Medium, ✓ Sample All Layers]

When you reposition an object this way, Photoshop attempts to fill the space left by the moved object using pixels appropriate to the surroundings (which didn't work very well in this case) and also to fit the object into its new surroundings as neatly as possible.

In our case, Photoshop copied the moved object but left obvious traces of the previous version in its original position.

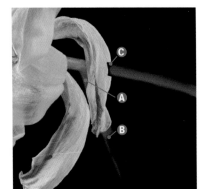

[10-44] Our image following step 7

7. We then used the Free Transform command (Ctrl / ⌘ - T) to rotate and place the new stem to the right of the petal. Figure 10-44 shows the interim result, which still needs some work.

8. We began retouching the remaining stem Ⓐ using the Clone Stamp on a separate layer. But first we used the Quick Selection tool 🖌 to outline and limit the area affected by the stamp (figure 10-45). Only then did we start with the Clone Stamp.

9. We then repeated step 8 for the rest of the stem Ⓑ.

[10-45]
Using a selection to limit the area
affected by the Clone Stamp

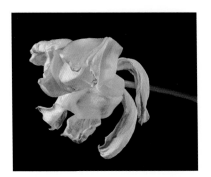

[10-46] The improved version. We removed
the old stem and the parts visible to the left
of the petal using the Clone Stamp tool

10. We used a layer mask to mask the part of the new stem Ⓒ that protruded into the neighboring petal.

11. Having fixed these major issues, we began to fine-tune the exposure using the Dodge and Burn techniques described in section 4.4:

 a. Create a new layer in *Overlay* mode and use the 50% Gray Fill option (see the dialog in figure 4-24 on page 136).

b. Use a soft black brush to darken and a soft white brush (both set to 15% opacity) to lighten the appropriate areas. Alternatively, you can use the Dodge 🔍 and Burn ✋ tools (using 10–15% opacity and the *Midtones* Range option) to achieve similar results.

These steps make any remaining detail in the shadows and highlights visible. If you use the black and white brush technique, you can switch between the foreground and background colors (i.e., between the black and white brushes) using the ⌷X⌷ key. If, however, you use the dodge and burn option, pressing the ⌷Alt⌷ key temporarily switches between the two tools.

These techniques can be used to emphasize outlines by dodging on one side and burning on the other (figure 10-47). The appropriate technique is explained in detail in section 4.4.

 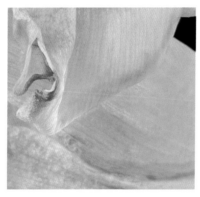

[10-47]

Before and after emphasizing the outlines using dodge and burn techniques

To enable precise fine-tuning, it is always good idea to perform these types of local corrections using multiple brush strokes and a weak opacity setting. Take regular breaks to make sure you don't have to repeat too many steps if you undo an adjustment (⌷Ctrl⌷/⌘-⌷Z⌷ to undo or ⌷Ctrl⌷/⌘-⌷Alt⌷-⌷Z⌷ to step backward). This technique doesn't help for completely burned-out highlights, which you can reconstruct by using the Clone Stamp to copy detail and color from neighboring areas on a separate (reduced-opacity) layer.

12. To finish up, we increased local contrast in the petals. There are various ways to do this, including using the DOP EasyD Plus DetailResolver script (page 272), using the High Pass filter with a high Radius value (page 264), or using the Calculations tool to blend the blue channel into a new layer set to *Overlay* mode (section 4.12).

However, because the petals in our sample image were already quite bright (and are the only detail that we wanted to enhance), we used a Curves adjustment layer to apply a shallow S-Curve, thus increasing contrast. We used *Luminosity* blending mode to prevent this step from increasing the color saturation too much.

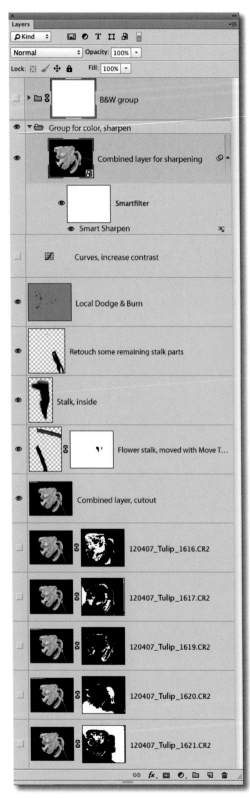

Whichever technique you use, you can always regulate the strength of the final effect by adjusting the adjustment layer's opacity. In our case, we used a setting of 60%.

13. This image also looks pretty good in black-and-white. If you decide to try out a monochrome conversion, the best way to start is to create a new layer group to contain the conversion and any Dodge, Burn, or Levels adjustments that you may have to make. The conversion itself is performed using the Black & White adjustment layer.

 Because we were interested in both the color and black-and-white versions of our image, we handed the processed file back to Lightroom for conversion, where we had more fine-tuning options and didn't need to create a new layer.

 To produce a monochrome version of a color image, create a virtual copy of the original (select the image and enter Ctrl/ ⌘ - ' or use Photo ▸ Create Virtual Copy). A virtual copy refers to the original image but saves its own set of adjustment parameters in the Lightroom database, enabling you to freely make global and local corrections.

 Isolating the subject from the background (figure 10-50) is not possible using the tools in our Raw converter, so we used the Photoshop selection tools and a layer mask to perform this particular step.

14. As in all our other examples, the final steps were to save our image, create a copy, and scale and sharpen the copy for output, as described in section 10.1.

 If you are managing your images in Lightroom, you can always hand an image back to Lightroom and apply the appropriate scaling and output sharpening steps there.

Figure 10-49 shows the finished color version of our image, which we sharpened on a new combined layer using the Smart Sharpen filter. The layer stack for the finished image is shown in figure 10-48. Figure 10-50 shows the black-and-white version, which we isolated from the background using a layer mask.

[10-48]

The layer stack for figure 10-49. The Curves-based increase in contrast and the black-and-white conversion layer group are hidden.

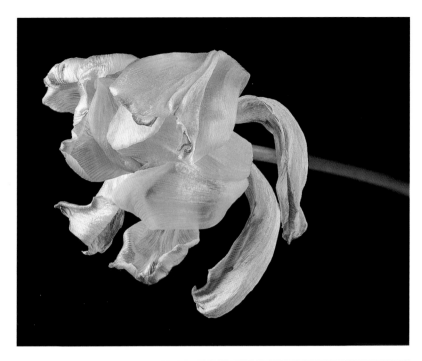

[10-49]
The finished color image

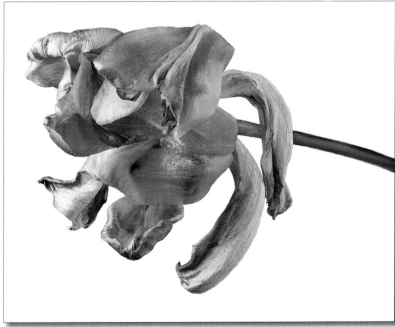

[10-50]
The monochrome version.
This version no longer required the black
background to provide contrast, so we
isolated the subject using a mask.

10.4 Adding Atmosphere Using Textures

* Check out
www.flickr.com/photos/wmphotograph/
for more samples of Werner's work.

The photos and processing idea for this example were provided by my colleague Werner Mayer.* The original material here comprises an outdoor portrait (figure 10-51) and a macro shot of a cobweb on a tree (figure 10-52). Both shots were captured in Raw format.

At the beginning of the process, we only had a vague idea of how we wanted the finished image to look, and we fine-tuned the overall look and feel as we went along. The following section details the steps we took and our considerations at each stage of the process.

[10-51] The portrait image

[10-52] Macro shot of a cobweb on a tree

Using a Raw Converter

All the adjustments we made at the Raw conversion stage could have been made using Photoshop layer techniques, but performing them in the Raw converter environment helped prevent loss of image quality and saved a lot of disk space. Both programs can process JPEG files if necessary.

[10-53] The image following step 2

1. Both source images were captured in Raw format using a Sony Cyber-Shot DSC-R1 bridge camera. We handed the Raw files over from Adobe Bridge to Adobe Camera Raw (ACR) using the Ctrl/⌘-R shortcut.

2. We began by darkening the portrait to make it look more mysterious. In Adobe Camera Raw, this involved setting *Blacks* to –100 and *Whites* to –53 (figure 10-53).

3. To give the image a softer look, we set a negative *Clarity* value and used the *Vibrance* slider to significantly reduce color saturation. These types of adjustments provide a lot of potential for creative experimentation.

Save usable versions as snapshots so that you can refer back to them later if necessary. Figure 10-54 shows the Basic settings we used to produce figure 10-55.

4. We used the Adobe Camera Raw Adjustment Brush tool 🖌 to locally brighten and darken selected image areas. We used a total of three pins with settings for brighter, darker, and brighter with increased contrast. Once again, experimentation is key, and don't forget that you can undo recent brush strokes by painting with the Alt key pressed. If you are unhappy with a complete step, simply delete the pin and start again. As in many of our previous examples, we recommend that you work with a low Density value (20–25%) and build up a correction slowly using multiple brush strokes. This approach enables you to produce precise adjustments and allows you to take a break and check the results between brush strokes. Don't just use the *Exposure* slider to adjust the look of selected images areas; use the *Contrast*, *Shadows*, *Highlights*, *Clarity*, and *Saturation* sliders to vary the effects.

5. To give our image an enigmatic, vignetted look while not darkening the center of the frame too much, we increased *Exposure* by +0.50 EV and added a vignette effect to the edges. This resulted in the image shown in figure 10-55, which we then handed over to Photoshop as a Raw Smart Object. (Pressing the ⇧ key in Adobe Camera Raw turns the `Open Image` button into the `Open Object` button. Click this button to load the current image as a Photoshop Smart Object.)

Opening a Raw Smart Object embeds an independent copy of the original image in the Photoshop file, enabling you to perform non-destructive adjustments without using too much memory or disk space.

[10-54] The Basic settings used to produce figure 10-55

[10-55]

The image, as handed over to Photoshop from Adobe Camera Raw (as a Smart Object)

In Photoshop

In spite of the versatility of today's Raw converters, we still needed Photoshop to perform the complex masking and merging steps involved in this example.

6. This step added a texture overlay using the File ▸ Place command. The image from figure 10-52 is placed above the portrait.

7. If the texture layer requires resizing, rotating, distorting, or repositioning, the Free Transform command (Ctrl/⌘-T) is the best tool to use. Make sure that the canvas is large enough to perform any transformations that you are planning. The slight loss of quality that transformations produce is not really an issue when you are working with texture layers and, because we are working with Smart Objects, the quality losses caused by multiple adjustments don't accumulate.

 To ensure that we could see when the cobweb was correctly placed over the portrait, we used *Screen* blending mode, although we could have used reduced opacity instead. Always take the time to experiment with different blending modes when you work on fantasy images like this.

[10-56] The portrait and cobweb loaded as layers with an additional texture mask

8. We then used a mask on the texture layer to darken or hide the parts of the texture that were still too bright (see the layer stack shown in figure 10-56). The image now looks like figure 10-57.

[10-57]
The image following step 8

9. There is still room for increased contrast (i.e., darker shadows and brighter highlights), so we applied a classic S curve using the Curves (figure 10-58) in *Soft Light* blending mode.

[10-58]

The effect of using the curve shown above

10. We used a Levels adjustment to increase the overall tonal range and in-
 crease definition. Pressing the [Alt] key while adjusting Levels settings dis-
 plays potentially clipped areas in the preview window.

[10-59]

Adding a Levels adjustment

11. The image is now approaching the state we had in mind at the start, but
 it can still do with a little dodging and burning to emphasize a few se-
 lected details. We used an Action that we recorded earlier to create a new
 Dodge & Burn layer group containing two 50% gray layers in *Overlay* mode.
 We used a white brush to dodge on the upper layer and a black brush to

burn in parts of the lower layer. One layer would probably have sufficed, but using two enabled us to set the opacity and blending mode for each separately, giving us more control over the final effect. We set our *Dodge* layer to *Soft Light* mode to give it a more diffuse look.

We used a hard, white brush on the *Dodge* layer to add some subtle lighting accents. How you approach an adjustment like this is, of course, a matter of personal taste. The mask we created looked like figure 10-60.

[10-60]
We used a custom hard white brush to produce bristlelike traces on our *Dodge* layer. Using *Soft Light* mode attenuated the hardness and made the layer's effect slightly more diffuse.

12. With the exception of output sharpening, our image is now finished and can be saved. Figure 10-61 shows the final result.

[10-61]
The finished image

The layer stack for figure 10-61 shows an additional Smart Sharpen step that we performed as described on pages 266 and 267.

The slightly modified version of the image that we used for this chapter's header (on page 260) was mirrored to fit the page layout.

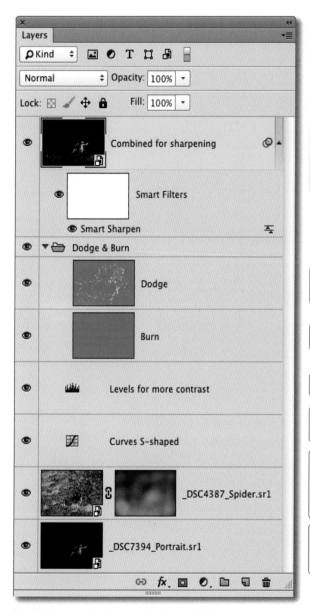

Ⓖ Final sharpening on a new combined smart layer using the Smart Sharpen filter. The sharpening settings depend on output size and medium. Smart Sharpen enables us to sharpen less in shadows and highlights. The blending mode is set to *Luminosity*.

Ⓕ The Dodge layer in *Soft Light* mode, adjusted using a custom hard white brush.

Ⓔ The Burn layer in *Overlay* mode (in this case it was unused)

Ⓓ A Levels adjustment increases tonal range and contrast.

Ⓒ An S curve increases midtone contrast and slightly darkens the shadows.

Ⓑ The texture image, also loaded as a Raw Smart Object. *Screen* mode provides the right blending effect, while the mask protects parts of the portrait from unwanted effects. The texture file was appropriately scaled and distorted.

Ⓐ The original (Sony Raw) image, opened as a Smart Object. This embeds a copy of the original in the Photoshop file and enables subsequent changes to adjustments.

[10-62] The complete layer stack for figure 10-61

10.5 Death Valley in Black-and-White

Death Valley National Park in California has always attracted photographers. The lowest point in the park is at 282 feet below sea level, which means the temperature can be as high as 133 degrees Fahrenheit. The valley is surrounded by high mountains and consists mostly of desert, but it still offers a wide variety of views and photo opportunities. Our original image for this example (figure 10-63) was captured there. The image is pale and lacks impact, making it an ideal candidate for conversion to black-and-white.

[10-63]
The original image is pale and colorless, and it lacks impact

But before we go ahead with our conversion, here are a few steps we took to enhance the original (Raw) color image:

The Steps in Adobe Camera Raw

The following adjustments were quick and easy to perform in Adobe Camera Raw (ACR), but they could have been executed in Photoshop:

[10-64] Increasing midtone contrast

1. We began by straightening the horizon and cropping some of the foreground using the Crop tool.

2. We used a graduated ▊ filter to darken the overexposed sky and enhance the detail in the clouds. We set *Exposure* to –1.35, *Contrast* to +21, and *Clarity* to +35. This type of adjustment is much easier to perform at the Raw conversion stage than on TIFF and JPEG files in Photoshop.

3. Applying a slight *Medium Contrast* S curve (figure 10-64) increased the contrast. The power of successful monochrome images usually depends on the contrast they contain and the feeling of abstraction it creates. To enhance this effect, we set the Clarity to +15.

4. We then reduced the luminosity in the sky and increased the saturation using the Targeted Adjustment tool 🔘 and the adjustments located in the *HSL/Grayscale* tab (▤).

 This produced implausible blue and magenta tones (figure 10-66). However, since we will convert this image to monochrome, the colors are not really an issue.

5. The overall microcontrast was deliberately high, but it was still too strong in the foreground, so we applied the Graduated Filter 🔘 to cover the area from the lower edge of the frame to the foot of the nearest range of mountains and set *Clarity* to –35 to soften the effect.

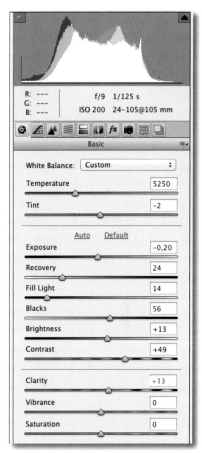

[10-65] The *Basic* settings we used in Adobe Camera Raw

[10-66] The adjusted beige, brown, and pink tones have become more realistic, but the blues and magentas are now completely over the top.

6. Adobe Camera Raw and Lightroom both include great black-and-white conversion functionality, and both offer an even greater range of sliders for fine-tuning compared to Photoshop's *Black & White* tool. Performing the conversion in the Raw converter environment once again saves disk space and gives us the advantage of a non-destructive conversion, so we proceeded using the *Convert to Grayscale* option in the Adobe Camera Raw *HSL/Grayscale* tab (▤). We also used the Targeted Adjustment tool 🔘 to darken the sky and soften the magenta tones in the hills directly beneath the sky.

 The image is now finished and ready to be handed over to Photoshop as a Smart Object.

In Photoshop

We could have used Adobe Camera Raw or Lightroom to give our image its finishing touches, but we decided to take Photoshop for a final spin.

[10-67]
Our image as it was handed over to Photoshop

7. The final stages involved slight selective dodging and burning, which we performed on a new 50% gray layer set to *Overlay* mode. We set opacity to 15% and the Range option to *Midtones* before using the Burn 🖐 and Dodge 🔍 tools to darken and lighten the remaining badly exposed details.

8. We used a Levels adjustment to increase the overall tonal range, and we simply accepted the slight shadow and highlight clipping that this caused (figure 10-68).

9. The very last touch involved applying Uwe Steinmueller's DOP EasyD Plus DetailResolver script that we described in detail on page 272. Figure 10-69 shows the settings we used, and the script automatically adds an abbreviated version of theses settings to the layer's name (figure 10-71). Any remaining fine-tuning can then be performed using the script layer's opacity setting.

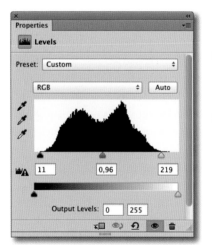

[10-68] The Levels adjustment increases the overall tonal range and increases contrast but causes slight shadow and highlight clipping

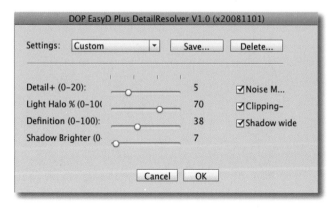

[10-69]
The settings we used for the DOP EasyD Plus DetailResolver script

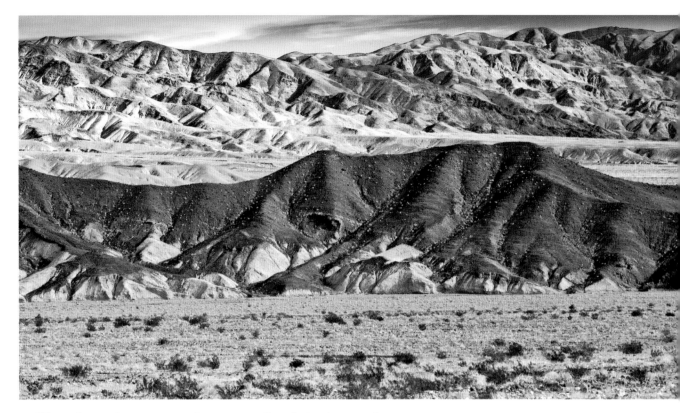

10. We used a mask to prevent microcontrast from being increased every-where. We reduced the effect in the sky and in the direct foreground. Figure 10-70 shows the finished image.

[10-70] The finished image

11. Output sharpening using Smart Sharpen, for example, is an optional last step.

[10-71]

Because most of the major adjustments took place at the Raw conversion stage (using Adobe Camera Raw 7.3), the final layer stack is quite small

Resources

A
This is a list of the references cited throughout the previous chapters. Please keep in mind that some of the URLs listed here might change or disappear over time.

Help us keep this information current by reporting missing or broken links to jg@gulbins.de.

[1] *Digital Outback Photo* is Uwe Steinmueller's website, where you can find a wealth of up-to-date information and articles on digital and analog photography:
www.outbackphoto.com

[2] To enable you to follow our examples and hone your own processing techniques, you can download most of the images used in this book from www.rockynook.com/PSL/

A.1 Recommended Books

[3] Bruce Barnbaum:
The Art of Photography:
An Approach to Personal Expression.
Rocky Nook, Santa Barbara, 2010.

[4] Christian Bloch:
The HDRI Handbook 2.0.
Rocky Nook, Santa Barbara, 2013.

[5] Juergen and Rainer Gulbins:
Photographic Multishot Techniques.
High Dynamic Range, Super-Resolution, Extended Depth of Field, Stitching
Rocky Nook, Santa Barbara, 2009.

[6] Juergen Gulbins and Uwe Steinmueller:
Fine Art Printing for Photographers, 3rd Edition.
Exhibition Quality Prints with Inkjet Printers.
Rocky Nook, Santa Barbara, 2013.

[7] Uwe Steinmueller and Juergen Gulbins:
The Digital Photography Workflow Handbook.
Rocky Nook, Santa Barbara, 2011.

[8] Harald Woeste:
Mastering Digital Panoramic Photography.
Rocky Nook, Santa Barbara, 2009.

[9] Vincent Versace:
From Oz to Kansas. Almost Every Black and White Conversion Technique Known to Man.
New Riders, Berkeley, 2013.

A.2 Useful Resources on the Internet

Please keep in mind that some of the URLs listed here might change or vanish over time.

[10] Autopano Pro (,) is a fast, effective panorama stitcher from the Kolor company:
www.autopano.net

[11] Flypaper Textures offers a broad range of downloadable textures:
http://flypapertextures.com

[12] Alan Hadley's CombineZM and CombineZP are fine focus stacking freeware programs (⊞):
http://hadleyweb.pwp.blueyonder.co.uk/CZM/News.htm

[13] HDRsoft is well known for its Photomatix Pro HDR tools (⊞,). The company's Tone Mapping tool is great for tone mapping and producing enhanced contrast effects:
www.hdrsoft.com

[14] Helicon Soft's Helicon Focus (, ⊞) is a powerful focus stacking program available in Lite or Pro versions. Helicon Remote is a great tethered shooting application:
www.heliconsoft.com

[15] Andreas Schoemann's Full Dynamic Range Tools include three tone mapping tools for download: FDRTools Basic (free, , ⊞), FDRTools Advanced (, ⊞), and the FDR Compressor Photoshop plug-in (, ⊞). His site also includes interesting articles and discussions on HDR imaging:
www.fdrtools.com

[16] Nik Software is now owned by Google and manufactures Color Efex Pro (effect filters), Silver Efex Pro for black-and-white conversion, Viveza for selective color correction, HDR Pro for HDR images, Dfine for noise reduction, and Sharpener Pro for advanced sharpening. Some Nik products have a Lightroom, Aperture, or Capture NX interface. All plug-ins are available for Windows (⊞) and Mac OS X ():
www.niksoftware.com

[17] Hugin (, ⊞) is an easy-to-use, cross-platform panoramic imaging tool set based on Panorama Tools (also known as PanoTools). PanoTools is an open source panorama stitching program available for download at:
http://hugin.sourceforge.net/

[18] PTGui and PTGui Pro (, ⊞) are panorama stitching programs:
www.ptgui.com

[19] OnOne Software offers a broad range of Photoshop, Aperture, and Lightroom plug-ins (, ⊞), one of which is Perfect Layers:
www.ononesoftware.com

[20] Topaz Labs (like Nik Software and onOne) offers a variety of Photoshop and Lightroom plug-ins:
www.topazlabs.com

[21] Zerene Stackers a very powerful focus stacking program (, ⊞,):
www.zerenesystems.com

[22] *Enfuse* and *Enblend* (, ⊞) are Open Source modules. They can be used for image blending in focus stacking and panorama applications:
http://enblend.sourceforge.net

[23] Uwe Steinmueller, coauthor of many of my books, sells a number of useful script for image tuning on his website
http://handbook.outbackphoto.com/section_photo_tuning_filters/index.html
One of the scripts I frequently use is
DOP EasyD Plus DetailResolver.

[24] AKVIS Enhancer (, ⊞) is a Photoshop plug-in for enhancing image microcontrast:
www.akvis.com

Index

Get in the Picture!